D1423026

REGENT'S
UNIVERSITY LONDON
WITHDRAWN

Superbrands

AN INSIGHT INTO SOME OF BRITAIN'S STRONGEST BRANDS 2011

superbrands.uk.com

MIX
Paper from
responsible sources
FSC® C015829

Chief Executive
Ben Hudson

Brand Liaison Directors
Anna Hyde
Liz Silvester

Brand Liaison Manager
Heidi Smith

Head of Accounts
Will Carnochan

Managing Editor
Laura Hill

Authors
Jane Bainbridge
Karen Dugdale

Proofreader
Anna Haynes

Designer
Paul Lynan

REGENT'S COLLEGE	
ACC. No.	17019269
CLASS	658.827 Sup
S.I.	
KEY	

Also available from Superbrands in the UK:
CoolBrands® 2010/11 ISBN: 978-0-9565334-0-1

To order further books, email brands@superbrands.uk.com
or call 020 7079 3310.

Published by
Superbrands (UK) Ltd
22–23 Little Portland Street
London
W1W 8BU

© 2011 Superbrands (UK) Ltd

All rights reserved.

No part of this publication may be reproduced or
transmitted in any form by any means, electronic, digital or
mechanical, including scanning, photocopying, recording
or any information storage and retrieval system relating to
all or part of the text, photographs, logotypes without first
obtaining permission in writing from the publisher of the
book together with the copyright owners as featured.

Printed in Italy

ISBN: 978-0-9565334-1-8

CONTENTS

006
Endorsements

008
About Superbrands

CASE STUDIES

A
Acer Ⓑ
adidas ©
Andrex® ©
Autoglass® ©
Aviva Ⓑ

B
B&Q ©
Barclaycard Ⓑ©
BBC ©
Beechams ©
BlackBerry Ⓑ©
Blue Arrow Ⓑ
Bold ©
Bosch Ⓑ©
BSI Ⓑ
BT Ⓑ©

C
Chartered Management Institute Ⓑ
Classic FM ©
Clear Channel Outdoor Ⓑ
CNN ©
Coca-Cola ©
Conqueror Ⓑ

D
Deutsche Bank Ⓑ
Discovery ©
Duracell® ©

E
Eddie Stobart Ⓑ
EDF Energy Ⓑ
ExCeL London Ⓑ

F
Facebook ©
Fairy ©
FedEx Express Ⓑ

G
Gatwick Express Ⓑ
ghd ©
Guinness ©

H
Hard Rock Cafe ©
Heathrow Express Ⓑ
Highland Spring ©
Howdens Joinery Ⓑ

I
ibis Ⓑ
ICAEW Ⓑ
Investors in People Ⓑ

K
Kall Kwik Ⓑ

L
Lloyd's of London Ⓑ

M
Manchester United ©
Marshalls Ⓑ
Mercedes-Benz ©
Microsoft Ⓑ©

N
Nationwide ©
Norton Ⓑ
Novotel Ⓑ

P
Pret A Manger ©
Prontaprint Ⓑ

R
Reed Ⓑ
RIBA Ⓑ
Robinsons ©
Rolls-Royce Ⓑ
Rotary Ⓑ©
RSA Ⓑ

S
Sage Ⓑ
Sandals ©
Santander ©
Siemens Ⓑ©
Silentnight Beds ©
Silver Cross ©
Skanska Ⓑ
Sodexo Ⓑ
Stannah ©
Starbucks ©
Sudocrem ©

T
Tate ©
Ted Baker ©
The Co-operative Ⓑ©
The Law Society Ⓑ

Thomas Cook ©
Tommee Tippee ©
TONI&GUY ©

V
Virgin Ⓑ©
Visa Ⓑ©

W
Warwick Business School Ⓑ
Weber Shandwick Ⓑ
William Hill ©

THOUGHT PIECES

172
The Conversation Chasm
By Tim Bourne

174
Branding from the Front Line
By Joshua Gilbertson

176
Join the Culture Club
By Adam Kaveney

178
Culture Brands
By Anna Vinegrad

APPENDIX

180
The Centre for Brand Analysis

182
Superbrands Selection Process

184
Superbrands Expert Councils

191
About YouGov

192
Superbrands Results Highlights 2011

198
Qualifying Business and Consumer
Superbrands

Key

Ⓑ Business Superbrands
© Consumer Superbrands

Endorsements

John Noble
Director
British Brands Group

This collection conveys some impressive qualities of brands. The sheer range of sectors featured, and the fact that some individual brands serve so many sectors (Virgin and The Co-operative spring to mind), stand as testament to their versatility and adaptability. The varying lengths of time they have been around (Guinness since 1759 and Facebook since 2004) shows that age is no barrier to a Superbrand.

One quality they all share is value. Delivering value to the consumer is of course what makes them a Superbrand in the first place. However, they are also immensely valuable in financial and economic terms, contributing significantly to the market value of their owners but also strengthening competition and acting as a spur to ongoing innovation. This grows markets and creates new ones, while providing better ways of living and working. Brands are worth showcasing and worth fighting for, which is why we are delighted to support this latest collection.

Chris Lenton
Chairman
The Chartered Institute
of Marketing

The Chartered
Institute of Marketing

I never cease to be amazed by the high standard and quality of the achievements of the brands listed in this book. Even in the most difficult of economic circumstances it is very pleasing to see how organisations achieve success through innovation, hard work and recognising opportunities when they arise.

These top brands are the standard setters, and individuals browsing these pages will find an organisation or a company with which they can identify and from which they can take ideas to be applied in their own businesses. I am particularly heartened to see professional bodies mentioned, rubbing shoulders as they do with such iconic consumer brands. There is not an organisation in the UK that cannot take something positive out of the brand success stories listed here, and for any student of brand management these case studies represent some of the best of examples.

Darrell Kofkin
Chief Executive
Global Marketing Network

Global Marketing Network
The new home of marketing

As the worldwide membership association for marketing and business professionals committed to raising standards in marketing practice, we are absolutely delighted to endorse and support the Superbrands Annual 2011 and the role it plays in the advancement of the marketing profession.

Marketing professionals are increasingly being seen as guardians of highly valuable corporate assets – as is evidenced by the launch of the brand valuation standard ISO 10668, which will transform the acceptance of brands and brand valuations in boardrooms and among investors. In turn, this is raising the profile both of marketing and brand management as disciplines, and of the marketing and brand directors within companies.

On behalf of everyone at Global Marketing Network, our congratulations to those people who have contributed to the achievements contained within this edition and for continuing to inspire us to develop our own Superbrands.

Professor Derek Holder
Founder &
Managing Director
The Institute of
Direct Marketing

THE INSTITUTE
IDM
DIRECT • DATA • DIGITAL

It's quite unfashionable today to talk of branding, brand marketing, brand identity or brand recognition. It smacks of old-fashioned push messages full of what marketers want customers to know about their products. Surely today, it's all about the customer.

Customer 2.0 has an opinion and a voice – along with the channels and the tools to make them both heard. Today, if brand owners want people to engage with, buy and recommend their products, they must listen to those voices and opinions and respond appropriately. But hasn't this always been the case? Haven't the successful brands of every era achieved success by providing the brand experience their customers seek?

Today's online tools give prominence to something that successful brand owners have always recognised. That a brand is about perception and branding is a dialogue. Get the dialogue right, like the brands in this book, and how you want to be perceived and how you are actually perceived will amount to the same thing.

About
Superbrands

First published in 1995, the Superbrands books investigate some of the strongest consumer and B2B brands in Britain and establish how they have managed to achieve such phenomenal success. The 2011 Annual explores the history, development and achievements of 80 much-loved brands, with each case study providing valuable insights into their branding strategy and resulting work.

Brands do not apply or pay to be considered for Superbrands status. Rather, the accolade is awarded to the country's strongest brands following a rigorous and independent selection process; full details are provided on page 182.

This publication forms part of a wider programme that pays tribute to Britain's strongest brands. The programme is administered by Superbrands (UK) Ltd and also features SuperbrandsDigital.com, a national newspaper supplement and editorial features throughout the year. The company also hosts regular events that promote networking amongst senior brand owners.

Superbrands was launched in London in 1995 and is now a global business operating in more than 55 countries worldwide. Further details can be found at superbrands.uk.com.

The Superbrands Award Stamps

Brands that have been awarded Superbrands status and participate in the programme are licensed to use the Superbrands Award Stamps. These powerful endorsements provide evidence to existing and potential consumers, media, employees and investors of the exceptional standing that these brands have achieved.

Acer was established in 1976 with US$25,000 in capital, 11 employees and the mission to break down the barriers between people and technology. Since then, Acer has successfully grown to become the second largest PC and notebook brand in the world, with the fastest growth among the top five players. Today Acer Group employs more than 7,000 people worldwide working in 70 countries. In 2009 it achieved revenues of US$17.9 billion.

Market

Over the last decade, Acer has grown from a small-scale manufacturer with a little known brand into one of the largest PC companies in the world.

Boasting a diverse product portfolio, Acer's success is largely attributed to its Channel Business Model (CBM) and it consistently invests in strategies aimed at the success of its partners.

Acer's commitment to its channel partners extends beyond product placement. By constantly monitoring business trends, Acer can tailor its entire product development and go-to-market strategies to suit the needs of specific target customers, helping the channel, as a result, to grow.

The global PC market grew by 21.6 per cent year-on-year in the second quarter of 2010. In this period Acer achieved a market share of 12.3 per cent based on total PC shipments, a 28.1 per cent increase compared with the same quarter in 2009.

Product

The company's product portfolio covers diverse areas of IT equipment for both consumers and businesses. Its PC-centric product offering includes mobile and desktop PCs, tablets, servers and storage, LCD monitors and high definition televisions, projectors and smartphones.

Sub-brands include the consumer-focused Aspire series, the commercial sector's TravelMate and Veriton, and a Ferrari model from its design partnership with the luxury motor manufacturer.

Most recently it has launched the TimelineX series notebooks, which balance lightweight credentials with up to 12 hours of battery life for all-day mobile computing; and Iconia, a dual-screen touch device that offers an innovative approach to personal computing.

Achievements

Acer has grown exponentially in recent years and has evolved into a Group with companies that have widespread success. Strategically structured and globally focused, but responsive to the needs of the markets, Acer delivered US$17.9 billion in revenue in 2009. Acer's consolidated revenue was US$5.35 billion in the third quarter of 2010. This was also a significant period for Acer as it moved from being the third, to the second largest PC brand in the world with 12.3 per cent global market share and 17.5 per cent mobile market share.

Acer has achieved this unrivalled success not only by adopting a successful CBM strategy but also by investing heavily in research and development – meaning it continues to gain recognition for its products that lead the market in terms of innovation, technology and design.

In 2010 Acer won three Computex Taipei Design & Innovation Awards for the Aspire TimelineX 3820T/TG and Aspire X series desktop PC, while the Acer Aspire Ethos 8943G notebook garnered one of only four Gold awards. The awards honour products that stand out through excellent design, with the evaluation criteria including the degree of innovation, design quality, choice of materials, environmental friendliness, functionality and brand value.

1976	1980s	1995	1996	1997	2001
Acer is founded under the name Multitech, focusing on trade and product design.	The Micro-Professor computing tool is launched in 1981; the size of a large dictionary and costing under US$100, it is an instant hit. In 1987 Multitech formally changes its name to Acer.	The breakthrough design of the Acer Aspire transforms the company from an anonymous PC manufacturer into a trendsetter.	Acer introduces the Nuovo notebook PC, featuring the innovative Heuristic Power Management system that learns the user's specific behaviour, and then distributes power accordingly.	The company acquires Texas Instruments' notebook division.	Acer adopts a new corporate identity to symbolise its commitment to enhancing people's lives through technology.

Acer is among the recipients of Japan's Good Design Awards, which have become a trademark for outstanding design and quality, internationally. Acer won for its Aspire Ethos 8943G and its Liquid Metal smartphone. A panel of 70 judges screened more than 3,000 entries from around the world on their contributions toward society, culture and the global environment.

Acer is dedicated to developing integrated sustainability and corporate social responsibility (CSR) strategies, and is committed to being a global PC and IT player that embeds CSR as a key priority. The five focal points of its environmental objectives are to fortify its Environmental Management System; strengthen green product development; expand product recycling and processing services; and strengthen both its green supply chain management and environmental communication platforms.

Recent Developments

2010 has been another significant year for Acer, with the company successfully consolidating its position as second in the global PC market, and introducing innovative new products: the Aspire and TravelMate TimelineX ranges, which deliver up to 12 hours of battery life from a single full charge, giving

the benefit of all-day computing; the Aspire Ethos 8343 and 5943 series, embodying power, style and simplicity; and Acer Iconia, a new concept tablet that combines the versatility of a conventional 14-inch form factor with a unique

dual-screen layout and intuitive all-point multi-touch functionality.

Early 2011 sees the launch of a full range of Acer tablets, supporting the company's goal to simplify content consumption. It is a strategy that began with the development of Acer's multimedia sharing system, Clear.fi, and is based on the concept of sharing and enjoying multimedia content across any device.

Promotion

Acer has always believed that sports and technology share the same ideals: strength, passion, competitiveness, coherence, skill and the determination to overcome new challenges. Acer's ability to identify strategically favourable alliances has helped make its brands recognised outside the IT industry, with high profile sponsorships representing the spirit of the Acer brand and coherent ideals.

Since 1st January 2009, Acer has been a proud Worldwide Partner of the Olympic Movement, including the Vancouver 2010 Winter Olympics and the London 2012 Olympic Games. Created in 1985, The Olympic Partner programme is the only sponsorship with exclusive worldwide marketing rights to both Winter and Summer Games, and gives leading corporations the opportunity to support the staging of the Olympic Games and the development of sustainable sport.

Acer's collaboration with Scuderia Ferrari began in 2003 and has enabled the two companies to introduce distinctive Ferrari licensed products featuring cutting-edge technology pioneered and perfected in the world of Formula 1. Today, products include notebooks, LCD monitors and smartphones, all engineered to conjugate state-of-the-art performance and distinguished design.

The brand's other key sponsorships include FC Internazionale Milano and London Wasps.

Brand Values

In 2006, Acer celebrated 30 years of long-term growth in the fast-paced IT industry. The Acer Group remains firm in its commitment to develop easy-to-use and reliable products. Its mission is 'Breaking the barriers between people and technology' through the creation of empowering hardware, software and services. It is committed to designing IT products that improve usability and add value to its customers' needs – be it at work or leisure.

It also believes that innovation is not the mere creation of new technologies and solutions, but the guarantee that users receive the benefits of these developments, and feel truly empowered.

Things you didn't know about Acer

Acer developed one of the first IBM-compatible computers.

Acer was founded in 1976 under the name Multitech, focusing on trade and product design. The company had just 11 employees and US$25,000 of capital.

Acer sells an average of 57 million devices in a year.

Acer introduced the world's first 3D notebook in 2009.

2003	2007	2009	2010
The next-generation Empowering Technology platform is launched, integrating hardware, software and service to provide easy-to-use, dependable technologies.	Acer completes the acquisition of Gateway, eMachines and Packard Bell. The following year it implements a multi-brand strategy to exploit awareness of Acer and its acquired companies.	Acer becomes the world's number two company in the PC market.	Acer Inc. and China's Founder Group sign a memorandum of mutual understanding, to enhance ITC business in China.

≡ adidas®

When Adolf 'Adi' Dassler founded adidas in 1949 his goal was to provide every athlete with the best possible equipment. The three-stripe motif has since become one of the world's most instantly recognisable brands. Comprising two divisions that reflect two distinct market segments – Sport Performance and Sport Style – the brand is driven by its belief that 'impossible is nothing'.

Market

The sporting goods market is dominated by a few global brands including adidas. In addition there are various smaller players as well as a growing number of traditional fashion labels that are trying to enter the market.

It is adidas' ambition to be the leading sports brand in the world, by providing unique product concepts spanning apparel and footwear for professional athletes through to sports-inspired premium fashion. adidas' commitment to product innovation and its rich heritage differentiates the brand from competitors and provides a solid platform for future growth.

Product

adidas products are divided into two distinct market sectors: Sport Performance and Sport Style. The guiding principle of the adidas Sport Performance division is to help athletes achieve the 'impossible' by equipping them with the best products on the market. While adidas Sport Performance brings its passion for groundbreaking products to athletes across the sporting spectrum, it focuses on four key categories: football, running, training and basketball.

Sport Style, the brand's style division, offers creative and inspirational products, from street fashion to high fashion. The division encompasses: Originals – vintage clothing, retro shoes and urban wear that blend timeless 1970s and 1980s designs with sports styles;

the Fashion Group – heralded as the future of sportswear, including Y-3 and Porsche Design Sport; and adidas NEO – marketed as a fresh, young and accessible, sport-inspired label.

Achievements

As Official Sportswear Partner for London 2012, adidas will design and produce the official kit for Team GB and ParalympicsGB. The partnership underpins its long heritage with the Olympic and Paralympic Games that stretches back to 1928.

In July 2010, adidas announced the appointment of leading British fashion designer Stella McCartney as creative director for its adidas Team GB ranges, overseeing the design of both athlete kit and fan wear for the adidas brand. It is the first time in the history of the

1928	1949	1970	1982	1995	1996
Adi Dassler equips Olympic athletes with shoes for the very first time.	adidas is registered as a company, named after its founder: 'Adi' from Adolf and 'Das' from Dassler.	adidas introduces the Telstar ball for the FIFA World Cup™. It features 32 hand-stitched panels and is the first white football to be decorated with black pentagons.	The Copa Mundial is launched. It will go on to become the world's best selling football boot.	adidas goes public with the flotation of the company on the Frankfurt and Paris Stock Exchanges.	At the Atlanta Olympics 6,000 athletes from 33 countries wear adidas, winning 220 medals between them.

Brand Values

adidas is the first genuine sports brand, founded by a true athlete whose one guiding principle was to create equipment that makes athletes better. It is this ethos that made Adi Dassler authentic then, makes the adidas brand authentic today and will continue to do so tomorrow.

Passion is at the heart of sport and it is this same passion that guides the adidas brand, ensuring it continues to innovate in every area of business.

adidas is determined to ensure its commitment to athletes and sport is uncompromised, unwavering and forever. It will continue to sponsor, advise, listen and support with the same resolve as Adi Dassler.

Summer Games that a top fashion designer has worked with a leading sports brand to design competition wear for both the national Olympic and Paralympic Teams.

In conjunction with its sponsorship of the London 2012 Games, adidas has introduced a community participation initiative called adiZones, which has seen the installation of local community multi-sports areas – in the shape of the London 2012 logo – across the UK. The 40 adiZones have been introduced to break down barriers to sports participation and to make physical activity more accessible; they are free to use and are open all day, every day. Inclusive to all but targeted at engaging youth, the adiZones are intended as a clear sporting legacy from the Games.

Recent Developments

The new adidas F50 adiZero – the lightest football boot ever made, weighing only 165g – debuted at the 2010 FIFA World Cup™ in South Africa. Worn by some of the world's most skilful players, such as Lionel Messi, David Villa, Thomas Müller and Diego Forlán, the boots played their part in 43 goals – more than double that of any other boot at the tournament.

The award-winning miCoach device was also launched in 2010. miCoach is an interactive training system that motivates athletes to reach their individual training goals – just like a personal coach. The real-time training aid keeps its user at the correct level of activity for their heart rate. In 2010 the smartphone miCoach app won Stuff magazine's Mobile App of the Year award.

Promotion

Following on from House Party in 2009, adidas continued to 'Celebrate Originality' in 2010 with The Street Party brand campaign, featuring David Beckham, Mr Hudson, Agyness Deyn, Snoop Dogg and Noel Gallagher.

To promote its sponsorship with the 2010 FIFA World Cup™, adidas also created one of the year's most viewed YouTube videos with the Star Wars Cantina creative, which featured a host of stars including Snoop Dogg, Daft Punk and David Beckham. Launched in the build up to the first England World Cup match, Cantina became an overnight success with more than 4.6 million views on YouTube.

Jonny Wilkinson, Jess Ennis, Andy Murray and David Villa, meanwhile, came together to promote the launch of the miCoach app. The television campaign saw the athletes in training using the real-time coaching device.

To promote the association between Lionel Messi – arguably the best football player in the world – and the adidas F50 football boot, adidas flew Messi into London for a day of activity that kicked off with his surprise appearance on Hackney Marshes, arriving by helicopter.

During November and December 2010, adidas Originals celebrated London talent through its We Are London campaign: its biggest ever campaign in the capital, featuring emerging local talent and star artists such as Bashy, Scorcher, Devlin, Loick Essien and Maxsta. We Are London aimed to celebrate the diversity of 'young London' through interactive sounds and sights.

Things you didn't know about adidas

In December 1970, Muhammad Ali fought Argentinean boxer Oscar Bonavena in New York's Madison Square Garden. For this fight, Ali asked adidas to produce a special boxing shoe just 24 hours before the fight started – a shoe inspired by the elegant movements of female dancers. The solution: a unique three-stripe boot with red tassels.

In 1986, Run-DMC released 'my adidas', a song about adidas trainers called Superstar. The song helped to make the trainers not just culturally acceptable but a true fashion statement.

As Official Sportswear Partner of the Beijing 2008 Olympic Games, adidas supplied more than three million products to federations, volunteers, officials and others. Shoes for 27 different sports were created as part of the Made For Beijing range.

1997	2005	2006	2010
adidas acquires the Salomon Group and the brands Salomon, TaylorMade, Mavic and Bonfire, becoming adidas-Salomon AG.	The Salomon Group is sold. The new adidas Group focuses on its core strength in the athletic footwear and sportswear markets as well as the growing golf category.	Reebok is acquired, marking the start of a new chapter in the history of the adidas Group.	On the back of a successful 2010 FIFA World Cup™, adidas further strengthens its leadership in football by reaching sales in excess of 1.5 billion euros.

It's The Little Things

For more than 40 years Andrex® has been the nation's favourite toilet tissue. The Andrex® Puppy, recently voted the UK's most loved brand icon, has embodied the brand's strong, caring and fun-loving nature since first appearing on television screens in 1972. Andrex® continues to lead the market by providing high quality tissue, outstanding value and relevant product innovation for consumers, young and old.

Market

As a household essential, toilet tissue is one of the UK's largest grocery product categories – and it is increasingly growing in terms of product innovation and competition. The toilet tissue category in the UK is worth more than £1 billion and is dominated by mainstream white products, which account for 55.8 per cent by volume (Source: Nielsen Scantrack 27th November 2010). The premium sector is showing strong volume growth at 11 per cent, driven by luxury quilted, lotioned and moist variants (Source: Nielsen).

By constantly providing new product innovation to satisfy consumer needs, Andrex® has maintained and strengthened its position as the branded market leader, growing both its value and volume shares of dry and moist tissue in 2010 by circa one per cent (Source: Nielsen).

Product

Andrex® offers a wide range of toilet tissue variants that cater for a diverse set of consumer needs, from Andrex® Mainline – the soft, strong and long product for the whole family – through to the kids' Puppies on a Roll tissue, which is extra soft, embossed and decorated with a playful Puppy design.

Andrex® Quilts, launched in 2005 and sitting in the premium segment of the category, was developed as a result of consumer research identifying a desire for a toilet tissue with greater cushioning. In March 2010 the tissue was upgraded to 4-ply, adding an additional embossed layer of quilting. This was followed in November by its rebrand to Andrex® Gorgeous Comfort, aimed at fully reflecting the product's key attribute.

Similarly, Andrex® Aloe Vera was relaunched in October 2010 as Andrex® Skin Kind, the new name highlighting the benefit of the lotioned toilet tissue with its rippled texture base sheet that glides smoothly against skin.

Launched in 2009, Andrex® Shea Butter is enriched with shea butter lotion and is positioned as being the most luxurious and indulgent variant in the Andrex® portfolio. A textured, lotioned toilet tissue, it has a scented core that adds another sensory level to reinforce the product's premium status.

Andrex® Fresh moistened toilet tissue continues to drive incremental category growth. Lightly moistened and fragranced flushable sheets, they are designed for use after normal toilet tissue for an even cleaner feeling. The range also includes Andrex® Kids with puppy-embossed sheets.

Achievements

Andrex® has been the leading brand in the toilet tissue market since 1961. The brand grew

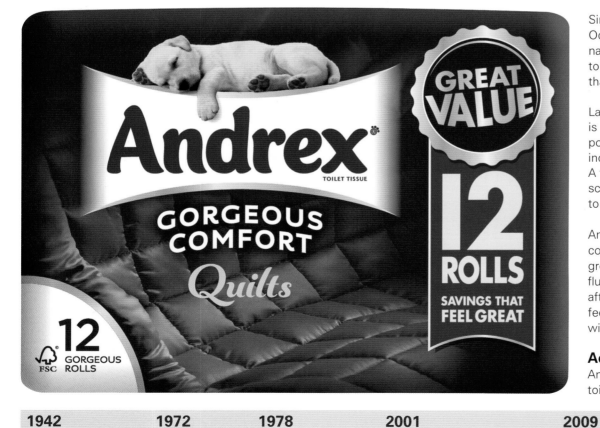

1942	1972	1978	2001	2009	2010
Andrex® toilet roll is first launched.	The first Puppy advert airs.	Andrex® is granted a Royal Warrant.	Andrex® Aloe Vera launches as the brand's first premium toilet tissue. This is followed in 2005 by a second premium product: Andrex® Quilts.	A third premium product launches: Andrex® Shea Butter.	In November Andrex® launches a new communications platform, 'It's The Little Things', along with a 21st century makeover for the Andrex® Puppy.

by more than £2.5 million from 2009 to 2010, achieving a 32.4 per cent value share and 25.2 per cent volume share of the dry toilet roll market (Source: Nielsen). Its market success is echoed in the plethora of product, packaging and advertising awards that the brand has received over the past 20 years.

Recent wins include Household Paper Product of the Year 2007 for Andrex® Quilts; Household Paper Product of the Year 2009 for Andrex® Mainstream; and Kids' Hygiene Product of the Year 2009 for Andrex® Kids. Andrex® Shea Butter, meanwhile, claimed the 2009 Gramia Packaging Award, with its Pour le Pup campaign winning the Gramia Best Consumer Press Award in the same year.

An instantly recognisable brand emblem, the Andrex® Puppy was recently voted Britain's all time favourite advertising icon by Marketing magazine, and its resonance with consumers has been put to good use in numerous charity partnerships. In recent years Andrex® has teamed up with pop group McFly to support The Teenage Cancer Trust, donating £1.50 from every sale of a special edition Winter Puppy to the charity. The partnership won a Third Sector Excellence Award for Best Corporate Partnership in 2009. Similarly, in 2007 sales of limited edition Red Nose Day Puppies raised £425,000 for Comic Relief.

Guide Dogs for the Blind and Dogs for the Disabled have also benefited from the sale of special Puppies and in 1999, the Andrex® Puppy Appeal raised £110,000 for the National Canine Defence League.

The latest Puppy partnership, in September 2010, saw Andrex® work with Tesco to support children's cancer charity CLIC Sargent, with £1 from the sale of each limited edition Puppy donated to the charity.

Recent Developments

In November 2010, Andrex® launched its new communications platform: 'It's The Little Things'. Andrex® realises that in today's busy lifestyles its the little things that make a difference, yet are often forgotten. 'It's The Little Things' will be at the heart of everything the brand now does, demonstrating to consumers that Andrex® toilet tissue is one of those little things in life that can make a difference.

Supported by a £15 million marketing campaign, the new look and feel for the Andrex® brand revealed the Puppy's first makeover since 1972, utilising computer-generated technology and giving an insight into the Puppy's World. Further executions of 'It's The Little Things' and Puppy World are in development, to be rolled out across marketing for the entire product portfolio.

Promotion

The renowned Andrex® Puppy advertising has been in place for nearly 40 years and ensures the brand is instantly recognisable.

Today the brand's promotions continually evolve to keep pace with consumers' ever-changing needs and new communication channels, with the success of the Andrex® Puppy page on Facebook the latest example of this. Within its first year the page attracted more than 180,000 fans, and the number is steadily growing.

In 2009 Andrex® launched Andrex® Shea Butter, its most premium toilet tissue to date. Andrex®

enlisted the help of former Atomic Kitten singer Liz McClarnon to model exclusive and luxurious 'Shea Butter Knickers'. The project raised money for the Look Good...Feel Better charity, which runs skincare and cosmetic workshops for women undergoing cancer treatment.

Brand Values

The Andrex® Puppy stands for many of the quality cues of Andrex® toilet tissue, such as softness and strength, yet also strives to tap into the emotional positioning of family and friendship value, encompassing charm, trust, care and mischievousness. The new communications platform, 'It's The Little Things', will be at the heart the brand, demonstrating to consumers that Andrex® toilet tissue is one of the little things in life that makes a difference.

Things you didn't know about Andrex®

One in 10 homes in the UK and Ireland owns an Andrex® Puppy cuddly toy, which equates to six million Puppies.

Andrex® is the UK's number one non-food brand (Source: The Grocer 2010).

Andrex® sells 29 rolls of toilet tissue every second – that's enough rolls to go twice around the earth every day.

The Andrex® Puppy has been voted Britain's favourite advertising icon by Marketing magazine.

Since 1972 there have been more than 120 adverts starring the Andrex® Puppy.

Autoglass® is a leading consumer automotive service brand, providing vehicle glass repairs and replacements to more than 1.5 million motorists every year. With the widest reaching auto glazing network in the UK and Ireland, Autoglass® has over 100 branches nationwide and 1,300 mobile service units operating 24 hours a day, 365 days a year. Autoglass® is part of Belron® group, operating in 33 countries with a team of more than 10,000 highly skilled technicians.

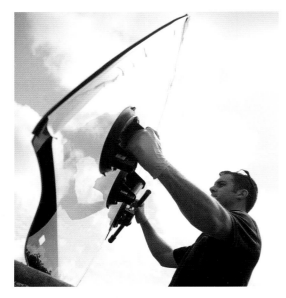

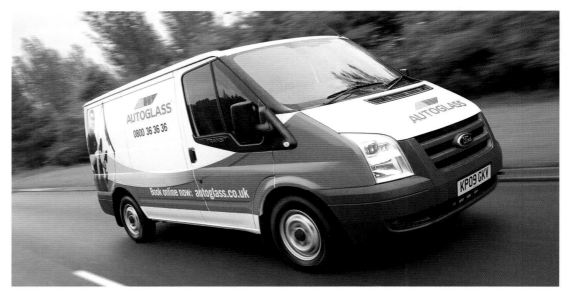

Market

Over the last 20 years, windscreens have evolved to play an integral role in modern automotive design and today's cars typically use 20 per cent more glass than in the 1980s. Windscreens can also incorporate complex technology such as rain sensors, wire heating and satellite navigation components. The latest BMW 3-Series, for example, has 12 variations and the 5-Series has nine. Specialist skill is required to ensure they are repaired and replaced to the highest safety standards and that's where Autoglass® excels. The company is the UK's market-leading auto glazing expert.

Product

Quite simply, Autoglass® fixes broken vehicle glass on any make, model or age of vehicle. The company operates a 'Repair First' philosophy ensuring that wherever possible, its technicians

will repair a chipped windscreen rather than replace it so that the existing seal doesn't have to be disturbed; a safe solution that saves time, money and is better for the environment.

If the damage is beyond repair, Autoglass® will replace the windscreen. It only uses glass manufactured to original equipment maker (OEM) standards, whether sourced from original manufacturers or other suppliers, ensuring that each replacement windscreen is as good as the original and a perfect fit for the vehicle. It also uses one of the quickest drying bonding systems for safety and customer convenience. As part of its commitment to the environment, Autoglass® reprocesses any laminate screens it removes.

Appointments can be made by phone or online and customers can choose to take their vehicle into their local branch or arrange for one of the

company's 1,300 mobile technicians to come to a location of their choice.

Achievements

Thanks to its focus on delivering a first-class service, in 2010 Autoglass® was awarded the prestigious Regional Training Award by UK Skills for its high standards in training and for setting an example in skills development to UK industry.

Other accolades include a number of independent awards, including two National Training Awards, a Glass Training Ltd (GTL) Commitment to Training Award and the Insurance Times Training Award. In addition, Autoglass® holds ISO 9001 quality certification.

Because a windscreen accounts for 30 per cent of a vehicle's structural strength, Autoglass®

1958	1982	1983	1990s	2002	2005
FW Wilkinson is founded. In 1973 it becomes Autoglass Ltd and opens headquarters in Bedford.	Autoglass becomes part of Belron®, the world's largest vehicle glass repair and replacement company, extending its UK service into all five continents.	Autoglass Ltd merges with Bedfordshire-based Windshields Ltd and becomes Autoglass Windshields, rebranding to Autoglass in 1987.	In 1990 the windscreen repair service is launched. In 1994, Autoglass® becomes a registered trademark after a seven-year IP registration process.	Carglass Ireland rebrands to Autoglass®.	Autoglass® launches the Heroes radio campaign, using real Autoglass® technicians to explain the benefits of repairing windscreen chips.

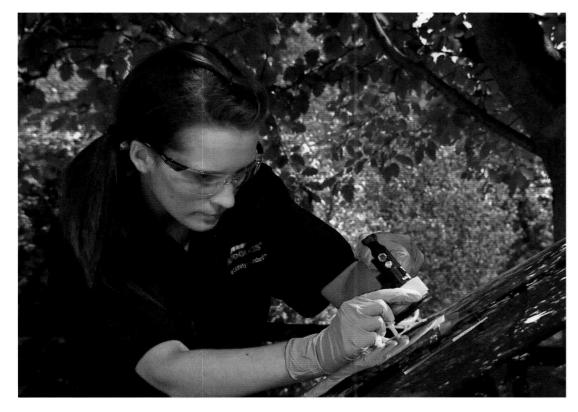

places considerable emphasis on training its technicians to ensure every screen is fitted safely. It remains the only company in its industry to have achieved accredited status from Thatcham and the Institute of the Motor Industry (IMI) for its National Skills Centre in Birmingham and its Startline Induction and Repair training programmes.

Recent Developments

Autoglass® has demonstrated its commitment to raising standards within its sector by becoming the first to introduce the Automotive Technician Accreditation (ATA) scheme. Under the ATA, technicians work towards three accreditation levels dependent on knowledge, skills and experience, ultimately leading to Master Auto Glazing Technician status.

Autoglass® takes an innovative approach to delivering work of the highest standard. The newly introduced Ezi-wire, for example, helps technicians safely remove the glass from the

windscreen and enables them to carry out their job both safely and professionally.

The Lil' Buddy, an innovative lifting and positioning device, has delivered many benefits and has encouraged more women to consider a career as an auto glazing technician; Autoglass® now employs 22 female technicians.

Autoglass® has also established a team of 'home workers' to provide greater flexibility for its customer contact centre workforce, enabling it to maintain call quality throughout peak periods of demand.

Promotion

Autoglass® became a household name in the 1990s after becoming the main sponsor of Chelsea Football Club. Since then it has invested in a number of high profile brand campaigns to ensure it remains at the forefront of motorists' minds.

In 2005 Autoglass® launched the Heroes radio campaign, using real Autoglass® technicians to explain the benefits of repairing windscreen chips. The campaign has become the most successful in Autoglass® history, helping to boost brand recognition and drive contacts via the call centre and website up by 20 per cent.

The campaign took double honours at the 2007 Media Week/GCap Radio Planning Awards, winning the award for Outstanding Campaign Above £250,000 and the Grand Prix for Most

Outstanding Radio Planning. In 2008 it went on to win the Effectiveness Award for Campaign with Best Results.

In April 2008 the firm brought the award-winning radio concept to TV with a super-heavy-weight campaign. The advert shows real life Autoglass® technician Gavin, the popular voice of the company's radio campaign, explaining the importance of getting windscreen chips repaired and highlighting the quality and safety benefits of the Autoglass® service. This campaign has continued into 2010, delivering record numbers of enquiries.

The brand has reinforced the Heroes concept on the firm's new van livery and website, which feature a variety of technicians from across the country. In addition the Heroes are featured on the Autoglass® Facebook page.

Brand Values

The Autoglass® vision is to be the natural choice through valuing its customers' needs and delivering world-class service. Its brand values are: Teamwork, Improvement, Care, Excellence and Trust.

Things you didn't know about Autoglass®

Autoglass® doesn't just repair chipped windscreens; it has even repaired a chip on the viewing glass at the tiger compound at Glasgow Zoo.

The jingle used in the Heroes adverts has been translated into 12 different languages and is now used by Belron® subsidiaries in 20 countries.

During 2009, the Autoglass® 'Repair First' philosophy resulted in savings of around 7,500 tonnes of CO_2 equivalent emissions and almost 3,000 tonnes of waste glass.

2007	2008	2009	2010
Autoglass® becomes the first windscreen repair and replacement company to offer online booking at autoglass.co.uk.	Autoglass® launches its first ever TV adverts and Lil' Buddy is introduced into its workforce.	The Heroes campaign is extended to the website and outdoor advertising with the introduction of new van livery. Ezi-wire is also introduced into the Autoglass® workforce.	The first female Autoglass® technician appears in the Heroes TV campaign and the brand sponsors the Sky Sports News bulletin. A Facebook page and Twitter presence also launch.

AVIVA

Aviva is the world's sixth-largest insurance group and the largest insurance services provider in the UK. While its core activities are long-term savings, fund management and general insurance, Aviva's 46,000 employees – including more than 20,000 in the UK – offer a diverse portfolio of services to some 53 million customers in 28 countries.

Market

In addition to being the key provider of life insurance, pensions and long-term financial services in the UK, with a market share of around 10.8 per cent, Aviva is also one of the leading European market players. 2010 saw continued strong profitability and good sales growth from both its life and general insurance businesses. As the brand heads towards the next phase of its growth, the company strategy is to focus on these key sectors. By deepening its position in these prime markets the brand is well placed to become one of the world's leading insurers, capitalising on the benefits of running life insurance, general insurance and asset management under one strong global brand.

Product

Aviva has grown from the merger of a number of businesses to become a key player on the global insurers market, providing a wide range of products that includes retirement and investments and its composite model of long-term savings and general insurance. Over the past 10 years more than 40 brands have migrated to the Aviva name, with its incumbent brands, Norwich Union, Hibernian and Commercial Union, completing the process in 2009/10.

While Aviva's life and general insurance businesses are successful in their own right – each with strong market positions, good growth prospects and attractive returns – there are clear benefits to combining them under one global brand. Aviva's expertise in both sectors means it can offer customers complete protection under a single trusted brand. It also makes Aviva an attractive business partner.

Aviva is the largest 'bancassurance' provider in Europe; meaning more European banks choose to sell its insurance products over other providers. Sales through banks in Aviva Europe increased by 20 per cent in 2010 against the same period the previous year.

Achievements

Aviva was the first insurer to announce its intention to carbon neutralise its global operations, setting the standard for other businesses to follow suit.

Since 2002 Aviva has cut building and travel-related CO_2 by 54 per cent. Aviva has long promoted effective corporate response to climate change and more recently become a signatory to the United Nations Principles of Responsible Investment and the Institutional Investors' Statement on Climate Change.

Aviva's Street to School project is a five-year global commitment that underlines the brand's continued dedication to corporate responsibility. The project supports initiatives to help and encourage children living and working on the streets get back into school or training, and aims to help 500,000 children over the next five years.

Aviva is included in both the World and the Europe Dow Jones Sustainability Indexes, each of which has stringent inclusion criteria.

In 2010 Aviva was named Company of the Year at the Money Marketing Financial Services

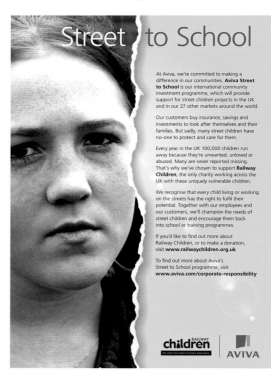

1797	1997	2000	2002	2005	2006
Aviva Insurance UK is established as the Norwich Union Society for insuring of buildings, goods, merchandises and effects from Loss by Fire.	The company changes its name to Norwich Union Insurance.	On 21st February Norwich Union plc, the holding company, merges with CGU plc to form CGNU plc.	The board of Aviva plc announces that the company has formally changed its name to Aviva.	The company acquires leading roadside and breakdown specialists, RAC plc.	Aviva announces its commitment to become the first insurer to carbon neutralise all of its operations on a worldwide basis.

In 2010 Aviva in the UK adopted a single creative vehicle to advertise products on both sides of its composite model (life and general insurance), with comedian Paul Whitehouse playing a series of satisfied Aviva customers. Historically, advertising long-term saving products and insurance together has proved difficult due the differing decision-making criteria consumers apply to each: for long-term purchases, decisions must be considered within the context of a number of years, whereas the immediacy of a short-term purchase means it is often driven by price. Amalgamating both into a successful and creative campaign demonstrates the strength of operating as one unified brand and Aviva's growing market position.

Since 1999 Aviva has sponsored UK athletics and in 2010, became the title sponsor of Premiership Rugby with the new national rugby stadium in Dublin called the Aviva Stadium. Outside the sporting arena, Aviva also sponsors ITV television drama premieres.

Brand Values
Aviva is modelled around the needs of its customers, with company values aimed at ensuring they feel understood, appreciated and respected. The company ethos combines its 300-year industry expertise with empathy to ensure that the brand promise, 'No one recognises you like Aviva', can be delivered to customers.

The overall brand aim is embedded in its values: to make recognition the familiar quality that distinguishes Aviva from its competitors anywhere in the world.

Awards, voted for by a panel of 1,000 financial advisers from around the UK.

Recent Developments
In 2010 Aviva launched its first global brand advertising campaign, You Are the Big Picture, encapsulating the core element of the brand: its commitment to the real people at the heart of Aviva – customers, employees, partners and communities. Kicking off in October in London, Warsaw, Singapore and Paris, giant portrait photographs were posted in landmark places across six key cities around the world. The innovative campaign featured real customers and employees talking in their own words about what the brand has helped them to achieve, underlining the company's commitment to engaging with customers first and foremost as people not policies.

The campaign also invited the wider public to donate photographs in return for the opportunity to have their own image projected

onto buildings. For each photograph received Aviva donated £1 to help street children in India, via Save the Children and its Street to School programme. The campaign resonated well with the public, with more than 57,000 Facebook users expressing their 'like' within its first two months.

2010 also saw Aviva team up with the Economist Intelligence Unit to convene the Future Prosperity Panel. The panel – which includes renowned thinkers from outside the financial services industry such as philosopher and author, Alain de Botton, and chair of the Royal Society for the Encouragement of Arts, Matthew Taylor – will look at the role of individuals, business and policymakers in improving future global prosperity.

Promotion
In the UK, the move from the Norwich Union name to Aviva was announced to the general public in 2009. A high profile advertising campaign starred celebrities who had changed their name and subsequently gone on to bigger and better things, such as Bruce Willis and Ringo Starr. As a result, awareness of the name change leapt from 32 per cent to 79 per cent in the space of four weeks. The unprecedented success of the campaign increased spontaneous awareness for Aviva, which now rates higher than for Norwich Union.

Leningrad to St. Petersburg
Brosnan to Craig
Norwich Union to Aviva

Britain's biggest insurer is changing its name. AVIVA

Things you didn't know about Aviva

LS Lowry, Jayne Torvill, Sir Walter Scott and Leonard Rossiter are all past employees at Aviva.

Famous customers include Sir Isaac Newton, Sir Winston Churchill and John F Kennedy.

One in three people in the UK has an Aviva product.

The RAC is also part of Aviva.

2009		2010	
Norwich Union Insurance Ltd is renamed Aviva Insurance UK Ltd, as part of the group's strategy to grow and transform on a global arena.	On 20th October Aviva begins trading on the New York Stock Exchange under the ticker symbol AV.	The brand completes its migration to the Aviva name in the UK.	Also in 2010, Aviva launches its first global brand advertising campaign: You Are the Big Picture.

B&Q is the largest home improvement and garden centre retailer in the UK, with 330 stores and 30,000 employees. B&Q strives to offer exciting and innovative products and services for the home that are good value, and to have friendly experts on hand to help. The company is part of Kingfisher plc, Europe's leading home improvement retail group and the third largest in the world.

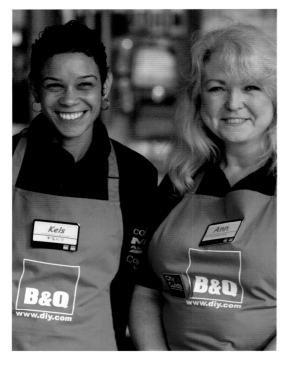

Market

The UK home improvement sector is worth £31 billion per year and B&Q is the market leader, with a 14 per cent share. B&Q has annual retail sales of £4 billion and an average of three million customers every week (Source: Kingfisher plc Annual Report 2009/10). B&Q's key competitors include home improvement retailers such as Homebase, Wickes and Focus DIY, garden centre retailers such as Wyevale, and general retailers such as John Lewis, Marks & Spencer and Tesco.

Product

B&Q's product portfolio comprises more than 40,000 home improvement and garden items.

The company also offers planning, design and fitting services. Its own brands include leading names such as Cooke & Lewis (bedrooms, bathrooms and kitchens), Colours (interior décor), Performance Power (tools) and entry-level brand, B&Q Value.

The company continues to grow its One Planet Home range of eco products to help customers reduce their energy bills and environmental impact. Indeed, B&Q is the only high street retailer offering an independently accredited eco range. The 4,000 products now account for more than 10 per cent of B&Q's total sales and include insulation, water-saving shower heads, peat-free compost, water butts, clothes lines,

LED Christmas lights, energy-saving light bulbs and minimal volatile organic compound (VOC) paint to name but a few.

Achievements

Employees at B&Q have been rated among the most engaged in the world for the fourth time running by workplace behaviour experts Gallup. B&Q is one of only six elite organisations worldwide to win the prestigious Gallup Great Workplace Award four times, and the only UK business to be awarded.

Sustainability remains at the heart of B&Q's business model, both in its business operations and its customer-facing activities.

1969	1982	1990s		2002	2004
Richard Block and David Quayle found B&Q and open the first store in Southampton. Ten years later the company goes public and has 26 stores.	FW Woolworth acquires B&Q before a takeover by Paternoster (later known as Kingfisher). A period of growth sees B&Q operating 155 stores by 1984.	B&Q begins to move away from its depot format, opening its first B&Q Warehouse in 1995, in Aberdeen. Towards the end of the decade, acquisitions and	mergers include NOMI (Poland's leading DIY retailer), Castorama (the French number one) and Dickens and Screwfix (the UK's largest hardware mail order business).	B&Q opens its first store in the Republic of Ireland. The following year its 100th B&Q Warehouse opens in Northern Ireland.	B&Q announces a four-year partnership with the British Olympic Association to sponsor Team GB. In 2005 it sponsors solo around-the-world sailor, Ellen MacArthur.

B&Q started championing the benefits of sustainability more than two decades ago with its progressive timber strategy. It has continued on this journey and in 2007 partnered with sustainability charity, BioRegional, to work towards becoming a One Planet Business. In the last three years B&Q has reduced its absolute carbon emissions by 16 per cent and its efforts have been recognised with the company gaining a place on The Sunday Times Best Green Companies list and winning The Observer's prestigious Ethical Business Award.

Recent Developments

In 2010 B&Q became the largest user of City & Guilds qualifications with two-thirds of its employees having undertaken a qualification. The retailer was the first on the high street to launch an eco qualification and to introduce Eco Advisors in its stores as part of a bid to help people 'ecovate' their homes. Staff are being qualified to City & Guilds Level 2 Diploma in Retail Skills (specialising in eco products) to enable them to help customers reduce the carbon footprint of their homes and to save money on their energy and water bills. Eco Advisors are being introduced to B&Q stores throughout 2011.

The retailer was also a proud sponsor of The Prince of Wales's 'A Garden Party to Make A Difference'; an initiative to entertain and educate visitors on how to make small steps towards sustainable living. B&Q created a number of interactive installations during the festival to bring these steps to life.

Seventy-two year-old Terry Robinson from B&Q Oxford is believed to have become the country's oldest person to complete an apprenticeship.

His training in retailing is a result of B&Q's all-encompassing apprenticeship programme, which has no upper age limit. Throughout 2011 B&Q will look to increase the number of enrolments, which in 2010 stood at 150.

The retailer has also introduced TradePoint into B&Q Warehouse stores, with an investment of around £26 million now taking the trade counter concept to 118 B&Q stores. The proposition combines the best of B&Q with the added benefits of Screwfix's ranges and logistics expertise to create a merchant environment with trade-only prices. Access is restricted to TradePoint members who have been verified as genuine tradespeople.

B&Q and Birmingham City Council scooped a Silver Flora medal for their Road to Recovery Garden in support of Help for Heroes at the 2010 RHS Chelsea Flower Show. The design was inspired by the way in which nature can help Service personnel towards recovery. B&Q supported the activity by selling a limited edition Help for Heroes petunia mix, as featured in the garden, together with distinctive wrist bands and additional fundraising, resulting in more than £180,000 for the charity.

The year also saw B&Q partner with Alan Titchmarsh, who gave his expert advice to keen and novice gardeners in a campaign designed to get more Brits gardening.

Promotion

With a history of classic advertising featuring the well-known strapline, 'You can do it if you B&Q it', today B&Q's promotional campaigns focus on 'making it easier'. 2010 saw a series of adverts highlighting helpful services and products such as colour matching and mixing for paint, timber cutting, and paste-the-wall wallpaper.

The retailer also took its first steps into social media, launching a presence on both Twitter and Facebook as well as an iPhone app, which is free to download and provides expert knowledge for DIY novices and more experienced handymen and women alike. From advice on safety while working, what to wear, and how to use basic tools and equipment, to more advanced jobs such as fixing a burst pipe, replacing electrical switches, and erecting or fixing gates and fences, the 'How To' guides feature step-by-step instructions to guide users through each job. The app creates a list of tools needed to complete each task and also locates the user's closest B&Q store.

Brand Values

B&Q aims to be a company of 'friendly experts' in home and garden improvement and to make it easier for customers by providing expertise in a helpful, open and motivating way – as only B&Q people know how.

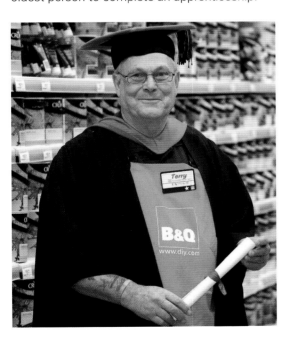

Things you didn't know about B&Q

B&Q derives its name from the surnames of its founders, Richard Block and the late David Quayle.

B&Q welcomes around three million people through its doors every week.

The majority of people in the UK are no more than a 20-minute drive from their nearest B&Q.

A quarter of B&Q's workforce is over the age of 50, with a similar percentage under the age of 25.

B&Q's oldest employee, Syd Prior, is 96 years young and has just celebrated 20 years' service with the retailer.

2007	2009	2010	
B&Q partners with Bioregional, to become a One Planet Business. The decorative range, Colours, relaunches with new paints, wallpapers and soft furnishings.	B&Q begins its sponsorship of Channel 4's property portfolio including programmes such as 'Property Ladder', 'Grand Designs' and 'Relocation, Relocation, Relocation'.	B&Q launches kids classes and You Can Do It centres to help people relearn lost DIY skills. The retailer also teams up once again with Dame	Ellen MacArthur, becoming a corporate partner to the Ellen MacArthur Foundation to 're-think, re-design and re-engineer the future'.

Barclaycard is a global payment company delivering market-leading levels of new technology and innovative business solutions. Founded in 1966, Barclaycard is one of the few businesses that facilitates the making, taking and managing of payments for companies of all sizes. It is one of Europe's leading commercial card issuers and one of the UK's largest payment processors.

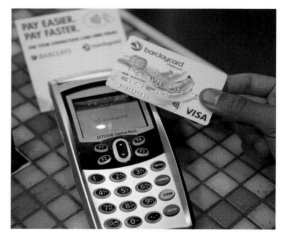

Market

Barclaycard has a total of 11.1 million cardholders in the UK and 21.6 million worldwide. Barclaycard credit cards can be used to pay for goods and services in more than 28 million locations in over 200 countries as well as at 600,000 ATMs and banks worldwide.

Barclaycard, part of the Barclays Global Retail Banking division, is a leading global payment business that helps consumers and businesses to make and accept payments flexibly, and to access short-term credit when needed. The company is at the forefront of developing viable contactless and mobile phone payment schemes for today, and cutting-edge forms of payment for the future.

Product

Barclaycard processes card transactions for around 85,000 retailers and merchants. In 2009, around 2.5 billion purchases were made with credit and debit cards through 159,000 of Barclaycard's customer outlets in the UK.

Barclaycard has more than 150,000 commercial card customers, including the UK Government, to which it has issued over half a million credit and charge cards. Barclaycard is also Europe's leading issuer of Visa commercial cards and offers a range of payment solutions to meet a variety of business needs, including secure online payments.

Barclaycard's business presence is split into four business units: Barclaycard Commercial, Barclaycard Payment Acceptance, Barclays Partner Finance, and Loyalty Management.

Barclaycard Commercial offers procurement and corporate award-winning solutions, such as Barclaycard Hotel Tracker and the Barclaycard Commercial Visa CodeSure card. These solutions help it meet the needs of its customers on a global scale, while ensuring that it gives as tailored an approach as possible. Barclaycard Commercial has also recently developed a new payments management platform called Barclaycard

Spend Management, which enables organisations to manage their global spend in a more effective and controlled manner. Barclaycard Commercial is also part of the framework to provide The Government Procurement Card.

Barclaycard Payment Acceptance provides credit, debit and charge card acceptance to companies ranging from small shops to multinational businesses across Europe. Multiple currency payments can be made in person using Chip and PIN or contactless terminals as well as online, by telephone and mail order. Barclaycard Payment Acceptance has built a reputation as a European payments expert and its services are fully compliant with all industry standards. It is a key member of the PCI Security Standards Council.

Barclaycard is at the forefront of promoting contactless technology, enabling customers to make payments below £15 in less than a second by using a traditional card or even

1966	1977	1986	1990s	2007	2008
Barclaycard is launched – the first all-purpose credit card in Europe. The following year Barclaycard becomes the first ATM card used in the UK.	Barclaycard becomes a founder member of the international Visa system and launches the business element as the Barclaycard brand.	Barclaycard launches the UK's first credit card loyalty scheme, Profile Points.	Barclaycard MasterCard launches in 1990. In 1995, the launch of Barclaycard Netlink sees Barclaycard become the first UK credit card company to have a presence on the internet.	Barclaycard launches the first contactless card.	Barclaycard launches a new visual identity, which includes redesigning its card range and introducing a new multicoloured logo and typeface.

a mobile phone. More than one million contactless transactions were processed in the first nine months of 2010, a 217 per cent increase from January 2010. The Barclays Group has issued more than 10 million of its contactless cards, and merchants such as The Co-operative and Pret A Manager have embraced the technology. Barclaycard is also pioneering new contactless platforms that are set to revolutionise the world of global payments.

growth. Its success is reflected in winning Best Innovation in a Loyalty Programme at the Cards International Awards 2010.

Achievements

Barclaycard has been recognised industry wide for making and taking payments as well as for advertising, design and innovation. In 2009, it won Best Business Travel Product for its Hotel Tracker product at the Business Travel Awards, and received the Most Innovative Commercial

Promotion

Barclaycard has moved away from traditional product advertising to place an emphasis on the core brand message and functional excellence.

It has successfully launched contactless technology through both traditional and digital media channels. The 2009 Waterslide campaign, recently voted as one of the top ads of the decade by ITV, both raised the profile of Barclaycard as a payments brand and educated customers about contactless technology. The 2010 campaign, Rollercoaster, built on this success and placed an emphasis on Barclaycard being a global payments brand.

Barclaycard launched Rollercoaster Extreme for the iPhone in July 2010. The game has had more than 10 million downloads to date and includes a global competition that is hosted on Facebook. Its predecessor, Barclaycard Waterslide Extreme, became the number one free download in 57 countries within two weeks of launching – and the most successful free branded app in the history of iTunes.

Barclays Partner Finance supplies point of sale credit solutions to more than 3,000 retail, motor and leisure clients. Through a choice of tailored products, clients can offer their customers a range of finance solutions for purchasing their goods or services, and allow them to spread the cost across a term that suits them.

Loyalty Management launched Barclaycard Freedom in March 2010 with more than 20,000 retail outlets. The rewards programme helps drive value for Barclaycard's business partners with new technology that delivers real-time rewards at point of sale. Retailers are able to target customers at an individual level with offers and discounts to help drive business

Card accolade for the Barclaycard Commercial Visa CodeSure card at the Oscards Awards. Also in 2009, it was the winner of the Best Use of Visa Innovation for the Barclaycard Commercial Visa CodeSure card at the Visa Europe Member Awards.

In 2010, Barclaycard was short-listed for Best Business Card Programme and Best Industry Innovation of the Year for the Becta programme at The Card Awards. Also in 2010, Barclaycard won the Channel Award for Contactless in the 2010 European Acquiring Forum Awards.

Recent Developments

Barclaycard is continuing to push boundaries in innovation to meet the needs and demands of all sizes of businesses. Indeed, Barclaycard has implemented Visa CodeSure technology in a business card programme, meaning that a keypad, LCD screen and a battery with a three-year lifespan are all incorporated into a standard payment card.

Barclaycard has recently developed Prepaid card solutions that offer a simple way to improve efficiency and gain more control over the way customers distribute cash used within their organisation.

Movement into additional services such as music payment with Barclaycard Unwind has further highlighted the total brand value.

Brand Values

Barclaycard has always been a customer-centric organisation that aims to provide confidence, convenience and control in financial services. The brand is focused on constantly improving by thinking ahead, so that smart and innovative solutions can be designed to suit the ever-changing needs of all customer segments. Barclaycard's goal is to ensure that customer experiences are as seamless and easy as possible through excellent customer service and simple payment solutions.

Things you didn't know about Barclaycard

More than one in six UK credit cards is a Barclaycard.

Barclaycard has issued more than five million contactless credit cards in the UK.

Barclaycard's first foray overseas was in Germany in 1991. Today, Barclaycard International operates in more than 60 countries across Europe, the US, Africa, Asia and the Caribbean.

2009

Barclaycard launches the first ever Visa CodeSure card, comprising an LCD screen, keypad and battery. It will help minimise fraud for

card-not-present transactions. Also in 2009, Barclaycard Unwind sees Barclaycard move into music sponsorship and ticketing.

2010

Barclaycard launches the innovative loyalty programme Barclaycard Freedom. The scheme gives customers Reward Money, rather than points or vouchers, to be used at selected stores.

Also in 2010, Prepaid card solutions are launched, giving customers increased control over the way they manage their money.

BBC

The BBC is the world's best known broadcasting brand, offering the full range of programmes from independent journalism to live music, arts and specialist factual programmes to ambitious drama and comedy and outstanding children's content. BBC programmes are accessed via 10 UK-wide network television services, 10 national and 47 Nations and regional radio stations, plus online and interactive services.

Market

Broadcasting is changing rapidly worldwide as technologies and markets converge, and as content and competition become increasingly global. The UK continues to see commercial broadcasters emphasise their national and global roles, often to the detriment of local provision. The BBC recognises that it exists in an increasingly global marketplace, but through its partnership strategy aims to support UK public service broadcasting and the wider UK media sector.

Difficult economic and trading conditions continued in 2010, highlighting the opportunities and support that the BBC is able to offer to the media industry through its careful investment of the licence fee. It works with the big players such as ITV and Channel 4 through Freeview, the digital terrestrial service – with independent producers on a range of programmes – and the best of UK on-air and off-air talent across its portfolio.

The BBC is committed to delivering efficiencies and is on target to deliver savings of £2 billion by 2013. By 2016 it aims to invest 90 pence in every pound of the licence fee in programmes and distribution.

The recent licence fee settlement as part of the Government's Comprehensive Spending Review gives stability to the BBC and its partners and ensures that much of their valuable work to engage audiences is able to continue.

Product

The BBC is primarily a creator of high quality content and programming on television, on radio and online, with a varied portfolio of major service brands including BBC One, BBC Two, BBC Three and BBC Four on television, while on radio the main terrestrial services – BBC Radio 1, 2, 3, 4 and 5 Live – are complemented by the digital brands BBC Radio 1Xtra, BBC Radio 5 Live Sports Extra, BBC 6 Music, BBC Radio 7 and Asian Network.

The BBC supports much of its output online; for example, ensuring children's shows are further enhanced by websites that encourage learning in a fun space. The bbc.co.uk website is a recognised brand leader in the UK, and one of the most popular content sites in the world. It is also home to the increasingly popular BBC iPlayer.

1922	1927	1936	1953	1967	1980
British Broadcasting Company (BBC) is formed by a group of leading wireless manufacturers.	The BBC gains its first royal charter, ensuring its independence from government, political and shareholder interference.	The BBC begins the world's first regular service of high definition television from Alexandra Palace, North London.	On 2nd June around 22 million people watch the Queen's coronation live on the BBC – an historic event that changes the course of television history.	BBC Two begins transmission of the first regular colour television service in Europe.	After 25 years, Children in Need becomes an event with a whole evening of dedicated programming – and raises £1 million for the first time.

Each year the BBC invests more than £1 billion in the UK's creative industries, and it is working to further spread the benefits of the licence fee and to continue to showcase the best new and existing talent. By 2016 at least half of its programming (in terms of hours) will come from outside London.

The BBC's commercial activities are highly regulated, but designed to deliver cash back for the BBC to invest in original content. BBC Worldwide sells content, format and merchandising rights in order to optimise the initial investment made by licence fee payers. BBC Studios & Post Production offers facilities to both the BBC and the external market.

Achievements

The BBC continues to claim a host of awards in recognition of its high quality programming. In 2010 these included 40 Royal Television Society Awards, 10 International Emmy Awards, 22 BAFTA Awards, 14 Broadcast Awards, 11 Gold Sony Awards – including Station of the Year – and two Webby Awards. Since its launch, BBC iPlayer alone has received more than 35 marketing and technology awards.

In addition, the BBC maintained its Platinum ranking for 2009/10 in the Business in the Community Corporate Responsibility Index.

Recent Developments

The BBC has to balance retaining a valuable brand heritage with staying relevant in an era of on-demand content across a range of new platforms. The launch of BBC One HD in

November 2010 epitomises the way in which the BBC is rising to the challenge, allowing viewers with high definition (HD) to tune in to a dedicated simulcast of BBC One in HD for popular programmes such as Strictly Come Dancing, The Apprentice and EastEnders, which has recently started filming in HD.

Promotion

The trademark block letters of the BBC master brand are associated worldwide with values of quality, trust, independence, creativity and distinctiveness.

Subsidiary brand identities – for channels and services, or for specific events such as the UK election branding in May 2010 – are designed to build on those core values and to help audiences find the content they will enjoy through integrated communications campaigns.

The BBC News Election 2010 campaign, aimed at establishing the BBC as the home of the general and English local elections, comprised a set of TV and radio trails, online content and editorial cross-promotion leading up to and beyond election day. The campaign message, Making It Clear, reflected audience perceptions of the role the BBC plays in bringing clarity to frequently complex election or policy issues,

as well as its independent analysis that allows viewers and listeners to make up their own minds. More than four out of five people in the UK engaged with BBC election coverage (Source: YouGov).

For CBBC, the Get the Horrible Histories Look campaign launched the 2010 series of the channel's historical sketch show aimed at 6–12 year-olds. The television trail, mobile audio file and online app were well received and positioned the CBBC brand as cool, feisty, bold, fresh and infectious.

In 2010, BBC Proms continued to offer low cost tickets (from £5), broad and accessible programming, creative use of interactive technology, an extensive learning programme, and pre-concert and participatory events to attract new and younger attenders. Attendance was up by five per cent year-on-year, with 313,000 attendances for the 89 concerts. More than 18 million people had a Proms experience in 2010, either live or via BBC iPlayer.

Brand Values

The BBC exists to serve the public interest and to inform, educate and entertain audiences with programmes and services of high quality, originality and value. The BBC brand depends on the BBC's reputation to offer original and independent news, formal and informal learning to all age groups, and unique and innovative content not found elsewhere. The BBC is a supporter of, and showcase for, the best of British creativity.

Things you didn't know about the BBC

The BBC costs each licensed UK household just under 40 pence per day.

Its coverage of the FIFA World Cup was seen by 44.5 million in the UK.

BBC iPlayer is the UK's most popular catch-up service online, with almost 120 million requests per month.

The BBC set up the first dedicated children's programme department more than 60 years ago – and Blue Peter has been a stalwart in its schedules for 53 of them.

1998	2007	2008	2010
BBC Choice, the first BBC digital TV channel, launches. It goes on to become BBC Three in 2003.	BBC iPlayer launches at Christmas and transforms media consumption in the UK, with 360 million views in its first three months.	The first full digital switchover takes place in Whitehaven, Cumbria.	BBC Television Centre, the world's first purpose-built television building, celebrates its 50th anniversary, and long-running soap EastEnders celebrates 25 years on-air.

Beechams is one of the UK's longest standing British brands, dating back to 1842. In 1926 the brand launched Beechams Cold Remedy, laying the foundations for the iconic cold and flu brand as it is known today. Beechams has spent almost a century studying cold and flu and how to minimise its impact, pushing the category forward through progressive consumer understanding and excellence in the science and marketing of cold and flu remedies.

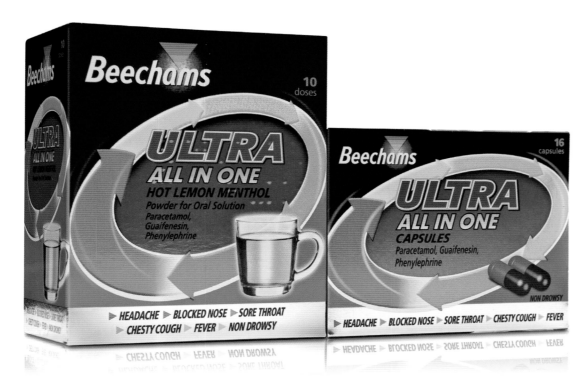

The brand's core strength is in multi-symptom, the largest cold and flu sector and a major contributor to growth when cold and flu incidence is high. Beechams Ultra All in One, Beechams All in One and Beechams Flu Plus are the brand's flagship multi-symptom offerings. Within the multi-symptom segment Beechams is also the market leader in both the liquid and solid dose formats amongst the general sales list (GSL) offering.

Tablets, caplets, liquids and hot drinks are available across the range, with key products available in a variety of pack sizes to fulfil shopper needs.

Achievements

Beechams has been a consistent winner in the Reader's Digest Most Trusted Brand awards – taking the top slot in the cold and flu category in eight of the last 10 years. Respondents were asked to rate their brand of choice on four criteria – quality, excellent value, strong image and understanding customer needs.

Beechams Ultra All in One Capsules won the 2010 Pharmacy Product of the Year – as voted by pharmacists – and has previously won Brand of the Year at the OTC Marketing Awards, as judged by an expert retail panel.

Looking forward, Beechams will continue to draw on its core strengths and heritage to bring innovation into the cold and flu category. Its focus will remain on delivering products that truly meet consumer needs.

Market

The cold and flu market is valued at £407 million, equating to 217 million units – making it the second largest over-the-counter (OTC) category behind analgesics. It is a highly seasonal market, with 36 per cent of annual sales taking place during the key months of November, December and January (Source: Nielsen w/e 27th November 2010).

Beechams is the second largest brand in its category, with value sales of £37 million representing 12.7 million units (Source: Nielsen 2010). The brand was the first to bring an All-In-One product to the market (Source:

Nielsen Value Sales 2004–2010) and continues to be the category's number one selling brand with a 57.1 per cent share (Source: Nielsen 2010).

Product

Beechams offers a comprehensive range of products in a variety of formats to cater for today's busy and demanding lifestyles. From Beechams Powders and Beechams Flu Plus through to Beechams All in One, the range provides effective symptomatic relief for a variety of conditions.

1842	1859	1891	1913	1926	1943
Thomas Beecham launches the Beecham's Pills laxative business in England.	Beecham opens the world's first factory to be built solely for making medicines, in St Helens. The first adverts for Beecham's also appear.	Advertising spend on Beecham's Pills reaches £120,000 – a significant investment at this time.	Production of Beecham's Pills laxative reaches one million pills per day.	Beecham's Powders Cold Remedy is launched.	Beecham Research Laboratories is formed with the mission to focus exclusively on basic pharmaceutical research.

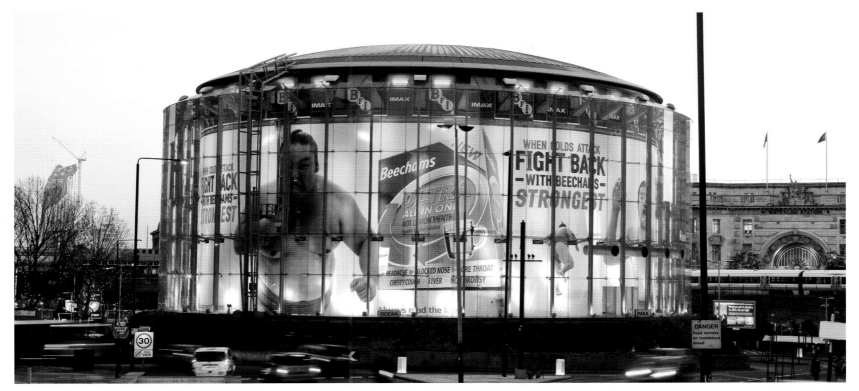

Recent Developments

Key to the brand's success has been category-leading new product development. The 2009/10 season saw the most recent launch with the Beechams Ultra All in One range, which was the most successful launch of the year within the multi-symptom segment. The range comprises two GSL products: Beechams Ultra All in One Capsules and Beechams Ultra All in One Hot Lemon Menthol, a soothing hot drink.

Beechams Ultra All in One is the strongest GSL cold and flu range now available from Beechams, providing a compelling proposition for consumers. In line with the brand's strategy to help cold and flu sufferers find the fighting spirit to overcome colds and flu, Beechams Ultra All in One uses breakthrough language for the category to signal power, strength and completeness.

Going forward, the brand will continue to focus on its premium and core ranges and will

support its hot drink range, which offers the greatest variety of flavours in the market.

Promotion

Thomas Beecham was aware of the power of advertising from the outset and Beechams was one of the first brands to embrace consumer advertising using bold straplines such as 'worth a guinea a box'. In the early days a variety of creative approaches were adopted but the focus tended to be on a positive outlook and good health, often delivered with a good dose of humour, which has since continued to be a feature of many campaigns.

FIGHT BACK
—— WITH ——
BEECHAMS

As the brand developed, the advertising evolved. A focus on comfort, relaxation and relief gave way to the caring magician, followed by a stronger emphasis on efficacy in later campaigns. By 2001 the idea of fighting back with Beechams was born with the 'I'm Still Standing' advert showing that consumers could get on with their lives with the help of Beechams.

The memorable Folklore campaign of the early noughties employed quirky humour

and simple messaging – 'Until there's a cure there's Beechams' – but the 'fight back' theme returned with a vengeance, with the award-winning 'Brian' execution in 2007. Over the 2009/10 season sumo wrestlers were bought in to support the launch of Beechams Ultra All in One before returning to Brian for the 2010/11 season with a new onslaught on cold and flu symptoms and a fresh strapline: 'That's the Spirit!'

In the past decade the brand has used outdoor advertising, including bus sides and London taxis, underground panels and radio to reinforce the television slots, while high in-store visibility has been integral to the brand's communications strategy.

Brand Values

Beechams aims to be a trusted, supportive, empathetic and efficacious brand, which helps its customers use the power of their own fighting spirit to fight back against colds and flu.

For the relief of cold and flu symptoms. Always read the label.

Things you didn't know about Beechams

The poet William Topaz McGonagall wrote a poem advertising Beecham's Pills, immortalising the brand in verse.

Beechams is likely to be the only brand to have featured a frog, yaks, an army and sumo wrestlers in its television adverts.

In the past 12 months, 12.7 million Beechams products have been sold, equating to 34,972 per day, 1,457 per hour or 24.2 products sold every minute.

2001	2007	2009	2010/11
The Beechams sub-brand All in One is launched – the first all-in-one remedy on the market. New advertising features Elton John's 'I'm Still Standing'.	Brian makes his first television appearance for the brand, taking on an army of symptoms with the help of Beechams All in One.	Beechams Ultra All in One is launched offering the strongest formula yet from the Beechams brand.	The award-winning Brian returns to television screens with a new strapline: 'That's the Spirit!'

BlackBerry

In 1999 Canadian-born Research In Motion (RIM) launched the BlackBerry 850 smartphone and in doing so, created the wireless email market. RIM is now one of the top five handset manufacturers in the world; it has shipped more than 129 million BlackBerry smartphones and has over 55 million subscribers worldwide.

Market

The BlackBerry solution has long dominated the corporate mobile market and is the mobile email solution of choice for more than 90 per cent of Fortune 500 companies, approximately 80 per cent of which have installed 500 or more devices. Once seen as the preserve of business users, BlackBerry smartphones have ever-growing consumer appeal with 80 per cent of new subscribers and more than 50 per cent of the global subscriber base now classified as 'non-enterprise'. This growth is thanks to innovations such as its instant messaging service, BlackBerry Messenger (which experienced a 500 per cent increase in usage over the last year and has more than 25 million users worldwide) and BlackBerry App World, the on-demand application store that features more than 16,000 applications and from which an average of two million applications are downloaded every day.

Product

From the entry-level BlackBerry Curve smartphones, to the higher specification BlackBerry Bold smartphone series, the suite of the brand's smartphones is renowned for its high build quality, ease of use, secure content capabilities, network efficiency and market-leading physical QWERTY keyboard. Recent reports by Rysavy Research found that the BlackBerry solution is more efficient in using network bandwidth than any other mobile platform; specifically, it uses five times less for email, two times less for browsing and 2.5 times less for social networking.

BlackBerry offers a range of handsets for every type of smartphone user, with each product tailored to a different demographic.

BlackBerry Torch 9800 is a recently launched hybrid BlackBerry smartphone. It is the first device to encompass both a physical slide-out QWERTY keyboard and touch-screen technology, and to use the new consumer-friendly BlackBerry 6 operating system (OS).

A recent addition to the 'power BlackBerry' family, the high specification BlackBerry Bold 9780 also features BlackBerry 6 OS, bringing a new level of innovation to one of the most iconic BlackBerry smartphones.

With simple to use media keys and BlackBerry Messenger, the entry-level BlackBerry Curve 3G targets the younger consumer. The Curve family regularly tops the UK market both in prepaid and contract categories.

BlackBerry Pearl 3G, the smallest BlackBerry ever made, comes with an innovative alphanumeric keypad. The Pearl family has historically been the BlackBerry of choice for smartphone users that have upgraded from a standard mobile handset and moved towards a smartphone offering.

BlackBerry Messenger, meanwhile, is a free to use social media application that has exploded in popularity since its launch in 2009, resonating particularly with the younger generation of smartphone users. The instant messaging service uses the secure BlackBerry solution to enable users to share messages and content in real time.

Achievements

In just over a decade, the BlackBerry solution has set the bar for mobile access to email, applications and more. Its comprehensive portfolio of products enables users to stay in touch with the people and information that matter most to them; its innovative devices embraced by consumers. Indeed, Vodafone UK estimated that in its first week on sale in 2008, the BlackBerry Storm 9500 – the brand's first touch-screen smartphone – sold one device every 13 seconds.

Having become Canada's most valuable company within eight years of launch, RIM was named the world's fastest growing company by Fortune magazine in 2009.

1999	2003	2007	2008	2009	2010
Mike Lazaridis founds Research In Motion (RIM) and launches the BlackBerry 850 and BlackBerry wireless email solution.	BlackBerry reaches one million subscribers, rising to more than four million in 2005.	RIM becomes Canada's most valuable company, as BlackBerry subscribers reach 12 million.	The first BlackBerry touch-screen device, the BlackBerry Storm 9500 smartphone, launches.	BlackBerry celebrates its 10th anniversary with the announcement that it has shipped its 50 millionth BlackBerry smartphone.	RIM announces shipment of its 100 millionth BlackBerry smartphone.

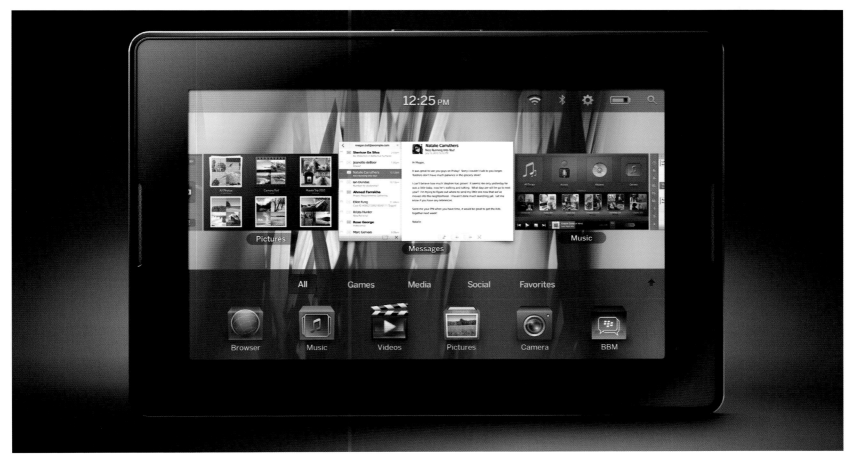

Recent Developments

RIM is always seeking to advance its mobile communications solutions and the announcement of a number of company 'firsts' in 2010 exemplifies this ethos. The BlackBerry Torch 9800 is the first BlackBerry smartphone to encompass both a physical slide-out QWERTY keyboard and touch-screen technology, and became the fastest-selling GSM smartphone in the company's history.

Also in 2010, the launch of the 7-inch BlackBerry PlayBook was announced for 2011. Building on RIM's strong heritage in delivering superior mobile communications, the BlackBerry PlayBook is the first 'enterprise-ready' tablet device, providing not only the industry's best professional-grade tablet experience, but also a strong web browsing function, multitasking capabilities and high performance multimedia.

Underpinning key product launches is the new BlackBerry 6 OS, which takes new functionality and wraps it into the core BlackBerry offering.

Promotion

The BlackBerry brand continues to reach out to the consumer with recent campaigns highlighting the expansion of BlackBerry Messenger, particularly amongst younger age groups.

Another recent campaign, 'Love what you do', has seen the brand embracing consumer behaviour and demonstrating how it enhances users' lifestyle habits. The campaign has been underpinned by key initiatives that bolster both brand awareness and provide consumers with clear 'proof points' to encourage purchase.

Brand Values

At the core of the brand stand key values to which all BlackBerry products and services adhere. BlackBerry offers a secure solution and stands by its philosophy of delivering complete peace of mind to its users, both at an individual and multinational corporation level. The company also prides itself on its efficiency, both to the user of the product or service and to the wider industry at the network operator and market regulatory level.

BlackBerry aims to be the ultimate communications tool; through SMS, MMS, email, voice and BlackBerry Messenger, the BlackBerry solution enables its users to communicate efficiently, securely and with ease.

Things you didn't know about BlackBerry

RIM won an Oscar for developing a barcode reader that transformed the editing process for motion pictures.

In 1996, RIM introduced the Inter@ctive pager – the first two-way messaging service.

BlackBerry has more than 55 million subscribers worldwide and has shipped over 129 million devices.

There are 16,000 apps available at BlackBerry App World.

blueArrow

Blue Arrow, part of Impellam Group plc, is one of the UK's largest recruitment businesses. For more than 50 years it has been dedicated to delivering bespoke recruitment solutions through a network of over 100 specialist branches and on-site locations. The key to Blue Arrow's success is the adaptability, versatility and sheer initiative of its people. Blue Arrow works in constant partnership to unlock people's potential.

Market

The economic climate in 2009 and 2010 presented much uncertainty for UK recruitment. The change of government in May 2010, coupled with the uncertainty surrounding public sector spending cuts, led to apprehension for the recruitment industry. According to the Recruitment and Employment Confederation (REC), turnover in the UK's recruitment industry fell by more than 12 per cent in the year to March 2010. Despite this, the market as a whole still managed sales of just under £20 billion.

Agencies have had to refocus and readapt business plans to accommodate both the economic downturn and the surge in popularity of online recruitment.

Key market players include Hays, Manpower and Adecco, all of which are direct competitors of the brands within the Impellam Group of companies, which forms the fifth largest recruitment group in the UK.

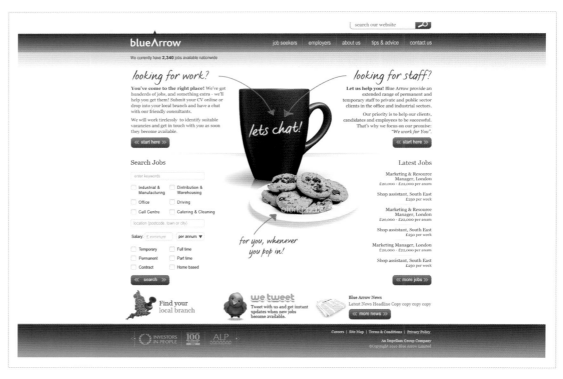

Blue Arrow enjoyed huge success in 2010; a great achievement for a company trading in a declining market.

Product

Blue Arrow provides an extended range of permanent and temporary recruitment services to a variety of private and public sector clients in the following divisions: industrial and manufacturing; distribution and warehousing; driving; office; call centre; and catering and cleaning.

As one of the UK's largest recruitment businesses, Blue Arrow believes in using its

expertise and experience to help shape the recruitment industry for the better, setting standards and shaping best practice. For more than 50 years, Blue Arrow has been recruiting people with a variety of skills across a number of disciplines, building a quality and diverse client base. The key to Blue Arrow's success is the adaptability, versatility and initiative of its people.

Blue Arrow offers a range of services tailored to suit the needs of its clients. These include: large volume recruitment and ad-hoc occasional supply; long-term and short-term cover; additional resources for seasonal demand;

cover for training, sabbaticals, holidays and sickness; and strategic long-term planning to develop business capacity and capability.

Blue Arrow boasts a network of more than 100 locations across the UK, made up of local high street branches and on-site offices (where Blue Arrow recruiters work from a client site to deliver strategic end-to-end large volume recruitment and workforce management solutions).

Achievements

Blue Arrow was included in The Sunday Times 100 Best Companies to Work For list in both 2009 and 2010, and was announced as a finalist

1959	1982	1994	2000	2008	2009
The Barnet Agency Ltd is incorporated.	The agency's name changes to Blue Arrow Personnel Services Ltd.	Blue Arrow Personnel Services Ltd is acquired by Corporate Services Group (CSG) plc for £47.8 million.	The company's name changes to Blue Arrow Ltd.	CSG plc merges with Carlisle Group Ltd to form Impellam. Blue Arrow becomes one of 15 staffing businesses under the Impellam Group.	Blue Arrow celebrates its 50th birthday.

in the Best Large Recruitment Agency to Work For category at the REC IRP Awards 2010. It has also recently been awarded the Silver rating by Investors in People; the company was recognised in particular for its "committed and motivated people", "development opportunities for all", "recognition and reward of success", "understanding of the importance of a work–life balance" and "encouragement of people's progression".

Corporate social responsibility activities include supporting a charity chosen by all Blue Arrow employees through a variety of fundraising activities. In 2010 the charities chosen were The Meningitis Trust and The Joshua Foundation. Staff raised money for the charities by cycling 1,800 miles from the most northerly Blue Arrow office, Inverness, to its most southerly, Plymouth, including every branch in between – as well as by running marathons, competing in a rally across Europe, parachuting and local branch-based events such as charity raffles. The company also actively sponsors its clients' charity events and works on local community projects. As an organisation with a focus on 'knowing your local market', Blue Arrow has also introduced an employee charity day, which encourages Blue Arrow employees to take a day out of the office to support a local charity of their choice.

On the environmental front, a group-wide recycling programme has been introduced to ensure that toners and paper are recycled appropriately. As part of the Impellam Group, Blue Arrow has achieved ISO 14001:2004 for its environmental management system.

Blue Arrow is not only committed to exceeding the minimum requirements of environmental legislation, but also to identifying and maximising operational efficiencies and value for money whilst reducing its impact on the environment.

Recent Developments

The Blue Arrow brand was founded in 1959 and has since grown substantially. It is now one of the largest and strongest performing brands in the Impellam Group. At the beginning of 2010 the Blue Arrow Group was formed from Blue Arrow Staffing Solutions and Blue Arrow Managed Services which, until that date, had operated as two separate businesses.

2010 also saw the opening of additional Blue Arrow branches, with three of its most recent being in Aberdeen, Brighton and Harrow towards the end of the year.

Promotion

Blue Arrow underwent a brand refresh towards the end of 2010, which included everything from a new logo and strapline to a programme of branch refurbishments, which are due to reach completion within the next two years. In keeping with the new Blue Arrow strategy, which centres on the idea of 'working in partnership' and acting as the 'voice of the ordinary people', Blue Arrow is working to create a more relaxed, inviting environment to improve both client and candidate experience.

The website has also been redesigned to focus on usability and information-giving. It aims to go beyond the stereotypical 'recruitment style' and provide users with an interactive portal covering all of their recruitment needs.

Blue Arrow's Mobile Recruitment Centre (MRC) has always been a unique selling point for Blue Arrow, and is well received by the public. The MRC provides a quick and easy way for busy people and those with transport limitations to register for jobs.

Brand Values

Blue Arrow takes a 'partnership' approach to business and focuses on unlocking the potential of employees, clients and candidates. People are an organisation's biggest asset and the brand is focused on helping people achieve their dreams and ambitions.

Its brand values are: 'Integrity' – doing the right thing; 'Extraordinary' – being so much more than ok; 'Inspire' – inspiring and enabling people to exceed their potential; 'Expert' – adding value by being knowledgeable, fact-based and purposeful; 'Challenge' – challenging the future by questioning 'norms'.

An entrepreneurial culture is integral to its success and the company has recently produced an improved career model for managers, including an incentive programme. It is proud of its low staff turnover, and boasts an average length of service of four years.

Things you didn't know about Blue Arrow

The average length of service of a Blue Arrow flexible employee is 18 weeks, which is far above the industry average.

Blue Arrow has, on average, 13,000 people working across the UK every day.

The divisional managing director of the Blue Arrow Group has been working for the company for 17 years, having started out as a recruitment consultant.

In 1974 Bold became the first low suds biological detergent on the market. The brand was relaunched in 1982 as the UK's only combined detergent and fabric conditioner and has since been a permanent fixture in laundry aisles. Bold represents an evolving brand that strives to offer new experiences by combining its cleaning credentials with a modern touch of luxury.

Market

Bold2in1 sits firmly in the laundry market where it is the third largest brand in terms of sales and performance in the UK and Ireland (Source: Information Resources Incorporated 2010). The market itself is a well-established one, with a static growth of around one per cent per year. Bold2in1 remains the only brand within this market to offer a combined detergent and fabric conditioner, which is reflected on-pack via its famous yin yang design.

Product

Bold2in1 comes in a range of formats, from the conventional (powder and tablets) to the more progressive (gels and liquitabs). A recent addition, the Bold 2in1 Gel Collection, is a concentrated liquid gel format condensed into a squeezable bottle. It is offered across all of the brand's popular fragrances, with each aimed at offering consumers a multi-sensorial experience.

Bold2in1 offers a wide range of variants for the scent-seeking consumer, including Lavender & Camomile, Crystal Rain & White Lily and Sparkling Pomegranate & Orange Blossom, as well as the premium scents from the Infusions collection: Ruby Jasmine and White Diamond & Lotus Flower.

Bold was the first brand to use floral perfumes in household products, offering a new experience in laundry: an evolving range of fresh scents that includes the luxurious Infusions selection. The range comes in powders, liquitabs and gels and includes three variants. One of the product's unique selling points is that perfume is slowly released throughout the day and can last up to a week when clothing is stored in a cupboard.

Achievements

In 2009 Bold 2in1 White Diamond & Lotus Flower was named Award Winning Laundry Fragrance by the British Society of Perfumers. The liquitabs were commended for using perfume in a household product, forging new territory in the laundry detergent market and taking the lead position in the premium product market.

Bold has supported various charities through retailer-specific charity events via on-pack endorsements and donations. Its patronage helps to increase awareness of the issues behind the campaigns – whether it is cancer research or encouraging children to grow their own produce through Morrisons Let's Grow campaign – and also helps to drive the brand's share of the market. For instance, when the brand supported Tesco's Muscular Dystrophy campaign in January 2010, Bold became the second biggest seller within

1974	1982	1989	1992	1994	2000
Bold Automatic Low Suds is launched – the first low suds biological detergent on the market.	Bold is relaunched as the first combined detergent and fabric conditioner.	Bold Liquid is launched.	Bold refills are launched.	Bold Summer Fresh is launched, and the core Bold product is renamed Spring Fresh.	Bold Tablets are launched.

the detergent market, a position mirrored in September 2010 when it supported Asda's Tickled Pink campaign.

Recent Developments
In early 2010, Bold2in1 underwent a complete brand re-stage across all of its product line-up, with the collection now containing Perfume Micro Capsule (PMC) technology. This technology infuses clothes with freshness bubbles within the fabric, which release fragrance through a person's daily movements, even after 12 hours of wear. To celebrate the new PMC technology, Bold2in1 launched the Big Bold Hug campaign across multiple touch-points 'to get the nation hugging'. This included a nationwide search to find children to star in its next advert, with brand roadshows across the country encouraging children to describe what a hug means to them.

In September 2010 Bold also relaunched its Infusions product range 'with a touch of Lenor

freshness' across its Ruby Jasmine and White Diamond & Lotus Flower variants.

Over the past few years Bold2in1 has made a strong push towards innovation, resulting in a new variant (Sparkling Pomegranate & Orange Blossom), a new format (the introduction of Bold Gel) and a new technology (PMC).

Promotion
At the time, it was a revolution: combined washing detergent and fabric softener. Bold2in1 advertising stretches back over 30 years and for many of those, campaigns were value-focused: promoting the cost benefits of two separate products rolled into one, and saving customers money from the household budget.

Brand communication in recent years has switched the emphasis from convenience to the key fragrance and softness benefits that Bold offers, highlighting the scent experience alongside its already well established cleaning

reputation. Campaigns recreate familiar and comforting family experiences in the home, while well-known celebrity mums – from Amanda Holden to Kim Wilde – have been used as the face of its products. This has been effective in terms of targeting the brand's key UK market – predominantly women who buy and use washing products for their family.

Most recently Bold2in1 communications have undergone a radical re-stage to support the addition of PMC technology to its range. A new strapline, 'Feeling good, Feeling bold', emphasises the positive, refreshing experience encapsulated by the brand and its latest campaign – Bold2in1 Infusions 'with a touch of Lenor freshness' – continues this throughout the first half of 2011.

Brand Values
Bold has built up a reputation as a maternal brand with key brand values stemming from the comfort and freshness it provides. The brand is built around shared experiences and feeling good about yourself – imagery in promotion tends to focus on cosy, familiar moments with enveloping imagery, whether it's wrapping children in towels on the beach or blankets on a cold day. Many of the brand's regular users believe it delivers a multi-sensorial experience, which helps turn what might otherwise be a dull routine into a pleasurable experience.

2004	2008	2009	2010
New packaging artwork and variant descriptors are introduced on Bold products.	Bold Infusions, a new concept in laundry detergent, is launched.	A Sparkling Pomegranate & Orange Blossom variant is launched, and Bold Gel is introduced to the market.	The Bold brand is re-staged with the line-up containing Perfume Micro Capsule technology.

Things you didn't know about Bold

Bold was the first laundry brand to use floral perfumes in its products.

All Bold products include dedicated softener and freshness technologies on top of Bold's high quality detergent.

Research has shown that 93 per cent of Cosmopolitan readers would recommend Bold2in1 Infusions to a friend (Source: Cosmopolitan Consumer Research 2008).

Over 10 years, Bold's parent company Procter & Gamble has filed 100 perfume patents, many of which relate to the delivery of longer lasting freshness for dry laundry.

BOSCH
Invented for life

In 2011 Bosch celebrates 125 years, during which time the Group has become a leading global supplier of technologies and services across automotive and industrial technology, consumer goods and building technology. With its history of innovation, driven by research and development, Bosch has remained at the forefront of new technologies, designed to improve customers' lives. This is reflected in the company's slogan: 'Invented for life.'

Market

Bosch has been a global company almost since its inception in 1886. Founded in Stuttgart, Germany by Robert Bosch as a 'workshop for precision mechanics and electrical engineering', the first overseas subsidiary opened in the UK in 1898. Today, Bosch employs almost 4,800 people in the UK across 37 sites.

Globally, there are around 280,000 Bosch associates in more than 150 countries. Bosch operates approximately 290 production sites worldwide, of which over 200 are located outside Germany – in Europe, North and South America, Africa, Asia and Australia.

In 2009, the company generated 38.2 billion euros, 1.6 billion euros of which were generated in the UK.

Product

All products and technologies designed by Bosch are 'Invented for life', providing solutions

that enhance the quality of life, increase safety, protect the environment and conserve resources across the world.

The automotive business, making up 60 per cent of the Bosch Group, produces a range of automotive products, technologies and systems that provide pioneering environmental and safety innovations. Examples include start/stop technology (which reduces fuel consumption by eight per cent), Antilock Braking Systems (ABS) and the Electronic Stability Programme (ESP®).

The industrial technology business makes up 13 per cent of the Bosch Group and includes divisions such as Bosch Rexroth, which offers drive control and automation technology solutions for the industrial and business-to-business market – such as gearboxes for wind turbines.

Bosch Security Systems division supplies CCTV, IP network video, public address and voice evacuation systems for the communication and security market.

Bosch Packaging provides automated packaging solutions for the food, pharmaceutical and consumer goods market.

Bosch Healthcare is a leading provider of Telehealth systems with a broad product

portfolio, including patient terminals and comprehensive evaluation software for remote patient monitoring and diagnosis, which provides a cost-effective alternative to quality patient care.

The consumer goods and building technology sector makes up 23 per cent of the Bosch Group and includes the Thermotechnology division, which incorporates the Worcester Bosch and Buderus brands in the UK. As a leading manufacturer of heating and water systems, Worcester Bosch has a forward-thinking approach to renewable energy efficiency solutions, from condensing boilers and solar panel water heating through to ground and air source heat pumps.

Bosch Siemens Home Appliances is an equal joint venture and one of the world's top producers of domestic appliances, manufacturing appliances such as refrigerators, dishwashers and washing machines.

1886	1901	1927	1930s	1950s	1960s
Robert Bosch opens his 'workshop for precision mechanics and electrical engineering' in Stuttgart. The first office outside Germany opens in the UK in 1898.	Robert Bosch establishes his first factory, with 45 employees. The next year the first high voltage ignition with the first spark plug is produced.	The first diesel injection pump is produced for commercial vehicles, followed in 1928 by the first Bosch power tool – Forefex electric hair clippers.	In 1933 production of household appliances begins, with the Bosch refrigerator. In 1936 the first diesel injection pump is produced for cars.	The decade sees the launch of the DIY Powertool range with attachments (1952), the first Bosch freezer (1956) and the first Bosch washing machine (1958).	In 1967 Bosch and Siemens merge their domestic appliance activities. In 1968, a combined heating and hot water boiler is introduced.

Bosch Power Tools division supplies both the DIY and professional power tools market, using lithium-ion battery technology on the cordless range. It was the first company to use lithium-ion batteries in power tools.

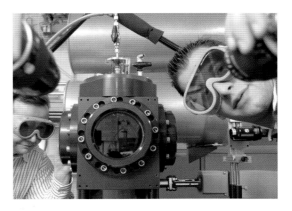

The Power Tools division also provides a complete range of lawn and garden products from lawn mowers, secateurs and chainsaws to pressure washers, many of which also use lithium-ion battery technology.

Achievements

The strength of the Bosch Group lies in its ownership structure. With 92 per cent of the equity retained by the Robert Bosch Foundation (Stiftung), entrepreneurial freedom is guaranteed and long-term planning made possible, thus enabling significant up-front investments to safeguard the future.

Bosch's passion for innovation and greater corporate social responsibility can be attributed directly to the company's founder, Robert Bosch. Created according to his wishes, the

Robert Bosch Foundation promotes the moral, physical and intellectual development of people. Since its establishment in 1964, the Foundation has provided grants worth 900 million euros to charitable causes in areas such as science, research, health and humanitarian aid and international relations.

Recent Developments

Each year, Bosch spends more than 3.5 billion euros on research and development and in 2009 applied for 3,800 patents worldwide. Of this spend almost 1.7 billion euros is dedicated to environmental products, which in turn go on to account for more than one-third of all Bosch sales.

Environmental protection has been a core component of Bosch's strategy since the early 1970s. Bosch offers its customers energy-efficient solutions for all areas of the home, from modern heating systems to motors that drive wind and wave turbines; from battery-powered lawn mowers and power tools to energy saving domestic appliances – such as the latest generation of fridges, which are 20 times more efficient than their predecessors.

In the home, its best-in-class condensing boilers turn at least 90 per cent of the fuel they use into heat – compared with just 65 per cent in many older boilers – and use 30 per cent less gas or oil than conventional systems.

In automotive, Bosch has developed many significant vehicle innovations that contribute to lowering fuel consumption and CO_2 emissions. Some of these advancements include petrol direct injection, common rail diesel injection, hybrid drive, electric vehicles and gearbox control.

Promotion

From the very beginning, Bosch has been characterised by innovative drive and social commitment. The celebration of its 125th anniversary in 2011 provides Bosch with a platform through which to emphasise the importance of its past achievements in fuelling its future success.

Brand Values

The company slogan and guiding principle, 'Invented for life', emphasises the quality and innovation that unites all Bosch products and services. Its ambition is to enhance the quality of life with solutions that are both innovative and beneficial. It strives for sustained economic success and a leading market position in all that it does.

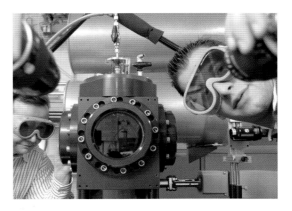

Things you didn't know about Bosch

Robert Bosch was only 25 when he set up his company. In 2011, Bosch celebrates 125 years in business and the 150th birthday of the founder.

Each year Bosch invests more than 3.5 billion euros into research and development, of which 45 per cent is dedicated to environmental products.

The Robert Bosch Foundation holds 92 per cent of the share capital of Bosch.

In 2009 Bosch registered almost 3,800 patents worldwide, which equates to 15 patents per day.

1970s–80s	1990s	2008	2011
Antilock Braking System (ABS) is introduced in 1978; the cordless hammerdrill and the world's first industrial robotic swivel-arm launch in 1984; and the condensing boiler is introduced in 1985.	Bosch's first CFC-free fridge enters the market in 1990. In 1995 the company introduces the world's first Electronic Stability Programme (ESP®).	A joint venture with Samsung, SB LiMotive is formed – producing lithium-ion batteries for the future passenger car. Bosch Logixx water-saving dishwashers launch.	Bosch celebrates its 125th anniversary.

BSI Group is a global independent business services organisation delivering standards-based solutions to help organisations improve quality, save money, reduce risk and be more sustainable. BSI does this through the development of standards; the assessment and certification of management systems and medical devices; testing and certification of products and services; software solutions; and training services.

Market

BSI works with clients operating in a myriad of sectors including communications, construction, energy, engineering, electronics, retail, food and drink, healthcare, agriculture, consumer goods, banking and the public sector. BSI's clients – which include 75 per cent of FTSE 100 companies, 42 per cent of Fortune 500 companies and 42 per cent of companies listed on the Hang Seng – rely on its expertise in delivering standards-based solutions. BSI's Registered Firm and Kitemark® certification are respectively seen as one of the best quality assurance marks and safety marks to be gained.

BSI employs more than 2,500 staff and in 2009 generated a turnover of £222.8 million. It services clients in 147 countries and assists nations such as Albania, Serbia and Sierra Leone in developing their emerging standardisation infrastructures.

Product

BSI is the UK's National Standards Body and at the heart of its work is the development of standards that help make life more efficient, easier, fairer and safer. BSI works with businesses, consumers and the Government to represent a spectrum of interests and to make sure that British, European and international standards are useful, relevant and authoritative. Standards are regularly updated by external experts through a process of consensus, with the goal of establishing blueprints for excellence.

Save money by managing your environmental impact
Environmental Management Solutions from BSI
raising standards worldwide™

BSI is also one of the world's largest certification bodies for assessing and certifying management systems. It has certified 69,536 locations in 147 countries and is market leader in the UK and North America. BSI's testing and certification services ensure that products and services meet safety and performance requirements – from vehicle bodywork repairs to fire extinguishers and renewable energy products. This work is exemplified by BSI's Kitemark®, one of the UK's most trusted quality marks. BSI also provides CE marking for products that need to comply with European Directives in order for them to be sold in the European Union.

BSI's software solutions help organisations manage their governance, risk and compliance. Entropy® Software provides auditable solutions to improve environmental, social and economic performance.

Best Practice for the Worst Case Scenario
Business Continuity Management Solutions from BSI
raising standards worldwide™

The healthcare and medical devices sector is an important part of BSI's business. As a highly respected, world-class Notified Body, BSI is dedicated to providing stringent regulatory and quality management reviews as well as product certification for medical device manufacturers around the world.

Achievements

BSI produces an average of 2,000 standards annually and recently published the world's first standards for risk management (BS 31100) and business continuity management (BS 25999). Of its long-established standards, the quality management systems standard, ISO 9001 – which started life at BSI in 1979 as BS 5750 – is now recognised as the world's most successful standard having been adopted by more than one million organisations in 178 countries.

In 2010 BSI became a Notified Body for the In-Vitro Diagnostic (IVD) European Directive 98/79/EC, establishing BSI as a full-service Notified Body supporting all types of

1901	1929	1953	1979	1992	2006
BSI Group is founded as the Engineering Standards Committee (ESC). Two years later, the Kitemark® is first registered as a trademark.	The ESC is awarded a Royal Charter and in 1931, the name British Standards Institution (BSI) is adopted.	In the post-war era, more demand for consumer standardisation work leads to the introduction of the Kitemark® for domestic products.	BS 5750 (later known as ISO 9001) is introduced to help companies build quality and safety into the way they work. The Registered Firm mark is also introduced.	BSI publishes the world's first environmental management systems standard, BS 7750 (later renamed as ISO 14001).	BSI acquires German certification company NIS ZERT, UK and Canadian-based Entropy International Ltd, and Australia's Benchmark Certification Pty Ltd.

devices encompassing medical, active implantable and IVDs.

BSI receives recognition from both industry and consumers. Indeed, in April 2010 Kitemark.com was voted website of the month by readers of BBC Good Homes magazine, while in the same year the Kitemark® itself was recognised as a Business Superbrand in its own right, for the fourth consecutive year.

Recent Developments

In 2009 BSI published a new standard designed to enable a consistent and comparable approach to carbon neutrality claims. Developed in partnership with The Department of Energy and Climate Change, Marks & Spencer, Eurostar and The Co-operative, PAS 2060 is helping to restore consumers' confidence in organisations' carbon neutrality claims.

BS 8901, published in 2007, is the first standard developed specifically to help the events industry to operate in a more sustainable manner. Revised in 2009, BSI has recently certified the Weymouth and Portland National Sailing Academy – the location for the London 2012 Olympic sailing events and the first UK sailing venue to gain the standard.

In 2010 BSI launched the Kitemark® Energy Reduction Verification (ERV) scheme. Based on the European standard for energy management, BS EN 16001, it helps organisations meet their obligations under the Government's Carbon Reduction Commitment scheme. The Kitemark® ERV scheme is one of only five approved by the Environment Agency.

In the US, the Department of Homeland Security adopted BSI's business continuity standard, BS 25999, as one of only three approved for its Voluntary Private Sector Preparedness Accreditation and Certification Program.

BSI contributed to the development of the world's first brand valuation standard, ISO 10668, which was published in September 2010. It specifies the requirements for procedures and methods of monetary brand value measurement and is aimed at both brand consultants, and finance and marketing professionals.

Finishing a productive year, in December 2010 BSI published the first-ever standard on collaborative business relationships: BS 11000. The standard was created to help businesses and organisations establish solid and profitable partnerships.

Promotion

In May 2009, BSI created the 'one BSI' vision to replace its three-divisional structure and associated sub-branding. BSI's activities are now sold and branded under the master brand identity.

In the same year, BSI overhauled its global recruitment communications. The new 'employer' brand identity, BSI Careers, has been implemented globally with a unified

logo, graphical language, tone of voice and strapline.

The majority of BSI's marketing activities are now delivered electronically, through its presence on YouTube and social networking sites such as Twitter, via the Kitemark® blog, and through its online business magazine, Business Standards. Public relations also play a key role in promoting BSI activities with regular coverage for BSI and its certification brands across national and international television and radio.

2010 saw the launch of the Kitemark® Supporters Network. An invitation-only programme that seeks to establish an association between organisations whose ethics, brand and values are shared with those of the Kitemark®.

Brand Values

Integrity, innovation and independence are the values at the core of the BSI brand, supporting the organisation as it strives towards its vision of inspiring confidence and delivering assurance to all customers. BSI continually endeavours to deliver its brand values, with the aim of building a powerful, globally recognised brand, satisfying the needs of all stakeholders.

Things you didn't know about BSI

The original BSI committee met for the first time on the day Queen Victoria died – 22nd January 1901. One of the first standards it went on to publish was designed to reduce the number of sizes of tramway rails.

Eighty-eight per cent of UK adults believe the Kitemark® shows that a product comes from a reputable company (Source: GfK NOP).

Of the world's top 25 global medical device manufacturers, 23 choose BSI as their Notified Body for CE marking certification.

2007	2009		2010
BSI publishes BS 25999-2, for business continuity management; BS 8901, for sustainable event management; PAS 125, a crash repair standard; and Kitemark® certification for vehicle body repair.	BSI acquires the Supply Chain Security Division of First Advantage Corp in the US, Certification International S.r.l, an Italian Certification company, and the	German healthcare certification and testing company EUROCAT. Also in 2009, BSI abolishes its divisional structure to create a single unified BSI brand.	BSI acquires the gas testing and certification body, GLCS.

BT operates in more than 170 countries and is one of the world's leading communications services companies. It is a major supplier of networked IT services to government departments and multinational companies. BT is the UK's largest communications service provider to consumer and business markets and is made up primarily of four customer-facing lines of business: BT Retail, BT Global Services, Openreach and BT Wholesale.

Market

BT operates in a thriving, multi-trillion pound industry that spans the whole world. In recent years the global communications market has been focused on convergence, whereby the boundaries between telcos, IT companies, software businesses, hardware manufacturers and broadcasters have become intertwined to create a new communications industry – driven by the relentless evolution of technology and insatiable customer demand for innovative communications solutions.

Product

BT provides a wide range of world-class communications solutions for all types of business organisation – from sole trader start-ups to multi-site global enterprises. The company's vision is to be dedicated to helping customers thrive in a changing world, through easy to use products and services that are tailored to their needs.

For business customers, traditional products such as calls, analogue/digital lines and private circuits are combined with products and services that exploit 'cloud' computing. Broadband, email, VoIP and online applications all help small and medium sized enterprises (SMEs) to keep in touch with their customers, employees and suppliers. BT's domain and web-hosting services also make it easy for businesses to get online whilst its mobile services help them to work on the move. Cloud computing has great potential for delivering IT services to SMEs at lower prices.

In the UK, BT Business customers have benefited from a number of firsts in the

communications market. BT was the first provider to launch an unlimited calls, lines, broadband and mobile option to SMEs via the BT One Plan Plus package. Meanwhile, BT Tradespace was the first ever business social networking site to launch in the UK, helping companies to interact with their customers as well as each other.

Bringing it all together
for a **better** world

For larger enterprises, governments and multinational corporations, BT Global Services provides networked IT products, services and solutions. This includes a range of specialist network-centric propositions such as high performance networking, applications management, outsourcing and managed services.

Achievements

BT has successfully transformed itself in recent times. It has evolved from being a supplier of telephony services to become a leading

1984	1991	2003	2005	2006	2008
BT is privatised, making it the only state-owned telecommunications company to be privatised in Europe.	British Telecom is restructured and relaunches as BT.	BT unveils its current corporate identity and brand values, reflecting the aspirations of a technologically innovative future.	Following the Telecommunications Strategic Review (TSR), BT signs legally binding undertakings with Ofcom to help create a better regulatory framework.	Openreach launches and is responsible for managing the UK access network on behalf of the telecommunications industry.	BT becomes the Official Communications Services Partner and a Sustainability Partner for the London 2012 Olympic and Paralympic Games.

global provider of innovative communications products, services, solutions and entertainment products. BT's business customers range from multinational, multi-site corporations to SMEs and start-ups. The UK Government, Unilever, Thomson Reuters, Microsoft, Volkswagen, Volvo, BMW, Fiat and the Spanish Government are just some of the organisations working with BT to maximise the power of networked IT and communications services. In November 2010, BT Global Services was named Best Global Operator at the World Communications Awards.

BT is one of six sustainability partners to the London 2012 Olympic and Paralympic Games. It is working hard to minimise the environmental impact of its activity wherever possible and last year became the first partner to the Olympic Games to commit to assessing the impact of the products and solutions it will be providing.

It is working with Race Online 2012 to help get at least 100,000 people online for the first time by 2012. BT has been helping people to get online since 2002 and its Get IT Together campaign is bringing the benefits of information communications technology to disadvantaged communities across the UK.

BT is developing the UK's biggest corporate wind power project outside the energy sector. BT Carbon Clubs are encouraging employees to raise awareness of how energy savings can be made at work, in homes, schools and in the wider community. Its solar energy installations at its US headquarters in California have also won BT awards further afield.

Recent Developments
BT continues to invest in bringing faster, more feature-rich services to its customers and plans are well underway to roll out super-fast fibre

broadband to two-thirds of UK homes and businesses by 2015. BT's £2.5 billion investment is the UK's largest ever investment in super-fast broadband and one of the biggest commercial investments in fibre in the world. It will deliver a range of services for customers, giving them top speeds of up to 100Mb/s with the potential for speeds of more than 1,000Mb/s in the future. This will allow them to run multiple bandwidth-hungry applications at the same time – for example in the home, some family members could be watching high definition films, while others play online games or work on complex graphics or video projects.

In recent years, BT has been transforming itself into a networked IT services company.

It continues to develop technology and platforms internally, changing from a hardware-based business to a software-driven company, so that it can deliver new software services for customers at the push of a button rather than through a process involving screwdrivers, rewiring and customer visits. This is dramatically increasing the speed at which BT can design new services and deliver them to its customers.

Promotion
BT is the Official Communications Services Partner for the London 2012 Olympic and Paralympic Games, and a Sustainability Partner. Responsible for providing key communications services to the operational workforce and at Games venues, BT is at the heart of the biggest event the UK will stage in the next decade. In addition, BT has exclusive marketing rights to use the London 2012 brand within its category.

In 2010 BT Retail launched its new super-fast fibre broadband, BT Infinity, which is being rolled out across the country. To demonstrate the benefits of up to 40Mb fibre broadband, the BT Infinity Bus was born. Touring the country across the summer, the bus was fitted out with demos that showcased the benefits for both homes and businesses. Events were held for local influencers, small businesses and consumers.

Brand Values
BT's corporate identity defines the kind of company it is today – and the one it needs to be in the future. Central to that identity is a commitment to create ways to help customers thrive in a changing world. To do this, BT focuses on 'living' its brand values, which are as follows: Trustworthy – doing what it says it will; Helpful – working as one team; Inspiring – creating new possibilities; Straightforward – making things clear; Heart – believing in what it does.

Things you didn't know about BT

Thanks to BT, more homes in Britain now have access to broadband than have access to mains water.

Eighty-nine per cent of the Forbes Top 500 global companies are BT customers, and the world's top 10 global stock exchanges depend on BT infrastructure.

BT Conferencing is the number one provider in Europe; the use of conferencing has reduced BT's own carbon footprint by 100,000 tonnes of CO_2.

In 2010, BT became one of the first organisations in Europe to have a data centre accredited by the European Commission for energy efficiency; Cardiff International Data Centre is now officially one of the greenest in Europe.

2009

BT becomes a Premier Partner of the Cultural Olympiad with the launch of the National Portrait Gallery/BT Road to 2012 project: commissioning 100 new photographs over the next three years, showing the people behind the London 2012 Olympic and Paralympic Games.

2010

The BT Tower is updated with a 360 degree LED screen wrapping the 36th and 37th floors.

BT picks up four awards at the World Communication Awards: Best Global Operator, Best Wholesale Carrier, Best Technology Foresight and The Green Award.

The Chartered Management Institute (CMI) is the only chartered professional body dedicated to developing and supporting managers and leaders, and the organisations they work in. In a turbulent market in which change is one of the few constants, the CMI's mission remains the same: to deliver management and leadership excellence across all sectors of UK industry.

Market

The essential skills required to survive and prosper in the modern business environment are constantly changing, having a significant impact on the way in which organisations structure and develop themselves and their managers. Strong business performance and the delivery of public services depend on high quality management and leadership.

The strength of CMI lies in the breadth and depth of its offering. A one-stop-shop for all management and leadership development, its business model spans several markets. The CMI's portfolio encompasses qualifications, training and development, membership, policy development, research and accreditation.

Product

The tailor-made training programmes and qualifications CMI offers are designed to meet the needs of today's management professionals, and to support its corporate members in developing and delivering management and leadership excellence across their organisations. CMI is the only body in the UK that awards Chartered Manager status, the hallmark of any professional manager. In 2010, the number of individuals working towards CMI qualifications increased by 36 per cent year-on-year.

The CMI prides itself on being one step ahead when it comes to understanding what might affect managers and leaders tomorrow.

It provides up-to-the-minute research on the hottest management issues; information and guidance through its online management centre; and consultancy services and guidance for managers at every level and across every type of organisation. In addition, CMI holds events throughout the year, the highlight of the calendar being the annual National Conference, which focuses on key management and leadership challenges.

As the UK's leading authority on management and leadership, CMI challenges policy-makers and opinion formers, ensuring issues affecting managers and leaders are firmly on the agenda. Its expertise also means it is regularly consulted by other organisations.

Membership of CMI aims to give managers and organisations an edge over the competition. Indeed, CMI member surveys suggest that its networking events, research reports, training and development opportunities, and information and advice provide members with unrivalled access to the gold standard in terms of management and leadership expertise, support and excellence.

1947	1951/52	1987	1992		1995
The British Institute of Management (BIM) is formed.	The UK's first Diploma in Management Studies is introduced by the BIM and the Ministry of Education.	The BIM, in conjunction with other bodies, issues two pivotal reports: The Making of British Managers, and The Making of Managers.	The BIM and the Institution of Industrial Managers (IIM) merge to form the Institute of Management (IM). The transfer of the IM's Awarding Body	status to the new Institute is approved by the (former) National Council for Vocational Qualifications, now the Qualifications and Curriculum Authority.	The IM publishes 'Test your management skills' – the world's first validated general management aptitude test.

Achievements

As an organisation with charitable status, CMI sees its role as being one of helping to shape the UK's future through the influence it exerts on behalf of employers and individual managers. In the months prior to the 2010 general election, CMI launched its own Manifesto for a Better Managed Britain, calling on government, employers and individuals to recognise that the economic, social and political challenges the UK faces demand a radical new approach to management and leadership. The CMI's argument – namely that the burden of action falls on government, employers and individuals alike – achieved cross-party support and its manifesto pledges received more than 3,500 signatories in support.

Recent Developments

In a difficult market, the value of professional qualifications continues to be appreciated. In 2010 CMI launched an accreditation and validation service for employers who recognise skills development as the route to future success. Among those first acknowledged were the General Medical Council, First Group, and Nottingham University Hospitals Trust.

In 2009 CMI launched its new brand identity, with the continued interest from organisations seeking partnership and brand association, evidence of its success. Recent partnerships include a formal agreement with the ACCA, and research projects with organisations including the Cabinet Office.

Promotion

Promotion of CMI focuses on the requirement to raise the brand profile, which is achieved through a full range of marketing and promotional activities, from branch events and regional conventions to more targeted PR and marketing activities. Brand marketing activities focus on three key areas: opinion forming, influencing, and brand building.

Today's generation of managers want both a physical and a virtual presence. CMI has invested in social media and its website to allow managers to stay connected with their peers, keep up-to-date with developments that interest them, and access practical resources.

Over the years the reputation of management has been tarnished by a number of high profile management failures hitting the headlines. In 2009, as champions of good management practice and guided by its own Code of Professional Conduct and Practice, CMI focused on revitalising the reputation of management while also raising the profile of the Institute itself. The campaign achieved more than 2,600 pieces of coverage and over 200 million people were exposed to its messages (Source: Durrants).

Brand Values

The re-launched CMI brand is encapsulated by the phrase: 'Passionate about managers and leaders making an impact.' Everything that CMI does is guided by this principle as it strives to help others achieve management and leadership excellence.

The brand's character can be summed up as: passionate – it believes in what it does and offers; challenging – it believes its members get better answers by constantly questioning the status quo; progressive – it looks forwards, not backwards; and savvy – its knowledge and expertise makes it smart and quick to respond.

Things you didn't know about Chartered Management Institute

The first Chartered Manager programme was launched in September 2003.

Recent winners of CMI's annual Gold Medal – which has been awarded to outstanding individuals in the field of management for more than 25 years – include Lord Tony Hall for his work across the creative industries and at the Royal Opera House in particular, and Lord Karan Bilimoria for his success in establishing and developing Cobra Beer.

The highest level of CMI membership is the Companion. Involvement is by invitation only, extended to leaders who have demonstrated superior management and leadership achievement in substantial organisations. There are currently around 1,000 Companions.

2000	2002		2010
The IM accredits its 250th approved centre to deliver IM management qualifications.	The IM's management qualifications are recognised as part of the UK's National Qualifications Framework for Higher Education.	Also in 2002, the IM is granted a Royal Charter and is renamed the Chartered Management Institute (CMI).	The CMI names the UK's 1,000th Chartered Manager.

CLASSIC *f*M

From the moment Classic FM went on-air, media pundits and classical music buffs alike were ready to write off the idea of a commercial station playing classical music. However, within months of launch Classic FM had an audience of more than four million people, with many listeners coming to classical music for the first time in their lives. Nineteen years on, Classic FM attracts 5.7 million listeners every week.

Market

Classic FM is the UK's largest commercial radio station, with an audience of 5.7 million people per week as well as nearly a quarter of a million children (Source: RAJAR Q3 2010). Alongside Classic FM, there are more than 500 radio stations broadcasting across the UK on FM, AM, online and digital.

Product

Classic FM is the nation's favourite classical music radio station and remains committed to making classical music accessible to everybody in the UK.

Key to its success as a multi-platform brand has been its ability to identify and pioneer new ways of engaging listeners, with online playing a crucial role. Classicfm.com, a rich source of information for people with an interest in classical music, allows users to listen again to the station's programmes, download the acclaimed Classic FM Podcast and catch up with news and interviews with some of the classical world's biggest stars. A free service for registered users also provides a monthly newsletter. Currently,

450,000 people are signed up to receive regular email news from the station. Social media plays a vital part in Classic FM's online strategy. The station's Facebook page and Twitter profile allow listeners to interact meaningfully with presenters and continue the classical conversation online.

The first issue of Classic FM Magazine rolled off the press in 1995. It is now the UK's

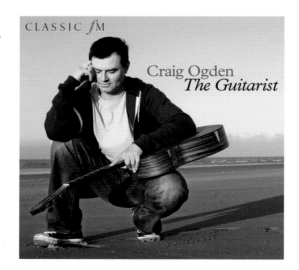

best-selling classical music title on news stands, with an average monthly readership of up to 249,000 (Source: National Readership Survey January – December 2009).

Classic FM also hosts a bi-annual concert, Classic FM Live at the Royal Albert Hall. Now in its 11th year, the event attracts the world's biggest classical artists.

Achievements

Classic FM's pioneering approach to its programming, advertising and marketing has won the station many accolades, including more than 10 Sony Radio Academy Awards. Classic FM has been voted UK Station of the Year four times, and has been nominated for the award on six occasions. It has won two Gold Awards for On-Air Station Sound. Other awards include Campaign Medium of the Year and the UK Brand Development of the Year award from the Marketing Society.

Off-air, music education is a subject close to the station's heart. The annual Classic FM Music Teacher of the Year Awards, now in their 12th year, recognise the classroom music teachers

1992	1994	1995	2000	2001	2003
At 6am on 7th September, Classic FM launches with Handel's Zadok the Priest. Four months later, the station is attracting 4.2 million listeners per week.	Classic FM is named UK Station of the Year at the Sony Radio Academy Awards.	Classic FM Magazine launches, quickly becoming the UK's best-selling classical music title on UK news stands.	Classic FM is named UK Station of the Year for the third time and also collects the award for On-Air Station Sound.	Classic FM launches its local partnership programme by signing up the Royal Liverpool Philharmonic Orchestra as Classic FM's Orchestra in the North West.	The station launches Classic FM Arts & Kids Week. The following year, Classic FM signs its first composer-in-residence, Joby Talbot, formerly of The Divine Comedy.

CLASSIC ƒM

DIGITAL RADIO | CLASSICFM.COM | 100-102FM

now with more music

who make a real difference to the musical life of their students. Classic FM's involvement with the Music For Youth Schools Proms meanwhile, celebrates the very best of the UK's vibrant musical scene. In addition, The Classic FM Foundation funds music education and music therapy projects benefiting disadvantaged children and adults across the UK.

Recent Developments

John Suchet, the respected journalist and classical music enthusiast, began hosting Classic FM's 9am to 1pm weekday show in January 2011. He joins an established daily programming line-up that includes Margherita Taylor as the voice of Smooth Classics, and The Full Works Concert, presented by Jane Jones on weekdays and Howard Goodall on Saturdays.

Other presenters include Myleene Klass, Jamie Crick, Mark Forrest, John Brunning, David Mellor and Laurence Llewelyn-Bowen.

Blur bassist Alex James takes the Sunday afternoon slot for a major series, The A–Z of

Classic FM Music. Recently commissioned for another series, the weekly programme is the biggest series in the station's history and aims to provide the definitive guide to classical music.

Working with Universal Music, Classic FM's record label also continues to go from strength to strength, becoming the second largest classical label in the UK in 2009. As well as a range of compilation albums, Classic FM has signed a number of artists directly to its label with two number one albums and four top 10 albums under its belt in 2010. Working with HMV, Classic FM has also developed The Full Works, a range of more than 160 CDs of the greatest classical works played in full. After running for just 18 months, the range became the top-selling classical value album range in the UK.

Classic FM has also developed a successful range of books that tie in to the station's programming and products, such as the hardback book accompanying The A–Z of Classic FM Music box set. Classic Ephemera

– written by station head Darren Henley, and presenter and creative director Tim Lihoreau – was published in 2009 and is Classic FM's best-selling book to date.

Promotion

Traditional broadsheet press advertising and online media have been used over the last year to talk to a relevant national ABC1 audience.

The station also noted that many people listen to Classic FM whilst studying; so for the first time in its history, Classic FM directly targeted students with an innovative social media campaign. For a chance to win a prize, the Classic FM Treasure Chase invited students to find the iconic red F of the Classic FM logo, hidden in universities across the UK, and to take their picture with it. The campaign was reinforced by the message that 'Classic FM can help your concentration' posted on online and social media channels. The promotion was shortlisted for a British Interactive Media Association award.

Alongside this, strategic partnerships have been forged with music and arts organisations to promote the brand to people at a local level. Partners include the London Symphony Orchestra, the Royal Liverpool Philharmonic Orchestra, the Philharmonia Orchestra, the Royal Scottish National Orchestra, the National Children's Orchestra, The Sixteen, the Northern Sinfonia and the Orchestra of Opera North.

Brand Values

Classic FM remains committed to its aim of presenting classical music to an ever-increasing audience by being modern, relevant, involving and accessible. These values have delivered Classic FM the largest commercial radio audience in the UK.

© Matt Crossick/PA

Things you didn't know about Classic FM

The sound of birdsong intrigued audiences and the media across the summer of 1992. It was, in fact, the test transmission of Classic FM.

Classic FM sponsored Queens Park Rangers during the first season of England's new elite Premier League.

Classic FM shares more audience with BBC Radio 4 than with any other radio station.

2005	2006	2007	2010
Research commissioned by Arts Council England shows that Classic FM is instrumental in bringing new audiences to the concert hall.	Classic FM launches the Classic FM Presents label. Its first release is of British tenor Alfie Boe.	Classic FM is named UK Station of the Year at the Sony Radio Academy Awards – for a fourth time.	In the 10th year of their association, Classic FM and the Royal Liverpool Philharmonic Orchestra win the BP Arts & Business Sustained Partnership Award.

Clear Channel

Clear Channel Outdoor is the world's largest out-of-home advertising company, with a portfolio of almost one million displays delivering intelligent and creative media campaigns in 44 countries. Its flexible out-of-home inventory spans multiple traditional and digital formats across roadside billboards and street furniture, retail, airport, transit and lifestyle environments. In the UK, Clear Channel provides more than 60,000 advertising opportunities.

Market

According to the Outdoor Advertising Association, the sector's revenues for the July–September 2010 period reached £212.2 million, up 12.4 per cent year-on-year. Roadside formats performed well, taking 52.4 per cent of the revenue – roadside's highest share since the fourth quarter of 2007. The other standout performance was digital small formats in the retail and leisure environments, which more than doubled revenue year-on-year following investment in the sector. Digital revenues accounted for £23.8 million in the third quarter, up 62 per cent year-on-year. For the first three quarters in 2010, the outdoor medium was up 14.9 per cent in 2010 overall – a performance that compares strongly against other media.

Product

Clear Channel Adshel is the UK's leading supplier of 6-sheet advertising, with 65 per cent of the UK roadside market. In addition, Clear Channel Adshel offers point of sale (POS) opportunities at some 300 Sainsbury's supermarkets and in more than 80 UK shopping malls.

Clear Channel Billboards is the market leader in quality 96-sheet billboards and provides national, high quality 48-sheet billboards across the UK. In 2009/10, Clear Channel conducted an extensive review of its inventory to focus on the highest quality sites and locations and is now reaping the benefits of this initiative.

The company's Pinnacle division offers market-leading premium advertising on more than 200 special high-profile sites such as London's Cromwell Road, Piccadilly Circus and M4 Towers.

Clear Channel also offers a network of 11 roadside digital LED sites across London and 140 digital sites in shopping malls across the UK.

Achievements

In 2010 Clear Channel's Collaboration team was named Outdoor Sales Team of the Year at the Campaign Media Awards. These awards are the most prestigious in the media calendar and recognise outstanding teams from media owners and agencies across product sector categories. Clear Channel's UK research team was also Highly Commended at the inaugural Media Research Group Awards.

Clear Channel is continually looking to reduce its energy consumption and promote sustainability; it was a finalist in the Low-Carbon Product category at the Green Business Awards and introduced a new LED lighting system that reduces energy consumption by

1936	1967	1996	2004	2006	2008
More O'Ferrall is founded.	The Adshel brand is launched.	The company is rebranded as the More Group. Two years later the More Group is acquired, Town & City billboard is bought, and the Sainsbury's contract is won.	The company wins the malls POS contract.	The company is rebranded as Clear Channel Outdoor. It buys Van Wagner in the UK and launches the Pinnacle brand.	The digital roadside network is formed and the Interact mobile services division launches. Bain Capital Partners LLC and Thomas H Lee Partners LP acquire the company.

92 per cent at selected sites, while reducing energy demand in others by nearly 70 per cent.

Clear Channel's green credentials are long established, from its commitment to liquefied petroleum gas fuels and greener fleets, which secured the Green Fleet Award 2006 and the Fleet Hero Award 2007, to being named one of the top 50 Best Green Companies by The Sunday Times for the third consecutive year in 2010.

Recent Developments

In 2010 Clear Channel Outdoor expanded its Sainsbury's POS portfolio with more than 300 6-sheet panels added in 120 stores nationwide. Working with Sainsbury's, Clear Channel updated the sites to provide the best possible proximity for advertisers.

Clear Channel also expanded its market-leading Pinnacle Collection of the most striking out-of-home structures with the launch of the A3 Halo Tower at Shannon Corner, achieving 1.6 million impacts per panel every fortnight. Advertisers

provides leadership, direction and resources across all of its businesses.

Promotion

Clear Channel not only communicates with its key audiences – advertisers, agencies and other stakeholders – but also promotes the outdoor advertising industry. In partnership with Haymarket Brand Media, Clear Channel launched the Outdoor Planning Awards in 2007,

artwork directly generated from the music being played. Each 6-sheet location was also geo-tagged, allowing the finished pieces of artwork to be tracked using a London map.

Thanks to its industry knowledge, Clear Channel can provide research and insight to help advertisers and support the medium. It is also a strong supporter of Postar, the audience research body for the out-of-home advertising industry.

Brand Values

The Clear Channel vision is to inspire and motivate people with powerful out-of-home campaigns. Clear Channel embraces the values of freedom, flexibility, being forward-thinking and fulfilling promises. They inspire the business to focus on services such as WAVe proof of posting and on the environmental management work and charity support that the company undertakes. The company provides high quality products and services that benefit its clients, partners and communities, and helps to set new standards for the whole sector.

so far have included Gatwick Airport, Barclays, Waitrose, Smirnoff and Mercedes-Benz.

An interesting partnership with Kinetic Worldwide saw Clear Channel undertake pioneering face-tracking research aimed at increasing understanding of consumer behaviour and interaction with out-of-home media. Insights from the research included the moods of mall shoppers and the performance of digital out-of-home campaigns carrying static or moving content.

One further significant company development in 2010 was the appointment of Matthew Dearden as chief executive of Clear Channel UK and as a member of Clear Channel International's Executive Committee that

now in their fifth year. Clear Channel has also championed creativity in outdoor advertising through the Student Design Awards, which it has run for more than 20 years, and through annual industry seminars. Clear Channel also sponsored the Campaign BIG Awards in 2009 and 2010 and sponsored the Outdoor category at the Cannes Lions for the first time in 2010.

Clear Channel's involvement in the 2010 Beck's Music Inspired Art campaign, in which interactive 6-sheets were placed in prominent Clear Channel Outdoor locations around London, demonstrates the brand's continued commitment to cutting-edge promotional concepts. Passers-by were encouraged to plug their MP3 players into a headphone socket. Once connected, the ad space was filled with

Things you didn't know about Clear Channel Outdoor

Clear Channel has created unique solutions to the 'way-finding' needs of cities, combining practicality with clean, modern design through signage, finger posts and maps.

Clear Channel has a presence on both Twitter and Facebook, and the company also broadcast its latest seminar – The Outdoor Social Space – on the internet, encouraging audience interaction via a Twitter feed.

Clear Channel holds more than 350 municipal contracts in the UK, including the largest street furniture advertising contract with Transport for London.

Clear Channel's flagship Piccadilly Lite site is the only flexible advertising opportunity offered at the Piccadilly Circus location.

2009	2010		
The digital malls network, national dry-posted billboards and WAVe technology launch. William Eccleshare is appointed president and CEO of Clear Channel International.	Clear Channel expands both its digital mall network and its Sainsbury's POS offering. The world's first 'Real 3D' out-of-home campaign also launches.	Also in 2010, 'The Cromination' launches – six consecutive 96-sheets that dominate one of London's prime locations, Cromwell	Road – with booked adverts including Nike, 20th Century Fox, Warner Bros, Emirates and Tourism Australia.

CNN is the world's leading global 24-hour news network, delivered across a range of multimedia platforms. Launched in 1985, the channel's output comprises its trademark breaking news, business and sports news, current affairs and analysis, documentary and feature programming.

worldwide across television, radio, online and mobile in more than 200 countries and territories via six languages.

CNN's global news group currently comprises nine international networks and services, five international partnerships and joint ventures, and eight US-based services. The channel's joint ventures include CNN Chile, CNN-IBN, CNN Turk, CNN+ in Spain and Japan's CNNj, as well as websites including CNN.co.jp and CNNenEspanol.com. While breaking news remains CNN's trademark, its feature programming line-up caters to a wide range of audiences, covering business, sport, lifestyle and entertainment, compelling documentaries and special landmark programming.

Throughout the year, CNN's best known faces, including Richard Quest and Becky Anderson, front prime time programmes such as Quest Means Business, Connect The World and special documentaries.

Market
Since CNN pioneered the genre of 24-hour news, the pan-regional news market has expanded to include more than 100 news channels worldwide. CNN has remained at the forefront of this increasingly competitive market, warding off competition from domestic and pan-regional news services, with its growing international newsgathering operation and intricate network of regionalised services and affiliates.

CNN continues to attract a range of high profile advertisers with its cross-platform advertising sales offering, one of the most comprehensive and innovative in the industry. Online is currently the fastest-growing driver of the advert sales

business while television remains strong, drawing major clients such as Standard Bank, Globacom, Vestas, Philips, Longines, DIFC, Mubadala, Rolex, Standard Bank, Abu Dhabi Tourism Authority, Skype and Vacheron.

CNN's leadership in reaching premium audiences positions the network well to embrace the new media challenges of an increasingly converged world.

Product
In 1980 CNN launched as a single US network available to 1.7 million homes. Some 30 years later, CNN's 22 branded networks and services are available to more than two billion people

Achievements
In 2010, CNN International won a George Polk Award in the International Television Reporting category for its documentary, World's Untold Stories: A Forgotten People. The award-winning documentary presented by Dan Rivers highlighted the ongoing persecution of the Rohingya people in Myanmar (Burma). In the same year, CNN International's Go Beyond Borders campaign was awarded both a Gold and Bronze Lion at the Cannes Lions International Advertising Festival, one of the world's premier showcases for excellence in advertising. CNN International was also short-listed for Channel of the Year in the 2010 RTS Television Journalism Awards.

1980	1985	1989	1995	1997	1999
CNN launches on 1st June as a single US network; the brainchild of media entrepreneur Ted Turner, it becomes the first round-the-clock news channel.	CNN International launches, along with live 24-hour transmission to Europe.	CNN is now available worldwide, 24 hours a day, with transmission via a Soviet satellite to Africa, the Middle East, the Indian subcontinent and South East Asia.	CNN.com, the world's first major news website, is launched. This is followed by the all-encompassing international edition.	CNN launches a regionalisation strategy with the guiding philosophy, 'Global reach, local touch'.	CNN Mobile launches. It is the first mobile telephone news and information service available globally with targeted regional content.

CNN has become synonymous with breaking news, acting as a visual history book for the world. As stories from across the globe have hit the headlines, CNN has been there – from Tiananmen Square and the 11th September terrorist attacks to the death of Michael Jackson and the global credit crunch. In 2010, CNN's registered iReporters exceeded the half a million mark as watershed moments such as the Haiti earthquake prompted considerable increases in traffic.

In 2010, 20 CNN staff raised funds – with the help of parent company Turner Broadcasting – to travel to Malawi for a two-week project to help build a new village school.

Recent Developments

CNN has a strong heritage of offering extensive coverage and analysis of international events and stories of global importance. It continues to invest in intelligent and compelling feature and documentary programming across all digital platforms, setting the standard for forging unique audience connections that truly engage consumers worldwide. With a network of more than 1,000 broadcast affiliates worldwide, CNN International broadcasts upwards of 90 per cent of its programmes exclusively for a global audience.

In 2009, CNN International launched a broadcast hub in Abu Dhabi, becoming the first Western broadcaster to broadcast a live daily show, Prism, from the Middle East. Programming investment continued into 2010 with the introduction of a new prime time schedule for Asia Pacific in November.

CNN International's European prime time line-up continues to go from strength to strength. Quest Means Business is the definitive word on how people earn and spend money. World One, hosted by Fionnuala Sweeney, is a fast-paced international news bulletin, designed to keep viewers up-to-date on the day's major stories. Connect The World, hosted by Becky Anderson, joins together seemingly unrelated global stories, exploring how an event or circumstance in one part of the world can have a significant impact elsewhere. BackStory, hosted by Michael Holmes, goes beyond the headlines to give viewers a look at how CNN news programming is brought to air, showing

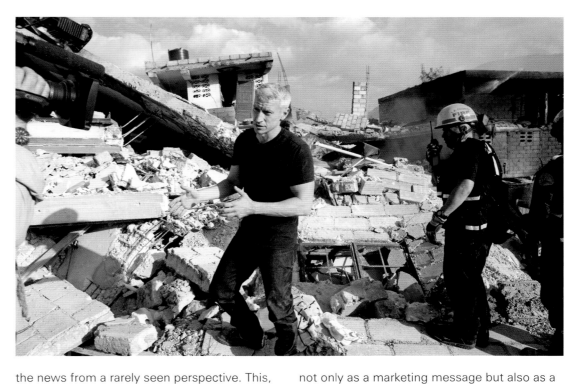

the news from a rarely seen perspective. This, alongside the network's existing feature and documentary slate, confirms CNN's evolution into much more than a multimedia 24-hour rolling news channel.

With an eye on changing consumer trends, CNN embraces the range of emerging, non-linear distribution outlets to maximise its presence across all platforms. Indeed, in July 2010 CNN International launched its new iPhone app for users worldwide. In the same year, CNN's pioneering global social media research into The Power of News and Recommendation was launched, giving the industry and advertiser a new way of quantifying news shared in the social media space.

Promotion

Since launch, the CNN logo has been one of the world's most instantly recognised brands, and it continues to be promoted through select marketing opportunities and partnerships.

In 2009, CNN International unveiled a new tagline 'Go Beyond Borders' to replace 'Be the First to Know', which debuted in March 2001. Go Beyond Borders is an articulation of the network's shared values and commitment to delivering intelligent news in a connected world. CNN International now uses this tagline

not only as a marketing message but also as a content filter; its news coverage promises to go beyond the expected.

Brand Values

For 30 years, CNN has stood by the news values of accuracy, intelligence, transparency and diversity. The network's commitment to digital integration also ensures that its audiences get access to CNN 'whenever, wherever and however'.

CNN is global in its reach and continually aims to break new ground and go beyond expectations. Go Beyond Borders demonstrates that stories and people are not defined or limited by geography, and neither is CNN – it speaks directly to viewers' aspirations and expectations. It also reflects the changing world, as news is consumed across an increasing number of platforms.

Transparency and diversity are crucial to CNN's viewers; they expect their news source to challenge and question, as well as deliver truly international reporting and perspectives.

Things you didn't know about CNN

CNN Breaking News (@cnnbrk) is the most followed Twitter feed in its Twittersphere location, with more than 3.5 million followers (Source: Twitaholic.com). CNN International can also be followed via @cnni or through its Facebook page.

CNN's iReport.com initiative now has more than 600,000 registered users, known as 'iReporters'.

CNN.com's coverage of the Chilean miner rescue delivered 4.6 million live video streams, making it the network's biggest live video event of the year.

2006	2008	2009	2010
CNN launches its citizen journalism initiative, iReport. The following year, CNN launches across major IPTV and VOD outlets, including YouTube, and CNN.com is redesigned.	iReport.com is born; an online incarnation of iReport, it is the company's first unfiltered, uncensored user-generated content website.	CNN International launches eight new prime time programmes for its European line-up and the 'Go Beyond Borders' tagline replaces 'Be the First to Know'.	CNN International launches a new iPhone app, reaching millions of users globally with the latest news and feature content.

The Coca-Cola Company is the world's largest beverage company and the leading drinks brand worldwide. In Great Britain, Coca-Cola and diet Coke are the country's two biggest soft drinks. The classic contoured original glass bottle has become synonymous with the brand and is an instantly recognisable icon the world over. For the last 11 years, Coca-Cola has remained top of the Interbrand Top 100 Best Global Brands (Source: Interbrand 2010).

Market

Coca-Cola remains one of the most successful and innovative brands in the world today. Ongoing brand and product innovation continues to reinforce its leadership in the soft drinks category.

In 2009 the My Coke portfolio became the first brand to top the £1 billion retail sales mark, with 6.6 per cent growth in value year-on-year. Within this, diet Coke saw 9.1 per cent year-on-year value growth, Coca-Cola Zero reached a sales value of more than £58 million and Coca-Cola achieved a sales value of over £550 million, remaining the most popular global soft drink (Source: Nielsen Total Coverage 52 w/e 10th July 2010).

Product

There are three core products in the Coca-Cola trilogy: Coca-Cola, introduced more than 100 years ago; diet Coke, launched almost 30 years ago; and the newer addition Coca-Cola Zero.

Achievements

Since its launch in 2008, the brand's engagement site, CokeZone.co.uk, has grown steadily and now boasts two million registered users. In 2010 the site was ranked the number one FMCG brand website (Source: Nielsen NetRatings 2010) and won four Institute of Sales Promotion marketing accolades, including a Gold award for Digital Promotions.

Keeping employees healthy and happy also remains pivotal to the Company's ethos and in 2010, Cola-Cola Great Britain was placed 22nd in the Great Place to Work® Institute's UK rankings.

Recent Developments

As part of a commitment to environmental sustainability, the brand has launched schemes such as Recycle Zone, through which recycling facilities have been placed in 80 areas across the UK, and Trace Your Coke, an app allowing consumers to trace their drink to its factory of origin and understand the role of recycling in cutting its carbon footprint. Elsewhere, the Company has continued to reduce packaging across its range and strives for its manufacturing sites to better their current rate of 97 per cent recycling of all waste to 'zero waste' by the end of 2011. The Company is also on target to achieve its goal of using 25 per cent recycled plastic in all bottles by 2012 and was the first sparkling drinks brand to become certified by the Carbon Trust.

Promotion

Brands within the Coca-Cola Great Britain portfolio are synonymous with innovative and relevant marketing campaigns that reach out to and inspire consumers across the globe. The Company continues to invest heavily in maintaining awareness across its Coca-Cola trilogy, communicating with each specific audience with activity that engages and

1886	1893	1915	1984	2006	2009
Coca-Cola is invented by John Styth Pemberton, a pharmacist in Atlanta, Georgia. Asa Candler acquires the business in 1888.	The famous signature Coca-Cola 'flourish' is registered as a trademark. By 1895, Coca-Cola is available in every US state.	The Coca-Cola contour bottle, made from Georgia green glass, appears for the first time. A unique 3D trademark protects it from its growing army of imitators.	Diet Coke is launched – the first brand extension of Coca-Cola in Great Britain.	Coca-Cola Zero becomes the third brand in the Coca-Cola family in Great Britain. Two years later, the brand's engagement site CokeZone.co.uk launches.	The My Coke portfolio becomes the first brand to top the £1 billion retail sales mark.

rewards. Using its position as an instantly recognisable and authentic brand, Coca-Cola has embraced digital communication, embedding consumer conversation and brand interaction at the heart of its marketing strategy.

This year, Coca-Cola amplified its global Open Happiness campaign with its sponsorship of the FIFA World Cup™, encouraging enthusiasm and support around the tournament by asking consumers: 'What's Your Celebration?' The brand tapped into the elation expressed during goal celebrations and brought to life the moment of happiness and uplift that is at the heart of Coca-Cola. A fully integrated programme was designed to spread excitement through ads, in-store displays, packaging, music, experiential and social media activation in more than 150 countries. Coca-Cola also took the FIFA World Cup™ Trophy on tour, allowing fans across 84 countries to enjoy a rare close-up of the biggest prize in football.

Elsewhere, the sequel to the internet hit Coca-Cola Happiness Machine came to the UK. This unique film, which set out to brighten up the days of unsuspecting British students, attracted more than 100,000 views within its first 48 hours online.

As a proud partner of the London 2012 Olympic and Paralympic Games, Coca-Cola is working to inspire healthy and active lifestyles; for example, through its support of StreetGames, a national charity set up to enable young people in disadvantaged communities to participate in sport. Similarly, through its sponsorship of the London 2012

Olympic Torch Relay, Coca-Cola is looking to bring the spirit of the Olympic Games to communities across the UK.

The brand also continues to support wider sporting events and in 2010, announced new three-year partnerships with The Football League and The Scottish Premier League.

In 2010 diet Coke earned its fashion stripes, with a multifaceted campaign that tapped into the target audience's passion points of trends, fashion, content and fun. The brand platform Love It Light featured engaging new creatives with three savvy, sophisticated and witty marionette puppets that epitomise the diet Coke ethos. The campaign was supported by a pan-European Facebook hub and brand partnerships with the likes of online fashion retailer ASOS, magazine mecca Bauer Media and of-the-moment nail brand, nails inc. The tie-ups were designed to offer consumers a moment of pleasure and a 'pick-me-up', rewarding loyal customers while also aiming to recruit a new generation of drinkers.

Meanwhile, Coca-Cola Zero sponsored box office hit AVATAR in more than 30 markets worldwide. Providing access to exclusive content, the campaign included an immersive cinematic ad and digital engagement across the Coke Zone website. Elsewhere, the popular Coke Zero Street Striker programme with Wayne Rooney returned to Sky for its third series, continuing to track down the UK's freshest, untapped football talent.

Promoting the My Coke portfolio, 2010 saw Coca-Cola launch a series of campaigns that positioned Coca-Cola, diet Coke and Coca-Cola Zero together for the first time. The Coke With Food initiative saw the brand join with ITV1 under the strap-line 'Saturday Night Tastes Better with Coca-Cola & ITV1'. Celebrating the role of Coca-Cola in delivering enjoyment and bringing families together at Saturday mealtimes, the partnership with ITV was the first of its kind for the brand. Later in the year, Coca-Cola continued to

highlight its food and family occasions heritage by launching a limited edition recipe book, When You Entertain, featuring recipes from high profile chefs and food personalities. To further push the category, an uplifting intrinsic-led spot highlighted the choice available across the My Coke trilogy, celebrating a Coca-Cola drink for everyone and every occasion.

Brand Values
The brand values of Coca-Cola have stood the test of time, conveying optimism, happiness, togetherness and authenticity. Coca-Cola aims to bring people together with an uplifting promise of better times and possibilities. These values make Coca-Cola as relevant and appealing to people today as it has always been, and the Company's reputation for strong marketing ensures that this connection remains as powerful as ever.

Things you didn't know about Coca-Cola

Coca-Cola has been an official partner of the Olympic Games since 1928 – the longest running sports sponsorship in history.

The Coca-Cola Company markets more than 400 brands worldwide, with 20 in the UK alone.

Coca-Cola will be 125 years old in 2011.

'Coca-Cola', 'Coke', 'diet Coke', 'Coca-Cola Zero' and 'Coke Zero' are registered trademarks of The Coca-Cola Company.

conqueror

Since 1888, Conqueror has been recognised worldwide as a symbol of premium, quality paper for business and creative communications. Conqueror is a pioneer in providing sustainable solutions for impactful communications and in 2010, undertook a complete rejuvenation to showcase the contemporary and dynamic nature of the brand.

Market

In today's digital age, the sensorial qualities of paper remain a powerful communications tool for companies of any size, playing a pivotal role in conveying their business image. Through their unique visual characteristics and tactile quality, Conqueror products are designed to enrich communications and to ensure messages stand out, while promoting values such as excellence, professionalism, respect and style.

Conqueror is the only premium brand of papers to be available in 120 countries.

Product

Conqueror offers a comprehensive and complementary array of papers, with a portfolio that features 29 colours, 11 grammage variants, 13 finishes, five sheet sizes and seven envelope sizes.

This extensive range is the result of significant product development that saw the brand thoroughly rework its offering in 2010. Key product developments included the launch of Bamboo – a range of FSC certified paper made

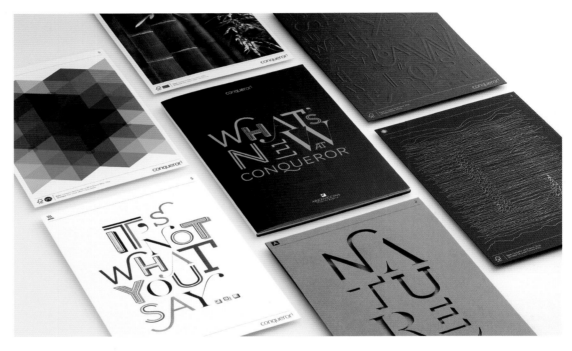

from bamboo fibres and natural pigments – and Print Excellence, new papers that are designed to produce high quality, high definition prints with faster drying times.

In addition, nine new contemporary colours have been added to the product range, as have 400g versions of Conqueror's best selling papers, new envelope sizes and an SRA3 size to appeal to digital printers.

Across its portfolio, the quality and versatility of Conqueror's products guarantee a look and feel of style and expertise combined with impeccable environmental credentials.

Achievements

Since its creation in 1888, Conqueror has been a pioneer in many areas. Today, it's perhaps

its unwavering commitment to high quality standards coupled with developing sustainable products that distinguishes Conqueror.

The Conqueror range offers a complete solution to the growing demand for high quality, yet sustainable papers: all papers are FSC certified; there is a choice of 100 per cent recycled papers, which utilise post-consumer paper pulp from Conqueror's sister company's Greenfield mill in France; and in 12 countries the full range is CarbonNeutral®. In 2010, Conqueror took another sustainable step with the launch of a paper made from bamboo pulp.

For many years Conqueror has pursued a plan of continuous innovation to achieve best-in-category performance and to meet changing market needs. Indeed, Conqueror has embraced

1888	1945	1990s	2001	2004	2007
Conqueror paper first rolls off the paper machine at Wiggins Teape. Conqueror Laid is born.	Changes in the production of Conqueror take place, and quality control and specialised colour matching are developed.	Arjowiggins Appleton group is formed from the merger of Wiggins Teape with the French paper manufacturer Arjomari and the US manufacturer Appleton Papers.	A new contemporary, stylised logo and identity based on the Conqueror name is launched. Innovative iridescent papers are also added into the range.	Conqueror Digital Multi Technology is introduced as the only fine paper that is printable on offset and digital presses.	Conqueror becomes CarbonNeutral® in the UK, whilst also using pulp from FSC certified sources across the entire range.

digital printing trends by offering papers that are fully compatible with dry-toner machines.

In terms of communications, Conqueror's 2009 Endless Possibilities campaign was a winner at the 2009 Benchmarks Awards, organised by Design Week.

Recent Developments
Conqueror is proud to be at the cutting-edge of the paper industry by investing heavily in product innovation.

The new Bamboo range is its latest eco-sustainable development and offers a unique paper experience. Bamboo provides a fast-growing and renewable source of pulp and the result of working with this unusual and creative substance is a modern paper with a

natural touch and feel. The paper is available in a range of organic colour shades that have been achieved by using natural ochre pigments sourced in the South of France.

Print Excellence uses the latest technology to open up Conqueror to new applications. This new strand of the Conqueror range offers faster drying times, greater uniformity, vivid colours and bolder blacks. The technology will ensure users can be confident that the paper will effectively handle even complicated creative prints and jobs.

Promotion
A 'push–pull' marketing strategy has been successfully developed for Conqueror. A strong emphasis is put on brand awareness, including collaborations with well-known designers and illustrators to increase brand awareness within the design community.

In 2009, Conqueror worked with illustrator Damien Weighill to launch a new campaign, Endless Possibilities. The campaign took an original approach to paper marketing by providing a free resource of more than 300 original illustrations.

In 2010, the comprehensive product rejuvenation was supported by a strong communications campaign based on the theme of 'It's not what you say… it's how you say it'. Conqueror commissioned world-renowned typographer Jean-François Porchez to develop five exclusive typefaces – a Chinese typeface is

also available. All are free to download from the updated Conqueror website.

Conqueror has also designed a brochure that showcases how to create a lasting impression through the use of business cards. Building on one of the brand's existing design partnerships it includes illustrations by Damien Weighill.

Brand Values
Conqueror has a rich heritage and shares its key values with the many businesses worldwide that choose its high quality, distinctive and sustainable papers: reliable, high end, contemporary, eco-sustainable, supportive and smart.

Things you didn't know about Conqueror

Today, there are some 600 different line items available within Conqueror, with users ranging from royalty to huge corporates to individually run businesses the world over.

Arjowiggins has calculated that if all companies switched to using Conqueror paper, UK businesses alone could save more than 23,000 tonnes of CO_2 each year, which is equivalent to the annual emissions of almost 4,200 households.

Conqueror participated in the inaugural One Young World summit in 2010, through its Blank Sheet Project. The summit saw young people address major global challenges and Conqueror's project was at the heart of the process, providing a giant blank sheet of paper on which the young delegates could pass their thoughts on to today's leaders.

2008	2009		2010	
Conqueror becomes CarbonNeutral® in Germany.	Conqueror launches the first premium 100 per cent recycled paper and becomes CarbonNeutral® in another 10 countries across Europe:	Denmark, Norway, Sweden, Finland, Iceland, Austria, Belgium, the Netherlands, Luxembourg and Switzerland.	Conqueror is rejuvenated and its offering is expanded to include the Print Excellence and FSC certified Bamboo ranges, and nine new colours in its Wove and Laid ranges.	

Stengthening Deutsche's
global proposition.

Passion to Perform

Deutsche Bank is a leading global investment bank with a strong private clients franchise.
A leader in Europe, the Bank is growing in North America, Asia and key emerging markets.
With 82,504 employees in 72 countries, Deutsche Bank offers unparalleled financial services
globally. The Bank competes to be the leading global provider of financial solutions, creating
lasting value for its clients, shareholders, people and the communities in which it operates.

Market

Deutsche Bank has been a leader, not a follower, throughout the global financial crisis and in its aftermath. While many banks struggled to weather the crisis, Deutsche Bank stood out among its global peers for its greater financial strength, stability and leadership, which have enabled it to make a quick return to profitability. Deutsche Bank's shares rose by more than 20 per cent in the year ending 5th August 2010 – more than any other leading investment bank. Corporate, institutional and private clients have recognised that Deutsche will be a long-term winner among global banks.

Product

Deutsche Bank is one of the most global of banks and offers its clients a broad range of products and services.

The Private Clients and Asset Management division comprises three areas: Private and Business Clients, which provides private clients with an all-round service encompassing daily banking, investment advisory and tailored financial solutions; Private Wealth Management, which caters for high net worth clients, their families and select institutions worldwide; and Asset Management, which combines asset management for institutions and private investors.

The Corporate & Investment Bank (CIB) serves corporates, financial institutions, governments and sovereigns around the world. It comprises three businesses: Corporate Finance, which provides investment banking coverage, as well as mergers and acquisitions

advisory; Markets, which partners with clients for sales, trading, structuring and research needs across equities, fixed income, currencies and commodities; and Transaction Banking, which offers cash management, trade finance, capital markets sales, and trust and securities services.

Achievements

Deutsche Bank continues to win accolades for its performance across all product disciplines and regions. In the Euromoney Awards for Excellence 2010, Deutsche Bank won 17 accolades, including Best Global Investment

Bank and Best Bank in Germany. As well as risk, debt and equity awards, Deutsche Bank was also named best FX house in every major region – Western Europe, North America and Asia – for the sixth year running.

Deutsche Bank achieved further success in The Banker Awards 2010 and was named Most Innovative Investment Bank for Risk Management.

Recent Developments

In June 2010, Deutsche Bank integrated its Global Markets and its Global Banking

1870	1872	1926	1970s	1989	2010
Deutsche Bank is founded in Berlin to support the internationalisation of business and to promote and facilitate trade relations between Germany, other European countries, and overseas markets.	The first international branches open, in Yokohama and Shanghai, and trade relations begin with the Americas. The following year the first London branch opens.	Deutsche Bank arranges the merger of Daimler and Benz, takes on advisory roles for BP in a major UK deal, and advises on and finances the £2.6 billion London Underground Financing.	The globalisation of Deutsche Bank continues: Deutsche Bank Luxembourg S.A. is founded and offices open in Moscow, Tokyo, Paris and New York.	Deutsche Bank takes over UK merchant bank Morgan Grenfell, a milestone in its presence in the City.	In November, Deutsche Bank announces successful conclusion of the Deutsche Postbank takeover offer.

Deutsche Bank

Passion personified.

Passion to Perform

businesses into a single Corporate & Investment Banking (CIB) business, capable of delivering the full spectrum of investment banking products to clients on a holistic basis.

During 2010 the Bank also completed a radical realignment of its business model to reduce its exposure to risk and meet the changing needs of clients after the financial crisis. With a strong and consistent management team, Deutsche Bank remains well placed to continue to seize the new opportunities available.

Promotion
Deutsche Bank's recently relaunched brand and visual identity places its renowned brand icon – first introduced to the public in 1974 – and the handwritten claim centre-stage. Conceptually, the new combination of these two core brand elements moves Deutsche into the league of the modern global 'super brands'. Integration, consistency and reduced complexity were the key objectives for introducing this new brand concept.

The now globally aligned framework ensures consistent delivery of Deutsche's 'newly defined' brand personality across businesses, regions and media channels, and positions it as a confident, premium brand. It provides the basis for a modern way to present and manage the Bank's identity – in terms of content and visual footprint, externally as well as internally, when communicating with clients, shareholders, employees and society at large.

The new brand and visual identity effectively supports the Bank's post-financial-crisis growth strategy as a global player in terms

of positioning it as 'one bank', and takes the established 'Winning with the Logo' brand communications concept to the next level. The concept underpins Deutsche's strength and confidence and builds new trust among stakeholders.

The concept was approved by the Management Board on 12th October 2009 and launched in February 2010 with an extensive employee engagement campaign, printed brand handbook and redesigned brand portal.

Deutsche Bank actively embraces its role as a corporate citizen. It regards corporate social responsibility (CSR) not as charity, but as an investment in society and in its own future. Deutsche Bank's goal as a responsible corporate citizen is to build social capital. The Bank leverages its core competencies in five core areas of activity: through its educational programme it enables talent; via social investments it aims to create opportunities; with its involvement in art and music it fosters creativity; through its commitment to sustainability it ensures long-term viability; and the Bank's employees regularly commit themselves as corporate volunteers in their local community.

The Bank's foundations and charitable institutions play a key role, firmly anchoring its CSR activities around the world. From an annual global CSR budget of more than 80 million euros, about 12 per cent is dedicated to the UK. Projects have included StreetSmart, an initiative that raises money for the homeless each November and December by adding

a voluntary £1 to the bills in restaurants; the CREATE festival, which sees key venues, galleries, outdoor festivals and arts organisations in East London collaborating to stage a multi-arts festival every year in the run-up to the London 2012 Olympics; and a wide range of employee volunteer programmes in disadvantaged areas of London. The Bank has more than 50 non-profit partner organisations and its projects indirectly benefit more than three million individuals each year.

Brand Values
Deutsche Bank's claim, 'Passion to Perform', has always been much more than a marketing slogan or advertising strapline: it's the way the Bank does business. Through consistent delivery of the claim and the Deutsche Bank brand personality, the Bank aims to live its brand promise of excellence, relevant client solutions and responsibility to all stakeholders.

Things you didn't know about Deutsche Bank

Deutsche Bank listed its shares on the New York Stock Exchange on 3rd October 2001.

Deutsche Bank's 'diagonal in the square' logo was developed by Germany's design pioneer Anton Stankowski and first introduced to the public in 1974.

Deutsche Bank is a multinational organisation, made up of employees from about 140 nations.

Deutsche Bank has one of the world's most significant corporate art collections of contemporary works on paper and photography.

In 1985 John Hendricks set out to satisfy a basic human instinct: curiosity. From his original vision, Discovery has grown into the world's leading non-fiction media brand, serving more than 180 television markets and 1.5 billion cumulative subscribers. In the UK, Discovery has been the leading factual brand since its launch in 1989, and a pioneer of pay TV, with a portfolio of 12 channel brands across the factual, lifestyle and entertainment genres.

Market

With more than 500 channels, the UK television market is the most competitive in the world. Within this landscape, Discovery operates a successful and growing pay TV business. Its channel portfolio serves factual, lifestyle and entertainment audiences, reaching 3.5 million viewers per day via satellite, cable and free-to-air platforms.

Discovery is at the forefront of new media technologies. A leader in the high definition (HD) market, it is also pioneering the creation of 3D television content for its 3D channel in the US – a joint venture with Sony and IMAX.

Product

Discovery content combines inspiring facts, gripping narrative and immersive experiences to make learning about the real world dynamic and engaging. Content on Discovery's channels is characterised by unparalleled production values, striking cinematography and compelling stories, and spans non-fiction genres including science, exploration, survival, natural history, the environment, technology, anthropology, health, engineering, adventure, lifestyle and topical events.

The flagship brand, Discovery Channel (and Discovery Channel HD), offers a window on the world through series such as 'Stephen Hawking's Universe', 'Mythbusters' and 'How Do They Do It?'; experts such as Bear Grylls and James Cracknell; and compelling accounts of real lives, such as 'Deadliest Catch' and 'Rescued: The Chilean Miners Story'. The factual portfolio is enhanced by special interest channels: Discovery History, Discovery Science, Discovery Turbo, Investigation Discovery and Animal Planet.

The lifestyle portfolio reflects the passions of its audience and explores extraordinary characters and stories from everyday life. Channels comprise Discovery Real Time, Discovery Shed, Discovery Home & Health, and Discovery Travel & Living.

Discovery expanded into the entertainment sector in 2008 and now has two channels

in the genre: DMAX, which delves into the quirkier side of life for younger audiences; and Quest, which is aimed at male viewers and offers action-based programming.

Achievements

In the UK, Discovery's brand portfolio has grown extensively over the past 21 years.

Discovery Channel has been the UK's leading factual channel since it launched in 1989,

1989	1997	1998	1999	2000	2005
Discovery Channel launches in the UK.	Discovery Home & Leisure launches (later rebranded to Discovery Real Time), and Discovery Science launches in the UK.	Animal Planet launches.	Discovery Civilisation launches (later rebranded to Discovery Knowledge).	Discovery Wings, Discovery Travel & Adventure, and Discovery Health all launch (later rebranded to Discovery Turbo, Discovery Travel & Living, and Discovery Home & Health, respectively).	Real Time Extra launches (rebranded to Discovery Shed in 2009).

only on Discovery

**BEAR GRYLLS:
BORN SURVIVOR
MONDAYS 9PM**

resulting in a number of prestigious awards including Digital Factual Channel of the Year at the 2010 Broadcast Digital Awards.

Discovery's creative and PR activities have also been recognised with more than 20 international marketing awards in the past two years.

Globally, Discovery's long-standing partnership with the BBC has created some of the most groundbreaking documentaries ever made, which include 'Walking With Dinosaurs', 'Planet Earth', 'Blue Planet' and 'Life'.

Recent Developments

In recent years Discovery has significantly increased its investment in local programming commissions, developing new on-screen

talent such as Harry Harris and Mike Brewer, and providing new platforms for established talent such as Professor Stephen Hawking, James Cracknell and Dan Snow. It also specialises in fast turnaround documentaries about topical events, such as 'Iceland Volcano: The Next Eruption'.

In September 2009 Discovery launched Quest, its first free-to-air channel, extending the portfolio reach to more than 93 per cent of UK households.

Promotion

Discovery is one of the most widely recognised media brands in the world. Its portfolio of channels is designed to appeal to specific audiences and interests, and the channels' individual brand identities clearly reflect this. Since 2009 Discovery has launched or repositioned Discovery History, Discovery Shed, Quest and DMAX in the UK market.

The Discovery creative team is committed to producing innovative, integrated communication campaigns informed by clear viewer insight. This approach, coupled with a highly evolved media strategy, allows Discovery to connect with its audience in a more meaningful way. Recent successes have included Discovery's first ever 3D cinema and television campaign, which launched the new season of 'Bear Grylls: Born Survivor', and a live lecture by Stephen Hawking at the Royal Society to support the launch of 'Stephen Hawking's Universe'.

Brand Values

The driving ethos of the brand is encapsulated in a single word: its name. Discovery's programming champions the mavericks and pioneers who are committed to making 'discovery' their life's work. The brand is underpinned by a promise to challenge, question, explore and never stop searching for new experiences and facts. Discovery is committed to offering its viewers an enjoyable, relevant and immersive television experience, by creating intelligent entertainment about the world in which we live.

Things you didn't know about Discovery

Discovery Channel has been the number one factual brand in the UK for 21 years – ever since it launched.

Discovery's 12 UK channel brands reach 3.5 million people per day.

Discovery Channel is broadcast in more than 40 languages globally.

2006	2008	2009	2010
Discovery HD launches in the UK.	Discovery's first entertainment brand launches: DMAX.	The crime channel Investigation Discovery launches, as does Discovery's first Freeview channel: Quest.	Discovery History launches, replacing Discovery Knowledge.

DURACELL®

Duracell® has been providing people around the world with portable power for more than 40 years. The UK's number one selling AA and AAA battery brand (Source: Nielsen July 2009 – June 2010), Duracell® provides a variety of personal power options to give consumers the best value for their power needs. The Duracell® Bunny is an important and enduring symbol of the brand; created in 1973, it has become one of the world's most successful brand icons.

Market

Duracell® is the leader in the battery market (Source: Information Resources Incorporated (IRI)/GFK last 12 months August 2010) and with a 48 per cent share, its sales are not only steady but growing.

Product

Over the past 40 years, Duracell® has built a reputation for manufacturing and supplying superior batteries that consistently lead the market in performance, quality and innovation. Duracell® recognises that different devices demand different levels of power and offers a range of products to ensure consumers can select the right battery for each device.

The two pillars of its portfolio are Duracell® Plus, the core line, and Duracell® Ultra Power, its premium offering. Between 2008 and 2010

the entire Duracell® alkaline range underwent significant performance upgrades and packaging refreshes. For example, Duracell® Plus now has a longer life than its predecessor, while Duracell® Ultra Power has been upgraded to become the brand's most powerful alkaline battery ever. In September 2010, Duracell launched new Simply Duracell®, aimed at the value-conscious shopper.

In addition to developing its core product portfolio, Duracell® is committed to excellence within the rechargeable sector. As a brand, Duracell® has made full use of its extensive research and development skills to bring to

market a range of rechargeable products. The full range features family-sized and compact chargers, including the premium One Hour Charger which charges four AA or AAA cells in just 60 minutes.

Achievements

Duracell® has continued to be recognised and rewarded for its portfolio of products. 2009 saw Duracell® Ultra win Product of the Year in the Battery category while independent consumer reviewer Which? bestowed Duracell® Ultra AAA, Duracell® Plus AA and AAA, and Duracell® ActiveCharge AA with its Best Buy accolade.

1920s	1950s		1964	2000s	
Scientist Samuel Ruben and a manufacturer of tungsten filament wire, Philip Rogers Mallory, join forces to form Duracell® International.	Ruben improves the alkaline manganese battery, making it more compact, durable and longer lasting than anything before it.	Eastman Kodak introduces cameras with a built-in flash unit that need the added power provided by alkaline manganese cells but in a new size, AAA – this puts alkaline cells on the map.	Duracell® introduces its AAA battery. Soon, the consumer market for Duracell® batteries rockets.	Duracell® continues to lead the way with product innovation, reflected in the Duracell® Plus and Ultra Power batteries.	Duracell® launches its Best Ever Formulation across the AA/AAA alkaline portfolio and a refreshed design of the entire product line-up.

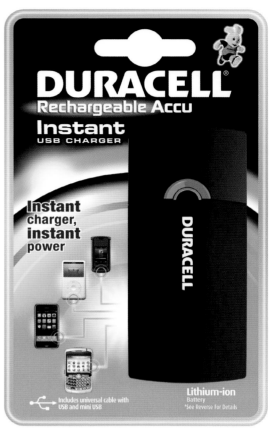

2009 builds on the success of the last few years, which have seen several Duracell® products recognised by consumers as 'products which genuinely enhance their lives'; in 2008, Duracell® Mini Charger won the Battery Product of the Year accolade after 12,008 consumers were surveyed and in 2007, an independent survey of 10,049 consumers chose PowerPix – a specialist digital camera battery – as the best innovation of the year in the Battery category.

Recent Developments

In its ongoing quest to innovate and add value for consumers, Duracell® has upgraded its formulation across all AA and AAA alkaline products as well as improving the functionality, user comfort and design across its product portfolio, including cells, rechargeables and torches.

The technology behind Duracell® Ultra Power AA and AAA cells has been improved and specifically designed to make them the longest lasting Duracell® alkaline batteries in all devices. Duracell® Ultra Power cells now have a new high performance cathode (HPC), with new superconductive graphite and a pure and higher level of manganese dioxide (the active ingredient) ensuring the best ever performance from Duracell® alkaline batteries.

Not only has the all-important formulation of the AA and AAA alkaline batteries been improved but the packaging has also been redesigned. The entire Duracell® portfolio is now set to feature a new 'Planets' identity, giving strong standout and a cohesive look across the range.

Finally, Duracell® recently moved into the wireless charging category with the launch of Duracell myGrid™, a charging pad that allows consumers to 'drop and charge' up to four devices at once.

Duracell® also offers a range of speciality batteries for watches and electronic, security, photo lithium and photo devices.

Promotion

Duracell® continues to invest in the long-term equity of the brand, marketing across multiple touchpoints and supporting both the alkaline and rechargeables portfolios. TV, print and PR continue to be supported, while digital spend against display, social media and gaming has been an increasing focus in the last 12 months.

Brand Values

Duracell® is committed to following consumers' personal power needs, whatever they might be, and this is what drives the brand's innovation. For example, as well as its market-leading alkaline products, Duracell® now also has a range of charging solutions for lithium-ion devices such as phones and MP3 players. As consumers look for convenient power for on-the-go charging, this has become a key focus for research, development and business building.

Things you didn't know about Duracell®

The name 'Duracell' is a portmanteau for 'durable cell'.

The Duracell® Bunny made his first appearance in a US advert in 1973.

A Duracell® battery appears in the film The Matrix. It is used by Laurence Fishburne's character, Morpheus, to illustrate how humans are being used as a power supply.

Eddie Stobart

Eddie Stobart is the road haulage element of Stobart Group, a fast-developing public limited company with wide-ranging multimodal transport interests. The UK's best known logistics brand employs more than 5,500 people at over 40 sites, operates around six million sq ft of premium warehousing capacity, has a fleet approaching 2,000 trucks and operates two airports and several freight trains.

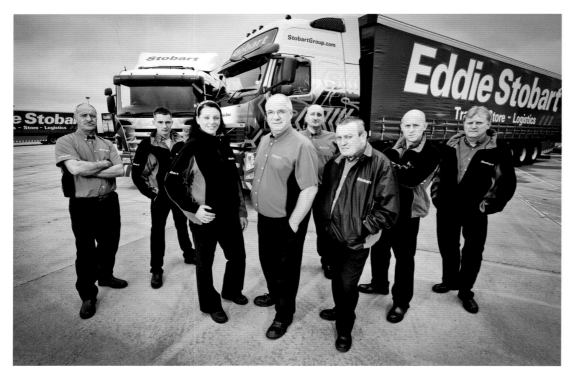

Market

In the notoriously hard-pressed road haulage sector, the iconic 'Eddie Stobart' name is one of the brand's greatest strengths. Highly competitive pricing and renowned levels of customer service and efficiency, combined with 95 per cent brand recognition throughout the UK, have ensured that Eddie Stobart is not only keeping pace but expanding and increasing in profitability. The UK logistics market remains highly fragmented with Stobart Group having a market share of around two per cent. Group turnover for the year ending 28th February 2010 increased to £447 million with profit increasing to £36.8 million.

Product

Eddie Stobart is a logistics specialist and as part of Stobart Group, has a full transport service encompassing road, rail, sea and air services as well as strategic warehousing and full distribution logistics offerings.

Achievements

In an ever-more environmentally conscious world, road transport is an increasingly contentious issue owing to its CO_2 emissions. Eddie Stobart has been at the forefront of the sector's responses to environmental considerations; Stobart Group was one of the first businesses to train drivers in the Safe and Fuel Efficient Driving (SAFED) techniques that can reduce carbon emissions by as much as 10 per cent.

A proactive approach has also been taken to address the traditional haulage problem of 'empty miles', as a result of which Eddie Stobart now has the best fleet utilisation figures in the industry: currently 85 per cent compared with the industry average of 72 per cent. Through incisive planning, shared capacity solutions and more strategic vehicle tracking, Stobart Group is committed to pursuing efficiency even further. Indeed, it is in the midst of high level negotiations to introduce a new environmental trailer design that could cut the number of trucks on Britain's roads by as much as 13 per cent.

Recent Developments

In March 2010, Stobart Group accessed the rapidly expanding market for renewable energy through a joint venture with A.W. Jenkinson Forest Products to form Stobart Biomass Products. The company will source and distribute supplies of biomass fuel to the UK renewable energy market, which has the potential to grow ten-fold in the next three to four years. Stobart's specialised fleet of walking floor and chipliner trailers will help to transport up to 10,000 tonnes per week.

While traditionally strong in ambient transport, strategic development and intelligent acquisitions have allowed Eddie Stobart to make a seamless move into the chilled market. The business now has a dominating – and increasing – presence in the crucial FMCG sector.

1950s	1980	1992	2001	2004	2005/06
Eddie Stobart establishes an agricultural contracting business in the Cumbrian village of Hesket Newmarket.	The business relocates to Carlisle. The fleet, numbering just eight vehicles, consists mainly of tippers but rapidly develops to include the more versatile artics.	Eddie Stobart is voted Haulier of the Year by the Motor Transport Industry, testimony to its dedication and hard work in revolutionising the sector.	Rapid, sustained growth results in a fleet of 900 vehicles and 2,000 staff operating from 27 sites and delivering a turnover of £130 million.	The company is acquired by WA Developments International. A major rebrand takes place, from vehicle liveries to clothing, heralding a new era for the business.	Eddie Stobart wins its first Tesco Distribution Centre contract. Stobart Rail freight services are launched and a new central control site is built at Warrington.

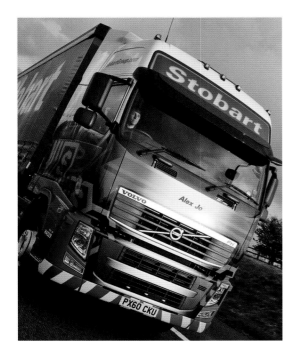

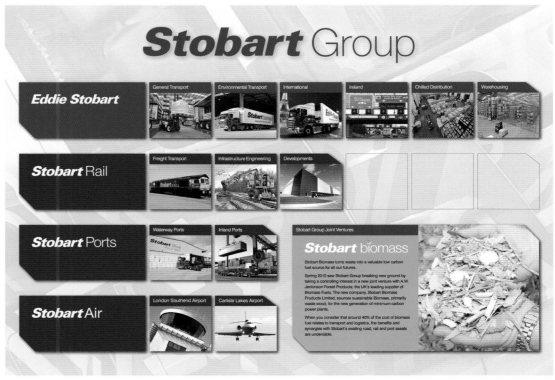

In October 2009 Stobart Rail launched a groundbreaking Iberian service in collaboration with rail giant DB Schenker. This dedicated weekly train, which links the fruit and salad growing areas of southern Spain with the UK's major grocery retailers, comprises 30 chilled containers each controlled and monitored using the latest satellite technology – ensuring produce arrives in exceptional condition. The five rail services will save 29.6 million road kilometres per year, cutting annual CO_2 emissions by 27,510 tonnes.

Promotion

An observational documentary charting the achievements of Eddie Stobart's transport operations was broadcast on Channel Five from September to November 2010. The six one-hour episodes gave a behind the scenes insight to the company and its staff. With each episode claiming around 1.8 million viewers, it helped raise awareness of the Eddie Stobart brand among a new audience.

Despite an enviable level of public awareness, the Eddie Stobart branding underwent significant changes in 2004, heralding a new era for the business. The development saw a complete reworking of corporate colours and the logo itself, while vehicle livery took on a simpler, more cost-effective design. Today, this look is the driving identity for the parent Group, flexible enough to be applied to the ever-expanding range of transport options without polluting the brand or reducing recognition. While the recognisable green and white livery plays a pivotal role in public awareness, the brand's impressive profile can also be attributed to an ongoing marketing and promotional drive that extends throughout the business' culture. The Group operates its own Members' Club with some 15,000 dedicated followers, and retails a wide variety of branded merchandise.

Brand Values

Since its inception, the Eddie Stobart brand has built its reputation through a commitment to courteous drivers, its high quality fleet, and exceptional levels of service. Today, adapting to society's changing needs, the Group has added exemplary employment and environmental practices to its core principles and is working to achieve its vision of building a fully multimodal transport offering for its customers.

Things you didn't know about Eddie Stobart

Every Stobart vehicle is individually identified by a girl's name that is unique within the fleet.

The Group has 37,000 tyres in use at any one time.

Recent surveys show that when driving on Britain's major roads a Stobart vehicle is passed, on average, every 4.5 minutes.

The Stobart fleet travels a distance equivalent to 21 laps of the Earth every day.

2007	2008	2009	2010
Eddie Stobart merges with Westbury Property Fund in a £138 million deal that sees the formation of the public limited company Stobart Group.	The business expands to a total workforce in excess of 5,000 and a fleet numbering around 2,000 vehicles.	A groundbreaking Iberian rail freight service is launched in collaboration with DB Schenker.	Stobart Biomass Products is formed to source and transport sustainable biomass. In addition, a six-part series is broadcast on Channel Five: 'Eddie Stobart: Trucks & Trailers'.

eDF
ENERGY

EDF Energy is one of the UK's biggest energy companies and the largest producer of low carbon electricity. The company supplies gas and electricity to more than 5.5 million business and residential customers, making it the largest supplier of electricity by volume in the UK. Its diverse customer base includes small and medium sized enterprises, public sector organisations and leading high street brands.

to develop a diverse energy mix, including low carbon technologies such as nuclear and renewable energy.

Finally, climate change. Carbon reduction through energy efficiency is taking hold as consumers and businesses realise that saving energy is a highly cost effective way to substantially reduce their carbon footprint. Legislation and national targets are bringing this to media attention.

Product

EDF Energy believes that businesses have four main requirements from their energy supplier and has developed its products and services to answer them.

The company offers a range of insight services to help its customers better understand how the energy markets work, current wholesale energy prices and the regulations affecting their business.

EDF Energy provides its customers with a selection of energy supply contracts, so they can manage their energy purchasing in a way that fits their in-house skills and appetite for risk.

Market

EDF Energy operates in both the business-to-consumer and business-to-business energy supply markets and generates approximately one fifth of the nation's electricity from its nuclear, coal and gas power stations, as well as combined heat and power plants and wind farms.

There are three key challenges facing the energy industry and its customers. Firstly, price volatility and affordability. The outlook for energy prices remains challenging. At this time of economic uncertainty, managing energy costs is crucial to the survival of many businesses and energy companies have a special duty to care for their most vulnerable customers. EDF Energy consistently offers competitive prices.

Secondly, security of supply. The phasing out of fossil fuels and closure of many existing power stations has produced a growing need for new sources of energy, known as an 'energy gap'. In response, EDF Energy is supporting the Government's commitment

1990	1998–2002	2003	2006	2007	
The UK electricity market is privatised.	London Electricity, SWEB and SeeBoard are merged.	The EDF Energy brand is launched in the UK.	EDF Energy becomes the first UK energy supplier to introduce a social tariff.	EDF Energy launches its Climate Commitments, the most significant package of environmental initiatives adopted by any major UK energy company.	Also in 2007, EDF Energy becomes the first sustainability partner of the London 2012 Olympic and Paralympic Games.

Administration can be tedious, so EDF Energy simplifies customers' billing arrangements and provides easy access to their account information.

EDF Energy helps its business customers to save energy, reduce costs and meet carbon reduction targets. Services include: extensive energy saving programmes designed by its Energy Services team; Energy View, which tracks energy usage against targets online and its free Energy Efficiency Toolkit, an interactive resource pack that provides businesses with a step-by-step guide to developing an energy saving strategy.

sustainability partner

Achievements
EDF Energy is committed to delivering excellent customer service and being as sustainable as possible.

In 2009, EDF Energy was ranked as the number one electricity provider for major business energy users in an independent customer satisfaction survey conducted by Datamonitor. It was also ranked as the top gas provider for residential customers in an independent survey conducted by JDPower on customer satisfaction in 2010.

The company has been awarded The Carbon Trust Standard, a mark of excellence given to organisations for measuring, managing and reducing carbon emissions. In addition, its Energy Efficiency Toolkit has been given a Green Apple Award by The Green Organisation in recognition of its commitment to helping others be more environmentally friendly.

In 2010, EDF Energy was awarded seven Big Ticks and chosen as an Example of Excellence by Business in the Community for its work with the British Red Cross to support vulnerable customers during

power cuts. In the same year, EDF Energy held the second Green Britain Day, a focal point for the Team Green Britain movement, which has been developed in partnership with the Eden Project, Global Action Plan and The London Organising Committee of the Olympic and Paralympic Games (LOCOG). The campaign helps people to save energy and money and have fun along the way. The initiative has hundreds of thousands of members and in 2010 won at the Sabre Awards, the Focal International Awards, the Festival for Media Awards and the Media Week Awards.

Recent Developments
In 2010, EDF Energy announced 'Our Sustainability Commitments', one of the biggest packages of environmental and social initiatives proposed by any UK energy company. They build on EDF Energy's existing Climate and Social Commitments and include an industry leading pledge to reduce the carbon intensity of EDF Energy's electricity generation by 60 per cent by 2020.

EDF Energy believes nuclear power has a key role to play in fighting climate change and ensuring secure and affordable supplies of energy. Subject to the right investment framework, EDF Energy has plans to build up to four new reactors, with the first commercially operational by 2018.

Promotion
Energy management is a complex and fast changing market for businesses so much of EDF Energy's promotional activity focuses on education to build credibility and enhance customer engagement.

In 2008, EDF Energy launched a two-year campaign to help businesses prepare for the Carbon Reduction Commitment (CRC) Energy Efficiency Scheme, a complex legislation related to reducing carbon

emissions. The campaign aimed to simplify the scheme for customers and was supported by a trade public relations programme. Among other activities, EDF Energy ran Café Energy workshops where its CRC experts explained the mechanics, risks and opportunities of the upcoming legislation. Nearly 1,000 major business customers have attended a workshop so far.

The EDF Energy Talk Power conference offers business leaders, policy makers and opinion formers the platform to discuss key energy issues and share learning. It is widely recognised throughout the industry as the best event of its type and always includes appearances from leading industry speakers, key government figures and EDF Energy's own supply and trading specialists.

EDF Energy has partnered with publishers of the well-known Dummies® franchise to create 'Carbon Management for Dummies' and 'Electricity Buying for Dummies', providing a step-by-step guide to successfully navigating today's energy market.

Brand Values
EDF Energy's challenge is to lead the decarbonisation of energy in Britain. To achieve this, the company aims to enable everyone to save today for a brighter tomorrow, together.

Things you didn't know about EDF Energy

EDF Energy is the largest producer of electricity in the UK. It is also the biggest generator of low carbon electricity.

EDF Energy is working with ParalympicsGB to make them a green team ahead of London 2012 and make their training camps more sustainable.

Waste ash from EDF Energy's coal fired power stations is reused by the cement and construction industry, preventing more than 200,000 tonnes of ash being sent to landfill.

Team EDF consists of 20 athletes who are training for the London 2012 Olympic and Paralympic Games. The athletes are all sponsored or employed by the EDF Group.

2008	2009	2010	
EDF Energy launches its Social Commitments, a set of pledges focusing on safety, energy affordability, security of supply, employee development and community investment.	EDF Energy merges with British Energy. It also partners with the Eden Project, Global Action Plan and LOCOG to launch Team Green Britain.	EDF Energy launches EcoManager, a wireless appliance controller that shows the cost of running electrical devices in pounds and CO_2.	Also in 2010, EDF Energy combines its Climate and Social Commitments to create Our Sustainability Commitments.

The official emblem of the London 2012 Games is © 2007 The London Organising Committee of the Olympic Games and Paralympic Games Ltd. All rights reserved.

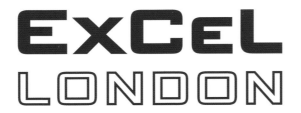

An ADNEC Group Company

ExCeL London has staged more than 3,500 events since 2000. More than 10 million people from 200 countries have visited, experiencing everything from sporting events and religious festivals to award ceremonies and conferences. ExCeL London is home to some of the UK's leading exhibitions, including Grand Designs Live and The London International Boat Show, and hosts events for blue-chip clients, government organisations and associations.

Market

ExCeL London is one of the UK's premier venues for exhibitions, events and conferences; a market that is currently worth £20 billion.

The venue operates across the sector and markets itself as able to handle almost any event imaginable. In addition to its two large halls, ExCeL London offers two conference centres, 45 meeting rooms and the UK's largest, fully-flexible auditorium. The campus also includes more than 30 bars and restaurants, five on-site hotels and a host of additional services.

ExCeL London has built a client list that includes BP, Tesco, Barclays, Toyota, Microsoft, NHS, Nokia, Coca-Cola and Panasonic. It has also announced further major wins including Diabetes UK (3,000 delegates), Cisco Live (5,000 delegates), EULAR 2011 (18,000 delegates) and the British Association of Dermatologists (8,000 delegates).

Product

ExCeL London is a £500 million international venue located on a 100-acre waterside campus in Royal Victoria Dock. It is the largest and most versatile venue in London, boasting 100,000 sq m of available multipurpose space, compared with the 65,000 sq m offered by its nearest competitor.

It's now also home to the capital's first International Convention Centre, ICC London ExCeL, which includes the UK's largest fully flexible auditorium and London's largest banqueting hall, the ICC Capital Hall. A conference suite is also on offer – the ICC Capital Suite – comprising 17 individual meeting rooms with the flexibility to host breakout sessions for 50–1,200 delegates, plus reception and registration areas.

There are five on-site hotels providing 1,200 bedrooms and ranging from budget to four-star; 3,700 car parking spaces; and three on-site DLR stations linking to the Jubilee line. London City Airport, which is five minutes away from ExCeL London, offers over 350 flights a day from more than 30 European destinations, and a business flight to New York.

Achievements

ExCeL London has received many industry accolades over the years and in 2010, was awarded Best Venue and Best Venue Support at the Exhibition News Awards, and World's Leading Meetings and Conference Centre at the World Travel Awards.

The venue has the additional accolade of being at the forefront of London's Thames Gateway regeneration and will play host to seven events and six Paralympic events during the 2012 Olympic Games.

ExCeL's green credentials have come to the forefront in the last few years. Developments include an on-site Materials Recycling Facility (MRF) and colour-coded bins for all events. The MRF recycles paper, cardboard, plastic, wood and glass. The venue also has the UK's largest and only commercial wormery, which recycles all types of food waste into

1855	1950s	1960s	1981	1988	1994
The Royal Victoria Dock site, on which ExCeL London will later sit, is opened by Prince Albert as a working dock.	Traffic through the Royal Dock reaches its peak.	Containerisation and other technological changes, together with a switch in Britain's trade following EEC membership, lead to the Royal Dock's rapid decline.	The dock finally closes.	The Association of Exhibition Organisers (aeo) approaches architect Ray Moxley to locate and design a new exhibition and conference centre within the M25; the Royal Victoria Dock site is found in 1990.	The London Docklands Development Corporation launches an international competition to appoint a preferred developer, which is won by the ExCeL London team.

productive, nutrient-rich soil. In the last four years ExCeL has reduced its gas consumption by 65 per cent and electricity by 28 per cent. This has led to a 65 per cent reduction in CO_2 emissions. The wormery and other initiatives have led to ExCeL recycling 80 per cent of its waste on and off site.

ExCeL was ranked 47th in The Sunday Times Best Green Companies 2010 list, and it was one of only nine companies in the Mayor of London's Green500 to be given the Diamond Award. Furthermore, in the Government's energy performance ratings ExCeL was placed in category C, showing that it was rated as 34 per cent more energy efficient than any other venue of a similar type. ExCeL is also committed to the United Nations Global Compact.

Recent Developments

In May 2010, ExCeL London successfully launched the capital's first International Convention Centre, with the opening of its new Phase 2 extension. After 18 months of construction and a spend of £165 million, the venue opened highly versatile spaces that now sit alongside the existing, award-winning conference and event facilities at ExCeL London.

ICC London ExCeL includes the UK's largest, fully flexible auditorium (with up to 5,000 seats), London's largest banqueting hall (for 3,000 guests), and a new multifunction conference suite (for 2,500 delegates).

ExCeL London also announced a further investment of £50 million from its owners ADNEC, to build the UK's first Starwood ALOFT hotel. Due to open in September 2011, the hotel will be a four-star, 252-bedroom business hotel linked to the ICC London ExCeL complex.

Promotion

The marketing team targets two distinct audiences: the exhibitions industry and the conference and events market.

UK exhibition organisers are targeted via a variety of communication channels, including e-bulletins, sales literature, PR and the ExCeL London website. The venue also undertakes as much face-to-face marketing as possible, through organiser forums, corporate hospitality, and strategy days with key organisers.

Unique to the consumer exhibitions campaign is an award-winning marketing and PR support package, tailored for trade and consumer show organisers. Benefits comprise inclusion in 'what's on' materials, local PR, support with exhibitor days and familiarisation trips as well as contra-deals with local organisations, London and UK-wide partners and media partners.

In 2010, ExCeL London launched a new marketing and PR support package for association, corporate and trade clients.

The package includes a variety of opportunities and partnerships designed to assist organisers with the marketing and planning of their events.

The conference and events marketing campaign targets both UK and international event planners and is focused on promoting the venue in the context of London, a key city in Europe. To this end, much of the international activity is executed in conjunction with Visit London, jointly promoting the destination and the venue.

ExCeL London also exhibits at international shows and is involved with key industry bodies, hospitality events, speaking at industry seminar programmes and organising UK, European and US road shows, as well as press and client familiarisation trips.

Brand Values

ExCeL London is more than an events venue. It's an organisation that promises its clients and staff 'space to perform'. This promise is underpinned by a commitment amongst staff to deliver the ultimate environment in which events can flourish; a blank canvas providing creative inspiration and flexibility; a meticulous approach to every aspect of a project; a caring attitude to the environment and to its neighbourhood.

Things you didn't know about ExCeL London

ExCeL London will be the most complex venue in the history of the Olympic Games, playing host to boxing, wrestling, judo, tae-kwon-do, weight lifting, fencing and table tennis, as well as six Paralympic sports.

ExCeL London is the only venue in the UK to span two railway stations.

Each hall could fit 2,047 Mini cars, 742 double-decker buses or two Boeing 747 jumbo jets inside.

2000	2008	2009	2010
ExCeL London opens in November, as one of Europe's largest regeneration projects.	ExCeL London announces its Phase 2 expansion to increase its event space by 50 per cent and include a convention centre with a 5,000-seater auditorium.	The official identity of Phase 2 – that is, London's first International Convention Centre – is launched and endorsed by the Mayor of London, Boris Johnson, and Visit London.	In May, ICC London ExCeL opens – on time and on budget.

facebook

Founded in 2004 by Mark Zuckerberg, Facebook has rapidly grown from a social networking tool for Harvard students to one of the most trafficked sites in the world – it now connects more than 500 million active users. Facebook is changing the way people communicate; allowing them to connect and interact with the people and things they know and like in a safe environment. The average user has 130 friends and creates 90 pieces of content every month.

Market

Since it was first devised in a Harvard dorm room, Facebook has been a driving force behind the rise of social networking and the internet's shift towards a social medium rather than just an information-led web. The internet is being rebuilt with people at its core as users increasingly use it to connect with the people, things and brands they care about – creating a 'social graph'.

More than two million websites have integrated with Facebook including more than 80 of comScore's US Top 100 websites and

major growth area for Facebook with more than 200 million active users accessing the site via their mobile devices. People using Facebook on their mobiles are twice as active as non-mobile users.

Facebook is headquartered in Palo Alto, California but employs more than 1,700 staff in offices across the world, with its European headquarters based in Dublin.

Product

The Facebook product is made up of core site functions and third-party applications,

can connect and communicate through Status updates, Chat, Messages, Wall posts, Comments, Groups and Pages.

Pages are free and enable public figures and organisations such as politicians, celebrities and brands to leverage the real connections between friends on Facebook, while also letting people keep in touch with who and what they are interested in.

Facebook advertising enables brands to connect with more than 500 million potential customers, with the opportunity to target people based on demographics such as likes, interests, gender and location.

Facebook Platform enables third parties such as developers and website owners to create social experiences to drive growth and engagement on their websites.

In terms of technology, Facebook uses an open source caching system, memcached, and has one of the largest MySQL database clusters anywhere. It has built its own search engine serving millions of queries each day, completely distributed and entirely in-memory, with real-time updates. Facebook relies heavily on open source software and releases large pieces of its own software infrastructure as open source in return.

more than half of its Global Top 100 websites. Since social plugins launched in April 2010, an average of 10,000 websites integrate with Facebook every day.

As people demand access to their social graph anywhere, anytime, mobile has become a

with its central features being a person's News Feed and Profile. The News Feed is a personalised feed showing updates from friends and connections – while detail shown on the Profile includes interests, education and work background alongside other information such as Photos, Events and Groups. Friends

Achievements

As founder and CEO, Mark Zuckerberg is responsible for setting the direction and product strategy of the company, leading the design of the service and development of its core technology and infrastructure.

2004	2005	2006	2007		2008
Mark Zuckerberg and co-founders Dustin Moskovitz, Chris Hughes and Eduardo Saverin launch Facebook from their Harvard dorm room.	Facebook expands to add high school networks.	Facebook expands its registration so anyone can join. Facebook Development Platform is launched and News Feed is introduced.	Microsoft takes a US$240 million equity stake in Facebook.	Also in 2007, Facebook Ads launches.	Facebook launches in Spanish and French. In August, Facebook has more than 100 million active users.

A reflection of his success, Zuckerberg was not only named Person of the Year 2010 by Time magazine, but also Media Person of the Year at the 57th Cannes Lions International Advertising Festival in 2010. The award goes to a prominent personality who is an influential figure in the development of the media landscape and who ultimately plays a part in shaping the future of the advertising industry. It is extremely rare for someone as young as Zuckerberg – and someone who is so early on in their career – to be awarded such honours.

Recent Developments

The key developments in 2010 included the launch of social plugins, simplified privacy settings, Places, Groups and Messages.

The user-facing social plugins, launched in April, enable websites to create a more social and personalised experience on their sites. These include the Like button, which lets people share pages back from a website to their profile with just one click. This action also creates a story in friends' News Feeds. Other plugins include the Recommendations box: for a logged-in Facebook user, the plugin will give preference to objects that their friends have interacted with.

Simplified privacy settings were launched in May to help people control how they share their information. Settings include a single control for consent, more powerful controls for basic information and an easy control to turn off all applications.

Facebook Places launched in the UK in September and allows people to share where they are in real time with their friends, see who's nearby and discover new places of

interest. Before the location is shared the person must actively check-in, so they have complete control over their information and can select with whom it is shared.

The Messages tool is being evolved and in November the company announced its social inbox and seamless messaging offering in the US. This means online conversations can be more easily maintained with all communiation – Chat, Messages, email and texting – integrated into a single thread. This will be rolled out internationally in the coming months.

Promotion

Somewhat unsurprisingly, Facebook effectively uses its products to communicate with users, developers and brands. Dedicated Pages – facebook.com/facebook and in the UK, /facebookuk – keep users informed about changes and feature stories of interest that are

related to Facebook. In addition the Facebook blog – http://blog.facebook.com – includes regular posts from the team.

For developers, http://developers.facebook.com includes both a blog and helpful collateral such as a showcase of sites that use social plugins.

Other specific interest Pages include: facebook.com/security to help users protect their information both on and off Facebook; /facebooklive, which shows live video streaming of special guests, latest innovations and live events from Facebook's Palo Alto headquarters; and /marketing, which shares news and best practice with marketers looking to make the most of Facebook for their brand.

Brand Values

Mark Zuckerberg's vision from the outset has been to create a service through which people can share information and connect more effectively with their friends, family and colleagues. The web is being rebuilt around people and Facebook facilitates the sharing of information through the social graph: the digital mapping of people's real-world social connections.

Things you didn't know about Facebook

In total, more than 700 billion minutes are spent on Facebook per month.

Facebook is home to more than 900 million objects including Pages, Groups and Events.

More than 30 billion pieces of content – such as web links, news stories, blog posts, notes and photo albums – are shared each month.

Fifty per cent of active Facebook users log on in any given day.

People on Facebook install 20 million applications every day.

2009	2010		2011
Digital Sky Technologies makes a US$200 million investment for preferred stock at a US$10 billion valuation.	In July Facebook has more than 500 million active users.	Also in 2010, Facebook launches Places.	Facebook continues to develop new products to help people connect and share with the people and things that they like.

Fairy is Britain's number one dish-cleaning brand and has been a trusted household name since it first appeared in 1898 on a bar of soap. Today the brand represents a range of products renowned for their cleaning ability and caring nature, with Fairy consistently bringing effective and innovative new formulas to market. In the last year, 122 million bottles of Fairy Liquid were bought, equating to 59 per cent of the total UK market (Source: IRI October 2010).

Market

The dish-cleaning market contains sink and dishwasher sectors, with Fairy leading the total category in both volume and value sales (Source: Information Resources Incorporated (IRI) October 2010). Fairy has maintained market leadership for more than 50 years thanks to its brand attributes of unbeatable performance and value: lasting up to 50 per cent longer than the next best selling brand (Source: Independent Laboratory Testing).

The value of this market continues to increase by two per cent per year, driven by the launch of premium products such as Fairy Platinum for Dishwashers and Fairy Clean & Care with a touch of OLAY; the future is bright for Fairy with a wealth of new product development in the wings. Fairy does not produce products for other brands or retailers.

Product

During the 1950s, most people used powders and crystals to wash dishes and it was Fairy that launched the first liquid product: Fairy Liquid. By the end of its first year, six out of 10 people in the UK had bought it.

Today the Fairy Washing Up Liquid range consists of Fairy Liquid Original and Lemon; the Fairy Aromatics range, featuring Tangerine & Gingerflower, Green Apple & Lime Blossom, and Pomegranate & Honeysuckle; the Fairy Antibac range, which helps prevent germ growth on sponges and dishcloths for up to 24 hours; and the Fairy Clean & Care collection, which comes 'with a touch of OLAY softness' and has been developed to make hands softer and smoother (vs. Fairy Original) while washing dishes.

The Fairy portfolio also encompasses a dishwasher range with Fairy for Dishwashers (All-In-One and Platinum), Fairy Rinse Aid and Fairy Machine Cleaner – as well as Fairy Non-Biological and Fairy Fabric Softener laundry products.

Achievements

Fairy is the UK's top selling homecare brand and saw the UK's highest value growth in the household sector in 2009, when turnover topped £157 million on the success of Fairy Platinum for Dishwashers (Source: IRI). In 2010 Fairy Platinum was awarded a Which? Best Buy accolade.

Other industry accolades include Dishwasher Product of the Year for Fairy All-In-One in 2007, Washing Up Product of the Year for Fairy Liquid Fresh Lavender in 2008, and Household Cleaning Product of the Year for Fairy Clean & Care in 2009.

The brand's top cleaning results together with its kindness to skin have seen Fairy certified by the British Skin Foundation. In addition, it is recognised by the RSPB as the best product for cleaning birds after oil spills, and Fairy donates products for use during disasters such as the 2007 south coast oil spillage.

Recent Developments

The past few years have seen a steady stream of product development from the Fairy brand, beginning with the introduction of Fairy Powerspray in 2003, designed to remove tough, burnt-on food from dishes.

In 2006 Fairy introduced the first of its Fairy for Dishwashers range of products. A revolutionary All-In-One detergent with a unique liquid top, Fairy All-In-One required no unwrapping prior to use to provide unbeatable cleaning and convenience. In 2007 Fairy Rinse Aid and Fairy Machine Cleaner were added to the range. Within its launch year, Fairy for Dishwashers became the second best selling dishwashing range (Source: IRI 2009), with 90 per cent of independent repairmen recommending it (Source: The Alliance Innovation Team 2006). In 2009, the innovative Fairy Platinum was launched, the first dual action dishwasher tablet that leaves dishes 'sparkling clean' and also maintains dishwasher cleanliness by helping to prevent the build up of fats and grease.

1898	1930	1987	1997	2003	2006
Fairy Soap launches through Thomas Hedley & Sons.	Procter & Gamble acquires the brand and Fairy Baby trademark.	Lemon-scented Fairy Liquid is introduced alongside Fairy Original. Two years later, a Fairy Non-Biological laundry product launches for sensitive skin.	Fairy Liquid with antibacterial action is introduced.	Fairy Powerspray launches, for tough, burnt-on stains, adding £9 million to the category.	Fairy Active Bursts for Dishwashers launches, and Fairy sales top £120 million. The following year the Machine Cleaner and Rinse Aid products are launched.

2010 saw Fairy Liquid continue its drive to deliver unbeatable performance, with a wide-ranging innovation programme across the key pillars of its entire portfolio. From formula upgrades in Original and Lemon, to new variants for Antibac and Aromatics, Fairy continues to bring the most effective and innovative formulas to market to ensure there is a top-performing Fairy product to suit every home and every usage occasion. The programme also saw Fairy Clean & Care partner with beauty brand OLAY to create a product that is designed to leave hands noticeably softer and smoother – in comparison to Fairy Original – when washing dishes. These breakthrough innovations saw Fairy Liquid reach its highest ever value share in the hand dishwashing market: 71.1 per cent in September 2010 (Source: IRI 2010).

The iconic Fairy bottle has also been updated over the years, with the introduction of a new ergonomic and stylish design in 2009. It was

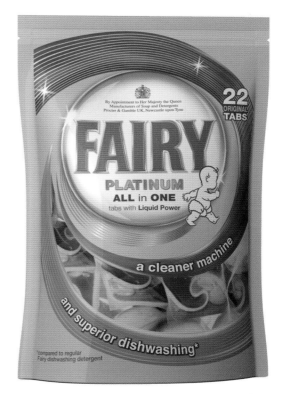

"hands that do dishes can feel soft as your face with mild green fairy liquid".

In recent years, Fairy's advertising has seen chefs Ainsley Harriott, Anthony Worrell Thomson and Gary Rhodes front the brand together. The use of glamorous spokespeople such as Jodie Kidd, Helena Christensen and Louise Redknapp has enabled Fairy to talk to a younger audience. Brand communications emphasise unbeatable performance and value due to product mileage. Its FAIRYconomy campaign, for example, highlighted the value benefits of its longer lasting formula to the consumer's pocket and the environment, with fewer bottles required.

Fairy supports a number of charities and has partnered with children's charity Make-A-Wish Foundation for the last seven years, raising more than £500,000. The 2010 Be a Fairy Godmother campaign, supported by Mylenne Klass, also set out to grant the wishes of children with life threatening illnesses.

dishwasher range is designed to be used in short cycles and at lower temperatures, saving energy. Fairy is part of the Future Friendly programme, a partnership between brands and leading sustainability experts that is aimed at inspiring and enabling people to live more sustainable lives.

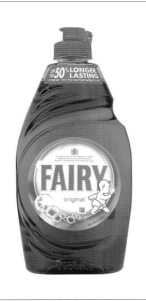 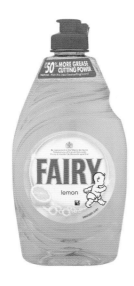 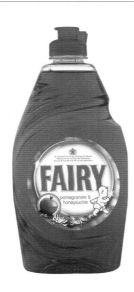

last changed in 2000, when the signature white bottle was replaced with a transparent version for the first time.

Promotion
Fairy Liquid television advertising campaigns first began in the 1950s. This led to a host of celebrity endorsements, including actress Nanette Newman with the much-loved line,

Brand Values
Fairy is a family-oriented brand with strong links to the kitchen and the role of mealtimes within families. It is also associated with environmental and sustainable organisations such as the RSPB, WWF, Energy Saving Trust, Waterwise and Waste Watch. Its products are concentrated in order to reduce packaging waste, bottles are recyclable, and the

Things you didn't know about Fairy

The Fairy baby that has appeared on all of the brand's products since the 1930s is called 'Bizzie' and has been reproduced as a figurine by Royal Doulton.

Every minute, 579 bottles of Fairy are produced, which equates to more than 10 million gallons of Fairy Liquid in a year.

One bottle of Fairy Liquid washed 14,763 dirty plates – a world record.

2008	2009	2010	
Fairy launches Fairy Clean & Care. The range provides the dual benefits of helping to keep hands soft and moisturised while leaving dishes 'squeaky clean'.	Fairy launches its unique dual action dishwasher tablet, Fairy Platinum. The Fairy Liquid formula is also improved and its bottle design updated.	Fairy launches a wide-ranging innovation programme, introducing upgrades to Fairy Liquid Original and Lemon, and introducing new variants to the Aromatics and	Antibac collections. The brand's sales top £174 million annually (Source: IRI 2010), and Fairy Clean & Care partners with beauty brand OLAY.

FedEx Express is the world's largest express transportation company, with a comprehensive global air and ground network dedicated to secure and timely delivery to more than 220 countries and territories. FedEx Express employs over 140,000 people throughout the world; all committed to delivering more than 3.1 million packages safely to their destinations every day, each with the responsibility to make every customer experience outstanding.

Market

Improved global economic conditions have resulted in a return to strong demand for FedEx services, and higher volumes and revenues per shipment. For the first quarter of the 2010/11 financial year FedEx Express delivered revenues of US$5.91 billion and an operating income of US$357 million.

A better-than-expected volume of FedEx International Priority shipments, decisive management actions and dedicated team members helped drive financial performance above initial expectations. FedEx believes wise investment and careful cost management will contribute to FedEx Express emerging a stronger, more profitable company as the global economic recovery takes hold.

Product

FedEx Express offers time-definite, door-to-door, customs-cleared international delivery services and can deliver a wide range of time-sensitive shipments, from urgent medical supplies, last-minute gifts and fragile scientific equipment, to bulky freight and dangerous goods. Each shipment sent with FedEx Express is scanned 17 times on average, to ensure that customers can track its precise location by email, on the internet and by telephone 24 hours a day. FedEx Express aims to treat each package as if it is the only one being shipped that day.

In addition to the international product range offered by FedEx Express, FedEx UK now provides customers with a wide range of options for domestic shipping. Within the UK this includes time-definite, next-day and Saturday delivery services. All services are supported by free and easy-to-use automation tools, allowing customers to schedule pick-ups and track their packages online.

Achievements

FedEx Express, which started life in 1973 as the brainchild of its founder and current chairman, president and CEO Frederick Smith, has amassed an impressive list of 'firsts' over the years. FedEx Express originated the overnight letter, was the first express transportation company dedicated to overnight package delivery, and the first to offer next-day delivery by 10.30am. It was also the first express company to offer a time-definite

1971	1973	1977	1980s	1994	2000
Frederick W Smith buys the controlling interest in Arkansas Aviation Sales and identifies the difficulty in getting packages delivered quickly; the idea for Federal Express is born.	Federal Express officially begins operations with the launch of 14 small aircraft from Memphis International Airport. It delivers 186 packages to 25 US cities on its first day.	Air cargo deregulation allows the use of larger aircraft (such as McDonnell Douglas DC-10s and Boeing 727s), spurring Federal Express's rapid growth.	Intercontinental operations begin with service to Europe and Asia, and the acquisition of the Flying Tigers network sees Federal Express become the world's largest full-service, all-cargo airline.	Federal Express officially adopts 'FedEx' as its primary brand, taking a cue from its customers who frequently refer to Federal Express by the shortened name.	The company is renamed FedEx Express to reflect its position within the overall FedEx Corporation portfolio of services.

service for freight and the first in the industry to offer money-back guarantees and free proof of delivery. In 1983 Federal Express (as it was then known) made business history as the first US company to reach the US$1 billion revenue landmark inside 10 years of start-up, unaided by mergers or acquisitions.

This illustrious history has resulted in many awards and honours. In 1994 FedEx Express received ISO 9001 registration for all of its worldwide operations, making it the first global express transportation company to receive simultaneous system-wide certification. In 2008 FedEx Express and FedEx UK were granted the highly regarded and internationally accepted ISO 14001:2004 certification for environmental management systems. In 2009 FedEx ranked seventh in Fortune Magazine's World's Most Admired Companies listing.

Recent Developments

FedEx Express has recently launched its FedEx Electronic Trade Documents (ETD) solution. ETD automates the flow of international documents, saving paper, trees, energy and printing costs.

Customers can interact electronically with FedEx by uploading either their own customs documents, such as commercial invoices, or FedEx generated documents, as well as add their company letterhead and signature image to customs documents. By reducing the need to manually print, sign and attach copies of these documents to their shipments, ETD not only makes it quicker and easier for customers to prepare shipments but also reduces their carbon footprint.

Promotion

FedEx has a history of tennis sponsorship and currently sponsors the Roland-Garros stadium in France. In addition, FedEx and the Association of Tennis Professionals (ATP) have signed a three-year agreement that brings FedEx on board as a new global Platinum Sponsor and Official Carrier of the ATP World Tour. The sponsorship launched in November at the 2010 Barclays ATP World Tour Finals at The O2 arena, London, and extends through 2013.

Reliability of performance is a prevalent theme across all sponsorship activity and is reinforced

visually with FedEx branding on court at tournaments across four continents, and on the popular tennis website ATPWorldTour.com.

Brand Values

The FedEx corporate strategy, known to FedEx Express employees as the 'Purple Promise', is to 'make every FedEx experience outstanding'. The Purple Promise is the long-term strategy for FedEx to further develop loyal relationships with its customers. The FedEx corporate values are: to value its people and to promote diversity; to provide a service that puts customers at the heart of everything it does; to invent the services and technologies that improve the way people work and live; to manage operations, finances and services with honesty, efficiency and reliability; to champion safe and healthy environments; and to earn the respect and confidence of FedEx people, customers and investors every day.

2006	2008	2009	2010
FedEx Express builds its service capabilities in Europe by acquiring UK domestic express company ANC, rebranded as FedEx UK in 2007.	FedEx Express celebrates its 35th year and is now the world's largest express transportation company, operating 650 aircraft and a ground fleet of more than 44,500 vehicles.	FedEx Express takes delivery of its first Boeing 777 Freighter, which has significant operational efficiencies and environmental benefits.	FedEx Express launches a new connection between Asia and Europe, becoming the first company to offer a next-business-day service from Hong Kong to Europe.

Things you didn't know about FedEx Express

In 2009 FedEx Express added 92 trucks to its converted hybrid–electric fleet, bringing its total to 264 and making the fleet the largest of its kind in the express industry. The conversion programme not only reduces pollution but also extends the life of the vehicles, helping to eliminate waste production.

In February 2010, The FedEx Panda Express – a specially branded 777 Freighter in the FedEx aircraft fleet – took off from Washington bound for Chengdu, China, with two special passengers on board. Two giant pandas, Tai Shan and Mei Lan, were transported to China to aid conservation efforts for this endangered species.

In July 2010 FedEx Express celebrated the 25th anniversary of its Stansted hub in the UK. Over the years, the Ryder Cup, racing cars, sound equipment for a Madonna tour and the Kentucky Derby champion horse have all passed through its doors.

GATWICK ·EXPRESS

Established in 1984, Gatwick Express is the longest-running dedicated airport rail service in the world and serves the UK's second busiest airport. Offering a non-stop journey time of 30 minutes with trains departing every 15 minutes, it carries more than 14,000 passengers per day between Gatwick Airport and London's Victoria Station.

Market

Gatwick Airport is the busiest single-runway airport in the world. It serves over 200 destinations (more than any other UK airport) in 90 countries and around 33 million passengers per year travelling on short- and long-haul point-to-point services. Part of Southern Railway, Gatwick Express holds more than 60 per cent of the rail market between Gatwick Airport and central London, and is the fastest way to travel the route; services run every 15 minutes with journey times of 30 minutes.

Within the business market, Gatwick Express has a market-leading 55 per cent penetration rate for all modes of transport between central London and Gatwick Airport.

Product

Gatwick Express is a dedicated and non-stop high-speed air–rail link operating between London's Victoria Station and Gatwick Airport. Services run from Victoria Station between 3.30am and 12.30am and from Gatwick Airport between 4.35am and 1.35am.

Unlike its competitors, Gatwick Express allows customers to buy their tickets on board the train at no extra cost, enabling seamless travel through the airport and station and onto the train. In addition, exclusive platforms at Victoria Station allow customers quick access to the trains, while the station at Gatwick Airport is located at the heart of the South Terminal.

On week days the route extends to Brighton, with six services during peak morning hours and six during peak evening hours.

Achievements

Customer satisfaction has been integral to the success of Gatwick Express and it has scored consistently highly in the independent National Passenger Survey. In the spring 2010 survey, Gatwick Express achieved a 93 per cent satisfaction rating.

Realising that travelling to and from the airport is an important journey, Gatwick Express works hard to consistently be the most reliable and punctual train operator serving Gatwick Airport.

In 2010 the service's reliability performance was high, with more than 98 per cent of advertised services operating, while its punctuality performance exceeds, on average, 93 per cent.

Gatwick Express has successfully invested not only in its services, but also in its marketing and brand. As a result, it enjoys 57 per cent spontaneous awareness and more than 98 per cent prompted awareness within its target market (Source: YouGov December 2010).

People who are aware of Gatwick Express's advertising are 12 per cent more likely to have a positive impression of the service and 16 per cent more likely to be advocates than those who have not seen the adverts. Indeed, 11 per cent more identify Gatwick Express as 'fast' and 17 per cent more recognise the service as 'premium' (Source: YouGov).

Recent Developments

The recent introduction of the Class 442 fleet means there is now increased capacity across the Gatwick Express network. Refurbished

1984	2001	2005	2008	2009	2010
The first dedicated Gatwick Express service is formed to provide an air–rail link to Gatwick Airport.	All rolling stock is replaced with the modern Juniper Class 460 trains.	Thirty-two million passengers pass through Gatwick Airport.	In June the Gatwick Express franchise is handed over to Southern. In December Gatwick Express extends its service to Brighton and introduces Class 442 trains for the new route.	Southern Railway retains the South Central franchise, which includes the Gatwick Express service.	A £53 million Gatwick Airport Rail Station redevelopment scheme is announced, to be completed in 2013.

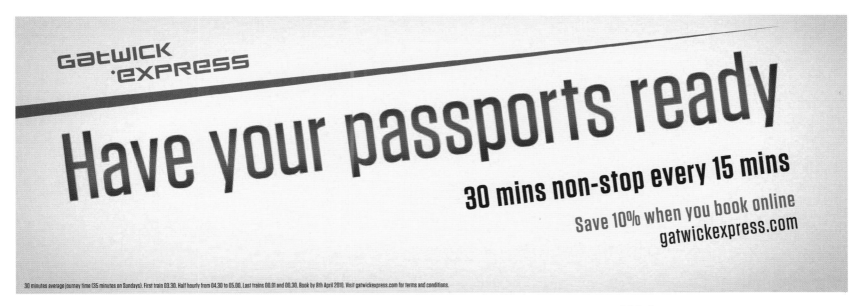

30 minutes average journey time (35 minutes on Sundays). First train 03.30. Half hourly from 04.30 to 05.00. Last trains 00.01 and 00.30. Book by 8th April 2010. Visit gatwickexpress.com for terms and conditions.

before entering service, the trains include additional Express Class seating, new First Class areas, large luggage racks and improved accessibility for disabled travellers.

A key business objective for Gatwick Express is to encourage increased use of the online purchase channel. By offering online-only discounts, bookings through the channel increased by 100 per cent in 2010.

A new staff uniform was introduced in December 2010, designed to showcase the premium nature of the service and the brand. Smart and visible to customers, its style is reminiscent of airline cabin crew uniforms, thus reinforcing Gatwick Express's position as a specialist airport service.

Promotion

With a customer base comprising both international travellers and UK residents, Gatwick Express ensures its advertising strategy targets both markets.

A key objective is to encourage pre-travel purchase, so digital advertising is used to reach the international traveller. This includes email and affiliate activity as well as display advertising in overseas markets.

Airline partnerships are key to brand promotions and Gatwick Express has developed solid relationships with growth airlines, such as easyJet, as a mechanism for reaching potential customers during the booking process or during their flight. Jointly branded microsites, reciprocal website links, in-flight announcements and advertising on airline seatbacks have all been effective methods for generating sales.

Gatwick Express also works closely with Gatwick Airport. A large portfolio of poster advertising in the airport arrivals route promotes the benefits of the service, while a number of ticket purchase points are located throughout the airport.

Within the UK, Gatwick Express uses a range of press, outdoor, radio and online communications to reach its customer base and execute its promotional strategy.

In addition, customer relationship marketing remains a focus, ensuring consistent communication with the existing customer base, providing news about offers, new products and service enhancements.

In early 2010 a new campaign launched to refresh the brand look and to establish a more confident tone of voice. A key part of the campaign development involved talking to passengers about their experiences of travelling between London and Gatwick. The journey was identified as stressful and complicated, with many different promotions and services to choose from, but little clarity as to their individual benefits or disadvantages. Gatwick Express identified the opportunity to position itself as a service that removes this stress, focusing on the fact that Gatwick Express is the fastest way to complete a journey that many view only as 'a means to an end'.

The campaign adopted a tongue-in-cheek stance and mirrored passenger feedback with advertisements featuring tag lines such as, 'The sooner you get off, the better'. Designed to appeal to customers in a self-assured way, the campaign's tone of voice allowed the brand to create playful messages; for example, the '4 for 2' offer became 'Make friends quick', while the Express Return discount translated into: 'You'll be back for less.'

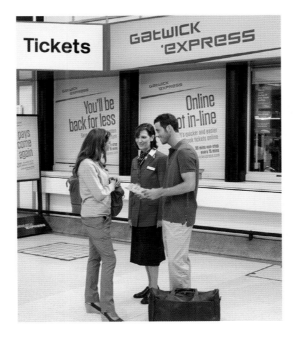

Brand Values

Gatwick Express bases its brand promise on the certainty that customers will arrive in a timely fashion; for most air travellers, the consequences of a delay can be significant.

This promise is broken down into rational and emotional benefits of using the service. Rational benefits include the speed and frequency of the service, as well as its punctuality and reliability. Emotional benefits include the dedicated service, trust and reassurance, premium feel and the belief that Gatwick Express is the 'official way' to Gatwick Airport.

Things you didn't know about Gatwick Express

A Class 442 train – the same as those used in the Gatwick Express fleet – holds the UK speed record for a third rail electric train, set in 1988.

Gatwick Express services offer a free porter service at London Victoria and Gatwick Airport stations.

Every day, more than 14,000 customers travel on the Gatwick Express service, on 160 services and over a 27-mile stretch of track.

Favoured by stylists and celebrities, ghd has been heralded as the 'Aston Martin of the hair world', an impressive accolade for a relatively young brand. Established in 2001, ghd is entering its 10th year as a leading innovator in styling irons. With its launch the brand became an immediate viral success, initiating a cult following around the globe that has grown over the last decade in line with the brand.

Market

Over a short period of time in business terms ghd has established itself as one of the leading players in the hair and beauty sector. It has achieved this through combining style, inspiration and emotive advertising with new product launches designed to address a classic modern day dilemma: how every woman can look her best.

At launch, ghd's ceramic styling irons became an almost overnight success. The brand is now at the forefront of the competitive fashion styling sector in which it is renowned as one of

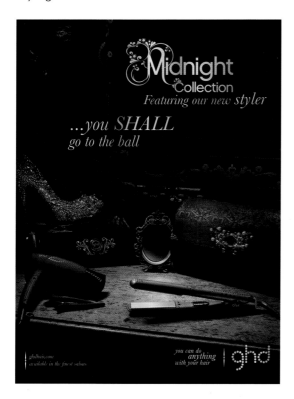

the leading hair styling brands globally. A key marketing decision in the brand's history was to make its products available exclusively through salons. Today stylists remain at the heart of ghd's business model, which is why it only supplies salons and selected premium retailers.

Product

The ghd range offers a revolutionary styler collection suitable for all hair types, from the ghd IV styler for everyday styling needs through to the ghd Gold Series featuring the ghd Gold Classic styler, the ghd Gold Max styler (with wider plates for long and thick hair) and the ghd Gold Mini styler (with narrow plates for short crops and fringes). Other ghd product offerings include a brand new range of brushes and combs as well as a range of hair styling products specially formulated for use when styling with heat.

As a brand ghd is committed to product innovation and improvements in technology that help it retain its leading market position. It places an emphasis on education, offering complimentary in-salon training, experiential and inspirational tours, hands-on educational support in seminars, and an academy education programme for cutting and dressing.

Achievements

Since its launch ghd has been aiming high, its cult following quickly translating into a host of industry-recognised accolades over the course of a decade. In 2010 awards included Now magazine's Best Styling Tool for the third successive year, The Sunday Times Style Magazine's Best Styling Tool, and Best Flat Iron in InStyle's 100 Best Beauty Buys for 2010.

Recent Developments

At the start of 2011, ghd launched its new Gold Series stylers, marketed as the brand's sleekest stylers to date; with improved features such as smoother plates, a cooler, lighter body and a protective plate guard to safely cover hot plates when a customer needs to simply style and go.

A further recent addition to ghd's product range is its collection of 10 brushes and two combs, developed in collaboration with professional stylists to ensure a smooth and sleek finish to hair.

Promotion

The central idea driving all ghd communications is encapsulated in its campaign strapline: 'You can do anything with your hair.' It projects the idea that hair can create a feeling of catwalk confidence while evoking the benefits of the ghd styler and its ability to transform looks.

2001	2002	2003	2005	2006	2007
The ghd brand is born.	ghd launches its iron oil product and the brand launches in Australia.	Annual turnover reaches £12 million and the first television advert airs. The following year ghd sets its sights on the US market.	The Sunday Times Fast Track names ghd Fastest Growing Company and turnover reaches £54 million.	The ghd global website and thermodynamics® are launched.	ghd launches new branding: 'Thy will be done.'

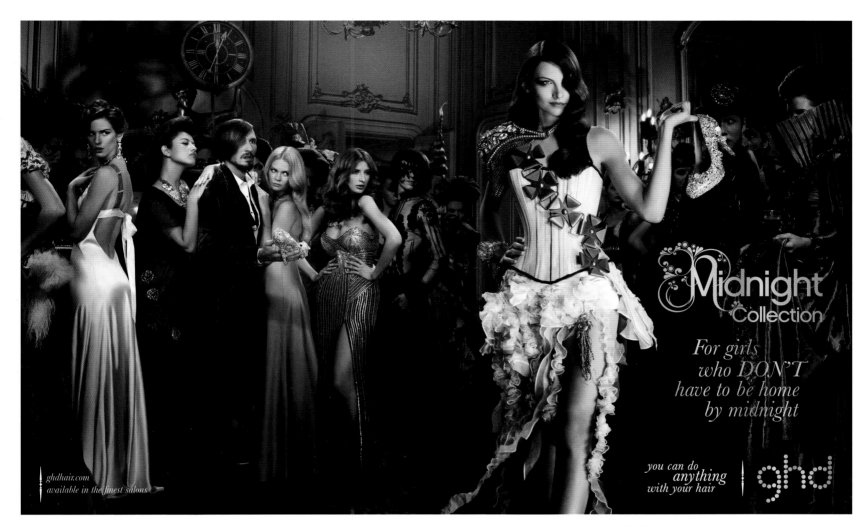

Its latest campaign series centres on a selection of Twisted Fairytales: the re-telling of famous tales, which have been adapted to feature a heroine empowered with ghd confidence, sending the stories in unexpected directions.

2010's Midnight campaign saw Cinderella fleeing to a powder room at the stroke of midnight, where she finds the ghd Midnight Collection and uses the styler to create an edgy party look.

The 60-second television spots, first aired during popular programmes such as The X Factor, were followed by shorter spots as well as on video-on-demand sites such as 4oD and at major airport terminals across the UK. Accompanying advertisements ran in leading fashion publications such as Cosmopolitan, Elle and Marie Claire, and a special four-page insert – featuring a pull out scene from the ball – was bound into weeklies such as Now, Look and You.

An extended version of the advert was premiered online for exclusive view by fans of the ghd Facebook page along with other behind-the-scenes footage. Meanwhile the brand website displayed looks featured at the ball with handy step-by-step videos showing consumers how to achieve the styles at home.

Across other media, Bond Street Underground train station played host to the campaign with a domination package that included various images showcasing the transformation of Cinderella before and after midnight, displayed in 6-sheet and 48-sheet formats as well as via digital escalator panels.

Brand Values

ghd's brand vision is to become the leading hairstyling brand used and recommended by stylists. Built around the premise that women only feel as good as they think they look, the brand promise is 'to make every woman look and feel amazing every day'. The company strategy focuses on conveying catwalk confidence, to help women feel more powerful, in control and ready for anything.

To achieve this goal ghd focuses on leading rather than following, continually pushing the boundaries of creativity. As a brand its personality is passionate about style, imaginative, charismatic and sassy, and is built around open and honest communication, reflecting its quest for creative excellence.

Things you didn't know about ghd

ghd was the first salon-only brand to advertise on television.

The brand has a large celebrity following including Alexa Chung, Danni Minogue and Blake Lively.

ghd has more than 500,000 Facebook fans.

The brand has associated with many fashion shows around the world including Matthew Williamson and Sass & Bide.

2008	2009	2010	2011
Friend of the stars, Jonny Woo, writes and performs three short plays for the launch of ghd dark or pure stylers.	ghd sponsors the Matthew Williamson Autumn/Winter New York Fashion Show, supplying a team of stylists for the show.	ghd launches the new ghd Gold Classic styler as part of the Limited Edition Midnight Gift Collection.	ghd launches the new range of Gold Series stylers, ghd's sleekest ever stylers featuring the ghd Gold Classic, ghd Gold Max and ghd Gold Mini stylers.

Guinness is a unique beer created in 1759 by Arthur Guinness – who famously signed a 9,000-year lease on the St James's Gate Brewery, where it is still brewed today. As the world's number one stout it has a passionate following among beer connoisseurs. The brewing is as much about the quality of the ingredients as the skill of its generations of head brewers, and the technology applied by its scientific brewing team.

Market

Guinness holds its own in a highly competitive market alongside key players that include Fosters, Carling, Carlsberg, Stella Artois, Heineken, John Smith's, Magners and Bulmers. Including restaurant venues the overall distribution of Guinness is 73.8 per cent, rising to 91 per cent in managed pubs and 92.3 per cent in leased. The brand is the world's number one selling stout with almost two billion pints sold annually and one million pints bought each day in the UK.

Leading markets for the brand are the UK, Ireland, the US, Nigeria and Cameroon; Guinness has a significant share of the African beer market, with around 40 per cent of worldwide total Guinness volume brewed and sold in Africa.

Product

Guinness has five distinct qualities that set it apart from its competitors: its ingredients, including malted barley that provides the foundation for the flavour of the beer and roasted barley that gives it its dark ruby red colour (often mistaken for black); the addition of extra hops; special yeast that converts brewing sugars to alcohol and carbon dioxide gas, creating the instantly recognisable flavour; the maturation process; and the skilful craft of its expert team of brewers.

There are three main product offerings: Original, Draught Guinness and Foreign Extra Stout. Original set the Guinness journey in motion more than 250 years ago, its dark colour and characteristic taste achieved by roasting a small portion of the barley that, coupled with the hops, produces its distinctive flavour.

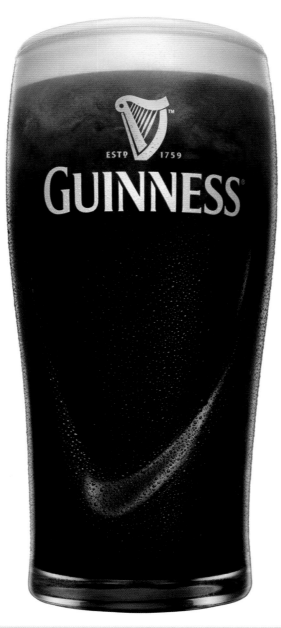

Draught Guinness, currently available in kegs, widget cans and bottles, has a creamy smooth texture and while historically associated with the Irish market, is now a global success story thanks to the brand's ingenious marketing campaigns. At 4.2 per cent alcohol by volume (ABV) it has less strength than Foreign Extra Stout that can range from five per cent ABV in China to eight per cent in Singapore. Foreign Extra Stout is renowned for its full flavour, achieved through brewing with extra hops and roasted barley for a natural bite.

Achievements

Launched as part of the brand's 250th birthday celebrations – and a continued celebration of the philanthropic legacy of the company's founder – the Arthur Guinness Fund Awards are part of a global fund to support social entrepreneurs worldwide.

The celebrity-endorsed fund recently announced a new partnership with Ashoka, the global organisation devoted to supporting social innovation, and is committing three million euros over the next three years. To date, contributions to the Arthur Guinness Fund total around 7.4 million euros.

Guinness has built up a reputation for groundbreaking creative advertising, accruing a host of awards and industry accolades along the way including Best Use of an Emerging Digital Channel in a CRM Campaign at the Connect 2007 Advertising Awards.

noitulovE, a 60-second television and cinema advert in 2005 to promote Draught Guinness, formed the cornerstone of a £15 million

1759	1769	1862	1886	1929	1955
Arthur Guinness, aged 34, signs a 9,000-year lease on a disused brewery at St James's Gate, Dublin for an annual rent of £45.	The first export shipment of six and a half barrels of Guinness stout leave Dublin bound for England.	The Guinness trademark label is introduced, comprising a harp and Arthur Guinness's signature. The Harp is registered as a trademark in 1876.	Guinness becomes the first major brewery to be incorporated as a public company on the London Stock Exchange.	The first Guinness advert is published, with the slogan: 'Guinness is Good For You.' Adverts featuring John Gilroy's cartoon characters soon follow.	The first Guinness Book of Records is published.

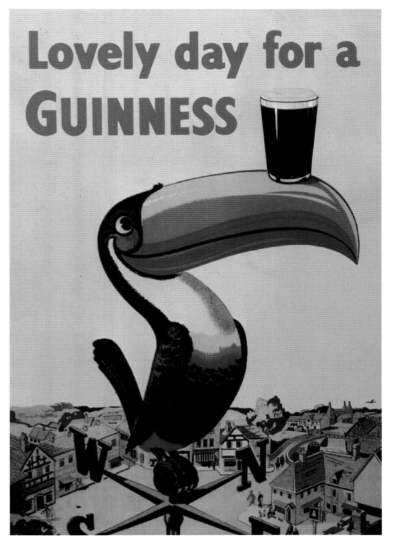

Lovely day for a GUINNESS

advertising campaign targeting men in their late 20s and early 30s. It was the fifth cinematic piece in Guinness's 'Good Things Come to Those Who Wait' series and with more than 30 advertising accolades, won the most awards in 2006.

Recent Developments
A key innovation currently being rolled out in bars across the UK is the Guinness Surger unit. Targeting bars without Draught Guinness on tap, the unit uses ultra-sonic technology that at the push of a button releases an ultra-sonic pulse into the glass, bringing the pint to life with the unmistakable surge and settle motion its counterpart is renowned for.

A new design on the Surger cans brings it into line with the latest 'widget' can design, introduced late in 2009. The new can also has a colour-changing band to indicate when it reaches the optimum temperature for pouring.

Promotion
2009 officially marked 80 years of trailblazing and iconic advertising for the Guinness brand and the following November, continuing its notable tradition, it launched an epic new advert as part of its 'Bring it to Life' marketing campaign. In a move away from the 'Good Things Come to Those Who Wait' strapline, the 'World' portrays a group of men coming together to bring a world to life. The creative parallels the famous surge and settle motion of a pint of Guinness – depicting the way the beer comes alive when poured at home or in a pub.

The advertisement was the brand's most challenging shoot to date and as a pioneer in advertising in high definition, premiered on Sky Sports 2 HD during a crucial Champions League match.

Taking on the extreme challenge of creating a parallel universe, director Johnny Green recruited an elite team including Oscar-winning set designer Grant Major and Oscar-nominated director of photography, Wally Pfister.

To accompany the release, the makers of Guinness teamed up with Google Earth to develop a unique online experience allowing fans to bring an imaginary planet to life.

Brand Values
Ever since Arthur Guinness signed the lease for the St James's Gate brewery in Dublin, Guinness has looked to lead by example; whether it be through its relentless pursuit of ensuring high quality Guinness everywhere, its award-winning advertising or the one-to-many philanthropic legacy laid down by Arthur Guinness and echoed by his successors. Since 1759 quality, innovation, entrepreneurialism and philanthropy have built Guinness into a global presence, and to this day are at the heart of what makes Guinness the brand that it is.

THE ARTHUR GUINNESS FUND
GUINNESS FOR GOOD

Things you didn't know about Guinness

More than five million pints of Guinness are sold in the UK each year on St Patrick's Day.

The outlying gas bubbles in a glass of Guinness travel downwards instead of upwards, hence its famous surge and settle motion.

The St James's Gate Brewery in Dublin produces four million pints of Guinness every day.

1959	1988	1999	2008
Draught Guinness is introduced.	Draught Guinness in a can launches, using a widget to recreate the creamy surge and winning an award for technological achievement in 1991.	Draught Guinness in a bottle is launched.	Ten million glasses of Guinness are enjoyed in more than 150 countries around the world.

Celebrating its 40th year in 2011, Hard Rock has embodied the spirit of rock music since its inception. Since the first Hard Rock Cafe opened in London in 1971, Hard Rock has become one of the most globally recognised brands through its restaurants, music memorabilia, live concerts, merchandise, hotels and casinos. A leading entertainment and leisure company, Hard Rock International has a network of 174 venues in 51 countries.

Market

The company has carved out a unique niche in the food and leisure sector with its mix of restaurants, hotels, casinos, memorabilia and merchandise. Hard Rock remains at the top of its sector, with no direct global competitor.

The first Hard Rock Cafe opened in London in 1971, with the Hard Rock International global expansion taking off in 1982. Its network of 174 owned and franchised operations now includes 133 cafes and 15 hotels and casinos, as well as three Hard Rock Live music venues. In the UK, its businesses are located in London, Manchester and Edinburgh.

More than 54 million guests visit Hard Rock Cafes every year to experience their high quality American fare, service and music atmosphere.

Hard Rock Hotels and Casinos first appeared in 1995, with the 670-room Las Vegas venue, and are now located across the US and Asia. The next phase is underway with new venues due to open in Panama in 2012; and in Hungary, Dubai and Abu Dhabi in 2013.

In 2007, the Seminole Tribe of Florida – a sovereign government with an elected Tribal Council – acquired the Hard Rock brand from The Rank Group for US$965 million.

Product

Hard Rock's core offering is food and retail. Customer service and quality are at the heart of its remit, and all the food is prepared and cooked in-house. Its 'product', however, is really the overall Hard Rock experience: high quality food and service, a rock 'n' roll environment, authentic memorabilia and music-related retail items.

Its memorabilia collection is the largest in the world and came into being when a regular customer, Eric Clapton, asked to hang his guitar on the wall next to his favourite spot. One week later, The Who's Pete Townsend added his guitar to the wall and the collection began.

The Hard Rock logo is featured on a wide range of merchandise – from sweatshirts and leather jackets to commemorative pins and key chains – and has gained almost cult-like appeal. T-shirts bearing the name of cafes visited have become an essential memento for many travellers.

In the music arena, Hard Rock's concert facilities include the 3,000-capacity venue, Hard Rock Live Orlando, which opened in January 1999 to showcase music from national

1971	1976	1978	1982	1990	1995
Founded by music-loving Americans, Isaac Tigrett and Peter Morton, the first Hard Rock Cafe opens its doors on Old Park Lane in London.	Carole King releases a song titled Hard Rock Cafe.	The second Hard Rock Cafe in the world opens its doors in Toronto, Canada.	The first Hard Rock Cafe in the US opens in Los Angeles.	Hard Rock launches the Signature Series t-shirt line to benefit charity organisations.	Peter Morton opens the first Hard Rock Hotel and Casino in Las Vegas. The following year Hard Rock America is purchased by The Rank Group plc.

acts and emerging artists. Hard Rock Live music venues are also located in Hollywood and in Biloxi, Mississippi. In the UK, Hard Rock presents the Hard Rock Calling event in London's Hyde Park every summer.

Achievements

First staged in 2006, Hard Rock Calling has established itself as one of the UK's premier outdoor music events, attracting more than 100,000 music-lovers each year. The 2011 show sees Hard Rock celebrate its 40th anniversary in the company of the illustrious American rock band, Bon Jovi.

Since its inception, Hard Rock has been committed to a wide variety of philanthropic causes and activities around the world. In every Hard Rock city, the staff aim to be seen as valuable community members, becoming Hard Rock Ambassadors and providing fundraising and volunteer services to community charities.

Its longest-standing waitress, Rita Gilligan, who has been with Hard Rock since it opened the original cafe in 1971, is now Hard Rock's official Cultural Attaché and most high-profile brand ambassador.

The company was working to 'save the planet' long before the environment became a widely supported cause, and Hard Rock has also contributed to and promoted charitable organisations including WhyHunger, The Breast Cancer Research Foundation, The Caron Keating Foundation, Musicians On Call, and Shakira's Fundación Pies Descalzos. Since 1990, the company's limited edition Signature Series t-shirt line, featuring artwork by influential musicians, has raised millions for various national and local charities.

Recent Developments

In 2008, Hard Rock added to its existing online presence HardRock.com by launching a new memorabilia website: Hard Rock Memorabilia 2.0. The site contains hundreds of evocative and valuable pieces of music memorabilia and there are plans for new features to allow users to create and share their own collections of items.

Promotion

In celebration of its 40th year, the brand's heritage and credentials will feature strongly

across all promotions in 2011, from social networking and digital marketing to traditional media such as print, point of sale and radio.

Brand marketing is also key at live music events such as Hard Rock Calling, while Hard Rock's partnership with Absolute Radio continues across the UK, creating interactive live music experiences featuring A-list artists.

In addition, Hard Rock International is revamping its approach to advertising with the launch of its 'See The Show' campaign. The campaign will highlight the key message that something is always happening at Hard Rock.

Brand Values

Customer satisfaction is a top priority; ensuring the quality of food, service and atmosphere is maintained across its estate globally is, therefore, fundamental to the brand. The company's core brand message is: 'Authentic experiences that rock!... Wherever you drink, eat or play!'

Hard Rock's brand mottos are: Take Time to be Kind; Save the Planet; All is One; and Love all – Serve all.

Things you didn't know about Hard Rock Cafe

The site of the original Hard Rock Cafe in London used to be a Rolls-Royce showroom.

A Hard Rock Cafe char-broiled burger cost 50 pence on the 1971 London menu. Each year the cafe celebrates its Founders' Day on June 14th by rolling prices back to those of 1971.

Hard Rock's logo was originally created by celebrity artist Alan Aldridge.

With more than 1,000 items, Hard Rock Cafe Orlando houses the most memorabilia pieces of any Hard Rock Cafe worldwide.

It's a Hard Rock tradition to 'christen' every new cafe, hotel and casino by smashing a guitar at the grand opening.

1998	2006	2007	2011
Hard Rock's Cultural Attaché Rita Gilligan is awarded with an honorary MBE for her services to tourism.	Hard Rock Calling is established in London's Hyde Park and launches with The Who and Roger Waters.	The Seminole Tribe of Florida acquires Hard Rock International from The Rank Group.	Hard Rock celebrates its 40th anniversary.

Serving the world's busiest international airport and carrying more than five million passengers per year, Heathrow Express is one of the most successful high-speed air–rail links in the world. The service carries more than 16,000 passengers a day on the 15-minute journey between Heathrow Airport and central London.

Market

Every year, more than 65 million passengers pass through Heathrow Airport. Compared with many other international airports, Heathrow has historically been one of the hardest to get to, with passengers travelling to and from London facing a long journey by tube or risking traffic congestion by car or taxi.

Heathrow Express was one of the first providers to offer a premium, dedicated and high-speed airport train service, giving passengers an easy, reliable and fast option for travelling between the city centre and airport. It reaches the airport in just 15 minutes, with services to Terminal 5 a further six minutes, compared with around 55–60 minutes by London Underground and 50–70 minutes by taxi.

Heathrow Express is a unique rail company as it is the only non-franchised mainline railway service operating in the UK, having been paid for by Heathrow Airport owner BAA.

Product

Heathrow Express is a dedicated and non-stop, high-speed, air–rail link that operates daily between Heathrow Airport and central London, departing every 15 minutes. Every day 150 services run from London Paddington to Heathrow Central (Terminals 1 and 3) and Terminal 5. Passengers wishing to travel to Terminal 4 can change at Heathrow Central and board the free rail transfer service, which takes just four minutes.

The Heathrow Express cabins are designed to be level with the platform, making it easier to get luggage onboard. All cabins are climate controlled and have accessible toilet facilities,
ergonomically designed seating and generous luggage areas, as well as onboard televisions to keep customers entertained. There are also Quiet Zones on the trains where the use of mobile phones is prohibited and Express TV is not in use. The First Class cabins deliver a high-end travel experience with leather-trimmed seats, complimentary copies of the FT, personal tables, and quicker and easier access to the terminals.

Achievements

Since its launch in June 1998, Heathrow Express has established itself as a favoured route for both business and leisure passengers. From the outset it was estimated that approximately 3,000 journeys would be removed from the roads every day, a saving to the UK economy in terms of time – compared with the use of tube, taxi or bus – of more than £444 million.

Heathrow Express has won a host of awards and has been recognised internationally as one of the most successful airport rail services. Its corporate identity, developed by Wolff Olins, is among the most comprehensive branding and design projects ever undertaken in transportation. This was recognised when the project became the 2000 Grand Prix Winner of the Design Business Awards.

Heathrow Express has worked hard to translate its customer service ethos into action and in 2006 claimed Customer Service Team of the Year at the National Customer Service Awards. Since 2007, Heathrow Express has repeatedly topped the poll in the independent National Passenger Satisfaction Survey and in 2010, maintained its top three position with a 93 per cent satisfaction rating.

Recent Developments

Heathrow Express is an innovative media owner and is constantly looking for ways to give other businesses commercial access to its hard-to-reach business audience.

In January 2007, it launched the first ever 'motion picture videowall' advert in Europe. Four hundred and fifty frames, each holding an individual printed image, were installed in

1990s	2001	2007	2008	2009	2010
In 1991 the Heathrow Express Railways Act gives BAA the power to construct the Heathrow Express. It officially launches in June 1998.	Heathrow Express places an order for five new carriages, costing a total of £6.5 million.	In partnership with T-Mobile and Nomad Digital, a WiFi Hotspot service is introduced, providing passengers with 2Mbps internet access throughout their journey.	Heathrow Express launches services to Terminal 5, introduces e-ticketing, and launches its biggest multimedia campaign to date: 'The Airport is closer than you think.'	Heathrow Express introduces Flight Information Display Screens and Airline Self Service Check-In at Paddington station. The WiFi service is now offered free to all customers.	Heathrow Express launches an improved service to Terminal 4, ensuring a fast, reliable and premium branded service now reaches all Heathrow terminals.

the train tunnel walls, covering a total distance of 1,500ft. Seen from a train travelling at 70mph this created a 15-second moving image advert.

Heathrow Express has also enhanced its groundbreaking onboard television service, Express TV, which was created specifically to cater for its passengers – delivering a live news and world weather bulletin covering domestic, international and business news, as well as travel clips and entertainment programmes.

The company continues to innovate to meet customer needs and in 2008 launched an e-ticketing service. Tickets can be sent to mobile phones in the form of a barcode, allowing passengers to book and board the service without having to queue for paper tickets.

In December 2009 Heathrow Express made London Paddington the first UK railway station to offer Flight Information Display Screens and Airline Self Service Check-In. Located at the Heathrow Express ticket office, the touch screen machines allow customers to print their boarding pass and view their flight information before they even arrive at Heathrow Airport. Customers can proceed direct to bag drop, helping them save time and feel more at ease on their journey.

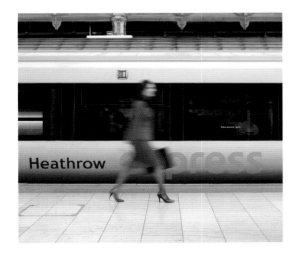

In June 2010, Heathrow Express launched an enhanced rail service to Terminal 4, refurbishing and rebranding the trains to ensure a premium Heathrow Express service now operates to all terminals. The £1 million investment project involved introducing a set timetable and synchronising the transfer service with existing Heathrow Express services, reducing passenger journey and wait times by more than 25 per cent.

Promotion

Heathrow Express' biggest multimedia campaign, 'The Airport is closer than you think', was launched in 2008 and saw a series of idents run worldwide on Sky News to complement press, outdoor and digital advertising. The campaign set out to reinforce Heathrow Express as the fastest way to the airport. Press advertising featured in key UK business titles while an international campaign ran at New York's JFK Airport and at Frankfurt, Schipol and Dublin airports.

The company uses below-the-line media to target its audience, investing in customer relationship marketing to boost frequency of use and retention amongst its most loyal customers, and developing marketing relationships with airlines at Heathrow Airport. For example, Heathrow Express partnered with Virgin Atlantic to provide Flying Club members with complimentary tickets along with their

Flying Club membership packs. Partnerships are communicated via email newsletters, membership packs and media activity.

Brand Values

Heathrow Express' key brand values are speed, frequency and certainty; recent research has shown that these are the service benefits most required by customers.

For both business and leisure customers, Heathrow Express aims to provide high levels of comfort and customer service. However, different aspects of the brand's personality are highlighted for each market. For the business traveller, the brand is portrayed as fast, frequent, reliable and convenient. When speaking to the leisure market, the brand is positioned as not being overly formal or austere but being fast, reliable, convenient, approachable and family friendly.

Things you didn't know about Heathrow Express

Since launch, Heathrow Express trains have carried more than 60 million passengers.

The Heathrow Express carbon-efficient electric trains are fitted with electrical regenerative brakes, which reduce vehicle speed by converting some of the kinetic energy into another form of energy. To date, they have generated enough energy to boil more than 400,000,000 kettles.

Heathrow Express was the first rail service in the UK to introduce onboard televisions, at its launch in 1998.

Heathrow Express trains are purpose-built and can travel at speeds of up to 100mph.

After 30 successful years, Highland Spring remains the leading British brand of bottled water (Source: Zenith Bottled Water Report 2010) and is the only major bottled water brand to have its catchment area certified organic by the Soil Association. Highland Spring ensures its water is as pure as can be, drawn from protected underground springs in the Ochil Hills, Perthshire, Scotland.

Market

Packaged water has grown significantly over the past 10 years, but has suffered more recently from poor summers in 2007 and 2008, and in the challenging economic climate. The market returned to growth in 2009 with volume sales increasing by 4.6 per cent in the 52 weeks to October (Source: Zenith 2010). With production exceeding 228 million litres, Highland Spring recorded a sales turnover of almost £55 million in 2009, an increase of 7.5 per cent year-on-year, benefiting from UK shoppers' increasing preference for British brands.

Product

Highland Spring's status as 'the water from organic land' is unique among major bottled water brands. The 1,000-hectare catchment area from where the water is drawn has been carefully protected for more than 20 years, earning it organic status as certified by the Soil Association. This approach reflects the company's overall commitment to minimising its environmental impact. In March 2010 new PET bottle designs were launched for the 1.5L and 500ml sparkling products – at that time the lightest branded sparkling water bottles on the market, using nine per cent less plastic and 39 per cent less paper than their predecessors.

Highland Spring remains the only bottled water brand recognised by the Eco-Management and Audit System, not only meeting the standard but going far beyond what is required in order to maximise protection of the environment.

Achievements

Highland Spring continues to be at the forefront of category growth, retaining second place in the market whilst increasing volume to 228 million litres (Source: Zenith 2010). In grocery multiples, Highland Spring is the leading sports cap brand (Source: Nielsen 2nd October 2010) and was the pioneer of the 'Kids' water market in 2001. The brand's top selling 'on the go' purchase, the 500ml screw cap, has increased value sales by 25 per cent year-on-year. Highland Spring also supplies more than

1979	1993	1998	2001	2006	2007
Highland Spring Ltd is formed.	Highland Spring displaces Perrier from the top spot in the sparkling water market and secures the contract to supply bottled water to British Airways worldwide.	Highland Spring becomes the official water supplier to the World Snooker Association.	The brand continues to innovate, pioneering the 'Kids' bottled water market.	The first national TV advertising campaign is rolled out.	Highland Spring is revealed as the exclusive drinks sponsor to British tennis star Andy Murray and his brother, former Wimbledon doubles champion, Jamie Murray.

18.8 million litres to the on-trade every year and was awarded Gold at The Publican Licensees' Choice Awards 2010.

The brand also dominates the sparkling 'impulse' market and commands one-third of all sales of this format. This has helped cement the brand's number one position in the sparkling sector – outperforming its nearest competitor by more than two to one (Source: Zenith 2010). Also contributing to this success is the redesigned sparkling PET range, which has been awarded a prestigious Effectiveness Award by the Design Business Association.

Highland Spring is regarded as the most trusted bottled water in the UK (Source: NOP June 2010), and has also been recognised for the sixth consecutive year by The Good Shopping Guide 2011 as the leading ethical bottled water brand. The business is extremely proud of these achievements, and features The Good Shopping Guide logo across its packaging.

Recent Developments

Highland Spring Group is a privately owned business, headquartered in the UK. In 2009 the Group acquired the Speyside Glenlivet brand, followed by the water business of Greencore Group plc in 2010, thus becoming the leading producer and supplier of naturally-sourced bottled water in the UK market. Highland Spring Group's brand portfolio includes Highland Spring, Speyside Glenlivet, Gleneagles, Green Valley and a range of retailer own-labels and flavoured waters. The Group consists of five rural catchment areas and manages water abstraction

rights for 2.2 billion litres per annum. It's anticipated that the business will have supplied more than 350 million litres of bottled water in 2010, with an estimated turnover of £75 million.

Promotion

2010 saw further development of the major marketing thrust that began in 2009.

Having successfully communicated its organic status through advertising in previous years, Highland Spring set out to make an emotional connection with consumers. The new line, 'Brought to you with care', sets out to emphasise the care taken in protecting the brand's catchment area along with the importance of nurturing loved ones with the best – the water from organic land.

As advocates of healthy lifestyles, Highland Spring is proud of its comprehensive sports sponsorship portfolio.

Highland Spring is the exclusive drinks sponsor of professional tennis players Andy Murray and his brother, Jamie, as well as being the official bottled water supplier to the Lawn Tennis Association. In 2010, the brand used its association with Britain's number one tennis professional for a major on-pack promotion: 'Best Seat In The House'. The promotion encouraged consumers to collect and redeem tokens for tennis-related rewards, driving consumer loyalty and overall category growth.

Highland Spring also sponsors Scottish cyclist and

Olympic gold medallist Sir Chris Hoy, and is the official water supplier to high profile rugby teams and athletics events, as well as sponsoring top golf and snooker professionals.

At a grassroots level, Highland Spring sponsored more than one hundred 5km and 10km events, half marathons and marathons during 2010.

A new development in 2010 has been the Coachcast Series, an innovative set of online videos on Highland Spring's website that promote training tips from sports stars including Andy Murray, Sir Chris Hoy and London Wasps.

Brand Values

Highland Spring is an iconic Scottish brand and is committed to protecting the wider environment and developing its business in a sustainable and eco-friendly way.

As the guardian of its land, the company goes to great lengths to protect its source, and to extend its ethical approach to production, packaging, recycling and transport – a nurturing approach that reflects the views of its consumers.

Things you didn't know about Highland Spring

In 2001 Highland Spring became the first British brand of bottled water to have the land from which it is drawn certified organic by the Soil Association.

Highland Spring has been chosen as the leading ethical bottled water for six years running by The Good Shopping Guide, the world's leading information resource for ethical shoppers.

Highland Spring is a founder member of the Natural Hydration Council.

All of Highland Spring's packaging is 100 per cent recyclable.

2008	2009	2010	
Highland Spring signs a major sponsorship partnership with Sir Chris Hoy, multi-gold medal winner at the Beijing Olympics.	A refreshed brand identity is introduced across packaging and classic Hollywood stars are used to promote 'the water from organic land'.	A new sparkling PET range is launched and wins a prestigious industry award.	Highland Spring Group is formed following acquisition of Greencore Group plc bottled water division, making it the UK's leading producer and supplier of naturally-sourced bottled water.

HOWDENS
JOINERY CO.

MAKING SPACE MORE VALUABLE

Howdens Joinery was founded in 1995 in order to serve the needs of small builders undertaking routine joinery and kitchen installation work. It is now one of the UK's leading suppliers of kitchens and joinery products to the trade. Howdens has achieved this by creating a strong entrepreneurial culture within its depots, a close relationship with its customers, and a range of kitchens specifically designed to meet the needs of modern living.

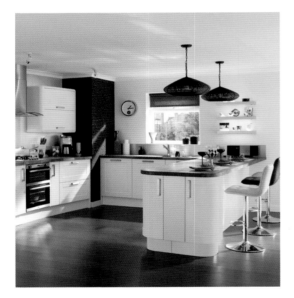

Market

Howdens Joinery operates within the trade or 'done for you' kitchen market, its core customer base comprising local builders and skilled professionals. The company has always believed that project management by the local builder is the best solution for installing a kitchen. The introduction of additional legislation to govern materials and services, combined with increasingly 'cash rich, time poor' and design-savvy end-users, has seen this market grow dramatically.

Howdens helps builders to manage their businesses by guaranteeing product availability from local stock with rigid cabinets that are ready to install, saving builders time and money as well as allowing them to plan effectively. Its versatile supply chain ensures its depots, and in turn its customers, receive a high level of service. Specifically within the trade sector, key competitors are Jewson, Travis Perkins, Magnet Trade and Benchmarx.

Product

Howdens sells kitchens – encompassing appliances, accessories, handles, worktops, sinks and taps – and joinery, such as doors, flooring, stairs and hardware. A free survey and Computer-Aided Design (CAD) service, which includes a site visit, is also available. The company has the UK's largest kitchen range available from stock and ensures its portfolio remains informed by new product development. As all depots hold stock locally they are also able to offer local delivery when and where required.

Achievements

Since it was established in 1995, Howdens has demonstrated strong growth with a turnover that exceeded £750 million in 2009. In 16 years it has expanded from 14 depots to more than 480, supplying over 260,000 building trade professionals as well as more than 350 local authorities and housing associations with around 400,000 complete kitchens each year. In 2003, Howdens also set up Houdan Menuiseries in France with a further 11 depots.

2010 was the fifth anniversary of the partnership between Howdens Joinery and Leonard Cheshire Disability, which in September 2007 was named Best Corporate Partnership at the Third Sector Excellence Awards. Howdens works with Leonard Cheshire Disability services across the UK to develop affordable, attractive and practical kitchen facilities for people with physical disabilities. It offers a highly accessible kitchen collection called 'Inclusive Kitchens', which is sold through its depots.

1995	1999	2003	2004	2006	2007
Howdens Joinery starts trading in October with 14 depots supplying trade professionals with joinery, hardware, kitchen ranges, accessories and appliances from stock.	Howdens opens its 100th depot.	Howdens opens 11 depots in France under the name Houdan Menuiseries.	Howdens sets the standard in the trade kitchen market with its new format high quality Kitchen Brochure.	Howdens Joinery launches a market-leading Joinery Brochure featuring doors, joinery and flooring.	The Howdens website launches in April and the 400th depot opens.

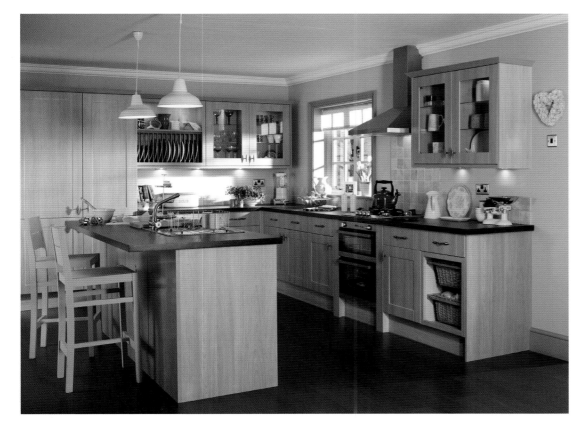

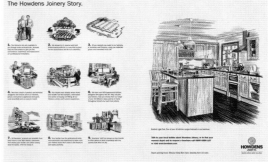

In December 2009, Howdens reached the top 25 of the Big Companies category in The Sunday Times 100 Best Companies to Work For 2010 list.

Recent Developments

Product development remains key to the company's focus on continued growth and in 2010, Howdens recategorised its kitchen ranges into six families. By offering products that are both affordable and in line with the latest design trends for the home, Howdens aims to meet changing market needs head on.

The company has been awarded FSC and PEFC chain of custody certificates for a number of its joinery products, worktops and kitchen ranges, and it continues to strive for certification on additional ranges and products. In 2010, Howdens was awarded the Energy Saving Trust Recommended Certification Mark for selected appliances, and all of its

manufacturing and warehouse sites achieved ISO 14001 for environmental standards. It also remains certified under the Carbon Trust's prestigious Energy Efficiency Accreditation Scheme, an accolade that it has held for more than 10 years.

As consumers become ever more design conscious, increased emphasis is being placed on building brand awareness so that the Howdens name is recognised and recommended not only by builders but also by end-users themselves. The company runs a fleet of more than 400 branded delivery trailers and in 2010, launched promotional items including cast iron trivets and miniature Corgi trucks to further develop the brand.

Promotion

Howdens puts the relationship between local depots and builders at the heart of its promotional strategy. As such its kitchen, joinery and appliance brochures, alongside other literature, are specifically designed to help builders in discussion with their own customers. Local marketing is crucial and the depots tailor their promotional activity to meet customer needs. Many depots also provide donations to local charities and community projects, including sponsorship of grassroots football and rugby teams.

Howdens has further developed its website to showcase the company and its complete range of products, and has also built on the

consumer and trade advertising campaigns that it launched in 2008. These ventures have been carefully considered to raise brand awareness and help the local depot and local builder in selling Howdens products to end-users.

In 2009, Howdens introduced a series of Truly Local books, published quarterly, to tell the stories behind their customer relationships and to show how the business is an integral part of the local community.

Brand Values

Howdens is guided by the aim of providing small builders with kitchen and joinery products of the highest quality, at the best price and from local stock. The company attributes its success to the strength of the depots' relationships with their customers and the breadth of the market they serve; the quality and range of Howdens products; the ability to service customers from local stock; and the opportunity to streamline the business around supplying one customer, the small builder.

Things you didn't know about Howdens Joinery

Howdens sells 400,000 complete kitchens every year.

Two million doors are supplied annually by Howdens.

Howdens sells 500,000 appliances to UK homes every year.

In 2009/10, Howdens depots made around 1,750 charitable donations to local good causes, which amounted to £599,000 across the Group.

2008	2009	2010	
The first Howdens Joinery branded delivery trailers go on the road. The first consumer and trade advertising campaign launches.	The Lamona appliance, sink and tap brand, exclusive to Howdens Joinery, is launched. The series of Truly Local books is introduced.	Howdens Joinery launches a new Appliance, Sink and Tap Brochure featuring its entire range of Lamona, Bosch and Freestanding appliances.	The Kitchen Range Families are introduced and there are now 480 depots across the UK supplying more than 40 kitchen ranges from stock.

Created by Accor co-founders, Paul Dubrule and Gérard Pélisson, ibis was launched in 1974 and pioneered the modern budget hotel concept. With a goal to guarantee consistent accommodation and service quality, and at prices 30 per cent cheaper than the local market average, this revolutionary concept was an immediate hit. ibis is now the European market leader in budget hotels, with more than 850 hotels and 100,000 rooms in 43 countries.

Market

The market leader in Europe and the fourth largest chain in its category worldwide, ibis has earned its global reputation for excellence at competitive prices thanks to its worldwide standard of offering all the major services of a modern hotel at the best local market value.

In 2007 ibis launched the biggest expansion plan in its history, strengthening its leading position across the world and intensifying its growth in emerging markets, particularly in Asia and Latin America. The ibis network expands by about 70 hotels per year, and now totals more than 100,000 rooms across five continents.

ibis is part of the budget brand portfolio of Accor, one of the world's leading hotel operators (Source: STR Global 2008). Present in 90 countries with 4,100 hotels and close to 500,000 rooms, Accor's broad range of hotel brands provides an extensive offering from luxury to budget.

Product

ibis stands on the strength of its worldwide standards – a global guarantee to all customers – and provides conveniently located hotels that are set in easy-access destinations across the globe.

ibis aims to provide a warm welcome, at any time of night or day; from high quality reservations management and a fast check-in process through to clean, peaceful and comfortable rooms, at the right temperature, and with bathrooms maintained to high hygiene standards. It is this contemporary hospitality combined with on-site security, 24-hour dining facilities every day of the year and a self-explanatory bill – with no hidden extras – that makes the ibis brand.

The concept is also combined with innovations in modern hotel design, new restaurant formats (more than 20 around the world), multi-skilled employees, and services such as the 'early bird' and 'late riser' breakfast choices.

In adapting to meet the demands of local markets by providing the best value for money, this ibis standard allows the full-service hotel chain to satisfy the needs of its national and international business.

See more for less with ibis hotels this Spring

UP TO 50% OFF per room per night at UK & Ireland hotels

✓ Budget hotels that tick every box

Cardiff FROM £28
London FROM £34
Birmingham FROM £39
Belfast FROM £39

And more offers at our 54 hotels across the UK & Ireland

over 800 ibis hotels worldwide

Book now at
ibishotel.com

ibis HOTEL

Hotels the way you like them

Achievements

In 1997 ibis was the first economy chain to receive the international quality standard certification ISO 9001, which is recognised in more than 150 countries.

As a pioneer in commitment to the environment, 2004 saw ibis become the world's first hotel chain to secure the ISO 14001 environmental certification. This certification is recognised worldwide and validates corporate management

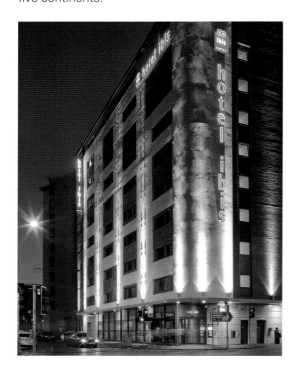

1974	1983	1985	1992–96	1997	1999
The first ibis opens in Bordeaux, France. Two years later ibis opens in Paris and in the same year, the chain expands to Amsterdam.	The 100th ibis opens.	The first ibis hotel in the UK opens, at London Heathrow. Hotels also open in Austria and Belgium. Two years later, the 200th ibis opens and the chain expands to Switzerland.	At the start of the decade there are 300 hotels worldwide. Further expansion sees ibis hotels open for the first time in Poland, Australia, Hungary and Asia.	ibis commits to the ISO 9001 quality certification.	ibis opens its first hotels in Latin America.

policies regarding waste reduction and water and energy consumption. One-third of ibis hotels have already been certified ISO 14001 and it is being rolled out worldwide.

ibis received the Best Advertising Campaign award for its TENor15 'Rock Star' campaign at the 2010 Worldwide Hospitality Awards held in Paris. The promotion was showcased via a groundbreaking 360 degree, pan-European campaign conceived and executed by Y&R Paris, who worked in partnership with Wunderman for the viral communication. It played out over two months across television spots, press inserts, online, events, internal communications, point of sale and social media.

Recent Developments

A first from ibis is the 15-Minute Satisfaction Guarantee: a unique contractual agreement between ibis and its guests, whereby ibis invites every guest to immediately report any issue that may arise. If the hotel is responsible and the issue takes more than 15 minutes to resolve, that service is free of charge to the guest for the night.

As part of its brand development, ibis is investing in its network by developing new hotels and refurbishing older properties to reflect a new look and feel. At the heart of the hotel, the ibis bedroom has been redesigned to ensure maximum comfort and therefore a good night's sleep. All new rooms feature layouts designed to best utilise space, make use of natural colours and materials – such as wooden floors – and also include an LCD television.

Additional developments include the rollout of ibis Web Corners to all hotels by 2012, allowing guests free access to the internet (for a set period of time) in the public areas.

ibis is one of the rare budget hotel brands to reward its guests via A|Club, the unique loyalty programme from Accor. Members earn points at more than 2,000 hotels worldwide and redeem them for reward vouchers or airline miles.

Promotion

The ibis brand successfully communicates to its global audience via a standard creative platform, as evidenced by its 2010 win at the Worldwide Hospitality Awards. The TENor15 'Rock Star' campaign conveyed the message that in ibis hotels, you don't have to be a star to get a special offer.

Both global and tactical communications focus on people and the warm ibis welcome,

with ibis staff – as a key driver of the brand – featuring prominently in campaigns to convey its friendly and welcoming tone. Belief in the brand is promoted further by its 15-Minute Satisfaction Guarantee, promising that if a reported problem is not fixed within 15 minutes, 'that service is on us!'.

ibis's main objective is to drive direct sales to ibishotel.com through integrated campaigns. To do this, it employs targeted tactical campaigns in national press alongside online creatives across key travel and event networks. In addition, as a brand aimed at 'online' customers, ibis has developed its social networking and rich media presence.

Brand Values

The ibis brand is recognised worldwide, thanks to its simple-to-understand values and personality. The brand is operated according to global standards, giving the frequent traveller reassurance on international quality. The brand leads the way in offering full-serviced facilities, in modern creative environments at budget rates. Above all, the ibis brand sets out to combine creativity, quality and product with a passion for hospitality worldwide.

Things you didn't know about ibis

ibis opens, on average, one hotel each week worldwide.

Today, 82 per cent of ibis hotels are located in Europe.

ibis was the first budget hotel chain to be certified ISO 9001 for quality globally, and the first to secure ISO 14001 environmental certification.

2004	2007	2008	2009
ibis commits to the ISO 14001 environmental certification and opens the first ibis in China.	ibis launches the new ibis room concept and opens its first hotel in Turkey.	ibis opens its 800th hotel. The chain expands to India, Russia, Kuwait and Benin, and 14 hotels open in China.	ibis hotels open in Singapore, Algeria, Madagascar, Jordan and Oman. The chain's 100,000th room opens, in Munich, Germany.

ICAEW is a professional membership organisation with over 136,000 chartered accountants worldwide. Through its technical knowledge, skills and expertise, it provides leadership to the global accountancy and finance profession. Its members provide financial guidance based on the highest technical and ethical standards. ICAEW develops and supports individuals, organisations and communities to help them achieve long-term, sustainable economic value.

Market

During periods of economic uncertainty, people making business decisions need the knowledge and support of finance professionals who are trained to provide objective and impartial advice at the highest levels. ICAEW members challenge people and organisations to think and act differently. The training and professional development they receive gives them the capability to provide leadership and direction to organisations of any size, across all industry sectors.

Collectively ICAEW members make a major contribution to economic activity, as well as to the effective operation of markets. Chartered accountants work across the full breadth of the economy, using their expertise in business, practice and the public sector to drive efficiency. For example, last year 86 per cent of the FTSE 100 boards included one or more ICAEW members. Its members working in private practice are a first port of call for many of the small and medium sized enterprises that form the backbone of the UK economy.

Product

ICAEW is committed to developing the knowledge and skills of finance professionals around the world. Its approach to learning and professional development ensures individuals gain the experience and expertise they need to reach their full potential.

The internationally recognised ACA qualification provides a broad scope and depth of accountancy, finance and business skills, technical excellence and best practice, relevant across all industry sectors. ICAEW offers ACA training through more than 2,500 authorised training employers around the world. From the UK to Malaysia, Pakistan, Russia, China, Cyprus and the United Arab

1880	1893	1919	2006	2007	2010
A new professional body, The Institute of Chartered Accountants in England and Wales (ICAEW) is created by Royal Charter.	Chartered Accountants' Hall, in the City of London, is completed and opened by ICAEW's president, Edwin Waterhouse. It goes on to become a Grade II listed building.	Mary Harris Smith is admitted to ICAEW, becoming the first female chartered accountant in the world.	ICAEW is appointed by the European Commission to study the implementation of IFRS throughout the European Union.	ICAEW wins a £1 million tender from the World Bank to raise standards across the accountancy profession in Bangladesh.	Nineteen of ICAEW's recommendations in its Going for Growth manifesto are echoed in the Labour, Conservative or Liberal Democrat UK 2010 general election manifestos.

Emirates, it works in partnership with leading education providers worldwide.

As well as the ACA, ICAEW offers a suite of qualifications and personal development programmes designed to support people at all stages of their career progression. From the Diploma in Charity Accounting to the Financial Talent Executive Network, certificates in International Financial Reporting Standards (IFRS) and the Forensic Accreditation Scheme, it covers a range of specialist financial subjects and skills.

Achievements
A key part of ICAEW's role is to encourage and promote informed debate on the future of the accountancy profession. Its thought leadership activity in areas such as tax, auditing, financial services and corporate reporting feeds directly into the public policy debate both in the UK and increasingly, internationally.

In 2010, ICAEW contributed to the debate on the future of audit through the Financial Services Faculty's work on the role of bank auditors. It also developed the first ever Code of Governance for Audit Firms for the Financial Reporting Council, which has since been adopted by all the major UK accountancy firms.

The three major political parties all drew inspiration from ICAEW's Going for Growth manifesto to develop their own policy proposals and manifestos in the run-up to the UK general election in May 2010. This saw a record number of chartered accountants elected to Parliament and three ICAEW members taking ministerial roles within HM Treasury.

ICAEW has continued to build on the work it does on behalf of the World Bank to encourage the profession in developing economies. It has launched a project with the Botswana Ministry of Finance and Development Planning and Botswana Institute of Accountants to strengthen the country's accountancy profession.

Through its financial capability initiative, ICAEW continues to encourage its members to work with schools and colleges to help deliver personal finance education. This initiative helps students develop the basic skills needed to manage their personal finances and it is now being extended to community groups.

Recent Developments
With the increased importance of high quality global accounting standards, ICAEW has launched several new IFRS products. IFRS continues to be adopted in markets around the world, challenging those who produce and use financial statements. ICAEW offers specialist online programmes and resources to help meet international financial reporting requirements in the private and public sectors.

In partnership with cebr (Centre for Economics and Business Research), ICAEW has undertaken research on the scale of the public sector deficit. This focuses on issues of financial management in the public sector, encompassing a campaign for greater transparency and accountability in the public finances.

As chartered accountants, ICAEW members are recognised as experts in their field. In response to the need to regulate expert witnesses engaged in providing evidence to the courts and investigations, it developed the Forensic Accountant and Expert Witness Accreditation Scheme.

Promotion
As a world leader of the accountancy and finance profession, the role of ICAEW is to raise the profile of chartered accountants and the professional reputation of its members. It engages in a full range of marketing and promotional activities through various channels, targeting key audiences around the world. To support the ICAEW brand positioning and ensure recognition and distinction in the marketplace, it launched a refreshed brand identity in January 2010.

In November 2010 ICAEW participated in the World Congress of Accountants in Malaysia. The congress, which only happens every four years, focused on the theme of 'sustaining value creation'. Key ICAEW experts led discussions and debate around topics such as: accountants in the next decade, developing a global profession, and fighting corruption and money laundering.

Brand Values
ICAEW believes in acting responsibly, in the best interests of its members and the general public. It acts with integrity, creating effective partnerships with organisations and communities worldwide to ensure the highest professional, technical and ethical standards.

Things you didn't know about ICAEW

ICAEW is the only international professional body to be invited to join the World Economic Forum in Davos.

It is a founding member of the Global Accounting Alliance (GAA), which represents more than 775,000 members worldwide.

The ICAEW Library and Information Service holds the largest collection of UK accountancy auditing and taxation resources in the world.

The quarterly ICAEW/Grant Thornton UK Business Confidence Monitor report is drawn upon as an accurate barometer of business thinking by the UK Government and the Bank of England.

Many of the founding fathers of the 'Big Four' accountancy firms were early presidents of ICAEW – such as Arthur Cooper, William Welch Deloitte, Edwin Waterhouse and Sir William Peat.

INVESTORS IN PEOPLE

Investors in People is a flexible framework that helps organisations transform their business performance and boosts the productivity of the UK economy. The framework is outcome focused, outlining what needs to be achieved, never prescribing how. Employers find Investors in People easy to use because the assessments are all interview-based; no paperwork or evidence gathering is required.

On 1st April 2010, the UK Commission for Employment and Skills became responsible for the strategic ownership of Investors in People. This move has strengthened Investors in People's position, placing it at the heart of the Commission's mission to improve employer ambition and to maximise UK competitiveness and individual opportunity.

Product

At the heart of Investors in People is The Standard, which has 39 outcome-based evidence requirements that encourage employers to 'plan, do and review'. This allows organisations to build up a complete picture of how they are managing their people and where they can make improvements. Organisations need to meet these 39 evidence requirements to be recognised as an Investor in People and to display the laurel logo and plaque.

Market

Born out of the recession of the early 1990s, Investors in People was launched by business, for business. Investors in People helps organisations manage change, become more efficient, maintain employee engagement and retain key talent – all important issues for employers coming out of a recession.

Since Investors in People started, thousands of UK employers have worked with its framework alongside expert advisors and assessors to enhance their performance and meet their goals. Currently over seven million employees in more than 28,000 organisations, based in 75 countries worldwide, are working with Investors in People. Of those, 4,700 have been recognised for 10 or more years.

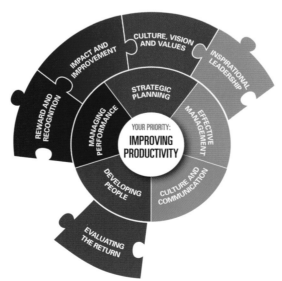

In May 2009, following extensive consultation with customers, Investors in People launched a new approach to working. The extended framework offers more choice, and a greater breadth and depth of expertise. This was introduced alongside a more tailored approach to delivering business support that centres on achieving each organisation's goals by listening to the organisation's priorities, applying the framework towards meeting objectives, and giving in-depth feedback on the issues that matter most.

The extended framework provides customers with more scope for continuous improvement and stretch. To celebrate progress, additional Bronze, Silver and Gold recognitions have been introduced to acknowledge additional

1990	1991	1993	1995	2001	2004
Investors in People is created when The Employment Department is tasked with developing a national standard that sets out a level of good practice for training and development to achieve business goals.	The first 28 Investor in People organisations – both large and small – are celebrated at the formal launch of Investors in People on 16th October.	Investors in People UK is formed as a business-led, non-departmental public body. The following year the first Investors in People Week launches.	The first review of The Standard is carried out and an operation is established in Australia.	A total of 5,939,825 employees are in organisations working with Investors in People.	Investors in People launches the latest version of The Standard, and the Champions programme is introduced.

achievement beyond The Standard. In excess of 700 organisations have achieved Bronze status, with more than 250 claiming Silver and over 200 reaching Gold. In November 2010, Sainsbury's became the biggest organisation globally to achieve Investors in People Gold.

Investors in People offers several free online support tools, including Interactive. This tool is built around five management practices that relate directly to the Investors in People framework. It is designed to guide organisations through development activities so that they can establish a clear understanding of their current strengths, and prioritise areas that require further focus.

Achievements

Recent independent research from the Cranfield School of Management has found empirical evidence that Investors in People underpins effective management. This includes enhancing the knowledge, experience and skills of managers; supporting the development of an organisational learning culture; improving the effectiveness of management development practice; and facilitating the creation of a high-performance environment.

The research shows that compared with non-accredited companies, those recognised by Investors in People have better managerial capabilities, which then trigger a chain of events leading to better financial performance and higher profitability – as shown in their published accounts. The findings are illustrated in the flow diagram below, reproduced from the Cranfield School of Management's report. Furthermore, it found that the more the companies embrace

the Investors in People framework, the better their performance will be (Source: 'Investors in People, Managerial Capabilities and Performance' Cranfield University School of Management January 2010).

Recent Developments

Investors in People introduced its Health and Wellbeing Award in March 2010. The award helps employers develop effective health and well-being strategies, ensuring that activity is linked to corporate objectives and the impact of interventions is evaluated. It helps build resilience and engagement with employees, enabling organisations to adapt and remain innovative in a continued climate of change.

A new benchmarking and good practice tool, Compare and Learn, is currently in development. It will allow employers to compare their performance against that of other Investors in People organisations, and will also provide benchmarks by size, sector and region. The UK Commission is piloting the tool with a view to launching it in the spring of 2011.

Promotion

Investors in People's marketing strategy focuses on the promotion and positioning of the brand as a business improvement tool. It thrives on word-of-mouth recommendation through trusted, respected sources like the Champions programme, which recognises the value of advocacy. Champions are organisations that disseminate and share best practice with employers of all sizes and sectors, engaging in additional promotional activity to extend understanding of Investors in People and its

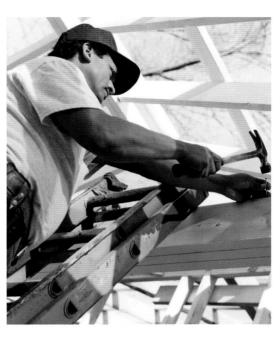

benefits. Currently more than 90 organisations have gained the prestigious status of Investors in People Champion.

Brand Values

Investors in People takes pride in offering an accessible, flexible and responsive service to customers, reflecting its promise to deliver real benefits to employers of all sizes and in all sectors throughout the UK. The brand defines itself as confident, credible and energising – values that are underpinned by research findings and reflected in customers' pride in achieving success with Investors in People.

These values are expressed in a new identity and revised logo that was launched alongside the extended Investors in People framework in May 2009. The brand's regional delivery partners have rebranded using the new logo to ensure a seamless identity throughout the delivery network.

Essentially, the Investors in People brand represents a promise; it is an expression of the positive performance improvement experience that everyone – customers, suppliers and its own people – expects and should receive.

Things you didn't know about Investors in People

Investors in People has introduced a new approach that can transform performance by targeting an organisation's specific business priorities.

Since 1991 over 40 per cent of the UK workforce – more than 10 million people – have worked in an organisation recognised by Investors in People.

Investors in People brings a wide range of benefits to organisations of all sizes. Any changes are always developed in consultation with customers so the framework remains universally relevant.

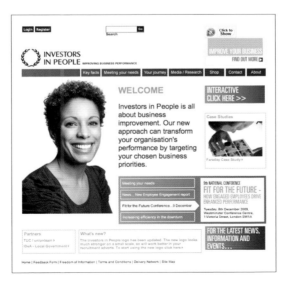

2007	2008	2009	2010
Investors in People Interactive, a free online support tool, is launched.	Some 7,771,357 employees are in organisations working with Investors in People.	Investors in People unveils an extended framework plus Bronze, Silver and Gold recognition for those who work beyond The Standard.	The Health and Wellbeing Good Practice Award is launched.

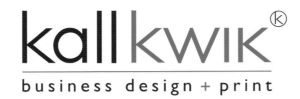

Already one of the leading forces in the UK design, print and copying market, Kall Kwik continues to add to the range of services offered by its UK-wide network of Centres and is rapidly gaining a reputation for creative design that makes business print even more effective. At the same time, the company has expanded into new markets including email communications and web-to-print.

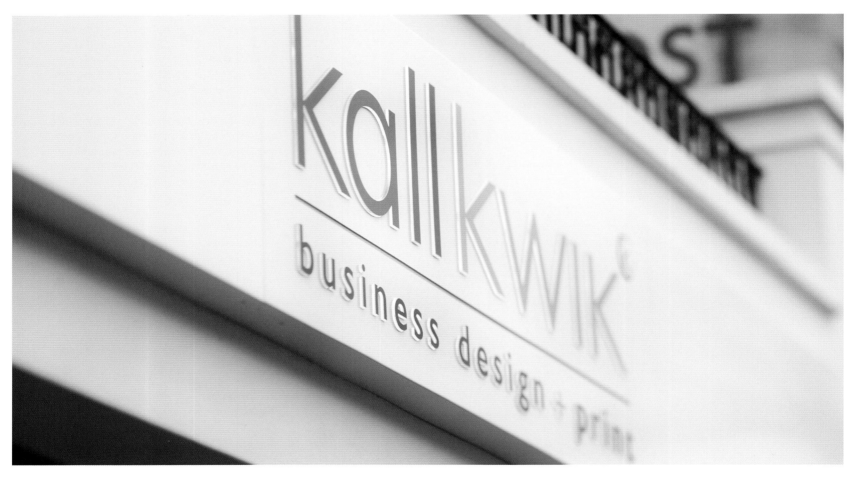

Market

With virtually every UK business requiring professional design, print or copying services, the total market exceeds £1 billion per annum. Kall Kwik is the UK's largest design and print group – with a seven per cent market share – and the company is proactively helping Centre Owners to expand into new market sectors.

Today, as businesses and public sector organisations seek to improve efficiency and focus on their core activities, there's a growing need for suppliers that offer a wider range of services, so that administrative burdens are eased and fewer suppliers need to be briefed for each project. While building on its strong position in the traditional print market, Kall Kwik is introducing non-print products that help

Centre Owners respond to customer demand for integrated communications services.

Product

For many design and print projects, 85 per cent of the total spend goes on creative design – leaving just 15 per cent for print. Therefore, by placing greater emphasis on selling design services, Kall Kwik is helping Centre Owners to

1978	1979	1999	2005	2008	2010
The company is founded by Moshe Gerstenhaber, who purchases the master franchise from the US Kwik Kopy organisation.	The first Kall Kwik opens in Pall Mall, London.	Kall Kwik UK is acquired by Adare Group, the leading provider of print, mailing and data management solutions throughout the UK and Ireland.	Kall Kwik UK is named Franchisor of the Year by the British Franchise Association. Kall Kwik also launches D2D and the first k design studio opens in Winchester.	Kall Kwik celebrates its 30th year of trading and the number of k design studios grows by 20 per cent.	Kall Kwik launches its web-to-print solution: Kall Kwik Studio.

business image operational print promotional print exhibitions and events

increase order values. In addition, as the choice of printer often lies in the hands of a project's designer, Kall Kwik Centre Owners that work with customers at the design level have greater ownership of the entire project. This design-led sales strategy is helping to position Kall Kwik as a trusted advisor in design and print; Centres are able to engage with customers from the outset of a project, contribute ideas on a consultative basis, and oversee every aspect from design through to print.

In line with market research, Kall Kwik has reorganised its business offering into client-focused categories around the business lifecycle. The new categories are: business image (encompassing logo creation, corporate identity and business stationery); operational print (such as invoices, statements and purchase orders); promotional print (including leaflets, brochures, flyers and posters); and

in design-related business was achieved through support programmes that helped Kall Kwik and kdesigngroup Centres to recruit and train skilled design personnel.

Recent Developments
Long established in printed direct mail services, Kall Kwik is now helping clients to execute email-based communications. The emphasis is on offering an integrated service with help at every stage – from sourcing targeted email address lists, to design, copywriting, email distribution and monitoring click-through rates.

Kall Kwik Studio is an innovative service whereby Kall Kwik offers clients an online ordering facility and works with them to create a portfolio of standard templates for a range of printed items. The online templates enable clients to offer their employees

Centre Owners. It selects only those candidates who have the necessary qualities to build a successful business and support Kall Kwik's reputation for consistently high customer service. Once a franchise agreement has been signed, the sales team oversees Kall Kwik's Marketing Launch Promotion (MLP) programme, which provides business and marketing support. Following the 12-month MLP programme, Kall Kwik Centre Owners continue to receive direct access to specialist marketing and business expertise in order to help generate demand and manage growth.

Brand Values
Brand image is vitally important – both in attracting new Centre Owners and promoting services to each franchise's customers. To Centre Owners, Kall Kwik represents an established, respected brand with a proven business model. For customers, Kall Kwik offers a convenient, local service that has access to nationwide resources.

creative printing clever thinking Ⓚ

exhibitions and events (comprising pop-up banners, displays and signage).

Quick to recognise the potential of new technologies, Kall Kwik continues to adopt the latest in digital print. Personalised print – whereby printed items include content that is personalised to individual recipients – is just one area in which Kall Kwik helps customers to ensure that items such as direct mail stand out from the crowd.

Achievements
Over the years, Kall Kwik has won many awards for its franchise model including the prestigious title of Franchisor of the Year from the British Franchise Association.

Kall Kwik has also accelerated the development of its design services offering. During 2008, Centre Owners undertook a record level of design and consultancy work and the number of Kall Kwik's specialist kdesigngroup Centres grew by 20 per cent. This growth

a self-service facility for the generation of new brochures, business cards or promotional materials. Logos and key design elements are fixed within the template, in order to ensure consistent layout and branding. The customised items can then be checked online before the final order is placed. Kall Kwik Studio helps to streamline the entire design, proofing and ordering process, which helps customers to reduce administration overheads, cut costs and eliminate errors.

Promotion
Kall Kwik has steadily increased the resources it devotes to generating sales leads for Centre Owners. While many new campaigns promote specific products and services, Kall Kwik's marketing team has used a range of techniques to help Centre Owners publicise their consultative approach to solving business communications issues.

The company has expanded its Franchise Sales Team, which works closely with potential

The company strives to ensure consistency across the franchise network. Each Kall Kwik Centre provides customers with access to an approachable team of design, print and communications experts, capable of contributing ideas to transform a concept into a finished product that achieves better results.

Things you didn't know about Kall Kwik

Across the group, Kall Kwik employs more graphic designers than any other UK private sector company.

Kall Kwik's corporate clients include Parcelforce Worldwide, Saks Hair & Beauty and Dulux Decorator Centres.

Kall Kwik has been recognised as a Business Superbrand for eight consecutive years.

LLOYD'S

Lloyd's is not an insurance company but a market of independent businesses where many of the world's most skilled and experienced underwriters come together to insure and reinsure risk. Business comes into Lloyd's from more than 200 countries and territories, and includes 96 per cent of FTSE 100 companies and 87 per cent of Dow Jones companies.

Market

Lloyd's has the capacity to underwrite a significant amount of business. Just under half of the business it writes is for UK listed and other corporate clients, but Lloyd's also underwrites significant amounts of business for the worldwide insurance industry and for private individuals.

The London insurance market is more than just Lloyd's alone. Of the world's 20 largest reinsurance groups, 18 have a physical presence in London. However, this is only part of the global picture. New competitor markets, such as Bermuda, are on the rise and there are other reinsurance markets in the US and Europe. All have to compete with alternative techniques for transferring risk, and deploying and redeploying capital, supported by an army of analysts and consultants.

Product

Like any market, Lloyd's brings together those with something to sell (underwriters, who provide insurance coverage) with those who want to buy (brokers, working on behalf of their clients who are seeking insurance).

Lloyd's is structured as a society of corporate and individual members, who underwrite insurance in syndicates. The make-up of Lloyd's underwriting membership has gone through a major change. Today most of the capital supporting underwriting in the Lloyd's market comes from corporate bodies, while private individuals – or 'Names', as they have become known – supply only 15 per cent of the market's capital backing. Lloyd's unique capital structure, often referred to as the 'chain of security', aims to provide excellent financial security to policyholders and capital efficiency to its members.

A member, or a group of members, forms a syndicate. A syndicate's underwriting is managed by a managing agent, who employs underwriters to accept or decline risk. There are around 80 syndicates operating within Lloyd's, covering many speciality areas that include marine, aviation, catastrophe, professional indemnity and motor.

Businesses from all over the world can come to Lloyd's to find insurance, often for highly complex risks. There are 180 firms of brokers working at Lloyd's, many of whom specialise in particular risk categories.

Lloyd's underwriters are renowned for devising tailored, innovative solutions to complex risks. As a result, Lloyd's covers the world's most demanding and specialist risks – from insuring oil rigs, man-made structures and major sporting events through to new areas such as cyber-liability and terrorism.

Achievements

Lloyd's has been around for more than three centuries, helping communities and businesses to survive major world crises from the San Francisco earthquake of 1906 to the terrorist attacks of 9/11. During that time,

1688	1871	1887	1904	1906	1998
Lloyd's coffee house is recognised as the place for obtaining marine insurance.	Lloyd's is incorporated by an Act of Parliament.	The first non-marine policies are underwritten at Lloyd's by Cuthbert Heath.	The first Lloyd's motor policy is issued, followed seven years later by the first aviation policy.	San Francisco earthquake claims are met by Lloyd's underwriters, establishing Lloyd's reputation in the US.	The Government announces independent regulation of Lloyd's by the Financial Services Authority, effective from midnight on 30th November 2001.

many aspects of Lloyd's have changed, but its priorities and values have remained consistent. This incredible history and reputation mean that Lloyd's is a truly famous global insurance brand.

It has earned this reputation through the expertise shown by its talented underwriters and the development of many pioneering and innovative insurance products. It's an offering that few can rival.

Key to Lloyd's dependable reputation is its financial solidity. Lloyd's strength and robust capitalisation is reflected in its ratings. Lloyd's currently holds A+ ratings from Fitch Ratings and Standard & Poor's, and an A rating from A.M. Best. These ratings apply to every policy issued by every syndicate at Lloyd's since 1993.

Recent Developments
After two years of exceptional hurricane activity in 2004/05, which saw the Asian Tsunami and Hurricane Katrina devastate major regions, 2006 was exceptional for very different reasons. A lack of catastrophe activity meant that Lloyd's produced a strong profit.

In 2007 Lloyd's received the formal licence document from the Chinese regulators for its new reinsurance company in Shanghai, which enables Lloyd's to underwrite onshore reinsurance business throughout China.

A series of initiatives then commenced in 2008, to continue to strengthen Lloyd's presence across emerging regions. New offices were set up in Ireland and Poland, and Lloyd's became the first reinsurer to be granted 'Admitted' status in Brazil, permitting the market to underwrite Brazilian reinsurance business. This trend continued into 2009 when Lloyd's secured an establishment licence in Portugal. Then in 2010, the China Insurance Regulatory Commission granted Lloyd's a licence to write direct insurance business in China.

Lloyd's has emerged relatively unscathed from the global financial crisis. Since the 1990s, Lloyd's has changed almost every aspect of its business, taking steps to improve the quality

of business and stringency of governance. In addition, Lloyd's has stuck to the traditional reinsurance and insurance products, and its businesses have always maintained a conservative investment strategy – meaning that any fallout from the crisis could largely be dealt with through its normal course of business. As a result, and due to a benign year in insurance, Lloyd's was able to post record profits in 2009.

Thanks to a combination of underwriting for profit rather than market share, the use of state-of-the-art modelling tools, and better availability and application of data, the flexibility, responsiveness, resilience and underlying financial strength of Lloyd's is greater than ever before.

Promotion
An important part of the promotion of Lloyd's is creating a high level of awareness of what Lloyd's is, how it works, what it stands for and what makes it different.

Over the past two years Lloyd's has launched two major campaigns to address key industry issues of Thought Leadership and Talent.

Lloyd's 360 Risk Insight brings together the views of the world's leading business, academic and insurance experts to analyse the latest material on emerging risk. The campaign is focused on driving the global risk agenda as it takes shape and providing organisations with practical advice and information to help them turn risk into opportunity.

The attraction, development and retention of talent are key issues facing the insurance industry today. In response to this, Lloyd's launched a graduate programme in 2008 and is promoting it through a range of media, including its website, brochures, print and online advertisements, recruitment fair attendance and direct mail.

Brand Values
The Lloyd's brand is a massive asset, not just for the market itself, but for all the businesses associated with it. It is recognised all over the world as a leading global market that is able and trusted to take on the world's toughest risks. It is a highly distinctive brand, known for its traditions, unique way of doing business and ability to meet highly specialised requirements.

The core brand idea for Lloyd's is encapsulated in the phrase: Constant Originality. 'Constant' conveys its good faith, security and reliability, while 'Originality' conveys Lloyd's creativity, individuality, authenticity and adaptability.

2002	2005	2007	2010
Lloyd's Members approve the proposals of the Chairman's Strategy Group outlining major changes that will transform Lloyd's into a modern, dynamic marketplace.	In the aftermath of Hurricane Katrina, Lloyd's emerges with only a small market loss and reinforces its commitment to help a devastated region rebuild.	Lloyd's opens an onshore operation in Shanghai. Two years later, Lloyd's secures an establishment licence in Portugal.	Lloyd's is granted a licence to write direct business in China.

Things you didn't know about Lloyd's of London

Lloyd's provides insurance for 84 per cent of the world's top banks and 83 per cent of the world's top airlines listed in the Fortune 500 companies.

Lloyd's paid out an insurance policy for Rolling Stones guitarist Keith Richards when he injured his finger while on tour in the 1990s.

Lloyd's offers hole-in-one insurance, which protects golf tournament organisers against the rare event of a player hitting the shot and claiming the large prize that has been offered for such an achievement.

Manchester United is the biggest and most valuable football club in the world. During its 130-year history its trophies have included 18 league titles, 11 FA Cups and three European Cups. Its 'beautiful game' of football is appreciated by 333 million fans globally. Under Sir Alex Ferguson's control it has enjoyed its most successful period as he has forged its reputation as a passionate and entertaining team of world-class footballers.

Market

Famed for its attacking football, Manchester United is the most popular club in the most popular sport in the world. It is a global iconic brand. Attracting the best international players as well as nurturing young, home-grown talent, the Club has a family of approximately 333 million fans globally.

As well as producing spectacle and entertainment in the football arena, Manchester United is a global business. In 2010 the Club's gross turnover was more than £286 million with a record group operating profit of £101 million EBITDA.

It has been ranked by Forbes as the world's most valuable team sports brand in 2008, 2009 and 2010.

Product

Playing 'the beautiful game in a beautiful way' is the core product of Manchester United. World-class footballers across its history have included Duncan Edwards, Bobby Charlton, Denis Law, George Best, Bryan Robson, Eric Cantona, David Beckham, Cristiano Ronaldo and Wayne Rooney – all playing the most exciting football of their time.

Manchester United attracts more than three billion TV viewers per season and its games are shown on 80 per cent of the world's televisions; the Club enjoys unrivalled exposure.

But there are other elements to the brand. Old Trafford has been voted the world's favourite stadium by fans of all clubs. Nicknamed the Theatre of Dreams, it has been the Club's home for more than 100 years. The stadium is the largest club ground in Britain; it was expanded in 2006 taking its capacity to 76,000 including executive boxes seating up to 8,000.

The Manchester United Museum collection comprises over 25,000 items of memorabilia and has had several million visitors through its doors.

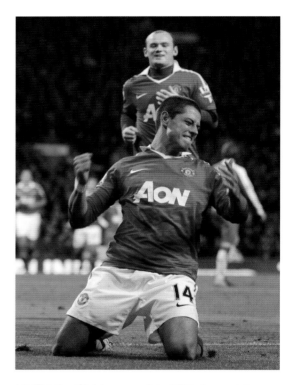

MUTV, the Club's own global TV channel, has been in operation for 11 years and broadcasts exclusive interviews with players and staff, matches, football news and other themed programming. On the web, manutd.com receives more than 15 million unique visitors every month, across 226 counties. It currently has almost seven million Facebook followers and a CRM database of more than 10 million.

The Manchester United Foundation was formed to celebrate 50 years of the Club playing in Europe. Its aim is to use the passion around the Club to educate, motivate and inspire young people to build better lives for

1878	1940s–50s	1968	1999	2008	2010
Newton Heath is set up by Victorian industrialists so their workers can benefit from some healthy exercise. It is renamed Manchester United in 1902.	In 1945 Matt Busby takes over as club manager. In 1958 the Club is devastated by the Munich Air Disaster in which eight of the Busby Babes lose their lives.	With a team including George Best, Denis Law and Bobby Charlton, United becomes the first English team to win the European Cup.	Manchester United succeeds in doing the 'treble': winning the Premier League, FA Cup and Champions League in one season.	After winning the UEFA Champions League for a third time, United goes on to be the first English team to win the FIFA Club World Cup.	Sir Alex Ferguson, the Club's most successful manager, becomes the longest serving manager in its history.

themselves and improve the communities in which they live. The Foundation offers football coaching, skills training and life-changing experiences for young people. The Club is also partnered with UNICEF.

Achievements

Few football clubs can match Manchester United's record. Its honours include 18 top division/Premier League titles, 11 FA Cups, three European Cup/UEFA Champions League titles, one European Cup Winners Cup, one UEFA Super Cup, one FIFA Club World Cup and four Football League Cups. The Club was the champion of the Premier League most recently in 2008/09.

Among the glory, however, the Club has faced dark days. In February 1958, United – riding high thanks to its outstanding young players dubbed the Busby Babes after its then manager, Matt Busby – was to suffer its most terrible moment in history. The aeroplane in which the team was travelling from Munich crashed during takeoff, killing 23 of the passengers including eight players and three staff. Yet, through determination, hard work and courage a new team was pieced together through emergency signings and reserve team players and once more the Club went on to greatness.

Recent Developments

As football has become big business, both in England and across the world, Manchester United has been at the forefront of building a global brand around the success of the football

club. It has extended the reach of the Club by ensuring that fans around the world have access to the Club and brand, even if they can't attend the live matches. Its mobile phone service reaches out to a customer base of 250 million subscribers.

In this globalisation of the brand, Manchester United's largest fan bases are in Asia (193 million), Africa (56 million) and Europe (53 million). Even in South America – replete with its own football heritage – it has 22 million fans. In North America, a continent more associated with baseball than football, Manchester United has nine million followers, and football is now the highest participation sport amongst young people.

Promotion

The single, core, iconic image by which Manchester United promotes itself is the Crest. The Crest is the focus of all its visual identity, and great effort is taken in protecting the mark.

To fans it represents the sum of all Manchester United's parts. It is the uniting symbol of all its activities both on and off the pitch. As well as the Crest, the colour red, as sported on its home shirts, is part of its brand and the team is affectionately known as the Red Devils. The Devil is one of its most famous icons, of which the Trident is used as a graphic extension – developed to give the visual identity an edge and dynamism unique to Manchester United.

Brand Values

Manchester United's brand values are about excellence, being progressive and successful. Its vision is to be the best football club in the world, both on and off the pitch.

Football is the world's number one sport and Manchester United the most popular club. It's the combination of on and off the pitch success, and the truly global reach of the brand that makes Manchester United a lucrative sponsorship platform for global partners including Aon, Nike, Audi, DHL, Epson and Hublot.

Things you didn't know about Manchester United

1957 saw United's first adventure into Europe, and a 10-0 victory over Anderlecht at Maine Road. The scoreline remains a club record in Europe.

Bobby Charlton remains the Club's record goal scorer, with 199 league goals in his career at United.

Old Trafford was severely damaged by bombs during World War II so United played all its home matches at Maine Road until the end of the 1948/49 season.

French legend Eric Cantona became the first foreign player to captain an FA Cup winning side when United defeated Liverpool 1-0 in the 1996 final, with Cantona scoring the winning goal.

Marshalls
Creating Better Landscapes

Marshalls is the UK's leading hard landscaping manufacturer and has supplied some of the most prestigious landmarks in the UK with hard landscaping solutions since the 1890s. Marshalls strives to improve environments for everyone by using its expertise to create integrated landscapes that promote well-being, from using Fairtrade stone and providing products that alleviate flood risks, to creating innovative anti-terrorist street furniture.

Market

Sustained growth has seen Marshalls expand to become the market leader in its sector. It supplies superior natural stone and innovative concrete hard landscaping products along with street furniture and water management solutions to the construction, home improvement and landscape markets. Its brand manifesto pledges a commitment to bring to life the visions of architects, contractors, town planners, landscapers, civil engineers, builders' merchants, paving installers and homeowners.

Product

Marshalls is committed to producing new products that better any existing market offering; to make them from the best materials it can source; and to care about the impact that the company and its products have on society. Investment in innovation continues to be a priority, both to launch new products and to develop a customer-focused marketing approach to the Group's product offer.

In the public sector and commercial end market, Marshalls satisfies the needs of a diverse customer base that spans local authorities, commercial architects, specifiers, contractors and house builders. Its integrated product ranges constantly evolve to meet the exacting standards and sustainable requirements of developments in areas such as public realm, education, homescapes and transport.

For the domestic market, Marshalls provides the inspiration and product ranges to create gardens and driveways that integrate seamlessly with people's lifestyles. A Marshalls garden or driveway is an affordable investment that adds real value to a property. The company's approved contractor scheme, the Marshalls Register, which continues to grow year-on-year, covers more than 1,000 landscapers and ensures high standards of construction and training, giving homeowners peace of mind – all backed further by the Marshalls Hard Landscape Guarantee.

Achievements

In 2010, Marshalls was honoured in the UK's leading awards for responsible business practice. After receiving a Big Tick at the Business in the Community Awards for Excellence, Marshalls went on to win the Example of Excellence award for Sustainable Marketing and Innovation.

Marshalls was also proud to receive another PLC Award in 2010, adding to its 2009 win. The Achievement in Sustainability Award recognises the significant accomplishments Marshalls has made in the areas of economic, environmental and social sustainability.

Following its acceptance into the United Nations Global Compact (UNGC) in 2009, Marshalls published its first Communication on Progress in April 2010. The UNGC is a framework for businesses that are committed to aligning their operations and strategies with the 10 universally accepted principles in the areas of human rights, labour, the environment and anti-corruption. In 2010 Marshalls was invited to attend the UNGC Leaders Summit in New York, joining the prestigious network of business leaders as a UK UNGC Network Champion.

Recent Developments

Marshalls has been working with independent think-tank, the New Economics Foundation (nef), to conduct research into both the application of well-being in the public realm and the way in which Marshalls' integrated product ranges can have a positive impact on individuals. The resulting 'Social Space: Impact Map' suggests stakeholders may experience

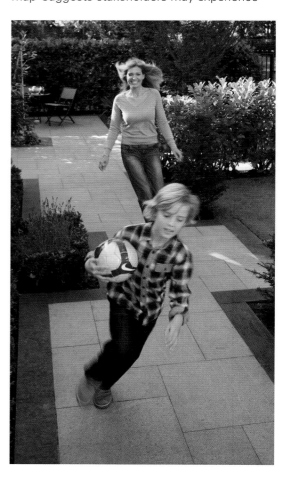

1890	1947	1955	1964	1972	1988
Solomon Marshall starts to quarry in Southowram, Halifax and in 1904 establishes S. Marshall & Sons Ltd in Halifax, West Yorkshire.	A second production site is opened at West Lane in Halifax producing lintels, steps and fence posts. The following year an engineering division is established.	The first wet cast product, Pennine Paving, is developed. This becomes another highly successful product for Marshalls.	Marshalls becomes a plc with shares quoted on the London Stock Exchange.	New product development sees the introduction of block paving and the famous 'Beany Block', which combines drain and kerb in one unit.	Brick manufacturer George Armitage & Sons is acquired and goes on to become Marshalls Clay Products.

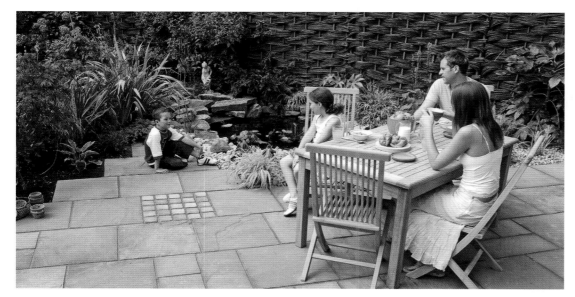

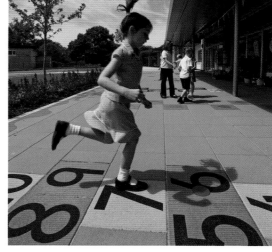

a number of different positive outcomes by utilising public spaces containing Marshalls products. These outcomes correspond to Local Government National Indicator (NI) and UK Sustainable Development Indicator (SDI) sets, which seek to maximise people's feelings of well-being through the use of products such as: street furniture to encourage social interaction; cycle stands and shelters to promote a healthier lifestyle; and street lighting to increase feelings of safety and security.

Carbon reduction is increasingly important for all businesses and having achieved certification under the Carbon Trust Standard during 2009, Marshalls is well prepared for the Government's Carbon Reduction Commitment scheme, introduced in April 2010. Marshalls has product carbon-labelled more than 2,000 of its products and is committed to reducing the carbon footprint of every labelled product.

As part of its ongoing commitment to the Ethical Trading Initiative Base Code, the Group has also pioneered the ethical sourcing of natural stone paving from India and China – and with a local partner, has established schools, health facilities and health insurance programmes in India. Marshalls' Fairstone product has recently been launched, combining the attributes of Fairtrade and ethical sourcing. Marshalls' ethical sourcing programme also incorporates regular independent supply chain audits.

Promotion

Marshalls' award-winning marketing team continues to produce groundbreaking and thought-provoking marketing campaigns that capture the imaginations of its target audiences. In 2010 'Marshalls Monopoly' was launched, with the slogan 'We've Paved the Monopoly Board' highlighting how Marshalls'

natural stone paving products have been used on some of the most famous streets in London.

Marshalls became one of the first British companies to introduce a free iPad app that gives users a digital toolkit to help them design their perfect outdoor garden space, bringing together Marshalls' landscaping expertise with inspiration for its customers' gardens.

Broadcast media has become a key focus to reach target audiences with Marshalls' latest product and Group news, and podcasts to

demonstrate product know-how and impart practical advice. Marshalls TV News, a 60-second roundup of news from across the Marshalls Group, provides a visual snapshot of current issues and new product developments. Marshalls also has a presence on a number of social media and networking sites including Twitter, YouTube and Flickr, and contributes to industry forums and blogs.

Brand Values

Marshalls believes that we all need places that make us feel safer, happier and more sociable; places to be ourselves, where we can live, play, create and grow. Its core brand values are based on trust, honesty and integrity.

Marshalls' vision is to be the supplier of choice to the landscape architect and contractor, and to the consumer for garden and driveway improvement projects. Customers are at the centre of its business and Marshalls ensures a high level of service, which it measures monthly against a range of values. Marshalls is committed to conducting its business to achieve sustainable growth, while incorporating and demonstrating a high degree of social responsibility with an experienced, qualified and flexible workforce.

Things you didn't know about Marshalls

Marshalls has paved all of the properties on the traditional Monopoly board.

In 2010, Marshalls supplied enough paving to cover 47 Wembley football pitches for the extension of Felixstowe Docks.

Marshalls was represented at the United Nations Global Compact Leaders Summit in New York. With more than 1,000 of the world's leading organisations in attendance, the summit was heralded as one of the most important UN business events ever held.

2000	2006	2009	2010
The range now includes street furniture and in 2004 Compton Group is acquired, opening up the portable buildings and greenhouses markets to Marshalls.	Marshalls agrees to sponsor the prestigious RHS Chelsea Flower Show for three years, raising the company's profile.	More than 2,000 of Marshalls' commercial products now have a Carbon Trust Carbon Reduction Label.	Marshalls launches its first iPad app and is further recognised by the Wildlife Trust for its biodiversity management.

Mercedes-Benz

The founding fathers of today's Daimler AG and its globally successful Mercedes-Benz core brand laid the foundation for all present-day passenger cars, commercial vehicles and buses. The company that invented the modern day motor car has since gone on to shape its development more diversely and enduringly than any other manufacturer – in all relevant areas, from drive technology to comfort and safety through to design.

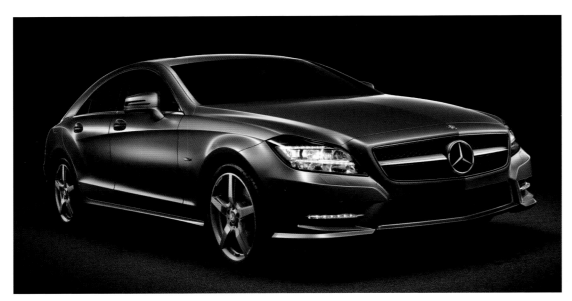

The two-seater concept vehicle was the starting point of a twin-track development that gave rise in the 1990s to the company's first compact car, the A-Class and the smart city coupé, the predecessor of today's smart fortwo.

Mercedes-Benz has some 19,000 researchers and developers around the world, a bank of knowledge that has led to a plethora of technical innovations and firsts – proof that the brand has consistently played a leading role in all key aspects of the further development of the motor vehicle market.

Achievements

Innovation is the key to success for car manufacturers and Mercedes-Benz, as the inventor of the modern motor car, has led the way. Indeed, the company has repeatedly underpinned its claim to technological leadership with more than 80,000 patent applications since 1886.

Building on this wealth of experience, Mercedes-Benz has introduced a series of

Market

Thanks to its systematic innovation strategy, Mercedes-Benz occupies a leading position in the league table of the world's most valuable brands. This is backed up by the latest 2010 international studies, which confirm the position held by the brand in no fewer than three categories: most valuable German brand, most valuable global premium car brand and most valuable global luxury brand.

Mercedes-Benz has been at the forefront of new concepts, opening up entirely new market segments. For example, the SLK, unveiled in 1996, was the first compact premium roadster, followed one year later by the M-Class, the first premium sport utility vehicle (SUV). The most recent example is the CLS, which in 2004 established the segment of the four-door coupé.

Product

On 29th January 1886 Carl Benz filed an application in Berlin for a patent on a three-wheeled motor vehicle. Since then, that date has been regarded as the official birthday of the motor car, now in its 125th anniversary year.

Today the brand encompasses a range of vehicles that includes compact passenger cars such as the A-Class; luxury saloons, for example the S-Class; vans, such as the Sprinter; buses, including the Citaro; and heavy-duty trucks, such as the Actros.

Under the smart brand, the portfolio is bolstered by the smart fortwo, a vehicle designed to be an ideal 'city runabout'. Its origins can be traced back to the 1980s when Mercedes-Benz conducted a study into a 'short-distance transport vehicle'.

1886	1926	1955	1959	1975	1994
Carl Benz files an application in Berlin for a patent on a three-wheeled motor vehicle.	Rival companies Daimler-Motoren-Gesellschaft and Benz & Cie. merge to create Daimler-Benz AG.	Driving a Mercedes-Benz 300 SLR racing car, British driver Stirling Moss completes the 1,000-mile Mille Miglia race in record time: 10 hours, seven minutes and 48 seconds.	Mercedes-Benz pioneers the concept of the passenger safety cell – a rigid structure designed to protect a vehicle's occupants in the event of a collision.	The company builds its one-millionth automatic gearbox.	The company's first hydrogen fuel cell prototype is unveiled.

modern vehicles with alternative drives that point the way to emission-free mobility. These include the S 350 BlueTEC luxury saloon, unveiled in 2006, featuring the world's cleanest diesel technology. Harmful NOx emissions are reduced by some 90 per cent. BlueTEC also features widely on Mercedes-Benz trucks.

Soon after, Mercedes-Benz brought out three state-of-the-art electric vehicles in rapid succession: the A-Class E-CELL car and the Vito E-CELL van, both with battery-electric drive, and the fuel-cell-powered B-Class F-CELL. The brand's line-up of electric cars is completed by the smart fortwo electric drive, which has been heralded as a revolutionary new development in urban mobility with zero local emissions.

Recent Developments
The future potential of the internal-combustion engine was strengthened by Mercedes-Benz in 2010 with the launch of the S 250 CDI BlueEFFICIENCY, the first 5L car in the luxury class. The engine achieves a fuel consumption of just 5.7L/100km in the New European Driving Cycle, a cycle that is designed to

represent the typical use of a car in Europe. With CO_2 emissions of 149g/km, the S 250 CDI BlueEFFICIENCY is the first vehicle in its class to better the 150g mark.

Also in 2010, a new BlueDIRECT generation of six- and eight-cylinder power units were launched in the S-Class, CL-Class and the CLS. Each of the engines offers increased power and torque in comparison with its predecessor, as well as increased fuel efficiency; in the new CLS, for example, fuel consumption has been lowered by up to 25 per cent. In terms of fuel efficiency, the modern BlueDIRECT direct injection petrol engines have thus moved a further step closer to their diesel counterparts. The increase in efficiency is due in part to a series of targeted measures, particularly the ECO start/stop function; already standard in many models, it is being rolled out across the entire Mercedes-Benz product range during 2011.

Promotion
Mercedes-Benz pursues a long-term design strategy with the aim of ensuring that a Mercedes is instantly recognisable. Its designers seek to emphasise the rich heritage of the company's car models by combining

proven stylistic elements of the brand with new ideas, continuously evolving the design and therefore carrying the brand identity through to the present day.

Such model-specific characteristics include the fins and lateral ventilation openings of the SL and the curving lines of the E-Class family – both of which date back to the 1950s, but are reinterpreted with a contemporary look in current models. In this way, Mercedes-Benz steers clear of fashionable, often short-lived retro trends. The outcome is a blend of visual distinctiveness and unmistakable brand identity, the Mercedes-Benz design idiom remaining clear in every detail: modern, but never 'trendy'.

Brand Values
It was Carl Benz who said, 'The love of inventing never dies', and Gottlieb Daimler who came up with the famous maxim: 'The best or nothing.' Mercedes-Benz has remained true to these guiding principles for 125 years. The spirit of innovation, one of its key driving forces, is firmly rooted in its corporate culture – along with the goal of guaranteeing mobility for future generations and providing individual customers with the optimal vehicle for their needs.

2005	2008	2010	2011
The S-Class luxury saloon pioneers with infrared night vision technology.	Attention Assist is fitted to the first Mercedes-Benz; using some 70 parameters to monitor alertness, the system warns the driver to take a break if it detects drowsiness.	The SLS AMG Gullwing is launched. Designed entirely by the Mercedes-Benz high performance division, it debuts as the official Formula 1 safety car.	Mercedes-Benz celebrates 125 years of innovation with the introduction of a new range of cars, including a new CLS four-door coupé and an SLK Roadster.

Things you didn't know about Mercedes-Benz

While Carl Benz invented the first motor car, Gottlieb Daimler invented the first motorcycle (1885), motor boat (1887) and truck (1896).

The company's three-pointed star logo represents transport on the land, in the air and on water. It is surrounded by a laurel wreath, symbolising its victories in motor racing.

The name 'Mercedes' originates from 1901 when a wealthy diplomat, Emil Jellinek, ordered dozens of cars from Gottlieb Daimler. Jellinek requested the cars be named after his daughter – Mercédès, meaning 'grace'.

Mercedes-Benz pioneered the use of safety systems that are commonplace today, including the passenger safety cell (in 1959); electronic stability programme (ESP®, 1995); and Attention Assist drowsiness detector (2009).

Microsoft®

Founded in 1975, Microsoft is the worldwide leader in software, services and solutions that help people and businesses realise their full potential. It has long been at the forefront of the personal computing revolution and its products power more than 90 per cent of the world's PCs, transforming business and communications in recent decades.

Market

Microsoft is the worldwide leader in software, services and solutions and generates revenue by developing, manufacturing, licensing and supporting a broad range of software products for computing devices. Its products include PC operating systems, cloud computing services, servers and mobile devices, productivity applications, music and gaming services, software development tools, and hardware including Xbox 360 and computer accessories.

The company runs four operation centres globally in Ireland, Singapore and the US and has subsidiaries in more than 100 countries around the world. It employs over 80,000 people, and net revenue for the year ending June 2010 was US$62.48 billion.

Product

Microsoft's products are managed across five major divisions: Windows and Windows Live, Server and Tools, Consumer and Online, Business, and Entertainment and Devices.

Microsoft continually develops products and services that shape the future of the fast-changing markets in which it operates. Recent high profile launches include Windows 7, which delivers on a simple premise: make it easier for people to do the things they want on a PC.

Microsoft also recently launched Bing, a decision engine designed to help internet users make faster and more informed decisions. It aims to offer a new approach to surfing with intuitive tools to help people gain better insight and knowledge from the web.

In 2010, Microsoft launched Windows Phone 7, a new category of consumer mobile devices designed to simplify and speed up everyday tasks. The phones feature tight integration with popular social networking sites, Bing search and Microsoft Office applications.

In the online arena Microsoft offers an advertising platform for publishers and advertisers as well as communication services such as email, instant messaging and MSN. The Xbox 360 video game system is at the heart of its entertainment and devices division and was recently enhanced with the launch of Kinect, the world's first controller-free gaming and entertainment experience.

Cloud computing has recently become a hot topic for business IT, yet Microsoft has been running some of the largest, most reliable cloud services for almost 15 years. Sites such as MSN.com, Windows Live Hotmail and Windows Live Messenger are used by more than 600 million users worldwide every month, across 46 countries and in 21 languages.

Achievements

Microsoft regularly receives awards around the world not only for its products but also for the way in which it does business and acts as

1975	1981	1989	1990	1995	2001
Microsoft is founded in Seattle by Paul Allen and Bill Gates.	IBM introduces its personal computer with Microsoft's 16-bit operating system, MS-DOS 1.0.	Microsoft launches the first version of its Office suite of productivity applications.	Microsoft launches Windows 3.0 and becomes the first personal computer software company to exceed US$1 billion in sales in a year.	Bill Gates outlines the company's commitment to supporting and enhancing the internet. Windows 95 launches and sells more than one million copies in its first four days on the market.	Office XP launches and is soon followed by Windows XP. Microsoft enters the gaming market for the first time with Xbox.

a responsible corporate citizen. In the UK, it is consistently named one of The Sunday Times 100 Best Companies to Work For.

Microsoft has nearly 700,000 business partners, many of which are small and medium sized enterprises that are deeply rooted in their local communities. It also partners with a diverse collection of government agencies as well as inter-governmental and non-governmental organisations (NGOs). These partners guide how technology should be used to address societal needs and help deploy software to benefit the millions of people they serve.

Recent Developments

Recognising that leading businesses need to do all they can to help people during the economic downturn, Microsoft UK launched its flagship employment and skills campaign, Britain Works, in September 2009. Britain Works is a multi-year plan aimed at addressing one of the biggest challenges in the economy: unemployment. Over a three-year period, through a series of partnerships with NGOs, community learning centres and public authorities, Microsoft UK is aiming to help 500,000 people into jobs in the areas of the economy that will lead the recovery. Many people will regain employment thanks to newly acquired computer skills and will work across a range of industries from manufacturing to services and the IT industry itself.

With more than 77 per cent of all jobs in the UK requiring some form of IT skills, Microsoft believes that it has a role as a responsible business leader to provide access to vital IT skills that could improve the employability of UK citizens.

Promotion

In 2011, Microsoft launched Cloud Power, a marketing campaign to raise awareness of new possibilities when customers use Microsoft software and services to harness the power of

the cloud. Windows Azure helps developers reduce the time needed to create and deliver business applications, while employees will

be able to access applications and information from anywhere with Microsoft Office 365. Microsoft believes that Cloud Power allows businesses to harness the full power of the cloud on their terms, with the flexibility to consume as much or as little IT as is needed to meet their unique business requirements.

Brand Values

Microsoft aims to provide consumers and businesses around the world with the tools to fulfil their potential. By playing an active role in developing a safer computer environment, Microsoft helps people benefit from advances in technology. It is focused on ease-of-use and quality improvements and works with government, law enforcement and industry partners to enable them to benefit from technological developments.

In the wider community, it is focused on raising awareness around security and child safety online through campaigns such as Get Safe Online, as well as making an active contribution to the public policy debate.

Things you didn't know about Microsoft

Microsoft works out of 629 office buildings around the world, which occupy more than 32 million sq ft of floor space.

Bill Gates moved from his day-to-day role in Microsoft in June 2008 to concentrate on his work at The Bill & Melinda Gates Foundation.

Over the past 30 years, Microsoft and its employees have donated more than US$2.5 billion to communities around the world.

2008	2009	2010	2011
Bill Gates steps down from the day-to-day running of the company to spend more time working with his charity foundation.	The Windows 7 operating system is launched.	Microsoft releases Windows Phone 7 and Microsoft Office 2010. Xbox Kinect becomes the world's fastest-adopted consumer electronics device, selling 2.5 million units in its first 25 days on the market.	Microsoft unveils Cloud Power and transitions its entire business product suite to high-productivity cloud-based services.

Nationwide

Proud to be different

Nationwide is more than 160 years old and is now the world's largest building society. Unlike its bank competitors it has no shareholders so its only focus is its 14 million members. This 'Proud to be different' approach has helped it to become the UK's third largest mortgage and savings provider with a quarter of UK households having a relationship with the society.

Market

The financial services market is well served by a number of players. Distinguished from its banking competitors, Barclays, Lloyds TSB, Santander, HSBC, NatWest and Halifax, Nationwide is a mutual society – so owned by, and run for, the benefit of its members (i.e. customers). With no external shareholders to pay dividends to, profits are reinvested for the benefit of its members. It is also the largest building society globally, and it is this unique position that enables it to focus on better serving its customers.

Nationwide has a 10.2 per cent share of the savings market, seven per cent of the main current account market, an 8.5 per cent share of the mortgages sector, and more than 14 million members in the UK. In recent years it has grown substantially through its amalgamation with a number of other mutual societies across the UK.

Product

Nationwide builds every product with its brand values of putting members first in mind; creating and sustaining rewarding relationships with members enables it to understand what members want and adapt its

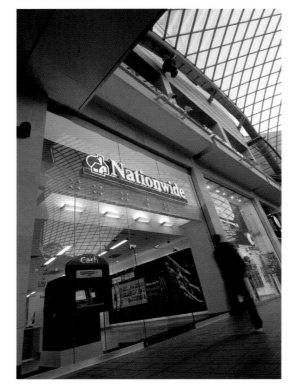

products accordingly. While its core market is mortgages and savings, Nationwide also offers a comprehensive range of additional products that includes a current account, credit cards, investments, general insurance – in the form of home, car, travel, life and lifestyle – and personal loans.

Nationwide consistently wins awards both for its core products such as mortgages – securing the accolade for Best Discount Mortgage Product at the What Mortgage Awards 2010 – and in other growing key sectors such as fraud prevention, for which it won Best Use of IT in Retail Banking at the Banking Technology Awards 2009.

Nationwide strives to ensure that customers can access its products and services in a variety of flexible and convenient ways that can be tailored to suit individual requirements. For instance, it was the first UK financial service provider to launch an internet bank; it now carries out 16.4 million internet banking transactions every month, allowing customers to manage their accounts and buy products online.

Achievements

Nationwide has established itself as a 'people's champion'. It has campaigned successfully for the use of cash machines to be free for consumers, and adopted a 'positive order of payments' for its credit card products

1846	1848	1884	1967	1970	1987
Provident Union Building Society is founded in Ramsbury, Wiltshire.	Northampton Town and County Freehold Land Society is founded.	The Southern Co-operative Permanent Building Society opens.	Northampton Town and County merges with Leicestershire Building Society to form Anglia Building Society.	The Co-operative Permanent Building Society changes its name to Nationwide Building Society.	FlexAccount is launched: the first full service current account to pay interest. In the same year, Nationwide merges with Anglia to become Nationwide Anglia.

many years before the practice was made the industry standard.

Nationwide has a dedicated team that organises its corporate social responsibility (CSR) activities based on real social, economic and environmental issues. It works closely with leading housing charity, Shelter, and in 2008/09 provided £100 million of funding for affordable housing.

During 2009/10 Nationwide introduced energy management controls at 30 of its branches, generating a 16 per cent reduction in energy use as well as cost savings. The scheme is being extended to an additional 180 branches. Nationwide also donates obsolete stock of corporate clothing to Dress for Success, a charity that helps women who have suffered domestic violence to get back into the work place.

Recent Developments
Nationwide creates products based on what consumers need and really want. A recent example is the Champion Saver, which tracks an average rate offered from the top five accounts from a basket of eight high street competitors and adds an additional bonus. Meanwhile, August 2010 saw the launch of Flexclusives, which offers main current account holders loyalty rewards such as free travel insurance.

Nationwide also recently introduced its Savings Promises, highlighting the way a mutual organisation works to benefit its members.

Promotion
Nationwide communicates through a range of press, digital, direct marketing, television, radio and outdoor media. In response to the

economic downturn it launched a campaign underpinning three of its core values: solid, stable and dependable. The campaign won Most Topical Campaign 2009 at The Awards for National Newspaper Advertising as well as two Money Marketing Awards, for Best Press and Best Outdoor in 2010.

With its strapline, 'Proud to be different', Nationwide's Bank Manager campaign (featuring Mark Benton) set itself apart from an often lack-lustre financial promotions market, helping the brand to compete effectively against the 'Big Banks'. The campaign idea – first aired on radio before being rolled out on television and in print in 2004 – dramatised Nationwide's 'difference' in an instantly engaging way. The consumer response to the campaign was strong, with levels of persuasion amongst the highest tracked in the market (Source: Hall and Partners).

Nationwide more recently launched a campaign featuring characters from the comedy sketch show, Little Britain. The campaign, also starring real Nationwide employees, focused on its no shareholders structure while simultaneously publicising some key products such as the Champion Saver.

Brand Values
The Nationwide brand is built around its strapline of 'Proud to be different' reinforcing that, unlike its main 'Big Bank' competitors, it has no shareholders to answer to. Nationwide aims to put members first, providing opportunities to create and sustain

rewarding relationships with them through its product range, services, member involvement, CSR activities and its commitment to acting responsibly.

These relationships are delivered and sustained internally and externally with PRIDE, Nationwide's set of shared values and behavioural principles that are embedded in its culture: Putting members first; Rewarding relationships; Inspiring trust; Delivering great service; Exceeding expectations. The brand promise ensures that members are put first in everything Nationwide does, underlining the company's fundamental difference from its key competitors.

Things you didn't know about Nationwide

In 1987 Nationwide's FlexAccount was the first current account to offer telephone banking.

Nationwide's asset size is bigger than that of all of the other building societies put together (December 2010).

Nationwide is the amalgamation of 73 businesses that have merged since its origin in 1846.

In 2010 – and for the fifth consecutive year – Nationwide's FlexAccount achieved a five-star rating from Defaqto, the independent financial research company, for its product features, benefits and costs.

None of Nationwide's corporate clothing goes to land fill; it is all recycled or reused.

Honest. Open. Trustworthy.
Your choice of words, not ours.

More trusted than any other bank or building society.

Proud to be a building society

Source: Hall & Partners November 2008, Mintel September 2008

1991	2007	2008	2010
The brand's name is shortened to Nationwide and a new logo is launched to reflect the change.	Nationwide merges with the Portman Building Society.	Nationwide merges with Derbyshire and Cheshire Building Societies, and acquires the Dunfermline Building Society the following year.	A new advertising campaign featuring Little Britain characters is launched.

Cybercrime has surpassed illegal drug trafficking as a criminal money-maker. More than six in 10 people have fallen victim. Today's cybercriminals are opportunistic and prolific, and consumers need the very best protection to stay safe online. As the security software ranked number one in online threat detection and performance, Norton is keeping more people safe from more online threats.

Market

Information is the lifeblood of today's connected world, playing a crucial role in personal lives and businesses. Each year, the amount of information created increases exponentially, and securing and managing this information-driven world becomes even more important and challenging.

Cybercrime has become a silent global digital epidemic, instilling feelings of powerlessness and a lack of justice in its victims worldwide. The alarming extent is uncovered within Norton's annual Cybercrime Report, which reveals that nearly two-thirds of adults globally have been a victim of some kind of cybercrime. It also highlights the need for better awareness and education for all internet users (Source: 'Norton Cybercrime Report: The Human Impact' 2010).

The internet security software market is mature and highly competitive. The market includes a host of established 'paid' solution providers with new players frequently entering the sector. With an established infrastructure, Norton by Symantec is a company that is able to grow and change quickly, adapting to its consumers' needs in order to remain competitive at all times.

Symantec is the fourth largest independent software company globally, with over 19,000 employees in more than 40 countries. In 2010 it ranked 419th in the Fortune 500 and achieved revenues of US$6.2 billion, US$1.8 billion of which derived from its Norton business.

Product

Norton's award-winning consumer products for individual users, home offices and small businesses focus on delivering online protection for its customers, their systems and the things they value most – photos, documents, videos and music – without compromising system performance. The

1990	1995	1997	1998	1999	2005
Symantec acquires Peter Norton Computing and becomes one of the 10 largest software companies in the world.	Norton AntiVirus, Norton Utilities and Norton Navigator are released alongside the launch of Windows 95. Symantec also executes its largest ever global marketing campaign: DAY1.	Symantecstore.com is launched, selling full versions of the software products online.	Norton SystemWorks – the industry's first integrated suite of utilities and antivirus products – is released, as is Norton 2000: an effective Year 2000 solution.	Norton Internet Security is released – Symantec's first product to offer a comprehensive and fully integrated internet security and online privacy solution.	Symantec is named one of Fortune's Best Places to Work and is ranked 65th in its Fastest-Growing Companies list.

Norton brand of products and services range from internet security and backup and recovery solutions to PC tune-up and PC Help – a service that assists its users to resolve their computer problems and allows them to get the most out of their PC.

Norton is constantly defining and redefining online security. Considering the true value of the information stored on digital devices, 'good enough' basic security is not good enough. Norton therefore strives to raise the bar with each and every product it makes, innovating new technologies to constantly keep ahead of cybercriminal threats and keep its customers safe.

- Computeractive
- Buy It! Award
- Norton 360 v4.0
- May 2010

- PC Pro
- Recommended Award
- Norton Internet Security 2011
- December 2010

Achievements

Over the years Norton's products have been consistently recognised by industry awards, standing as evidence of the company's strength in the market. Its 2010 range of products alone received more than 300 accolades, while the brand's 2010 'Cybercrime is Real Crime' marketing campaign won more than 35 awards.

Recent Developments

Following its launch in early 2011, the Cybercrime Index (CCI) is on its way to becoming a top online source of information on cybercrime for consumers and media. Based on a host of Symantec and third-party data sources, the CCI measures consumer risk online and provides daily detailed information about how people can protect themselves. The CCI can be viewed on or downloaded from a PC or mobile device.

Promotion

The Norton brand story and associated global brand marketing campaign is: 'Cybercrime is Real Crime and it is happening to all of us.' Launched in 2009, it remains the company's umbrella campaign and aims to educate the public about the far-reaching extent and implications of cybercrime, and to stimulate them to take action to protect themselves online by choosing Norton.

Norton's research shows that the prevalence of cybercrime has reached unacceptable proportions around the world, and despite 65 per cent of online adults experiencing the disruption and invasion caused by cybercrime, many people do not associate the term 'victim' with their negative online experiences (Source: 'Norton Cybercrime Report: The Human Impact' 2010). Norton seeks to remind people that they should. The campaign shows how real and personal cybercrime has become; it seeks to incite outrage among the public and to stimulate them to take action to prevent falling victim. Alongside this, the campaign shows what Norton is doing to help people combat the problem and emphasises that choosing the right security software is the most fundamental step in ensuring protection online.

Norton's brand story aims to empower people with a choice: it inspires consumers to act, lets them know that Norton is on their side and gives them the power to deny more digital dangers than ever before. These cybercrime messages are delivered using a multichannel approach through online, retail campaigns, partner programmes, public relations and social media.

Brand Values

In line with its market, Norton by Symantec is constantly growing and evolving. At all times, however, the brand remains true to its values, which are the ultimate foundation of its success today and in the future: innovation, action, customer-driven and trust.

Things you didn't know about Norton

Norton currently has more than 120 million active users.

Norton provides solutions beyond the PC including a range of products to protect mobile devices.

Norton's parent company Symantec has more than 1,000 technology patents.

Symantec is the fourth largest independent software company in the world.

Symantec is currently ranked 419th in the Fortune 500 with US$6.2 billion in revenue, of which US$1.8 billion derives from the Norton consumer business.

2006	2007	2009	2010
Symantec's consumer business reaches a key milestone, selling its 200 millionth Norton product.	Norton 360 launches and earns the prestigious CNET Editors' Choice Award as a top product in its technology category.	Norton launches its global brand marketing campaign: 'Cybercrime is Real Crime and it is happening to all of us.'	The new 'Norton by Symantec' logo is launched.

A modern four-star hotel brand, Novotel has been responding to the needs of business and leisure travellers for more than 40 years with a new concept in contemporary hotel experiences. From the beginning, Novotel hotels were conceived as places of relaxation; today the network comprises almost 71,900 rooms and more than 400 hotels set in the heart of 60 countries across the globe.

Market

In 1967 Novotel launched the very first standardised hotel, revolutionising the hotel industry. As the upper mid scale hotel brand within the Accor group, Novotel remains at the forefront of an intensely competitive marketplace with ever evolving brands.

Product

Consistency is the cornerstone of the Novotel brand, with guests having the assurance of high standards of service, wherever they are in the world: attentive staff and a modern living space bedroom that is designed to be comfortable for both work and relaxation. A variety of restaurant solutions are also on offer, providing a choice of balanced cuisine 24/7, as well as innovative concepts such as the 'Web Corner on Mac', Digital Art and the Eureka meeting room.

As a specialist in business meetings, Novotel provides customised facilities for small and medium sized meetings through its Meeting@Novotel concept. All hotels have meeting facilities and there are more than 2,800 meeting rooms around the world.

Novotel gives special consideration to families through its Family&Novotel concept, which includes free accommodation and breakfast offers for children, room reductions, welcome gifts, baby equipment, play areas and healthy children's menus.

In addition, the hotels provide relaxation and leisure areas designed to help guests relax and re-energise. The health and fitness concept, InBalance by Novotel, encompasses wellness and recreational leisure areas such as a swimming pool, sauna, steam room and gym facilities.

Novotel rewards its guests via A|Club, the unique loyalty scheme from Accor. Members earn points at more than 2,000 hotels worldwide and redeem them for reward vouchers or airline miles.

Achievements

Novotel is a pioneer in sustainable development and all hotels participate in the Green Globe programme. A worldwide environmental and social certification programme, Green Globe recognises the most responsible tourism products and services.

For 2005/06 Novotel was named AA Hotel Group of the Year, a prestigious award in recognition of its track record of striving to ensure the very best levels of service, food and accommodation across its hotels.

Novotel also won Business Hotel Chain of the Year at the 2007 TTG Travel Awards, with judges highlighting the chain's innovative offering, its good value and its restaurant facilities in particular.

Recent Developments

Novotel is continuing its expansion into the world's major destinations with openings in 2010 including Barcelona, Buenos Aires, Lima, Rio de Janeiro and Sydney.

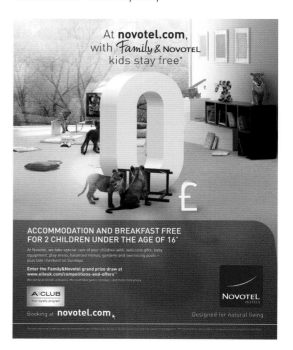

1967	1972	1977	1978	1982–92	2000
The Novotel brand is born, with the opening of the first hotel in Lille Lesquin, France.	The first Novotel hotels outside France open: Neufchâtel in Switzerland and Brussels in Belgium.	Novotel expands to South America, with the opening of Novotel Sao Paulo Morumbi in Brazil.	The 100th Novotel opens, in Amsterdam. Novotel reaches 120 hotels by the end of the year. The following year Novotel opens in the Middle East.	Novotel opens hotels in Asia (Singapore), North America (Toronto, Canada), China (Beijing), Australia (Sydney) and Russia (Moscow). By 1997 it has 320 hotels in 53 countries.	Novotel creates its dedicated meeting concept: Meeting@ Novotel. It is gradually implemented throughout the whole of the Novotel network.

The online NovotelStore (novotelstore.com), meanwhile, enables guests to bring the Novotel experience into their own homes by purchasing furniture and accessories used within the hotels.

Further development of Meeting@Novotel includes the introduction of Eureka – an all-inclusive meeting concept designed to inspire interaction and creativity. Other brand developments include the use of new design and technology innovations in bedrooms. The 'Next bedroom' uses technology to enable guests to tailor the space to their needs; for example, a glass wall between the bedroom and bathroom can be made transparent or frosted at the touch of a button.

Novotel not only invests in its product development, but also in its people. A global HR programme has therefore been developed to ensure staff are trained to deliver the best service, with a belief that happy staff mean happy customers.

For more than 10 years Novotel has been involved in a long-term venture to facilitate access to contemporary art and to support young artists. In 2009, Novotel built on this project and acquired original digital works from the Movingdesign studio.

More recently, the brand has launched Suite Novotel hotel, composed exclusively of suites. Designed as real living quarters, the spaces can be arranged to suit guests' needs.

2010 saw Suite Novotel open properties in Perpignan, Luxembourg and Malaga. All suites are equipped with the Suite Box, enabling guests to surf the net with high-speed access and make unlimited phone calls (to national landlines), as well as providing a choice of free entertainment options including videos and music. The Suite Novotel concept also offers a well-being space and a 24-hour fitness room, while guests staying for more than four days are provided with free use of a Smart car.

Promotion

Novotel's 'Designed for Natural Living' campaign has helped elevate the awareness and perception of the brand among leisure and business consumers. The campaign saw the brand communicate with its customers on an emotional level, not only emphasising its style and design but also targeting the issues at the very heart of a guest's hotel experience: comfort and well-being.

Launched across television and cinema, using atmospheric photographs of animals within hotel environments, the creative captures the essence of being 'at home' within your natural environment. The campaign was rolled out to more than 90 countries, and adapted to ensure consistency and effective communication of the brand to the local market. Above-the-line

advertising has been reinforced with below-the-line tactical advertising channels worked to drive traffic to the Novotel.com website, via online and offline.

Novotel has also started engaging with social media to strengthen its relationship with customers, launching its official Facebook page in late 2010.

Brand Values

The highest standards of service, a commitment to the environment, a dedication to creative contemporary design and intelligent use of technology are at the heart of the Novotel brand.

Things you didn't know about Novotel

The name 'Novotel' is a portmanteau for 'nouvel hôtel' (new hotel). At the hotel chain's inception in 1967 the name was originally intended to be 'Ami', with the supporting slogan, 'Votre Ami sur la route' (Your friend on the road); but Citroën beat the brand to it by naming a new car model 'Ami 6'.

In 2009 Novotel welcomed 1.9 million children as guests.

Novotel employs 30,000 people worldwide.

The hotel chain has the world's largest collection of private swimming pools, set across 75 per cent of its properties.

2006	2007	2009	2011
Novotel expands to India, with the opening of Novotel Hyderabad.	The brand celebrates its 40th year across 60 countries around the world. The first Novotel opens in Turkey in Istanbul.	Novotel continues to develop and opens its doors in Argentina (Buenos Aires) and Taiwan (Taipei).	Novotel plans further expansion, with an additional London hotel in development.

Since it opened in 1986 Pret A Manger has become the UK's leading independent retailer of premium sandwiches. Operating like a restaurant, all sandwiches, wraps, baguettes and salads are made from scratch on the day, avoiding the addition of chemicals, additives and preservatives. Pret is committed to sourcing natural ingredients and is unwilling to compromise on freshness or quality.

Market

Despite the recent recession the UK sandwich industry remains robust. Overall, the market has increased by 3.6 per cent in the last year to reach a value of more than £6 billion, with volume sales up four per cent (Source: The British Sandwich Association 2010). Pret performs well ahead of the market. While Pret A Manger continues to adapt to cater for changes in consumer demands and shifts in the market, its trademark 'formula' remains consistent.

As a private company Pret A Manger is able to set its own agenda for development; unlike many of its public company competitors it is not under pressure to expand too quickly. Currently it has 260 shops, 220 of which are in the UK, turning over in excess of £300 million per year.

Product

Since its launch Pret A Manger has revolutionised the sandwich market through the company's founding principle: serving freshly prepared good, natural food.

Each shop (bar a few of the smaller) runs its own kitchen. 'Sell by' dates are redundant as sandwiches and salads are prepared fresh, with any unsold at the end of the day going to homeless charities and shelters rather than being kept over to the following day. Since its inception the brand ethos has been, and remains, to create simple, delicious, confident flavours from natural source ingredients.

In 2010 Pret launched its Toasties. Using the same good, natural ingredients that are used in its sandwiches, wraps and baguettes, the Pret Toastie is made fresh in each shop's kitchen and is toasted in just one minute.

Achievements

Pret A Manger's longstanding association with homeless charities is an integral part of the company ethos, and part of this has been its long-established tradition of donating money raised from sales of Christmas sandwiches. In 2010 the company went further, donating 5p from every sandwich and bloomer sold from the beginning of November to the end of December, whether it was a Classic Christmas Lunch, a Beech-Smoked BLT or a SlimPret. The money raised provided hot meals and Christmas dinners for homeless shelters, hostels and soup kitchens across the UK.

1986	2001	2003	2004	2008	2010
Pret A Manger is founded by entrepreneurs Julian Metcalfe and Sinclair Beecham. The first shop serves more than 7,000 customers per week in its first year.	The McDonald's Corporation buys a minority stake in Pret A Manger, although it has no direct influence over what is sold, or how.	Soup, salad, sushi and hot drinks exceed 35 per cent of sales as Pret adjusts to changing eating habits.	The Pret DIY campaign is launched, in which Pret publishes its sandwich recipes for customers to try at home, and the brand introduces its quirky food images for the first time.	Bridgepoint, a European private equity firm, acquires a majority share in Pret, bringing an end to its relationship with McDonald's.	Pret celebrates its international expansion with a total of 260 shops in the UK, New York and Hong Kong, with recent openings in both Chicago and Washington.

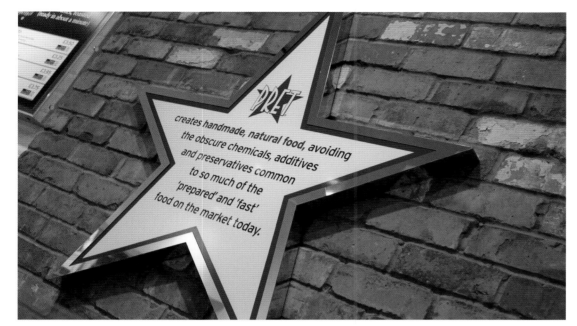

In 2010 Pret was awarded the London Mayor's Green500 Platinum Award for carbon reduction, underlining the importance it places on sourcing good local food and reducing rather than offsetting carbon. It's also leading the way in its commitment to the Food Standards Agency's trial of placing calorie counts next to products on shelves, menus and tills. Pret A Manger now displays calories and saturated fat content next to all its food products.

Recent Developments

Pret A Manger recently became the first UK high street cafe brand to switch to using a 100 per cent Higher Welfare British chicken, a move applauded by animal protection charities and key organisations. Indeed, Compassion in World Farming presented Pret with the 2010 Good Chicken Award. The Suffolk-reared chickens enjoy 20 per cent more space than

the current industry standard and meet RSPCA recommendations for stocking density.

A further company initiative is the launch of The Simon Hargraves Apprenticeship scheme, which offers three-month working placements to those often marginalised from conventional ways into employment – for instance, people with no fixed address or with prior criminal convictions. The scheme has taken on 14 apprentices to date, 75 per cent of whom have graduated to permanent employees.

Pret's ongoing commitment to avoiding landfill has seen it establish a 'back of house' recycling scheme and it recently launched organic waste collections for composting from its kitchens. In 2009 it reduced the number of plastic bags it used by 28 per cent simply by asking customers if they wanted one. A further 32 sustainability projects are underway, including paperless banking.

Promotion

Pret A Manger's philosophy is to communicate with its customers without the aid of traditional marketing teams. It doesn't use mass media and direct marketing, instead focusing on investing in its staff and the quality of its food, and in channels that allow for quality engagement with customers; a recent focus on online and social media being an example of this. Furthermore, the shops and packaging are used as channels through which the brand – known for its use of humorous and quirky images of food – is promoted.

Brand Values

Pret A Manger's success relies on staff pride in their work, a culture fostered from within. The egalitarian hands-on approach filters down from the CEO to shop assistants and emphasises the importance Pret A Manger places on training and retaining good staff. The brand personality is underpinned by its core values: passion for food, enthusiasm, integrity, honesty and belief in its convictions, with an uncompromising stance on quality and commitment to innovation.

Things you didn't know about Pret A Manger

Pret A Manger was the first retailer to move from plastic sandwich boxes to cardboard back in the 1990s.

In 2010 The Pret Charity Run donated 1.7 million sandwiches to more than 100 homeless charities and shelters.

Pret uses only Higher Welfare chicken sourced from the UK and free-range UK eggs – which are used in all products including muffins, cakes and sauces.

In 2010, Pret customers consumed 92 tonnes of chocolate powder – which is sprinkled on every Pret Cappuccino.

prontaprint

trusted to deliver, every time.

Prontaprint has maintained its position at the forefront of the corporate print-on-demand market by delivering distinctive design and print solutions, underpinned by a commitment to first class customer service. Through its ability to evolve and adapt to changing customer needs, Prontaprint has grown to become the largest and best-known brand in the business.

Market

In an age where design and print technology are rapidly developing, the business print world demands the very latest digital know-how the minute it hits the market.

Prontaprint is exploiting its commercial design and print expertise, concentrating on tailored communications for business clients – and the number of centres with turnover in excess of £1 million is growing rapidly. By remaining client-focused, understanding their needs, Prontaprint ensures that its network is in a strong position to capitalise on major changes within the business-to-business market.

In recent years, clients have increased in-house capabilities, becoming digitally enabled and web-smart. In response, Prontaprint has repositioned itself to provide an enhanced business offering covering the full business life cycle, comprising business identity, business operations, business promotion, conferences and events.

Product

Prontaprint offers a comprehensive portfolio of business communication solutions to businesses of all sizes, from design, print and display through to direct mail and finishing services. An ongoing programme of investment in the latest digital technology ensures its centres feature the most up-to-date design and digital print equipment alongside traditional print capabilities.

With most documents now produced digitally, clients' original designs can be enhanced, updated and amended, while work can also be securely stored electronically at Prontaprint centres. The versatile nature of the Prontaprint digital network means that material can be supplied to one centre and sent out digitally across the network to be produced at different centres simultaneously, simplifying distribution and increasing capacity and efficiency. This not only saves the client time and money with reduced wastage and storage costs, but also improves competitive

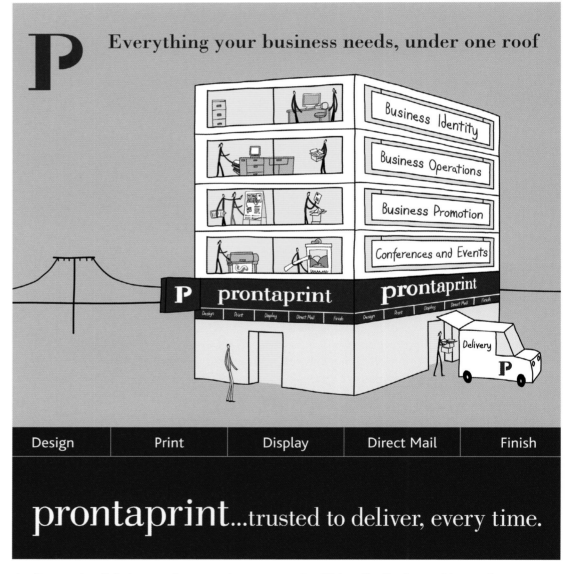

1971	1973	1980s	2009	2010	2011
The first Prontaprint centre opens in Newcastle upon Tyne, aiming to overcome the high prices, large minimum orders and long lead times associated with traditional commercial printers.	Following the signing of the first Franchise Agreement, the Prontaprint business model goes from strength to strength.	The company continues to expand widely across the UK, as well as into international markets.	Prontaprint completes the roll out of a new brand positioning, following an investment of more than £3 million and almost two years of research into the market, brand development and training.	Prontaprint commences the roll out of its bespoke web-to-print service, Prontaprint Gateway.	Prontaprint celebrates its 40th anniversary.

advantage by enabling clients to respond to market opportunities quickly.

Prontaprint's direct mail service focuses heavily on the use of variable data printing, enabling images and text to be customised to the recipient. This service, offering one-to-one marketing solutions, underpins Prontaprint's consultancy approach to servicing clients.

Achievements

Established 40 years ago, Prontaprint now has a fully integrated European network of nearly 125 digitally linked centres across the UK and Ireland, and employs more than 1,100 people with an annual turnover in excess of £30 million.

The company is a founder member of the British Franchise Association (BFA) and played a crucial role in establishing a regulatory body for the franchise industry. A former winner of the BFA Franchisor of the Year award, Prontaprint was appointed to the Association's board in 2005. It is also affiliated to the British Print Industry Federation, the British Association of Printers and Copy Centres, the Institute of Printers and XPLOR International.

Prontaprint was the first national print-on-demand network to sign a formalised licensing agreement with the Copyright Licensing Agency. This allows licensed copying of specified material within agreed limits. Prontaprint is therefore able to offer clients advice on copyright issues and help protect businesses from potential copyright infringements.

In 2007, Prontaprint won a prestigious Franchise Marketing Award for the work it had done repositioning the brand to appeal to higher value business clients; the Best Overall Marketing Campaign award was judged by a panel of experts from the franchising industry and the Chartered Institute of Marketing. In 2008, Prontaprint went on to win the title of Best Brand Management at the Franchise Marketing Awards.

Recent Developments

Proud of its heritage, Prontaprint remains focused on consistently evolving the brand to meet changing client needs in the commercial design and print market. With a corporate client base including British Airways, NEXT, Hush Puppies and Dixons, Prontaprint has rolled out a new brand positioning to develop this market further, investing more than £3 million following almost two years of research.

In 2010, Prontaprint launched its bespoke web-to-print service, Prontaprint Gateway, across the UK and Ireland. The system provides clients with 24-hour access to an online Gateway, where they can personalise pre-approved artwork templates, view proofs and place print orders. The service has applications in

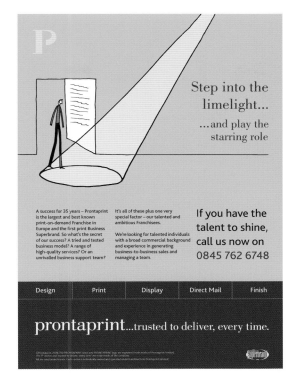

many businesses but is especially suited to large organisations and multi-site operators that want individual outlets to be able to order customised printed materials at a local level, but also need the guarantee that their brand integrity is maintained.

Promotion

Prontaprint has been transformed from a high street print and copy shop into a key player in the B2B print-on-demand sector through continual investment in its brand on a local, national and international level. It has maintained its market leading position through a sustained and structured approach to business planning, sales and marketing strategy at both macro and micro levels.

Marketing activity is based on extensive client feedback and market research. Independent in-depth surveys of existing, lapsed and potential customers help to identify changing factors of importance among small, medium and large businesses when buying print and related products and services. In light of such research, Prontaprint has reorganised its offering into more client-focused categories based upon the business lifecycle: business identity (encompassing logo creation, corporate identity and business stationery); business operations (such as invoices, statements and purchase orders); business promotion (including leaflets, brochures, flyers and posters); and conferences and events (comprising pop-up banners, displays, signage and exhibition stands).

Prontaprint believes that consistent and regular external sales and marketing activity is central to the ongoing profitable growth of each centre. This activity is focused on the acquisition, retention and development of

business clients. It also provides franchisees with a wide range of central sales and marketing tools and resources to enable them to grow their businesses locally, coupled with external sales support.

Brand Values

Prontaprint has four key brand values – Close, Connected, Can-do and Collaborative. 'Close' focuses on building long-term relationships with clients on a one-to-one level. 'Connected' refers to Prontaprint's network of talented and experienced people as well as the use of technology. 'Can-do' reflects the business culture of getting things done; whatever the job, large or small, Prontaprint aims to go the 'extra mile' ensuring it is 'trusted to deliver, every time'. Finally, 'Collaborative' reflects Prontaprint's belief that talking to clients is the start of a two-way conversation, rather than a one-way sales pitch. By working in partnership with clients and each other, Prontaprint consistently guarantees distinctive design and print solutions.

Things you didn't know about Prontaprint

Prontaprint was the first print brand to be acknowledged as a Business Superbrand.

Prontaprint is a former winner of the British Franchise Association's Franchisor of the Year award.

Prontaprint's central brand management was accredited with a prestigious Franchise Marketing Award in 2008.

REED

• • •

Founded in 1960, Reed is a specialist provider of permanent, contract, temporary and outsourced recruitment solutions; it also offers comprehensive IT and HR consulting. Operating in Europe, the Middle East and Asia Pacific, Reed has more than 3,000 employees working in 350 offices across 30 specialist areas. The company's online presence enables clients to interact with global recruitment services and jobseekers to identify opportunities.

Market

The Recruitment and Employers Confederation valued the UK recruitment sector at approximately £20 billion in 2009/10.

As the leading independent recruitment agency in the UK, Reed specialises in recruiting into 30 professions and sectors – from accountancy, HR and sales, to property and construction.

In December 2009 Reed began publishing the Reed Job Index, a comprehensive monthly analysis of the new job opportunities and salaries on offer. The index is based on data from the reed.co.uk job board, which lists more than 100,000 jobs daily from 8,000 recruiters across 37 career sectors throughout the UK. In October 2010 the Reed Job Index reached its highest ever level of 107, meaning employers were recruiting for seven per cent more vacancies than in December 2009.

Product

In the early 1960s Reed pioneered specialist recruitment services, a move that fundamentally changed the UK recruitment market. Reed Accountancy was the first specialist area, opening in 1961. Today Reed Specialist Recruitment has experts operating at all levels across 30 diverse specialisms, from banking to social care. In addition, Reed has industry-leading capabilities in key areas including assessment and graduate recruitment. The company's wide-ranging remit is reflected in the 1.5 million job applications it receives online each month.

Achievements

One of the company's most notable achievements has been the success of its online resource. reed.co.uk is the UK's most visited job site (Source: Hitwise January – December 2009). More than three million

jobseekers use the site each month to look for work opportunities, resulting in over 60,000 online job applications every day. The site is used by 85 per cent of the UK's top 100 recruitment agencies.

In terms of corporate responsibility, Reed is passionate about the environment – evidenced by its award-winning environmental

1960	1961	1972	1995	1996	
Alec Reed, aged 26, opens Reed's first office in a small shop in Hounslow, Middlesex. He starts with just £75.	Reed Accountancy opens; by pioneering specialist recruitment services, Reed fundamentally changes the UK recruitment market.	Alec Reed founds the Reed Business School, in a Cotswolds manor house, to provide residential courses for accountancy students.	Reed becomes the first UK recruitment company to launch online.	Reed Learning is launched, becoming one of the UK's leading business training providers: it will be the first to launch Green Learning courses;	become the exclusive training partner to Google; and will win several national training awards.

HAPPY HOUR: 9 'TIL 5.

MONDAYS

The UK's #1 job site. **reed**.co.uk

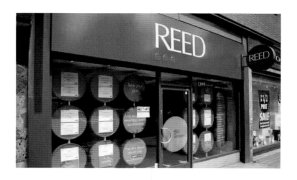

visit reed.co.uk the UK's largest site for jobs

programme and ongoing CarbonNeutral® status. The company is committed to being carbon responsible and is part of The Prince of Wales' Mayday Network, an initiative to commit businesses to collectively combat climate change.

Reed is also at the forefront of industry research and continuous development, having worked in partnership and published papers with organisations such as the Institute for Public Policy Research and the Commission for Racial Equality. In addition, the Reed group of companies has achieved membership of organisations that include The Confederation of British Industry, Employers' Forum on Disability, Chartered Management Institute and Investors in People, to name but a few.

Recent Developments

In 2010, its 50th anniversary year, Reed launched Reed Retail. Based in London and Manchester, with further expansion planned throughout 2011, Reed Retail specialises in all of the industry's disciplines, with particular expertise in the areas of design and development, buying and merchandising, and retail operation – both within fashion and non-fashion environments.

Reed's European business has experienced positive growth, especially in its newest sector, Multilingual Shared Services recruitment. Meanwhile the company's Australian offices continue to achieve above-budget performance year-to-date, with the growing economy providing a solid platform for future success. Offices in Hong Kong and Singapore have made record-breaking deals in 2010, while in the Middle East Reed has opened an office in Dubai, and the Qatar business has become the undisputed regional market leader.

In terms of future expansion, the brand has identified significant potential in the emerging Korean market, with the first consultants already recruited.

Promotion

As part of its half-century celebrations in 2010, Reed launched a programme of promotional communications that underlined its industry expertise, including the development of a report charting its first 50 years of recruitment and offering predictions for the next 50.

As a company Reed strives to keep ahead of its rivals by utilising contemporary digital communication platforms. It launched the UK's first online recruitment site back in February 1995 and a recent promotional activity saw it connect with employers and candidates through a market commentary series on YouTube. It also regularly shares valuable content on media such as Facebook, Twitter and LinkedIn.

Throughout Autumn 2010, Reed ran its biggest advertising campaign to date. Featuring the Love Mondays theme, the three-month campaign took in some of the UK's most sought-after outdoor advertising sites and most popular commercial radio stations. The brand has been encouraging the nation

to Love Mondays for more than three years, promoting positive messages about jobs, careers and the world of work.

The latest campaign saw advertising on more than 1,500 double-decker buses nationwide and on the Clapham Junction Colossus – Europe's biggest backlit poster.

Brand Values

Part of Reed's unique selling point is its commitment to and support of each and every one of its 3,000 'co-members'. The family-owned and run brand has developed organically, rather than by acquisition, ensuring that people are at the heart of everything it does – and how it does it. Its company mission remains as it has always been: 'To be the world's best recruiter, through constant innovation and continuous improvement.'

Things you didn't know about Reed

Reed is a family-run business. Founder Alec Reed is still involved in the company's management today. His son, James Reed, joined in 1994, became chief executive in 1997 and was appointed chairman in 2004.

In 1960, Alec placed Reed's first candidate, Tony Clark, as a trainee accountant. Tony went on to enjoy a career that included a brief spell in movie-making and the birth of many successful businesses. Tony remains firm friends with Alec today.

Reed's head office is on Baker Street in London, on the site of The Beatles' Apple Boutique.

During October 2010, reed.co.uk received half a million job applications in one week alone – a new record for the site.

1998	2004	2007	2010
Reed in Partnership launches – it will go on to place more than 100,000 long-term unemployed into work.	Reed Consulting is launched, helping organisations to approach their resourcing in a significantly more cost-effective way.	Reed wins the Sustainable City Award for Resource Conservation.	Reed celebrates its 50th anniversary as one of the UK's largest private companies.

RIBA

The RIBA is known to millions through the televised RIBA Stirling Prize, and from the work of more than 40,000 RIBA architects across the globe who bear its gold standard for practice. A champion for design quality, and with a passion to promote architecture through its website, exhibitions, talks and world-class collections, the RIBA has led the profession since its foundation in 1834 – and continues to lead as architects face 21st century challenges.

Market

The Royal Institute of British Architects (RIBA) provides support for its members through advice, training, and technical and business services. Its knowledge and information resources are backed by one of the greatest architectural libraries and collections in the world, and the RIBA's commercial activities make it the leading technical information provider to the UK construction industry.

The RIBA has a national network of 11 regional offices in England, plus the Royal Society of Architects in Wales (RSAW), and works with fellow Institutes in Scotland and Northern Ireland for the provision of services to members located there. The Institute also has a growing number of members and activities in the US and the Gulf.

The RIBA validates architecture courses across the globe, with one-third of the world's architects qualifying through a RIBA validation system.

Product

Through its commercial ventures, the RIBA is the leading source of technical expertise for those working within the built environment. Under the NBS sub-brand, it delivers the de facto national building specification system for buildings in the UK. It is also a key provider of technical and regulatory information, including being the Government's official publisher of the Building Regulations' Approved Documents.

As RIBA Publishing and RIBA Bookshops, it is the industry's leading publisher and re-seller of books, contracts and forms, while RIBA Insight

RIBA Trust
RIBA Stirling Prize Dinner 2010
In association with AJ and BENCHMARK

RIBA
Conservation Register Handbook

is in demand for its unique marketing opportunities that enable product manufacturers and service providers to promote their products to the architectural community and other construction professionals.

The RIBA's outreach activities help decision-makers, clients and the public to learn more about the built environment and engage with key issues. These include televised awards, exhibitions, talks and programmes for schools. A major digitisation project is also underway at ribapix.com, making the RIBA's world-leading collection of architectural drawings and photographs increasingly accessible online.

Achievements

The RIBA continues to influence policy on the built environment for the public good. Significant issues include combating climate change; reform of public procurement; reform of the planning system; and improvement in the quality of new housing.

With the UK facing challenging carbon reduction targets, turning homes 'green' is a key focus for the RIBA. The Institute's call for four million homes to be retrofitted within the lifetime of this parliament has been met by the coalition Government's Green Deal initiative, and the RIBA is now working with the Government to explore how homes can be improved to reduce their energy consumption.

In response to the threat of flooding, in 2010 the RIBA and the Institution of Civil Engineers published a scenario-based report: 'Facing Up to Rising Sea Levels.' Looking to Hull and Portsmouth, the report explored three

1834	1934	1996	1997	2004	2006
The Institute of British Architects is founded.	King George V and Queen Mary open the RIBA's new Art Deco style headquarters.	The inaugural RIBA Stirling Prize takes place.	The RIBA and Shelter collaboration, Architect in the House, is launched.	The V&A + RIBA Architecture Partnership is established at the Victoria and Albert Museum, London.	The RIBA Library is designated an Outstanding Collection by the Government.

The President's Medals
Student Awards 2010
In association with ATKINS

ways in which coastal cities could respond
to encroaching water levels – retreat, defend,
attack – which led to creative and unusual
solutions that were widely reported in
the media.

Recent Developments

With the issue of sustainability currently
transforming the marketplace for architects
– and encompassing all aspects of
historic building conservation, repair and
maintenance – the RIBA has recently launched
a Conservation Register that helps anyone
looking to commission work on heritage
buildings to find architects with the appropriate
skills and experience.

2010 also saw RIBA undertake a major research
project to investigate people's concerns
about their built environment; what matters
to them as they go about their daily lives; and
the language that they use to express these
feelings and concerns. The resulting insight

and data will fuel RIBA's brand development in
2011, enabling it to remain relevant and at the
forefront of the industry.

Promotion

The RIBA brand is driven through its press and
marketing activity, the high profile taken by its
president, and by its lobbying of government.
In addition, its members play a central role
in developing the brand as they practice – by
using the RIBA name and crest – while industry
partnerships also help to maintain the RIBA
profile. The RIBA works collaboratively with
bodies such as the Construction Industry
Council, Institution of Civil Engineers and Royal
Town Planning Institute. On the consumer-
facing side, RIBA's Architect in the House

scheme sees it work with the housing and
homelessness charity Shelter.

The RIBA Building Futures initiative is the
Institute's think tank and addresses 'big
picture' issues, such as how new technologies
will affect the buildings we all use every
day. This innovative thinking attracts media
coverage, which in turn also helps promote
the RIBA.

Brand Values

The brand is crystallised in the letters 'RIBA',
which represent architecture's gold standard,
and which are valued by RIBA members
and the public alike. The RIBA aims to be
responsive to its stakeholders and audiences;
to be influential through its advocacy and
campaigning; to be bold as it addresses 21st
century challenges of design and construction;
and to be authoritative at all times. In all that
it does, it aims to inspire trust, demonstrate
competence and show leadership.

2007	2008	2009	2010
The RIBA Lubetkin Prize is founded.	Ruth Reed is elected as the RIBA's first female president.	The Institute celebrates its 175th birthday.	The Palladio USA exhibition tours four North American cities.

Things you didn't know about the RIBA

First run in 1997, the RIBA and Shelter's
Architect in the House scheme has now
raised more than £1 million, helping
Shelter to provide essential advice and
support to those facing bad housing
and homelessness in the UK.

Every year RIBA Client Services helps
around 4,000 clients who are looking to
find an architect, matching their needs
with local RIBA chartered practices.

The RIBA Library holds four million
items devoted to the study of
architecture. This includes 350
original drawings by renowned Italian
Renaissance architect Andrea Palladio
– more than 80 per cent of his total
portfolio in existence today.

An established family favourite, Robinsons has been making drinks for more than 75 years and is one of the strongest British family brands. The brand consists of two ranges, each with a variety of sub-brands: squashes for the whole family and a ready-to-drink range for young children under the Robinsons Fruit Shoot brand.

Market

Robinsons operates within the squash and children's drinks categories of the drinks market, of which it has a 43 per cent and 24 per cent share of the market, respectively. The squash category is worth £497 million annually and the children's drinks sector is valued at more than £400 million.

The squash category has a diverse demographic with 75 per cent penetration of UK households and has remained consistent in terms of year-on-year growth. Offering good value in difficult economic times, it increased 4.6 per cent year-on-year in 2010 (Source: Nielsen Scantrack November 2010). Robinsons

has grown in line with the category and as the leading brand, has driven much of its growth. Key competitors are Ribena and Vimto – which have an 11 per cent and five per cent share of the market, respectively – in addition to retailers' own brand products which, combined, have a 30 per cent market share.

Within the competitive children's drinks category Robinsons Fruit Shoot, launched in 2000, is now the leading brand in the UK. Worth an estimated £97 million it offers three different ranges: the original Fruit Shoot juice drink, an active water drink, and a fruit juice blend that provides one of the recommended 'five a day' for kids.

Product

Fruit Squash and No Added Sugar make up the core of the brand's squash portfolio with six everyday flavours that include Blackcurrant & Apple, Lemon and Summer Fruits.

Barley Water – available in Orange and Lemon – is the original Robinsons squash, a British classic dating back to 1935 that has built up a reputation for its historic association with Wimbledon Lawn Tennis. Available only in a no added sugar format, Robinsons Fruit & Barley delivers the brand's distinctive flavour and quality with next to no calories. The range of flavours includes Apple & Blackcurrant, Peach and Pink Grapefruit.

Be Natural is the first 'all natural' squash offering from Robinsons, made with naturally sourced ingredients. Flavours include more unusual combinations such as Orange & Passionfruit alongside the more conventional pairings of Apple & Strawberry and Blackberry & Pear. Like pure fruit juices Be Natural, once opened, should be kept in the fridge.

The Fruit Shoot juice drinks range is marketed specifically for children, using bright colours and kid-sized bottles with child-friendly

1823	1862	1903	1935	1994	1995
Robinson & Belville manufactures Patent Barley and Groats – the Patent Barley powder is added to boiling water to make a barley drink.	The company is amalgamated with Keen & Son, a mustard business.	The company is acquired by Coleman's of Norwich, creating a new manufacturing base.	Robinsons Barley Water is invented at Wimbledon: a Coleman's medical representative mixes Patent Barley crystals with lemon juice, sugar and water to make a hydrating drink for the players.	The Fruit & Barley range is launched.	Robinsons is acquired by Britvic.

non-spill sports caps. It offers five different fruit flavours, both regular and no added sugar. Fruit Shoot Hydro is the brand's latest innovation and comes in a bigger sports bottle, with handgrips, filled with lightly fruit-flavoured water – making it well suited to active kids.

Achievements

2010 was a successful year for Robinsons in terms of industry accolades, picking up a Silver medal for its Fruit Shoot Skills campaign at the IPA Effectiveness Awards and the Best TV Sport Commercial for its 'Imagine' Wimbledon campaign at the Sports Industry Awards 2010. At the British Television Advertising Awards 'Imagine' also accrued a handful of honours including the Gold medal for soft drinks and two Silvers for the best 30–60-second commercial. In the same category, its 'Birdhouse' campaign picked up the Bronze.

Recent Developments

Most of the brand's recent developments have focused on new product launches. For instance, in 2009 Robinsons Be Natural became one of the top five new products launched across soft drinks and in the same year the company launched its healthier Fruit Shoot variant, Fruit Shoot My-5.

In 2010 a more sophisticated product offering was introduced to the market: Robinsons Select, aimed at older families with more contemporary tastes. In early 2011 Fruit Shoot Hydro then joined the brand's burgeoning range.

The project went on to win a prestigious Silver IPA Effectiveness Award in 2010.

Promotion

Whether launching a new product, adding leverage to its Wimbledon sponsorship or driving brand engagement, the Robinsons promotional campaigns seek to celebrate its unique position as a small but integral part of everyday British family life.

Over the past decade Robinsons and Robinsons Fruit Shoot have evolved to deliver highly engaging communications through traditional channels such as television and

saw it search the nation for talented kids through a combination of television advertising, online seeding and an audition road show that toured the UK. The nation's eight-year-olds then participated in an online vote to choose winners to become the faces of the Juice Crew 2010, taking centre stage in the brand's latest television advertisement.

Brand Values

At the heart of celebrating its place in British family life lies a value that is central to Robinsons: belonging – a universal human need that is relevant for Robinsons in the context of the family unit, and for Fruit Shoot in the context of the playground and anywhere else that children play.

But the company is also committed to projects aimed at improving the quality of family life and in the summer of 2009 launched the Skills campaign – a long-term initiative to get kids up and active and learning new skills.

in-store, as well as non-traditional channels such as digital and advertising-funded programming. The result is a genuine two-way relationship between consumers and the brands. The most recent Fruit Shoot campaign

Things you didn't know about Robinsons

Robinsons is bought by more UK households than any other soft drink, with 57 per cent penetration (Source: Nielsen Scantrack 30th October 2010).

Robinsons squash was created at the Wimbledon Tennis Championships and its association with Wimbledon is the second longest running sports sponsorship in the world.

Robinsons Fruit Shoot is the number one children's drinks brand in the UK; kids in the UK drink 15 bottles of Fruit Shoot every second.

2000	2009	2010	2011
Robinsons Fruit Shoot is launched.	Robinsons Fruit Shoot My-5 is launched.	Robinsons Select, the Robinsons premium squash sub-brand, is launched.	Robinsons Fruit Shoot Hydro is launched.

Rolls-Royce is a global business, providing and supporting integrated power systems for use on land, at sea and in the air. The Rolls-Royce Group has a broad customer base including more than 600 airlines, 4,000 corporate and utility aircraft and helicopter operators, 160 armed forces, more than 2,000 marine customers, and energy customers in nearly 120 countries. With facilities in over 50 countries, it employs 39,000 people worldwide.

Market

Annual sales for Rolls-Royce are more than £10 billion, half of which comes from services. The Group's order book by the middle of 2010 stood at £58.4 billion.

The Group operates in four long-term global markets – civil and defence aerospace, marine and energy. These markets create a total opportunity worth some US$2 trillion over the next 20 years. The markets have a number of similar characteristics: they have very high barriers to entry; they offer the opportunity for organic growth; and they feature extraordinarily long programme lives, usually measured in decades.

The size of these markets is generally related to world gross domestic product growth or, in the case of the defence markets, global security and the scale of defence budgets.

Product

Rolls-Royce is the world's number two aero engine manufacturer and its Trent family of engines is a leader in modern widebody aircraft. Rolls-Royce is also a market leader for business jet engines.

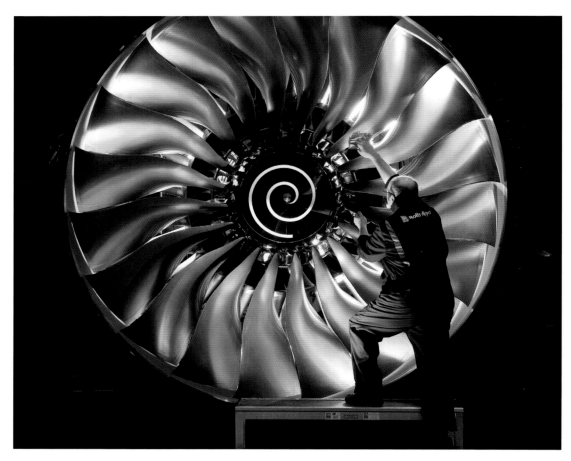

In civil aerospace, Rolls-Royce powers more than 30 types of commercial aircraft, from business jets to the largest widebody airliners. A fleet of 13,000 engines is in service with 600 airline customers and 4,000 corporate operators.

Rolls-Royce is also the leading military aero engine manufacturer in Europe and the number two military aero engine manufacturer in the

world, powering approximately 25 per cent of the world's military fleet.

In the marine market, Rolls-Royce serves more than 2,000 customers and has equipment installed on 30,000 commercial and naval vessels operating around the world. Its products and services include established names such as Kamewa, Ulstein, Aquamaster and Brown Brothers which, together with a

strong focus on research and development, have made Rolls-Royce a pioneer of many important technologies, including aero-derivative marine gas turbines, controllable pitch propellers and water jets.

The Rolls-Royce energy business is a world-leading supplier of power systems for onshore and offshore oil and gas applications, with a growing presence in the electrical power

1904	1914	1940	1953	1966	1976
Henry Royce meets Charles Rolls, whose company sells high quality cars in London.	At the start of World War I, Royce designs his first aero engine, the Eagle, which goes on to provide half of the total horsepower used in the air by the allies.	Royce's Merlin powers the Hawker Hurricane and Supermarine Spitfire in the Battle of Britain. Four years later development begins on the aero gas turbine.	Rolls-Royce enters the civil aviation market with the Dart in the Vickers Viscount. It becomes the cornerstone of universal acceptance of the gas turbine by the airline industry.	Bristol Siddeley merges with Rolls-Royce.	Concorde, powered by the Rolls-Royce Snecma Olympus 593, becomes the first and only supersonic airliner to enter service.

generation sector. It supplies products to customers in more than 120 countries and its main products include the industrial Trent and industrial RB211 gas turbines.

Achievements

Rolls-Royce is ranked in several external indices that benchmark corporate responsibility performance, including the Dow Jones Sustainability World and European Indexes – in both of which it has retained its position for eight consecutive years.

In 2009 it achieved Gold status for the third year running in the Business in the Community Corporate Responsibility Index; the Group's dedication to reducing its environmental and social impact translated into an overall score of 93 per cent.

For the second consecutive year, Rolls-Royce has been included in the FTSE 350 Carbon Disclosure Leadership Index, run by the Carbon Disclosure Project (CDP), in which the quality and depth of a company's response to the annual CDP questionnaire is scored.

Recent Developments

Among its ongoing corporate social responsibility activities is the Rolls-Royce Science Prize, an annual awards programme that helps teachers implement science teaching ideas in their schools and colleges. There is a total of £120,000 worth of prizes to be won each year. The competition builds on the Group's commitment to Project ENTHUSE, a £30 million partnership between industry, the Government and the Wellcome Trust that provides teachers with funding to cover the cost of attending courses at the National Science Learning Centre.

At major Rolls-Royce sites, the Group also sponsors a range of education projects. Employees get involved with local schools

to support young people and promote STEM subjects – Science, Technology, Engineering and Maths.

Promotion

The strategy for the Rolls-Royce Group centres on five key elements: addressing the four global markets; investing in technology, infrastructure and capability; developing a competitive portfolio of products and services; growing market share and installed product base; and adding value to customers through product-related services.

Over the past five years Rolls-Royce has invested £4 billion in research and development and it invests approximately £25 million annually in training.

The Group is determined to give an effective response to the problem of climate change and other environmental concerns and is committed to a programme of continuous improvement for its production and service activities around the world.

Similarly, it is committed to significant annual investment in research and development in order to provide leading-edge technologies that reduce fuel burn, emissions and noise across all its products. It is also at the forefront of research into advanced technologies that could provide entirely new approaches to low carbon energy solutions.

Brand Values

Rolls-Royce is one of the most famous brands in the world. The Rolls-Royce brand means more than engineering excellence – it is a standard of quality across all the company's activities. The brand is at the heart of everything Rolls-Royce does. Its brand values are reliability, integrity and innovation and its brand positioning statement is 'Trusted to deliver excellence'.

1987	1999	2009	2010
Rolls-Royce is privatised.	Rolls-Royce acquires Vickers for £576 million, transforming Rolls-Royce into the global leader in marine power systems.	Rolls-Royce Trent 1000 engines power the new Boeing 787 Dreamliner on its first flight.	The new Trent XWB engine for the Airbus A350 XWB runs for the first time.

Things you didn't know about Rolls-Royce

Rolls-Royce invests nearly £900 million annually in research and development.

The company celebrated its centenary in 2004.

Rolls-Royce was selected as first to power the Airbus A380 and the Boeing 787 into service.

The company has announced a new business to address the expanding market for civil nuclear power.

Its UT-Design of offshore vessel is the most successful in the world, with sales in excess of 500 units.

Rolls-Royce reactor plant designs power all of the nuclear submarines for the Royal Navy.

EST IN SWITZERLAND 1895 - WATERPROOF

Rotary is a fourth generation, family run company offering ladies and gents dress watches in the mid-market price bracket. Established in La Chaux-de-Fonds, Switzerland in 1895 by Moise Dreyfuss, Rotary is proud of its reputation as a trusted supplier of high quality, design-led timepieces at an affordable price point. In the UK, Rotary is a brand leader in the mid-market sector, defined as watches that retail for between £100 and £200.

Market

The watch market is worth an estimated £630 million and the average price paid for a watch is £45 (Source: GfK NOP 2010; the GfK NOP market read does not include high end purchases, and thus is not representative of the full value market). Growth in the market is being driven by an increasing incidence of multiple ownership as accessorising becomes more important to both men and women. The most significant growth is being seen in the higher price brackets, notably the £100 plus range, as consumers become more aware of the benefits of investing in a watch that will last a lifetime rather than a lower priced disposable model. Similarly, the market is showing a return to classic, timeless styling.

During the economic downturn, consumers made carefully considered purchases, looking to invest in trusted and established brands. Rotary's key mid-market competitors are Tissot, Citizen and Seiko.

Product

Rotary offers consumers a wide choice of dress watches with a range of more than 200 models – all designed to a high specification, guaranteeing longevity and reliability.

In 2009 Rotary launched the Aquaspeed range of sports performance timepieces. After uncovering a collection of vintage 1950s Rotary sports watches, the company took the bold decision to design an entirely sports-orientated line that includes both chronograph and slide rule models.

Rotary Les Originales is the company's Swiss-made collection of strap and bracelet watches that celebrates the company's unique history and Swiss heritage. With a distinctly vintage appeal, Rotary Les Originales is designed to appeal to consumers looking to invest in a timeless piece. At the end of 2010, four limited edition Super 25 models were added to the collection, inspired by an original design from the 1950s. This also marked the beginning of a new relationship with Help for Heroes, a charity that provides direct, practical support to those wounded in the line of duty. For each Super 25 watch sold, Rotary donates £3 to the charity.

New for 2011 is an avant-garde collection of high specification multi-function timepieces. Originally aimed at international travellers, the Rotary Evolution collection celebrates the fusion of futuristic styling with high quality

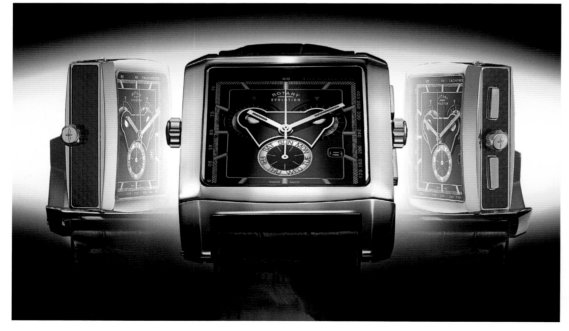

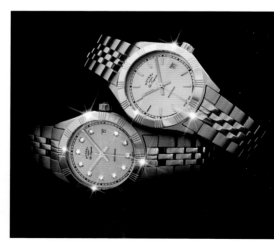

1895	1907	1925	1940	1985	1987
Moise Dreyfuss begins making timepieces in a small workshop in the Swiss town of La Chaux-de-Fonds.	Georges and Sylvain Dreyfuss, two of Moise Dreyfuss's three sons, open an office in Britain to import the family watches.	The company introduces its 'winged wheel' logo.	Rotary is appointed as official watch supplier to the British army.	The Swiss business and its trademarks, with the exception of the rights for the UK and Gibraltar, are sold to the Hirsch Group.	Robert Dreyfuss succeeds his father Teddy Dreyfuss as chairman, becoming the fourth generation of the family to run the company.

Swiss craftsmanship. The collection is split into Time Zone series: TZ1 satisfies a single time zone, whereas TZ2 and TZ3 can monitor two and three separate time zones, respectively.

Achievements
Rotary is a household brand name, with its reputation for high quality timepieces engendering trust and confidence in consumers and retailers alike. Such confidence is bolstered by Rotary's service and repair policy, which ensures customers will receive their fully repaired watch within seven days. Since its launch, the company has remained faithful to its promise and customers regularly cite this initiative as an unparalleled credit to the company.

In addition, every Rotary watch purchased after 1st January 2009 is protected by a lifetime movement guarantee. Subject to a regular service every three years, all Rotary Watches are guaranteed to offer reliability and confidence to the wearer for an indefinite period.

Recent Developments
The launch of the waterproof standard in 2009 marked one of the most important technological breakthroughs in watch making in the last decade. For consumers the new standard offers peace of mind thanks to a simple 'waterproof' promise. It is unique for two key reasons, the most notable being the fact that the standard marks a move away from the complex and confusing numeric system of water resistance criteria to which the rest of industry subscribes. Secondly, unlike most competitor brands, Rotary has applied the waterproof standard to virtually its entire range.

Promotion
In 2010, Rotary launched an iPhone application that includes an interactive powerboat racing game. The highly charged game has three difficulty levels and the ability to 'build your own' Rotary Aquaspeed watch by selecting from different bezels, dials and strap options. The app received an impressive 10,000 downloads within its first 10 days of going live.

In 2000, Rotary created the trade's first business-to-business trade website that allows retailers to order online with guaranteed delivery the following day for orders placed

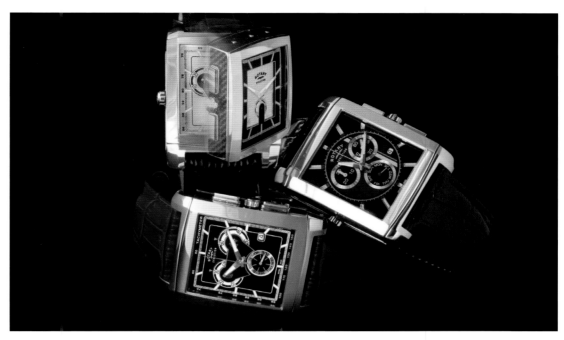

Swiss Watchmaking is our Family's Tradition

before 4pm. Not only did this set new standards of customer service, but it provided transparency in the form of online stock availability – which is updated in real-time via data links to the company's management information system – online statements and invoices, service and repair tracking as well as spare parts ordering.

Brand Values
For more than a century, Rotary has preserved its Swiss heritage, crafting watches with the same quality materials and testing each watch to ensure it can withstand the rigours of everyday life. Rotary builds on this heritage by investing in new product development, staff training and leading information technology to ensure it meets the needs of the modern consumer.

1992	2006	2009	2010
Rotary UK buys the trademarks back, now owning the right to use the trademark worldwide.	The patented Rotary Round Revelation™ is launched.	Rotary introduces two significant initiatives: the Waterproof Standard and the Lifetime Guarantee.	Rotary launches the Super 25 series of limited edition strap watches, inspired by designs from the 1950s – a £3 donation is made to Help for Heroes for each sale.

Things you didn't know about Rotary

In the 1950s three spectacular tests confirmed the quality and reliability of the Rotary brand: a watch was towed behind the QE2 as it crossed the Atlantic and remained in perfect working order; another was strapped to the Flying Scotsman and arrived intact; and a further watch, dropped from the top of Big Ben, survived undamaged.

Rotary has received many testimonials from customers of a certain age who have had their Rotary watch since they were 18 and it's still keeping perfect time – in some cases having gone through both World War I and World War II.

If a customer sends their Rotary watch into the company's service and repair department, it guarantees to turn it around in seven days, door-to-door.

RSA

With a 300-year heritage, RSA is one of the world's leading multinational insurance groups. It has the capability to do business in more than 130 countries and has major operations in the UK, Scandinavia, Canada, Ireland, Asia and the Middle East, Latin America, and Central and Eastern Europe. Focusing on general insurance, it has around 23,000 employees and in 2009, its net written premiums were £6.7 billion.

Market

While its origins lie in London, RSA is a global company with a balanced portfolio of successful businesses spread across both mature and emerging markets. Its single-minded focus on general insurance has allowed it to deliver strong, profitable performance even in the most challenging market conditions.

RSA is split into three regions: UK, International and Emerging Markets. In the UK, it is the largest commercial and fourth largest personal insurer. In International, RSA is the third largest insurer in Sweden and Denmark, the fourth largest general insurer in Canada, the second largest in Ireland and has a small business in Italy. In Emerging Markets, it is the largest general insurer in Chile, the largest private insurer in Uruguay and a leading marine insurer in Brazil. The company is also the number one insurer in the Baltics and Oman, and the leading direct insurer in Poland, the Czech Republic and Russia. RSA was the first overseas insurer to be granted a licence in China and through its associate, has a thriving business in India.

Product

From the epic to the everyday, RSA has been underwriting progress since 1710. Today 20 million customers in more than 130 countries trust it to look after their insurance and risk-management needs.

From the largest wind farms to the smallest cats and dogs, RSA has the technical skills, experience and expertise to insure them all. It provides commercial insurance services including construction, property, engineering, motor, marine and renewable energy

generation for the smallest enterprises right up to global multinationals. It also offers car, home, pet and travel insurance directly to consumers and through intermediaries such as insurance brokers and affinity partners.

Achievements

As a market leader, RSA strives to provide high quality products backed up by world-class service. It is also conscious of its role in society and runs its businesses in a responsible and sustainable way. This combination of operational excellence

and ethical business practices has been acknowledged through many awards.

In 2010 alone RSA was named General Insurer of the Year at the Insurance Times Awards, won the Best Implementation of a Rebrand at the UK Transform Awards, the British Business Award in China, the Arabian Corporate Responsibility Award and the Middle East E-Business Award. The Canadian business, meanwhile, was named a Top 100 Employer and one of the Financial Post's Top 10 Companies to Work For.

FROM THE EPIC TO THE EVERYDAY, WE'VE BEEN UNDERWRITING PROGRESS SINCE 1710.

CAPTAIN COOK COVERED MILLIONS OF SQUARE MILES.

WE COVERED HIS 450 SQUARE FEET BACK HOME.

1710	1765	1844	1845	1959	1996
Sun Fire Office is established.	Sun Fire Office insures the home of Captain James Cook, prior to the first of his legendary voyages.	Sun Fire Office provides insurance cover for Down House, where Charles Darwin writes On the Origin of Species.	The Royal is founded.	The Sun Insurance Office merges with The Alliance Assurance Company to form Sun Alliance Insurance Ltd.	Sun Alliance Group merges with Royal Insurance Holdings, becoming Royal & Sun Alliance Insurance Group plc.

In the UK RSA has been awarded the Carbon Trust Standard, achieved Platinum status in Business in the Community's Corporate Responsibility Index, a Silver ranking in the Dow Jones Sustainability Index and was named in The Sunday Times Best Green Companies list for the second year.

Recent Developments

In 2009 RSA signed a three-year global partnership with WWF. RSA recognises that an understanding of climate change and its impact will help the insurance industry protect itself from risk, but also that such partnerships provide an opportunity to promote sustainable behaviour and explore new business avenues. The partnership will see RSA and WWF work together to investigate emerging environmental risks and opportunities from climate change and to encourage action among governments, businesses and customers.

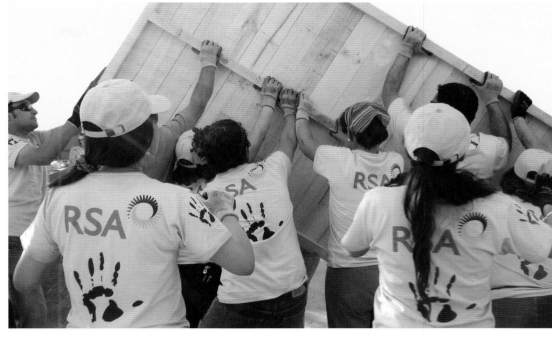

2010 marked the 300-year anniversary of RSA. The milestone gave the company an ideal framework within which to thank staff, business partners and customers for their loyalty and support. It also prompted significant emphasis on social responsibility, with RSA employees raising more than £750,000 for charity during the year as well as spending 37,000 hours volunteering and donating 200,000 items as gifts in kind for good causes worldwide.

In what was a challenging year for the industry, RSA built good top line momentum with strong premium growth in all its regions. The company continues to supplement organic growth with targeted acquisitions and 10 deals signed in 2010.

Promotion

In 2008 the company simplified, refreshed and modernised its brand, with Royal & Sun Alliance becoming known simply as RSA.

The 300th anniversary of the Group in 2010 was used to launch its first global advertising campaign aimed at opinion formers and businesses. This was supported by extensive broker roadshows and events programmes designed to inform business partners about RSA's vision and plans for the future.

Underpinning all of RSA's activities is a commitment to 'doing the right thing', and it believes corporate responsibility offers a competitive advantage, helping it to identify and serve new markets, and to cut operating costs by driving environmental improvements.

Brand Values

The RSA brand is all about keeping customers moving – whether in business, or as individuals. 'Keeping you moving' is not a strapline, it's the guiding principle that drives everything the company does: it's the emotional and functional benefit given to customers. RSA measures the performance of every one of its 23,000 employees against this single objective. It is brought to life through RSA's values of being straightforward and responsive, planning ahead and always being delivery focused.

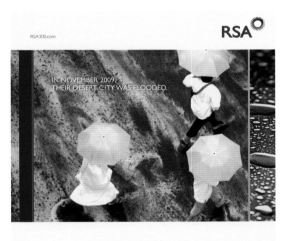

2001	2006	2008	2010
MORE TH>N launches in the UK.	Royal & Sun Alliance becomes the UK's first carbon neutral insurer.	Royal & Sun Alliance becomes RSA Insurance Group plc.	The RSA Group is 300 years old.

Things you didn't know about RSA

RSA's roots go back to the 7th April 1710: the founding of Sun Fire Office.

From 1884 RSA (then Sun Fire Office) provided Charles Darwin's home and contents cover for Down House in Kent, including his books, journals, paper and pens, with which he wrote On the Origin of Species.

In 1991 RSA insured the first offshore wind farm, located off the coast of Denmark; to date it has been involved in insuring around 80 per cent of all the world's offshore turbines.

In 2009 RSA launched a three-year global partnership with WWF to investigate emerging environmental and climate change risk.

Sage is a leading supplier of business management software, services and support that helps companies of all sizes to manage all areas of their business, from finances and people, to customer and supplier relationships, e-commerce operations and future growth. It achieves this through a diverse – but customer-centric – portfolio of evolving products and services to 6.3 million customers worldwide, more than 800,000 of which are in the UK and Ireland.

Market

Sage consistently ranks as one of the industry leaders in its market segment. Its UK and Ireland business is committed to helping businesses survive and thrive. Throughout the recession and during 2010 the brand maintained its focus and investment on delivering new products and services, the majority of which are developed and supported locally to ensure customer relevance.

As many customers increasingly look to expand into international and global markets, Sage has the understanding and expertise to provide them with the best solution for their needs. From managing small businesses, to local mid-market and global operations, the brand offers scalability, know-how and a choice of off the shelf or tailored, cost-effective solutions such as its award-winning Sage 50 Payroll, Sage 50 Accounts, Sage Saleslogix CRM, Sage ERP X3 or its payment processing service, SagePay.

The diversity of the brand's channels to market – direct, retail, business partners and accountants – demonstrates its understanding of the small and medium sized enterprise (SME) marketplace and promotes accessibility, while a close relationship with HM Revenue & Customs and a position on multiple industry panels places it at the heart of accountancy in the UK. As a brand Sage is trusted by accountants, businesses and the Government to understand the complexities of doing business in Britain and is regularly consulted on the impact on software of legislative changes to tax and filing mechanisms – such as VAT and the requirement for iXBRL-compliant accounts.

Product

While traditionally associated with accounting software, Sage has utilised its experience and insight over the past 30 years to extend its remit across a breadth of other sectors to create an all-encompassing diverse portfolio of business software, support and services.

The brand's pragmatic approach to technology enables it to offer flexible, scalable, integrated solutions and choices; customers can choose Sage to handle just one aspect of their business software needs or all of them. Solutions range from financial software enabling better cash flow management, VAT, invoicing and generation of year-end accounts, through to more sophisticated brand offerings such Enterprise Resource Planning (ERP); CRM software that helps to build profitable customer relationships; HR and payroll systems to improve employee performance and ensure legislative compliance; and payment processing solutions to keep money moving securely and efficiently. Sage prides itself on offering customers the freedom to choose how to use its software and services to meet the challenges presented by today's business environment.

Customer feedback is integral to the brand's product development cycle, while support

1981	1989	1997	1999	2004	2006/07
Sage is founded and headquartered in Newcastle upon Tyne.	Sage is listed on the London Stock Exchange.	The Pacs and Forecasting businesses are acquired.	Sage enters the FTSE 100 and acquires Tetra and Taxsoft.	The company moves to new global headquarters, but remains in Newcastle upon Tyne.	Sage enters the UK payment processing market through the acquisition of Protx.

businesses and larger organisations. Under the banner of 'Not just small business. All business', the campaign featured a number of its larger and well-known customers in online videos recommending Sage as a software solution provider. It also used key statistics to demonstrate the diversity of its customer base, including the fact that more than one-third of FTSE 100 companies use Sage to do business. The campaign helped to increase Sage's credibility in the mid-market and more than doubled the number of qualified sales opportunities.

service and aftercare are cornerstones of its success. Support is delivered by an experienced Sage team, and bolstered further by a UK network of 14,000 accountants, 1,000 developers and almost 500 business partners.

Achievements
In the past year Sage has accrued a host of industry accolades, from winning the Payroll Software category at the Software Satisfaction Awards, to being Best B2B Brand nominee at the B2B Marketing Awards 2010 and claiming a Revolution Award in the B2B category for trainyourbusinessbrain.com, a social networking campaign in partnership with LinkedIn. It was also recognised for its commitment to corporate social responsibility (CSR), picking up the prestigious European Contact Centre CSR Award 2010.

Sage recognises that its people make the difference and because of this, aims to make the company a positive and supportive place to work through initiatives such as its Guiding Principle Awards; the Sage 'Apprentice'; a new employee benefits programme; and a host of other CSR projects delivered in the local community.

Recent Developments
Sage recently revamped its UK website and in keeping with the brand commitment to put the customer experience at the heart of everything it does, the relaunch was based entirely on customer feedback. The website is integral to the brand's development not least because

Sage has a strong presence in all of the key social media channels; it is a well respected brand on Twitter and publishes a successful blog.

In regard to product advancements, Sage launched its global ERP product, X3, in the UK in 2010 and is also moving a significant number of products onto the cloud and mobile platforms, making access available via a BlackBerry or iPhone. Other key developments include the growing success of its payment processing business, Sage Pay and the launch of a dedicated HR Business Advice Service.

Promotion
With its brand identity recently refreshed, Sage took the opportunity to enter into the competitive television sector for the first time, sponsoring The Krypton Factor. Throughout 2009 and 2010 the hugely successful brand campaign centred on The Krypton Factor with an integrated media campaign that used search engine optimisation, pay-per-click advertising and social networking.

In association with sage

Building on its strong brand awareness in the SME market, Sage conducted a nationwide marketing campaign, including fully integrated online and print media advertising, to promote the fact that its customers are both small

Brand Values
The customer experience is at the heart of the Sage brand, supported by its guiding principles of simplicity, agility, innovation, trust and integrity – valued attributes that underpin the brand ethos. In acknowledging that ambition drives a business, the company also recognises that businesses can be overwhelmed by day-to-day operational practicalities. What differentiates Sage is its people – and their dedication to doing the right thing by the customer – and its commitment to supporting individual businesses to enable them to achieve their ambitions and potential.

Things you didn't know about Sage

More than six million businesses worldwide rely on Sage to help them manage their business.

Over one-third of FTSE 100 companies use Sage to do business.

Sage has almost two million conversations with its customers in the UK each year.

Sage's UK CEO calls one customer every day to find out what their experience of Sage is like.

2007/08	2008	2009	2010
Sage strengthens its position in verticals by acquisition, particularly in HR (Snowdrop), payroll (KCS) and construction (Tekton).	A new global brand is created.	The brand's first ever television sponsorship airs, with The Krypton Factor. The social network campaign, trainyourbusinessbrain.com, also launches.	Guy Berruyer is appointed Sage Group CEO from 1st October.

THE *Luxury Included* HOLIDAY

Since opening its first resort in 1981, Sandals Resorts has been at the forefront of the Caribbean all-inclusive travel sector by offering luxury, innovation and choice. In an industry brimming with new contenders, the combined knowledge and experience of Sandals' management team and resort staff has kept the company at the head of the expanding all-inclusive market by introducing the Luxury Included® holiday experience.

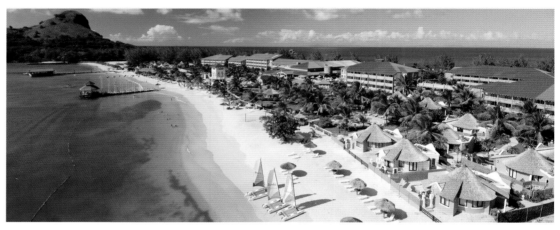

Market

In recent years the concept of luxury travel has steered away from conservative, off-the-shelf five-star packages towards tailor-made individualism. The market remains guest focused and it is people skills, along with an emphasis on personal choice, that Sandals Resorts sees as key in setting it apart from its competitors.

Right from the outset, the brand aimed to offer more; where others had inclusive meals and rooms at a set rate, Sandals' prices covered premium drinks, tips and taxes, in addition to all recreational and water sports activities, including scuba diving. Furthermore, while it was common within the market for meals to be served as buffets, Sandals built its reputation on gourmet speciality restaurants and white-glove service.

Sandals Resorts International (SRI) is now the largest operator of Luxury Included® resorts in the Caribbean. Currently there are 14 Sandals resorts aimed at 'two people in love' located in Jamaica, Antigua, St Lucia and the Bahamas, and four resorts belonging to its sister brand, Beaches, catering for everyone from couples to families and singles.

Product

Sandals prides itself on its top-of-the-range products, from à la carte restaurants and Beringer wines, to an extensive range of water

sports – Sandals Resorts is now one of the largest dive operators in the Caribbean. Its butler service, offered in partnership with the Guild of Professional English Butlers, represents the ultimate in luxury pampering: private in-suite check-in, unpacking and packing luggage, and catering to any special requests, such as a moonlit dinner or a soothing bubble bath.

Sandals was one of the first operators in the Caribbean to offer full-service spas. The exclusive Red Lane® Spas now feature prominently in all of its establishments; their scenic beachside locations and exotic indigenous treatments are an enduring signature of the brand.

Achievements

Both Sandals Resorts and the more family oriented Beaches Resorts continue to accrue industry awards that reaffirm the brand's leading position across the luxury travel market – for the last 14 years the brand has been voted the World's Leading All-Inclusive Company at the World Travel Awards.

1981	1985	1988	1993	1994	1996
Gordon 'Butch' Stewart buys a dilapidated hotel in Montego Bay, Jamaica. Despite no prior hotel experience he opens Sandals Montego Bay several months later.	Sandals unveils its signature swim-up pool bar, enabling guests to order refreshments without having to leave the swimming pool.	Sandals Negril opens its doors. Three years later Sandals becomes the largest operator of all-inclusive resorts in the Caribbean and opens its first resort in Antigua.	Sandals Regency St Lucia is launched in April, offering guests the opportunity to split their stay between two islands, Sandals Antigua and Sandals St Lucia.	WeddingMoons® is launched – a concept combining a holiday wedding with an inclusive honeymoon.	Sandals Royal Bahamian Resort & Spa opens. The following year the first Beaches Resort opens, Beaches Negril in Jamaica.

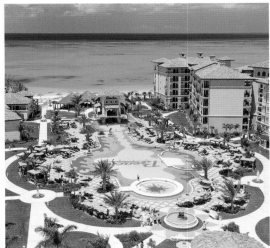

Further notable accolades in recent years include placements in Travel + Leisure Family's 2010 list of the Top 25 Best Hotels for Families in the Caribbean; Beaches Turks & Caicos Resort Villages & Spa took third place, while Beaches Negril Resort & Spa took fourth. Previously the brand also won at the 2008 TripAdvisor Travellers' Choice Awards, in which Beaches Boscobel Resort & Golf Club was recognised as one of the Top 10 Hotels for Families in the Caribbean and Latin America. A duo of Sandals Resorts, Sandals Royal Plantation and Sandals Whitehouse European Village & Spa, made it into the Top 30 Resorts in the Caribbean in Condé Nast Traveller's Readers' Choice Awards for 2010; an accolade that reinforces the brand's continued dominance within the luxury travel sector.

Recent Developments
Sandals recently introduced the concept of the Luxury Included® holiday with a collection of suites in Jamaica, Antigua, St Lucia and the Bahamas. The new experience features an extended range of premium services and amenities that include private plunge pools and Jacuzzi baths, as well as a selection of exclusive partnerships with the likes of celebrity designers Martha Stewart and golfer Greg Norman.

Continuing to expand the Luxury Included® concept, Sandals Emerald Bay has recently been added to the Sandals portfolio. Opening in Great Exuma, the Bahamas, it is an all-butler service

resort with exclusively designed championship golf course facilities.

In addition, in 2010 Beaches Resorts extended its newest collaboration with Martha Stewart Living Omnimedia to include Martha Stewart Craft Studio family activities at all four of its Beaches Resort locations. Beaches Resorts is also a sponsor of Sesame Street®, with an exclusive Caribbean Adventure Programme in which children benefit from character activities and weekly shows. Furthermore, Beaches Resorts collaborated with Microsoft® Xbox to create the Xbox 360 Game Garage Video Game Centres, and with the Scratch DJ Academy to offer exclusive programmes for their hard-to-please teen and 'tween' guests.

Promotion
Brand promotion comes in the form of a multimillion-pound advertising campaign that supports the efforts of travel agents and tour operators to market both the Sandals Resorts and Beaches Resorts brands. The campaign encompasses a broad range of media: flyers, property-specific brochures, posters, signage and window displays for travel agents, in addition to the more high profile television and ecommerce activities, consumer and trade advertisements, newspaper advertising and national billboards.

Sandals has often been recognised by the strong, vivid and colourful aesthetics that flow through its various media campaigns. However, this visual brand identity is evolving to suit global markets in the ever changing face of luxury world travel. The new brand image is more sophisticated and lifestyle focused, hence able to deliver the Luxury Included® ethos with more success.

Sandals Resorts and Beaches Resorts operate a sophisticated CRM programme, which includes a highly attractive loyalty scheme, Sandals Select.

Brand Values
Sandals is one of the best-known luxury resort brands in the world. It continues to build on its leading position in the Caribbean hotel industry with innovations such as the Luxury Included® concept, making it well positioned to address consumers' growing demands for luxury choices to be included in their package holiday. Throughout its history the company has striven to create the ultimate Sandals experience: luxury, service and uncompromising quality delivered in picturesque beachside locations.

Things you didn't know about Sandals

It took seven months and US$4 million to renovate the first Sandals Resort in Montego Bay to transform it into Sandals' flagship property.

Sandals was the first Caribbean brand to offer Jacuzzi baths, satellite television, swim-up pool bars and to equip every room with a king-size bed.

After some 30 years of philanthropic activities within Caribbean communities, SRI established The Sandals Foundation in 2009. Charitable efforts include volunteer projects, fundraising and donations from Sandals' chairman Gordon 'Butch' Stewart.

Sandals and Beaches have a strong ethical conscience. All their resorts in Jamaica, Antigua, St Lucia and the Bahamas are proud holders of Gold Travelife status, recognising their efforts for environmental sustainability in the region.

2004	2008	2009	2010
A butler service is introduced to Sandals' top suite categories – the ultimate all-inclusive pampering service.	Sandals Negril is the first hotel in the world to be awarded Platinum Certification by EarthCheck in recognition of more than 10 years' dedication to sustainable practices.	Beaches Turks & Caicos Resort Villages & Spa opens its Italian Village, including 162 family suites, five restaurants, a Scratch DJ Academy and 45,000 sq ft waterpark.	Sandals Weddings by Martha Stewart™ launches, Sandals Emerald Bay opens in February, and Royal Plantation Ocho Rios is rebranded as a Sandals Resort.

Santander has expanded considerably over the years to take it from its Spanish roots to become one of the world's biggest financial groups. It is the largest bank in the Eurozone by market capitalisation. With a business model forged on stability and customer relationships it is a solid, solvent bank with a strong balance sheet.

Market

Founded in Spain, Santander is now present in 10 core markets with around 14,000 branches globally, more than any other international bank. Even in difficult times Santander has continued to grow, requiring no government assistance and boasting a strong and stable balance sheet. It has a credit rating that is among the best in the world, being one of only four international banks with a rating of AA or above with three of the main credit ratings agencies (as at December 2010).

In the UK Santander has more than 1,300 branches and 25 million customers. Its sustained growth in revenue balanced against controlled costs resulted in half-year profit in 2010 of £875 million, up more than 10 per cent year-on-year.

Product

Santander continually strives to offer its customers relevant and value-for-money products. Innovation is an integral part of its strategy and this is encapsulated in 'Value from ideas', which reflects Santander's ongoing commitment to always seeking the best ideas.

In retail banking Santander is one of the largest mortgage and savings providers in the UK. The bank also provides bank accounts, credit cards, loans and a range of insurance products, pensions and investments. In 2010 it introduced the first current account in the UK with no fees and had more Best Buy mentions than any other bank.

In the UK its sub-brands encompass Abbey for Intermediaries, which deals directly with intermediaries and investment professionals; Santander Corporate Banking for small and

medium sized enterprises (SMEs); Cater Allen private banking and investments specialists; and a stand alone internet banking service operating as cahoot.

Achievements

Santander's commitment to providing efficient and competitive services has seen it claim a host of awards, with recent UK honours including Personal Finance Provider of the Year 2010 from MoneyFacts; Best UK Bank 2010 from Euromoney, for the third year running; and Banker magazine's Best Bank in the UK, for the second year running. It also won a Marketing Effectiveness Award for Best Integrated Consumer Campaign at the 2010 Financial Services Forum Annual Awards, for the company's highly successful, integrated communications campaign, which heralded the arrival of Santander to the UK high street.

Santander's corporate social responsibility (CSR) programme is based on six central tenets: providing customers with the best products and services; profitability and transparency for

1857	1950s	1994	1999	2004	2007
Banco de Santander is established in the city of Santander in northern Spain.	It opens branches in Latin America and European cities including London.	Santander acquires Banco Español de Credito – Banesto.	Santander expands further in Brazil, Mexico and Portugal.	It acquires Abbey and gets a presence in the UK market.	The bank acquires Banco Real in Brazil.

shareholders; professional development and work/life balance for employees; mutual respect and transparency with suppliers; financial and social development in society; and having firm policies in environmental protection.

Santander believes that investing in education and research is the most powerful means of promoting the development and prosperity of society. In line with this, 2009 saw 85 per cent of its staff involved in some element of learning, translating to a total of 152,057 staff training days.

The company launched the Santander Universities network in 1996, encompassing more than 900 academic institutions in 22 countries, including 42 universities in the UK. It invested 126 million euros in CSR in 2009 and over the years, has signed agreements with more than 900 universities to provide more than 14,000 students and researchers with scholarships and grants.

Through the Santander Foundation it also provides donations to charities and in 2010, gave more than £3 million within the UK, with staff-led Community Partnership Groups deciding where the funding for their region should go.

Recent Developments

2010 was a crucial year for Santander in the UK. The company underwent a rapid expansion with the integration and rebranding of the Abbey, Bradford & Bingley and Alliance & Leicester businesses. At the same time the service provided to new and existing customers continued to remain a priority.

Santander is committed to growing its business and in August 2010 reached an agreement to acquire 311 RBS branches in

England and Wales, seven NatWest branches in Scotland, 40 corporate centres and around two million retail, SME and corporate customers. The acquisition strengthens both its retail banking business and its presence in the SME sector.

Promotion

The launch campaign for Santander in the UK in January 2010 was recognised as being the most successful in financial services advertising. The campaign adopted a holistic approach as well as a new creative concept. The Red Bricks campaign was developed to represent Santander's strength and stability, enabling the creation of a clearly branded campaign to showcase the bank's products and services across any channel. The new

strapline, 'Together. We are Santander.' shows to staff, customers and consumers that Santander recognises the benefits of working and building a future together.

Sponsorship is an integral part of the brand's communications strategy and the majority of its focus since 2007 has been on Formula 1 sponsorships including a five-year deal to 2014 as Official Bank to Scuderia Ferrari; the 2010 Corporate Partner of Vodafone McLaren Mercedes; and title sponsorships of the British, German and Italian Grand Prix.

Brand Values

Santander's overall vision is to be the best commercial bank in the UK. The company adheres to six corporate values: dynamism, strength, innovation, commercial drive, leadership, and ethics and sustainability.

Santander's customers are at the heart of everything it does. Its strategy is to reward its loyal customers with even better value products, constantly looking for ways to make banking work better for them, never taking them for granted, and giving them a compelling reason to do more business with the bank.

We are Santander.
Our strength and stability is built on the relationship we have with our customers.

together

Together. We are ◆ Santander
VALUE FROM IDEAS
santander.co.uk

Things you didn't know about Santander

Santander has a relationship with 25 million customers in the UK.

The Santander Zero account was the first current account in the UK with no fees.

One in five mortgages in the UK is provided by Santander (December 2010).

Santander has more branches than any other international bank.

Santander invested 126 million euros in CSR in 2009.

2008	2009	2010	
Also in 2007, Santander celebrates its 150th anniversary and is the 12th largest bank by market capitalisation.	Santander acquires Bradford & Bingley and Alliance & Leicester.	It acquires Sovereign Bank in the US.	Abbey and Bradford & Bingley are rebranded to Santander, followed at the end of the year by Alliance & Leicester.

SIEMENS

As a leading global engineering and technology services company, Siemens provides innovative solutions to help tackle the world's major challenges, across the key sectors of industry, energy and healthcare. Established more than 160 years ago, Siemens plc now employs around 16,000 people in the UK. Revenues for the year ending 30th September 2010 were £4.1 billion.

Market

In the UK, Siemens provides essential services across three key sectors of the economy – industry, energy and healthcare – including maintaining fleets of electric and diesel trains and providing solutions for the NHS. In 2009 the company invested £63 million in research and development in the UK.

The company's global headquarters are in Munich, Germany but Siemens has offices and factories at more than 100 locations throughout the UK. Around 5,000 of its 16,000 UK employees work in manufacturing.

Siemens is the leading supplier of offshore wind turbines in the UK and installed its 1,000th wind turbine in March 2010 at the Gunfleet Sands wind farm. More than 40 per cent of the electricity from wind power in the UK is generated using Siemens technology. In 2010 global income from the Siemens environmental portfolio totalled slightly less than 28 billion euros.

In other sectors its performance is also strong. For example, in the healthcare sector Siemens is an integrated healthcare business with innovative solutions in imaging, workflow and diagnostics. Siemens is also the most experienced managed equipment services (MES) provider in the UK healthcare market.

Product

The Siemens product portfolio including its environmental portfolio is divided into: industry, energy and healthcare.

Siemens Industry is a leading supplier of automation, transportation, building and lighting technologies. In nearly every area of life in which technology plays a role, Siemens is at the forefront, offering knowledge, products and solutions; from intelligent factories and buildings, networked transportation systems, lamps and light-emitting diodes, to water and wastewater treatment products and electronic drives.

In energy, Siemens is the only company worldwide with the know-how and technologies along the entire energy conversion chain, from the production of oil and gas, to power generation and the transmission and distribution of electrical energy. Siemens is a leader in renewable energy technologies; wind power, biomass and solar as well as efficient conventional power generation and transmission. It is also pioneering sustainable technologies, including smart grid, e-mobility and smart energy management.

Siemens Healthcare provides solutions to increase efficiency and improve patient care

1843	1853	1858	1873	1984	1989
The 19 year-old William Siemens arrives in England to sell the rights to his brother Werner's electro-plating technique.	Sir William Siemens takes over the running of the UK business, which primarily involves the selling of water meters.	The independent company known as Siemens, Halske & Co. is set up with its own workshops. It is renamed Siemens Brothers in 1865.	The first Atlantic cable is laid by Siemens Brothers, with the Faraday cable steamer built specially for this purpose.	A Siemens sales company is founded under the name Siemens Ltd.	The Plessey Company is taken over jointly by Siemens and General Electric Company.

along the patient pathway. The company is pioneering new innovations such as the world's first fully-integrated PET MR system, the Biograph mMR, and low-dose computed tomography (CT) imaging.

Achievements

Siemens is actively engaged with the CBI on issues such as climate change and skills and education. The company aims to be best in class for corporate governance, compliance, climate protection and corporate citizenship.

Projects supported by Siemens include Caring Hands – an initiative that helps employees get

subjects. A revival of the apprenticeship route to engineering careers in the UK sees more than 142 UK apprentices currently working at Siemens, with more planned for the future.

The company has also instigated sustainability programmes to increase recycling, reduce energy consumption and to minimise the amount of waste that goes to landfill sites.

Recent Developments

In the past two years, the company has invested £8 million in an Energy Services Centre in Newcastle, which includes £3 million for a Wind Power Training Centre at the same

Siemens is a principal sponsor of the Science Museum's climate science gallery, 'atmosphere...exploring climate science'. The new gallery aims to make sense of one of the biggest issues today, climate change, in an interesting and engaging way.

Brand Values

The Siemens brand values are to 'achieve the highest performance through the highest ethics'. The company's three central tenets are to be committed to ethical and responsible actions; to achieve high performance and excellent results; and to be innovative to create sustainable value.

involved with volunteering, disaster relief and social giving during their leisure time – and Generation 21. The latter supports young people to gain knowledge and skills through initiatives such as the Sir William Siemens Medal Programme, which recognises top performing engineers at universities and schools.

Siemens realises that young people are the drivers of economic development and actively demonstrates its commitment to enthuse young people in science and technology

location. In addition, a total of £80 million is being invested in a new Siemens wind turbine facility in the UK.

The UK is also set to benefit from an innovative new Siemens train designed for this country's rail network. The Desiro City is 25 per cent lighter than current rolling stock and can reduce energy consumption by up to 50 per cent.

Continuing its focus on sustainability, plans are underway for Siemens to build a £30 million Urban Sustainability Centre in East London as part of the Green Enterprise District by spring 2012. Designed to be a global showcase of low carbon urban technologies – and a visitor attraction – it will include an exhibition space, education facilities and a 300-seat auditorium.

Promotion

Siemens is High Performance Partner to the GB Rowing Team until the end of 2012. It also sponsors the team's Start programme, a talent identification and development initiative looking for elite athletes of the future.

Things you didn't know about Siemens

More than one million people cross the road safely every day thanks to Siemens Traffic Solutions technology.

Red Bull Racing uses Siemens PLM software to design its F1 car. Siemens is also helping the team to reduce energy usage in its facilities and to improve the operational efficiency of manufacturing processes.

Siemens makes and maintains Heathrow Express trains, which carry 16,000 passengers each day between Paddington railway station and Heathrow Airport.

Every day its medical equipment screens 15,000 women in the UK for breast cancer.

More than one-third of the UK's mainland electricity supply is generated using Siemens equipment.

Siemens technologies connect 75 per cent of all onshore and offshore wind farms in the UK to the National Grid.

2005	2008	2009	2010
Siemens wins an order for the delivery of medical systems for both the Barts and Royal London hospitals.	In London, Siemens and McKinsey publish a study on sustainable infrastructure.	Siemens helps develop the world's first floating wind turbine, Hywind, enabling turbines to be installed in even deeper waters offshore.	Siemens invests in the UK's first tidal turbine to extract energy from tides around the UK; it is located in Strangford Lough, Northern Ireland.

Silentnight is a mass-market brand with a wide consumer profile and is continually updating its product range to give consumers a comfortable night's sleep. As the UK's largest manufacturer of branded beds Silentnight is synonymous with its Hippo and Duck characters, first created to demonstrate the unique 'no roll together' property of its beds.

Market

The last five years have seen considerable changes in bed retail. Traditional independent bed retailers and national bed specialists have been challenged by new entrants to the market, such as supermarkets and DIY stores, while a significant online retail presence has also developed, reflecting a wider trend for internet shopping. With twice the market share of its nearest rival, Silentnight Beds is the UK's number one in beds and mattresses and has a strong and growing presence in the bedding market. Spontaneous brand awareness is 34 per cent, rising to 83 per cent for prompted brand awareness.

Product

In the 1980s Silentnight launched a new spring system to the UK bed market. What later became known as the Miracoil® spring system was an innovative continuous coil of springs with three unique selling points: no roll together, no roll off, and extra back support in the centre third of the mattress.

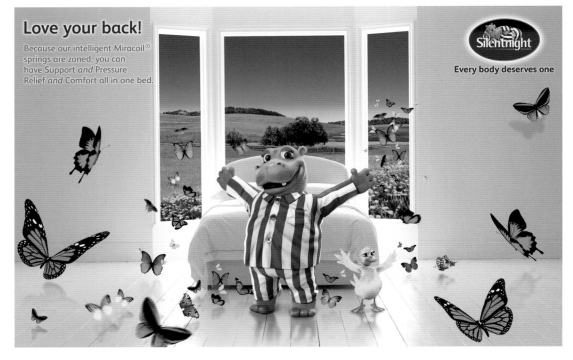

Love your back!
Because our intelligent Miracoil® springs are zoned, you can have Support and Pressure Relief and Comfort all in one bed.

Silentnight
Every body deserves one

For more than 20 years Miracoil® has been the bedrock of the Silentnight business and the core component of its range. In 2009 Miracoil®3 was launched, with stronger emphasis on the three zones in the spring system and the benefits of lower back support and pressure relief. An advanced sister range followed; Miracoil®7 offers seven support zones for 'total body relaxation', with targeted support for the lower back, softer areas for shoulders, and more advanced materials such as Cirrus Airflow fabrics that help maintain a comfortable sleeping temperature.

A growth in mattress purchases coupled with demand for instantly available products and the entry of general retailers to the bed market, led Silentnight to launch Mattress Now® in 2008. A full size memory foam mattress, it is tightly rolled, shrink-wrapped and boxed for immediate sale and 'take away now' convenience.

In recent years the brand has successfully diversified into pillows, duvets, mattress protectors, electric blankets and mattress toppers through a licensee agreement with bedding manufacturer Comfy Quilts. Silentnight Beds has additional licensing agreements that give it a presence in the sofa bed and cot mattress markets in the UK, as well as an international presence.

Achievements

Silentnight Beds is a full member of the Furniture Industry Sustainability Programme (FISP) set up by the Government and based around sustainable development. In order to become a member of FISP the brand has shown a commitment to social, economic and environmental sustainability across the

1946	1949	1986	2008	2009	2010
Tom and Joan Clarke form Clarke's Mattresses Ltd in Skipton, North Yorkshire.	As demand grows, the company relocates to a larger manufacturing site in Barnoldswick.	The Ultimate Spring System launches – the first new spring system in the UK for more than three decades – and the brand icons, Hippo and Duck, are first introduced.	Silentnight's first 'convenience' mattress, Mattress Now®, launches.	Miracoil®7 and PocketZing® launch, and the CGI Hippo and Duck are introduced.	Silentnight returns to television screens with sponsorship of American Idol.

business. As part of a wider commitment to sustainable manufacturing, the business, which uses timber, cardboard and paper in the manufacture and packaging of divan bases, has also recently achieved FSC accreditation.

In 2010, Silentnight Beds received the Allergy UK Seal of Approval for all mattresses containing Purotex, a natural pro-biotic treatment. Purotex has been independently proven to be a highly effective natural treatment to reduce dust mite allergens.

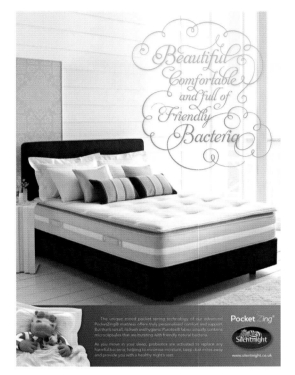

Recent Developments
In late 2009 Silentnight entered the pocket spring sector of the bed market – an established market primarily based on traditional mattress and divan styles – with a new range, PocketZing®. The new concept offers improved pocket spring technology that enables a pocket spring mattress to be zoned to support different parts of the body in different ways.

The new pocket springs are also more independent than traditional pocket springs, enabling every spring to properly support the body – meaning a Silentnight PocketZing® mattress has been designed to offer the ultimate in pressure relief.

Promotion
When the main Miracoil® product range underwent a facelift in 2009, Hippo and Duck, the faces of Silentnight since the 1980s, also received a makeover and were reanimated using state-of-the-art computer-generated imagery (CGI). The CGI Hippo and Duck were central to new brightly coloured point of sale materials that supported the Miracoil®3 and Miracoil®7 ranges and were rolled out to retail stores throughout 2009.

Heavy investment continued throughout the year, ensuring that the new Hippo and Duck characters and the Miracoil®3 and 7 graphics were seen as widely as possible. CGI animations were also created for use online to support the new ranges.

In early 2010 Hippo and Duck made their first television appearance since the early 2000s as Silentnight began a 19-week campaign sponsoring ITV2's American Idol. With a mass-market profile, American Idol resonates well with Silentnight's target audience and the long-running campaign delivered 23 opportunities to see among 25–45 year-old C1 and C2 women.

The television campaign was fully supported with promotional and online activity, such as Bedroom Divas, a competition in which entrants uploaded videos of themselves singing along to favourite songs to win a trip to LA to see the live American Idol final.

Brand Values
The long heritage of the brand and the warmth and friendliness of Hippo and Duck ensure that the Silentnight brand performs well on consumer attributes of quality, comfort and trust. The business has consistently invested in its products, plant and marketing to ensure that it is at the forefront of bed manufacturing in the UK, offering the very best in products, service and delivery.

Things you didn't know about Silentnight Beds

Almost all Silentnight Beds are made to order – the huge warehouse can only hold three days' stock.

During the American Idol sponsorship campaign, 1,704 idents were transmitted, delivering four hours and 44 minutes of airtime for Silentnight.

The bottom of Silentnight employee, Mr Graham Butterfield, has been insured for £1 million – he is the brand's official 'Bed Bouncer'.

Silentnight brand ambassadors have included Myleene Klass, Holly Willoughby, Lisa Snowdon and most recently, Kelly Brook.

Silver Cross is passionate about offering parents the highest levels of quality, baby comfort and safety, coupled with chic, contemporary design. A British brand with more than 130 years of heritage, Silver Cross now operates not only in the UK, but also sells products throughout the world, offering fashionably designed prams and pushchairs, child car seats, nursery toys and new for 2010, furniture and bedding.

Market

The UK baby market, which is defined as households with babies and children under the age of four years old, is currently worth an estimated £1 billion. Already a world leader in the design, development and production of high quality nursery products, Silver Cross is continuing to gain an increased share of the nursery goods market. Indeed, the particular focus for the brand in 2010 was to offer new parents across the globe a truly international selection of quality nursery products, and this continues throughout 2011.

Product

All Silver Cross products are created by in-house designers and product development specialists in its UK head office, and aim to make consumers' lives as simple as possible.

The highly acclaimed travel collection comprises a wide range of modern prams and pushchairs including the recently launched,

revolutionary Surf – an all-terrain from-birth pram system with state-of-the-art air sprung suspension and ultra compact fold. In addition, the Silver Cross travel collection includes three of the UK's best-selling pram and pushchair combinations in the class: Sleepover, Freeway and 3D. The larger pram systems are joined in the collection by Silver Cross' lightweight strollers: Halo, Dazzle, Fizz and the best-selling Pop, which continues to offer unsurpassed build quality and style at an affordable price.

There are five car seats in the Silver Cross collection: the multi-award-winning Ventura Plus group 0+, which combines with all Silver Cross prams to make travel systems; the Explorer Sport, a two-stage car seat that grows with the child; the Explorerfix, which uses a push–click ISOFIX installation; the Navigator,

a fully adjustable group 2–3 car seat; and the Navigator Fix, Silver Cross' latest ISOFIX group 2–3 seat for older children.

The world famous Heritage Collection features two traditional coach-built prams. The Balmoral pram has become a global style icon, highly favoured by the Royal Family and A-list celebrities; it sets the highest standard for handmade luxury. In addition, the Silver Cross Kensington pram comes from the same line and is defined by a sweeping, curved, hand-painted steel body and highly polished chrome chassis. All Heritage prams are handmade to the same high standards employed in the 19th century. Each comes with an individually numbered plaque and certificate of authenticity, including the craftsman's signature. The Silver Cross children's Heritage toy range includes exact miniature replicas of the full size Balmoral, and the Cottingley and Oberon dolls prams.

Three new toy collections were created in 2009, featuring classic teddy bears and rag dolls, a range of owl and pussycat themed nursery gifts, and a soft activity collection that develops young children's key skills.

Achievements

Silver Cross' leading British design and high manufacturing quality continues to be put through its paces by parents across the country, with the brand's travel collection winning numerous high profile parenting magazine awards – proof of the affection parents hold for Silver Cross.

The brand's popularity in the UK has aided growing recognition of its products

1877	1920s–30s	1951	1977	1988	2002
Silver Cross is founded by William Wilson, a prolific inventor of baby carriages who created a reputation for producing the world's finest carriages.	Silver Cross becomes incorporated and is crowned the number one baby carriage for royals, supplying its first baby carriage to George VI for Princess Elizabeth.	Silver Cross launches a new shape; the forefather of the Balmoral, it becomes synonymous with the name 'pram'.	Silver Cross celebrates its centenary by flying customers and buyers around the world in its new centenary aircraft, and by presenting a baby carriage to Princess Anne.	The Wayfarer is launched. It becomes Britain's best-selling pushchair for a decade, selling more than 3,000 per week.	Entrepreneur and businessman Alan Halsall purchases Silver Cross and relaunches the famous Balmoral.

internationally. With distributors operating across the world, Silver Cross products can now be seen in cities as diverse as Tokyo, where their lightweight strollers are particularly popular; Moscow, where the Sleepover has been a notable success; and Melbourne, where the new Surf has been a hit.

Recent Developments

During 2010 Silver Cross continued to drive forward with modern designs. A lightweight pushchair – Zest – is the latest addition to the travel collection, offering an ultra lightweight option to complement the successful Pop.

In a bold new venture, Silver Cross has also launched a new furniture, bedding and décor collection: an exclusive range for the nursery that has been meticulously built to Silver Cross' high standards. The furniture collection features three wooden styles – Devonshire, Nostalgia and Porterhouse – and is designed to grow alongside a child, from cot to junior bed, thus giving years of service. It also offers a full size wardrobe and dresser/changer. A new Silver Cross home delivery service adds a further dimension of customer care to the collection.

The three new styles of bedding and décor – Classic, Cherished and So Pretty – have been developed by top Silver Cross designers. Combining quality fabrics, trims and embroideries, the ranges are not only durable and practical, but appealing as well.

2011 will also see a further expansion of Silver Cross' soft activity toys, with the Riverbank collection providing a new range of fun, educational toys based on animal characters.

Silver Cross has a long history of charity work and the latest project is the funding of two bursaries at the Genesis Research Trust.

Under the leadership of Lord Robert Winston, the Genesis Research Trust is involved in cutting-edge medical research into the prevention of premature birth.

Promotion

Silver Cross invests heavily in marketing, with consumer advertising featuring in lifestyle and parenting titles; a presence at major nursery trade events and consumer shows; in-store point of sale promotions; and extensive online activity. This online activity includes the successful use of Facebook and Twitter as well as the Silver Cross blog pages, through which

customers and followers can interact with the brand on a daily basis.

Silver Cross communicates about its products in a straightforward, frank and honest way. Indeed, its strongest marketing tool has always been word-of-mouth. From trendsetters in the film and music world to everyday British mums, the brand is endorsed by those who have first-hand experience of Silver Cross products.

Brand Values

Silver Cross is one of the UK's most loved and established brands. In 2011, more than 130 years after its launch, Silver Cross still stands for elegance, fashion and cutting-edge British design. It strives to be known worldwide for its experience and passion in producing stylish and innovative products that deliver genuine value for money while making the lives of modern parents easier.

Things you didn't know about Silver Cross

Founded in 1877, Silver Cross is the oldest nursery brand in the world.

Silver Cross prams have been used by royalty for nearly 100 years; it supplied its first baby carriage to George VI for Princess Elizabeth.

More than 1,000 individual hand operations are required to manufacture each Balmoral pram.

Silver Cross sells prams in more than 30 countries worldwide.

2006	2007	2009	2010
Silver Cross goes global, forging partnerships with distributors in Europe, America, Canada and Japan.	Silver Cross launches its Home Collection and the combination stroller, Dazzle. The following year the lightweight stroller, Fizz, launches.	Silver Cross launches the Halo pushchair, Halo Rocker, Doodle high–low chair, and ranges of soft activity and gift toys. Silvercross.co.uk becomes a fully transactional online shop.	Silver Cross launches the Surf pram and pushchair, and the Studio Collection of furniture and bedding. The brand expands online, with a blog and presences on Facebook and Twitter.

SKANSKA

Skanska UK has operations in building, civil and ground engineering, utilities, infrastructure services and facilities management, mechanical and electrical engineering, PFI/PPP, and a range of specialist skills. Skanska integrates its core in-house disciplines to create solutions across its chosen markets, working with its clients, partners and supply chain to make a difference to the way construction is delivered.

Market

Skanska is one of the world's leading project development and construction groups with expertise in commercial and residential projects as well as public–private partnerships. The Group currently has 55,000 employees across Europe, the US and Latin America, of which approximately 5,000 are in the UK. Headquartered in Stockholm, Sweden and listed on the Stockholm Stock Exchange, Skanska's sales in 2009 totalled £11.4 billion.

The Group's operations are based on local business units, which have good knowledge of their respective markets, customers and suppliers. These local units are backed by Skanska's common values, procedures,

financial strength and Group-wide experience. Skanska is thereby both a local construction company with global strength and an international constructor and developer with strong local roots.

Product

In the UK, Skanska carries out all aspects of the construction, development and infrastructure process – from financing, design and construction right through to facilities management, operation and maintenance. UK construction operations include building, civil engineering, utilities and infrastructure services, piling and ground engineering, mechanical and electrical, ceilings and decorative plasterwork, steel decking and the

delivery of ModernaHus, Skanska's low energy residential solution.

The company works on a number of major projects each year in both the private and public sector and has undertaken some of the most technically challenging schemes across the UK. Most recently these have included the London landmarks 30 St Mary Axe (the Gherkin) and Heron Tower, which is the tallest new building in the City. Skanska is also responsible for the redevelopment of Barts and The London hospitals, as well as key motorway widening projects such as the M1 Junctions 6a–10. In a joint venture, Skanska is also undertaking the M25 Design Build Finance and Operate contract.

Skanska took on the UK's first private finance initiative (PFI) scheme in the late 1980s: the Queen Elizabeth II Bridge. Now a UK leader in PFI schemes, its portfolio is in excess of £3 billion and covers healthcare, education, defence, transportation and street lighting.

Although it is known mainly in the UK for its large high profile schemes, Skanska

1887	1927	1965	2000	2009	2010
Aktiebolaget Skånska Cementgjuteriet, later renamed Skanska, is founded by Rudolf Fredrik Berg.	Sweden's first asphalt-paved road is constructed in Borlänge in central Sweden – a milestone in Skanska's role in building Sweden's infrastructure.	Skanska is listed on the Stockholm Stock Exchange.	Skanska enters the UK construction market by acquiring Kvaerner's construction business, which had previously been part of the Trafalgar House Group.	Skanska announces it aims to be the leading green constructor and developer.	Skanska celebrates a decade of operations in the UK and announces it will establish a UK Residential Development Business.

It achieves this through the performance and behaviour of its people – Skanska people are 'team players who care and want to make a difference to the way construction is delivered' – and the creation of projects that its staff, clients, partners and the communities in which it works, are proud of. Every office and major Skanska construction site in the UK is planned using a bespoke approach according to its specific needs, creating a 'shop window' for the company's visual brand identity.

Brand Values

Skanska's key responsibility is to develop and maintain an economically sound and prosperous business. It is committed to the countries, communities and environments in which it operates, and at the same time, its employees and business partners.

Skanska stands for technical know-how and competence combined with an understanding of its customers' needs. The ability to apply these skills to new areas enables it to produce the innovation that its clients demand. Skanska aims not only to develop, build and maintain the physical environment for living, working and travelling, but also to be the leading green developer and constructor. By achieving this, Skanska believes it will be the client's first choice in construction-related services and project development.

also undertakes smaller projects such as public realm improvements, hard and soft landscaping, and utilities projects covering gas, electricity and water.

Skanska's focus is on creating sustainable solutions and it aims to be a leader in green construction, health and safety, and business ethics. Skanska acknowledges that almost everything it does affects both the environment and the lives of people in the communities in which it operates, both now and in the future. It employs community liaison managers to work closely with those communities, keeping them fully informed of the activities on Skanska sites. The company also employs local labour and trade contractors wherever possible.

Skanska runs its projects strictly in accordance with the Skanska Code of Conduct and the 'five zeros': zero loss-making projects, zero accidents, zero environmental incidents, zero ethical breaches and zero defects.

Achievements

The company's commitment to contributing to a more sustainable world is resolute. Skanska was named the UK's leading Green Contractor in The Sunday Times 2010 Best Green Companies list

and achieved second place across all industries. It seeks to use its position to influence clients as well as its supply chain to make more sustainable decisions, taking a longer-term view over the infrastructure it develops.

Skanska is proud of its third-party recognition, which it considers a true measure of the value and performance of the company and the brand. In the last few years, Skanska has received more than 100 external awards not only for the projects it has constructed, but also for key areas of its performance including health and safety, the environment and sustainability. 2010 not only saw Skanska receive a string of awards from the Considerate Contractors Scheme, amongst other accolades, but also saw the brand achieve Business Superbrands status for the fourth consecutive year and continue to improve its year-on-year ranking.

Recent Developments

Skanska UK undertakes approximately £1.5 billion worth of work each year and prides itself on being able to draw on a combination of the best in British engineering with the best in Swedish innovation and design. The company works throughout the UK, integrating the skills of its operating units in a collaborative style in order to provide a construction service to its clients that delivers real benefits.

In 2010, notable projects included a world-class cancer centre for University College London Hospitals; the completion of a number of schools in Bristol under the UK's first Building Schools for the Future (BSF) programme; Heron Tower, the tallest building in the City of London; and entering a new PFI market – street lighting.

Promotion

While the company does occasionally promote its services and skills in the traditional way with advertising and exhibitions, this is secondary to the way in which the company prefers to be seen and recognised. Rather, Skanska is focused on being truly recognised for the way it lives up to its brand values.

Things you didn't know about Skanska

Skanska's first international order was placed by Great Britain's National Telephone Company in 1887.

Skanska is the only Swedish contractor in the UK.

Globally, Skanska undertakes about £11 billion of work a year.

In 2010, Skanska took second place in The Sunday Times Best Green Companies awards across all industries and was named the UK's leading Green Contractor.

Miniland London at LEGOLAND Windsor was built with the help of Skanska.

Quality of Daily Life Solutions

Sodexo UK and Ireland is a leading provider of Quality of Daily Life Solutions for its clients in the corporate, education, healthcare, leisure, defence, justice and remote sites sectors. Its 43,000 people at more than 2,300 locations have the professional expertise to deliver its diverse range of On-site Service Solutions, while Motivation Solutions provides benefits such as SayCare childcare vouchers and SayShopping vouchers.

Market

The Sodexo Group is the world leader in Quality of Daily Life Solutions. Its 380,000 employees in 80 countries provide an unrivalled array of service solutions through its unique offer of On-site Service Solutions (previously food and facilities management services) and Motivation Solutions (previously service vouchers and cards).

With relatively low outsourcing rates in many of the markets in which it operates, Sodexo's activities offer considerable growth potential, with estimated markets of more than 650 billion euros in On-site Service Solutions and more than 130 billion euros in issue volume for Motivation Solutions. The Group is listed on Euronext Paris.

With an annual UK turnover of approximately £1 billion, Sodexo leads the way in creating added value for its clients and in its ability to support them in resolving their business challenges and achieving their objectives. Organisations are increasingly recognising the benefits of outsourcing many of their activities to one supplier, and although Sodexo's heritage is built on its catering expertise, today more than 50 per cent of its turnover comes from other services.

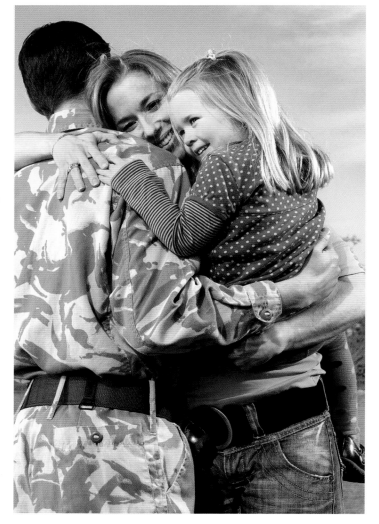

Product

Sodexo believes that quality of life plays an important role in the progress of individuals and the performance of organisations. As a strategic partner to businesses and organisations, it creates, delivers and manages comprehensive Quality of Daily Life Solutions that improve performance in three areas: people – increasing satisfaction and motivation by helping them to be more effective at what they do; processes – enhancing quality, efficiency and productivity; and infrastructure and equipment – optimising asset utilisation, profitability and reliability, and contributing to the attractiveness of living and work environments.

Achievements

Sodexo is proud of its many achievements and for being recognised as a responsible global business.

In the UK, Sodexo has achieved Silver status for the fourth year running in the Business in the Community Corporate Responsibility Index, as published in the Responsible Business supplement in the Financial Times in June 2010. In the same year, Sodexo's food manufacturing business, Tillery Valley, was awarded the Carbon Trust Standard.

Also in 2010, Sodexo was named one of the World's Most Admired Companies by FORTUNE Magazine and ranked first in the US DiversityInc Top 50 Companies for Diversity® list. It marked the fifth consecutive year that Sodexo was ranked in the top five companies of the Global Outsourcing 100® and the third year in a row that it was the highest-ranked company in the Facility Services category. Furthermore, Sodexo was recognised for the sixth time by the Dow Jones Sustainability Index as the global leader for its industry segment.

1966	1971–78	1983	1985–93	1995	1997
Pierre Bellon launches Sodexo in Marseille, founded on the Bellon family's experience of more than 60 years in maritime catering.	International expansion begins with a contract in Belgium. Development of the Remote Site Management business takes place, first in Africa, then in the Middle East.	An initial public offering of Sodexo shares takes place on the Paris Bourse.	Sodexo establishes activities in the Americas, Japan, South Africa and Russia, and reinforces its presence in the rest of central Europe.	Sodexo becomes the world market leader in food service, thanks to alliances with Gardner Merchant in the UK and Partena in Sweden.	The group's holding company changes its name to Sodexo Alliance. The following year, Sodexo Marriott Services is founded – Sodexo holds 48.4 per cent of the outstanding shares.

Recent Developments

Sodexo has recently formed successful joint ventures to further develop its suite of On-site Service Solutions. Rugby Travel & Hospitality Ltd, a partnership between Sodexo UK and Ireland and the Mike Burton Group, has been awarded the contract to create, implement and market the official travel and hospitality programmes for the Rugby World Cup 2015 and 2019 tournaments in England and Japan, respectively.

Integrated Pathology Partnerships, Sodexo's joint venture with Labco – the first of its kind in the UK – has been formed to enable UK health care organisations to deliver cost-effective pathology services.

Promotion

Sodexo's mission is to improve the Quality of Daily Life for the people it serves and contribute to the economic, social and environmental development of the areas in which it operates.

In 2010, Sodexo celebrated the 25th anniversary of Healthwise, the company's nutrition, well-being and lifestyle philosophy. Healthwise provides guidance and advice to help employees, clients and customers make informed choices about how to achieve a balanced and healthier lifestyle. Introduced in 1985, it has been embedded across all of Sodexo's business areas and has since become central to Sodexo's approach to procurement, its kitchen practices and its menu planning. Latterly, Healthwise is increasingly in step with the UK Government's stated ambitions to combat obesity and promote healthy eating and exercise.

In November 2009, the Sodexo Group reinforced its commitment to sustainable development with the launch of the Better

Tomorrow Plan, a strategy stretching to 2020 that aims to consolidate Sodexo's sustainability performance and provide a framework within which to measure the impact of the company's actions worldwide. Through this 10-year sustainable development strategy, Sodexo is committing to continuous improvement through a challenging but robust and structured approach.

The Better Tomorrow Plan is built around three pillars: 'We Are', which embraces values and ethics; 'We Do', which sets out 14 commitments to action on sustainability challenges; and 'We Engage', which recognises the stakeholder dialogue required to translate commitments into action.

The 14 key commitments span three areas of focus: nutrition, health and wellness; local communities; and the environment. For each, Sodexo is developing phased plans and indicators to measure the degree of implementation and impact across the business.

The plan's approach is collaborative, encompassing Sodexo's employees, clients, suppliers and non-governmental organisations to deliver its commitments. The plan is a long-term process and progress is to be reviewed in 2012, 2015 and 2020.

Brand Values

Sodexo views its values as the foundation of its success – both in the past and for the future. In pursuing its strategic goal to become the global expert in Quality of Daily Life Solutions, three enduring values guide Sodexo's business and its 380,000 employees: service spirit, team spirit and the spirit of progress. These values reflect the brand's aim to grow organically while contributing to the development of countries in which it operates.

Things you didn't know about Sodexo

In 2010, Sodexo served 103,000 bottles of champagne during the five days of Royal Ascot.

Sodexo has extensive experience in the Private Finance Initiative market and is involved in 24 projects across the defence, healthcare, education and correctional services sectors.

At Colchester Garrison in the UK, Sodexo Defence staff clean around 50,000,000 sq m per year.

Sodexo's STOP Hunger campaign spans more than 30 countries: in 2010, Sodexo employees helped collect more than 175,000kg of food for associated charities around the world.

In the UK, Sodexo is the only foodservice organisation to hold Red Tractor corporate membership.

2005	2008	2009	2010
On 1st September 2005, Michel Landel becomes chief executive officer while Pierre Bellon continues as chairman of the board.	Sodexo Alliance becomes Sodexo and a new modern, dynamic logo is adopted globally.	Sodexo launches its sustainability strategy, the Better Tomorrow Plan, which provides a framework to measure the impact of the company's actions worldwide.	Sodexo celebrates the 25th anniversary of Healthwise, the company's nutrition, well-being and lifestyle philosophy.

Stannah

When Joseph Stannah started his crane and hoist manufacturing business in the 1860s he laid the foundations of one of the UK's most trusted lift companies. Today, working from UK headquarters in Andover, Stannah manufactures and distributes a comprehensive product portfolio. It is the world's leading stairlift provider and a UK leader in passenger lifts, vertical platform lifts, and lift and stairlift servicing.

Market

Stannah aims to improve people's lives and work by making moving between floors a smoother, more straightforward experience. Customers range from the likes of large supermarkets that need a moving walkway or passenger lift to improve access, to individuals who can no longer climb the stairs and require a stairlift. Its products encompass its well-known stairlifts, through to premium passenger, platform and goods lifts, to escalators and moving walkways.

Stannah crafts its products with the aim of making them as practical as possible: safe, reliable, flexible, durable and good value. It is this dedication to providing the best products that has allowed Stannah to become a leading player in all of its target markets. Indeed, a 2010 study by Hall & Partners showed Stannah continuing to dominate the stairlift market in terms of brand awareness.

The Stannah Group now has a turnover of £183 million and operates in more than 40 countries including the US, France, Holland, Italy and Germany.

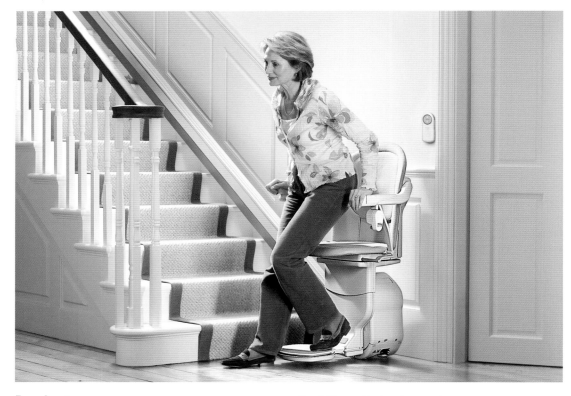

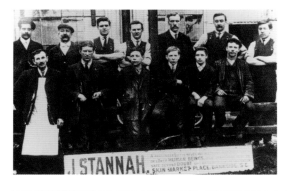

Product

The Stannah name is synonymous with stairlifts. Since 1975 the business has been installing stairlifts and in doing so has helped more than 400,000 people stay independent in their own home. Stannah combines high quality design with practicality to ensure its chairs are as comfortable as they are easy to use.

For more than 140 years, however, the business has also been manufacturing other kinds of lifts and is a leading producer of passenger lifts for low-to-medium rise buildings. Stannah is able to offer complete flexibility, tailoring its products to customer needs, and also supplies, installs and maintains innovative escalators and moving walkways for applications across the UK.

The Stannah range of goods and service lifts is designed with all sizes of public and business premises in mind, to help customers comply with today's rigorous manual handling regulations. Stannah's vertical and inclined platform lifts solve the challenges of modern day disabled access requirements for a broad range of commercial and public premises.

1860s	1975	1993/94	2003	2005	2010
Joseph Stannah starts manufacturing hoists and cranes in London, adding hand-powered lifts soon afterwards.	Stannah produces its first stairlift and begins exporting the range in 1979.	Subsidiaries open in the US and Holland and Stannah produces its 100,000th stairlift. The division also wins its second Queen's Award for Export Achievement.	Stannah wins awards from the Department of Trade and Industry for the best UK manufacturing and engineering factory, and a subsidiary opens in Slovakia.	Stannah's new Solus chair wins the Golden Trophy Award for design. The division also purchases its distributor in Ireland and sells its 300,000th stairlift.	Stannah receives the Queen's Award for Enterprise in the category of International Trade, and purchases its Norwegian distributor.

Ease into fitness with 'Easy Fit' Exercise DVD

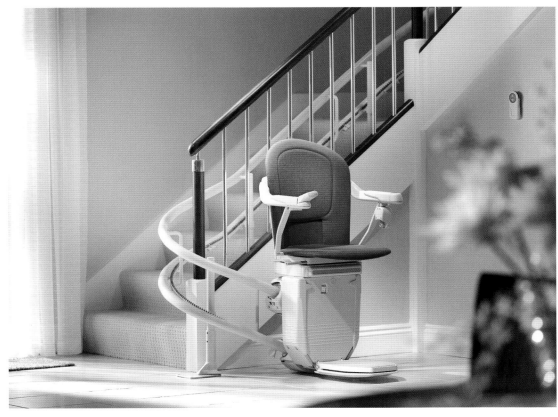

Achievements

Stannah Group divisions specialise in product and service areas. Uniting the divisions is a commitment to providing outstanding product quality and safety, backed by first-class customer service.

This commitment is demonstrated by Stannah's compliance with all relevant regulations and many voluntary codes. The company is also a member of the British Healthcare Trades Association and the Lift and Escalator Industry Association.

Stannah was honoured for the fourth time with the Queen's Award for Enterprise 2010 in the category of International Trade.

Recent Developments

In 2010, Stannah announced a new business communications approach following a year-long project led by the Group's director Jon Stannah. The aim of the brand review was not to change the Group's principles, but to celebrate the Stannah identity and the way in which the company goes about its business – and to communicate this effectively, building on its existing high levels of brand awareness. At the heart of the work a strong but simple

message emerged consistently from across the Stannah business, forming the basis of the promise that defines Stannah's new position within the industry: 'always true to our word'.

Promotion

Stannah's Think Again Fund – launched in 2007 in response to research that showed many people over the age of 50 felt they were too old to pursue their dreams – continues to show that age is no barrier to trying something new. In 2010 Think Again experiences included learning to fly a helicopter, learning to dive, and rock climbing along the Dorset coast.

Brand Values

Stannah is intensely proud that in today's changing world it has retained its status as an independent, family-owned business. The company has remained true to traditional British values of enterprise, dedication, diligence and integrity. Stannah's brand promise 'always true to our word' encompasses the messages that the business will always take care of its customers, will provide reassuringly practical products, will remain a resolutely independent business that operates honestly and responsibly and will only install products that will enhance the life or business of its customers.

Things you didn't know about Stannah

Before purchasing, consumers can test-ride a Stannah stairlift at their local Stannah-selected mobility shop or Stannah showroom.

Stairlift installers visit customers' homes with two pairs of shoes – one pair solely for use indoors so that they won't dirty the carpet.

All Stannah personnel who go into customers' homes undergo a Criminal Records Bureau check.

Today Stannah is run by a fifth-generation Stannah family management team who proudly uphold the company's original spirit and traditions.

In 2010 Stannah partnered with Diana Moran, Breakfast TV's 'Green Goddess', to create a fitness DVD aimed at the over 55s.

Starbucks Coffee Company is one of the leading retailers, roasters and brands of speciality coffee in the world. It is committed to offering customers the highest quality coffee and the finest coffee experience, while operating in ways that produce social, environmental and economic benefits for the communities in which it does business. Starbucks entered the UK market in 1998 and now employs more than 9,000 'partners' in over 700 coffeehouses.

Market

The branded coffee chain market remained resilient in 2009 despite the recession, although the rate of growth slowed. It is estimated that there were 4,100 outlets in the UK with an estimated £1.6 billion turnover. Starbucks remained the UK's leading branded coffeehouse by turnover, with 33 per cent of the market (Source: Allegra Strategies).

Product

Starbucks coffeehouses offer high quality whole bean coffees; fresh, rich-brewed, Italian-style espresso drinks; a variety of pastries and confections; and coffee-related accessories and equipment. In addition, Starbucks retails whole bean and ground coffees through selected UK supermarkets and has a well established business in the UK foodservice

sector. Starbucks also sells its instant coffee, Starbucks VIA™ Ready Brew, across the UK in supermarkets and its stores as well as on all easyJet flights.

Achievements

Since the company opened its first store, Starbucks has been committed to doing business responsibly. Building on years of expertise, in 2008 it launched its Starbucks Shared Planet™ programme, setting out a series of global goals in the areas of ethical sourcing, environmental stewardship and community involvement.

In the UK, the company made all its espresso Fairtrade in 2009 and served 80 million cups in the following year, helping make the company the world's largest purchaser of Fairtrade

coffee. In addition to its Fairtrade commitment, Starbucks provides agronomy experts, based in Rwanda and Costa Rica, to share technical and environmental expertise with farmers. This investment enables farmers to increase their yields and income, building sustainability into production.

Starbucks also continues its longstanding relationships with humanitarian and development organisation, CARE International, and Conservation International (CI). In a five-year partnership, Starbucks is working with CI to address climate change, contributing to the search for global climate solutions while also aiming to help coffee farmers ensure their coffee is responsibly grown and ethically traded.

Additionally, Starbucks invests in young people; both nationally through five-year partnerships with The Prince's Trust and the National Literacy Trust, and locally through the work its partners (employees) do from stores around the country. Starbucks also has a new partnership with UK Youth, identifying

1971	1982	1991	1998	2000	2003
Starbucks is founded in Seattle by three friends who met at the University of San Francisco in the 1960s.	The first store is a success and catches the attention of Howard Schultz, who joins the company. With the backing of local investors he purchases Starbucks in 1987.	'Bean Stock' is introduced – a stock option scheme for all employees to make them 'partners'.	Starbucks enters the UK market through the acquisition of 60 stores from Seattle Coffee Company.	The Starbucks Christmas Bookdrive is first launched with the National Literacy Trust. In the same year, Starbucks begins to sell Fairtrade Certified coffees in-store.	The Starbucks Coffee Master Programme is launched.

and investing in young community leaders, equipping and empowering them to make a difference in their communities.

Recent Developments

Starbucks continually strives to innovate and offer customers an even better experience. In December 2009 it became the first national chain to offer a new kind of coffee, the Flat White – a stronger, more intense drink that had become popular with coffee drinkers in London's Soho.

It also launched a new local store design philosophy, allowing designers to create individual stores that closely suit the needs and style of their neighbourhoods. The first was opened in London's West End at Conduit Street and others followed across the country in 2010. The coffee shops are built to an exacting environmental standard, saving both water and energy.

The UK Starbucks Facebook site was also established, allowing customers and fans to share stories, talk about their favourite drink and to initiate a conversation with the company. In just one year 350,000 people have become 'friends' with Starbucks. The website mystarbucksidea.com gives customers another way to be heard, and the number of ideas submitted to Starbucks through the site topped 100,000 in 2010.

In terms of products, 2010 saw the national launch of Starbucks VIA™ Ready Brew, a rich, flavourful instant coffee that is available in thousands of supermarkets across the UK as well as in Starbucks coffee shops and on easyJet aircraft. In total, nine million servings

were sold in the first six months of its launch. The coffee is made with the highest quality, ethically sourced 100 per cent arabica beans and is produced by a natural process that includes micro-grinding the coffee in a way that preserves its essential oils and flavour.

The company made a significant investment in its partners, offering them the chance to take externally recognised NVQ qualifications and launching a fund for personal development. Baristas were also taken to Africa to learn more about ethical sourcing and to meet Starbucks farmers, instilling enthusiasm and encouraging them to spread their knowledge to customers and colleagues.

Promotion

Storytelling is key to the Starbucks culture and, as part of a non-traditional marketing model,

the success of the company's communication strategy is rooted in its partners' passion for and involvement in its innovative product and experience.

The company has established seasonal favourites in the UK and Ireland, promotes individual beverage customisation and has been at the forefront of innovating the coffeehouse experience in the UK over the last 10 years. Starbucks coined the phrase the 'third place' – a restful environment between home and work in which to relax, take time for yourself and enjoy a freshly brewed cup of high quality coffee. Partnerships with BT OpenZone and the Guardian newspaper further enhance the Starbucks experience.

Brand Values

The Starbucks mission is to 'inspire and nurture the human spirit – one person, one cup, and one neighbourhood at a time', which is supported by a passionately held set of principles that guide how partners in the company live every day.

Things you didn't know about Starbucks

Starbucks is the largest purchaser, roaster and distributor of Fairtrade Certified coffee in the world, offering it in 28 countries.

Starbucks offers more than 87,000 possible drink combinations.

Starbucks buys only the finest arabica coffee beans and selects only the top 10 per cent of these, which are grown at an altitude of between 900 and 1,500 metres.

2006	2007	2009	2010
Starbucks is awarded a Business in the Community Big Tick for excellence in corporate social responsibility – for the second consecutive year.	Starbucks is named one of the Great Place to Work® Institute's top 10 Best Workplaces in the UK. The following year, Starbucks Shared Planet™ launches.	Starbucks Card Rewards and Starbucks VIA™ Ready Brew are introduced. Starbucks is ranked as one of the 100 Best Companies to Work For by Fortune.	Starbucks celebrates a year of offering 100 per cent Fairtrade espresso by taking baristas to Tanzania to meet farmers and learn more about coffee.

Sudocrem®

The Sudocrem brand encompasses skin care products. Celebrating its 80th birthday in 2011, Sudocrem Antiseptic Healing Cream has an illustrious heritage and has proved itself as a product that can be trusted to soothe, heal and protect babies' skin from nappy rash. Instantly identifiable, thanks to its familiar grey tub, this multiple award-winner is recognised as the nation's favourite nappy rash cream and has been market leader in its sector for decades.

Market

The UK baby nappy rash market is worth £23 million (Source: Information Resources Incorporated (IRI) October 2010) and is on the increase; between 2009 and 2010 market growth was seven per cent (Source: IRI 2010). Forest Laboratories' Sudocrem Antiseptic Healing Cream has dominated this category for the past 30 years and holds 65 per cent of total category volume sales (Source: IRI 2010). Even with the increasing popularity of disposable nappies, Sudocrem Antiseptic Healing Cream remains as popular today as ever.

Product

Sudocrem Antiseptic Healing Cream is clinically proven to treat nappy rash; however, the cream's combination of ingredients makes it a versatile product for use by the whole family. As well as treating a baby's nappy rash, it can help teenagers treat their acne, and older people treat skin problems such as incontinence dermatitis. Sudocrem Antiseptic Healing Cream is also recommended as a first aid box treatment for minor burns, sunburn, cuts and grazes thanks to its antiseptic and mild anaesthetic properties.

Sudocrem Antiseptic Healing Cream is available both over the counter and via prescription. Generations of healthcare professionals have put their trust in Sudocrem Antiseptic Healing Cream and in 2009, more than 600,000 prescriptions were written for Sudocrem Antiseptic Healing Cream.

Sudocrem Antiseptic Healing Cream is available in a range of classic tub sizes to suit every need, from the big value 400g down to a portable 60g mini tub that is well suited to the travel market.

Achievements

Sudocrem Antiseptic Healing Cream has been the market-leading nappy rash cream in the UK for more than 30 years and has achieved total penetration across the UK's pharmacies.

It has carved out a niche as a first aid cream that can be used at all life ages and stages, from birth into old age. As well as being a mother's staple, it has earned recognition and a following among healthcare professionals.

Thanks to its consistent, reliable positioning and proven product performance, the Sudocrem brand has earned a plethora of top-class awards over the years – and continues to do so, year in year out.

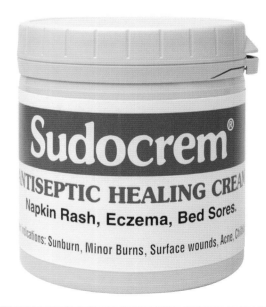

1931	1950s	1960s	1977	1985	2007
Thomas Smith develops Smith's Cream in his Dublin pharmacy. The cream is distributed across Ireland.	Smith's cream is renamed Sudocrem Antiseptic Healing Cream.	Sampling to parents and healthcare professionals, to broaden the cream's appeal, begins.	Sudocrem Antiseptic Healing Cream is launched across the UK.	A new manufacturing facility opens in Dublin.	Sudocrem Antiseptic Healing Cream celebrates its 30th UK birthday and continues its reign as the number one selling nappy rash cream.

Recent Developments

In 2009 Forest Laboratories launched a new addition to the brand portfolio: a portable 30g white tube of Sudocrem Skin Care Cream. This new cream has similar ingredients to the classic Sudocrem Antiseptic Healing Cream in the grey tub, but in slightly different proportions.

Sudocrem Skin Care Cream is aimed at helping to maintain healthy skin, whatever a person's age, as part of their daily skin care routine. The tube size is designed to make it appeal 'on the go', especially when travelling as it is compliant with aeroplane hand-luggage restrictions. The cream is versatile and thanks to its gentle and soothing properties, can be applied as often as is needed. It can be used on problem skin, such as spot or blemish-prone areas, or the dry patches common on elbows and knees, and is also suitable for use on skin that has been exposed to the sun.

During 2011 the Sudocrem brand will see further product development and new product launch plans.

In response to requests to provide more training to pharmaceutical assistants, Forest Laboratories has also embarked on an educational programme that focuses on therapeutic approaches to skin care.

Promotion

The brand makes use of a diversified range of promotional activities in order to communicate its unique selling points and illustrious brand heritage.

Consumer-facing promotion takes the form of traditional, above-the-line media such as television, outdoor and parenting press. In 2011 Sudocrem Antiseptic Healing Cream will continue to invest in television advertising aimed at mothers with young children (from babies up to five years of age) to communicate the product's many possible uses. The Sudocrem Skin Care Cream tube will also be

promoted to adults through further television advertising. The campaigns will be broadcast across terrestrial, digital and satellite channels.

In addition, two new press executions will feature in the leading parenting magazines. Multi-platform, fully integrated social media campaigns, as well as the current online campaigns on leading parenting websites, will complement the classic promotional channels.

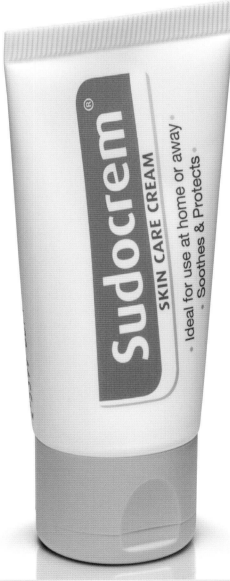

Alongside the consumer strategy, a full programme for promotion within the medical community sees the brand actively engage with primary care healthcare professionals and pharmacists. Annually, Forest Laboratories attends more than 50 nursing and specialist exhibitions, reaching thousands of health visitors, midwives and district nurses. Forest also arranges bespoke symposia, providing education and support to these vital individuals. In addition, a dedicated sales team visits nursing homes nationwide to promote the benefits of Sudocrem Antiseptic Healing Cream in caring for elderly skin.

Brand Values

Through its consistent and robust formula, Sudocrem Antiseptic Healing Cream, in the classic grey tub, has become a consumer stalwart with a strong brand heritage. A clinically proven cream that can soothe, heal and protect, its key brand values are: gentle, effective and trusted. Meanwhile, Sudocrem Skin Care Cream, in the white tube, is fast establishing itself as a 'use anytime, use anywhere', credit-crunch skin care cream.

Always read the label.

Things you didn't know about Sudocrem

Although it's best known for helping to ease babies' nappy rash, Sudocrem Antiseptic Healing Cream can also be used for treating sunburn, minor burns, cuts, grazes, eczema, chilblains and acne.

More than eight million tubs of Sudocrem Antiseptic Healing Cream were sold in the UK between September 2009 and September 2010 (Source: Company Data).

Many athletes such as runners and cyclists use Sudocrem Antiseptic Healing Cream to treat minor cuts and grazes.

The new Sudocrem Skin Care Cream tube further widens the brand's appeal and usage opportunities, thanks to its portable size.

2009		2011	
Also in 2007, the brand embarks on its first national television advertising campaign to highlight its multiple uses.	Sudocrem Skin Care Cream, for adults, is launched in a distinctive white tube.	A milestone year: the Sudocrem brand celebrates its 80th birthday.	Sudocrem products are now available in more than 35 countries worldwide – and counting.

Tate's impressive pedigree dates back to the 19th century, but in recent years it has built an unparalleled reputation for increasing public access to national collections of both home-grown and international modern, contemporary art. This ambitious and trailblazing agenda has been achieved through challenging traditional ideas of gallery-goers and embracing innovation across its four sites: Tate Britain, Tate Modern, Tate Liverpool and Tate St Ives.

Market

Tate defines itself through a commitment to making art more accessible, moving away from the view of galleries as 'elitist' – a legacy from the past. Opening up the market in this way is key to the brand's ethos of making visiting galleries and exhibitions a more social, people-focused experience.

Tate works hard to ensure it appeals to and attracts new audiences. It has been particularly successful at making gallery attendance attractive to young audiences and family visitors, with London's Tate Modern boasting one of the youngest global visitor profiles.

In an average year, around two-fifths of Tate Modern's visitors are from overseas, while at Tate Britain this figure is around one-third. All four galleries remain popular with indigenous audiences.

Product

At one time simply known as the Tate Gallery, expansion has seen the brand evolve with a family of four galleries now united under the Tate umbrella: Tate Britain, Tate Modern, Tate Liverpool and Tate St Ives.

The current Tate brand was developed in partnership with Wolff Olins for the launch of Tate Modern and Tate Britain in 2000. The brief was to create a distinctive, worldwide brand that broadened the appeal of Tate's four gallery sites and conveyed its forward-thinking approach to experiencing art. It needed to unify the collection through the notion of 'one Tate but many Tates'.

The galleries were joined together under the single powerful idea of 'look again, think again', offering both an invitation and a challenge. This is epitomised by an ever-changing, four-faceted logotype that reflects the fluidity and dynamic nature of the brand. In 2010 Tate refreshed its core values to focus on being open, diverse, international, entrepreneurial and sustainable. The invitation to 'look again, think again' remains relevant, reflecting the new trends in audience behaviour and the galleries' intention to provoke dialogue.

But Tate's product offering is not limited to its four galleries; for example, one of its many brand extensions is its subsidiary, Tate Catering, which places an importance on food not only tasting good but also being impeccably sourced and honestly priced. The Tate Modern restaurant benefits from impressive views across London and a wine list chosen by sommelier Hamish Anderson.

Achievements

Since opening Tate Modern in 2000, visitor figures to the four Tate galleries have risen from four million to 7.7 million. A key factor in achieving this significant increase has been the brand's emphasis on differentiation. Tate was the first major gallery in the UK to establish a distinct brand appeal through a pioneering approach to art that focuses on increased accessibility. It continues to lead the field internationally in regard to arts communication, through the democratisation of gallery-going (without dumbing down) and a shift of focus from 'the collection' to 'the experience', putting people before art.

1897	1917	1932	1988	1993	2000
The National Gallery of British Art opens at Millbank, London – commonly referred to as the Tate Gallery in honour of its founder, Sir Henry Tate.	The Tate Gallery is given responsibility for the national collection of international modern art and for British art dating back to about 1500.	The Gallery is officially renamed Tate Gallery.	On 24th May, Tate Liverpool is opened by HRH The Prince of Wales.	Tate St Ives opens. Within its first six months the 'Tate of the West', as it is dubbed by the press, receives 120,000 visitors, almost twice the expected number.	Tate Modern is created in a former London power station and the gallery at Millbank relaunches as Tate Britain.

Recent Developments

Tate's digital marketing, social media and interactive activities have increased significantly over the past year and Tate prides itself on its interaction with the public via its Twitter and Facebook channels. Since January 2010, Tate's Twitter following has risen from 14,000 to more than 200,000 followers, making it the leader in its sector, while Facebook fans now number around 130,000.

Engagement is prompted through a range of devices, from the Friday 'weather report', in which a painting from the Tate collection that reflects the coming weekend's weather is posted on social media channels, through to cutting-edge exhibition-specific apps. A digital card game, the Tate Trumps app is designed to be used across the Tate collection and epitomises the brand philosophy to 'look again, think again', encouraging users to assess the individual qualities of artworks – such as their 'mood' or 'battle strength'.

Tate's blog has attracted an increasing number of user comments, and visitor reviews are being encouraged, while Tate Online is now the

UK's most visited arts website, with more than 20 million unique visitors in 2010.

Promotion

Tate runs a number of campaigns throughout the year, some linked to its programme of events and exhibitions and some to the permanent collection. Core promotional

activity centres on high profile press campaigns, underground advertising and innovative strategies.

Tate started working with advertising agency Fallon in 2004 and has since developed a number of groundbreaking and award-winning campaigns. A recent key campaign evolved from a brief to target younger Londoners who rarely visit galleries. Tate Tracks – 'an experiment between art and music' – invited high profile bands such as The Chemical Brothers and Klaxons to pen an exclusive track about a Tate artwork of their choosing. Each track could only be heard through headphones placed beside the artwork that inspired it. Promotion took a range of forms such as via music channels, flyers outside gigs, blogs, Xfm radio, band fansites and legal flyposting – all designed to appeal to a new, younger audience. The campaign culminated in the autumn of 2008 with a competition

encouraging members of the public to write their own tracks inspired by Tate artworks, with the winning track played in the gallery.

Similar participation strategies have been used around The Unilever Series installations, with a recent example being the gallery's invitation for the public to write a science fiction story inspired by Dominique Gonzalez-Foerster's futuristic 'TH. 2058.' The competition was judged by a high profile panel that included actor Christopher Eccleston (of Doctor Who fame) and celebrated science fiction writer, Jeff Noon.

Brand Values

Tate's brand values are imbued throughout the organisation and include elements outside the presentation of art. The way Tate speaks in any form of communication reflects the spirit of the brand: inviting – it makes you curious and interested; intelligent but not academic – it doesn't underestimate your intelligence, but it's never obscure; challenging but not intimidating – it makes you think; and fresh – it has a contemporary point of view.

Things you didn't know about Tate

Tate Britain was built in the 1890s on part of the site of the old Millbank Penitentiary, a vast 19th century prison.

Tate has a collection that currently consists of some 67,000 works of art by more than 3,000 artists.

The Unilever Series of annual commissions – in Tate Modern's Turbine Hall – has been visited by more than 24 million people since its launch in 2000.

TED BAKER

L O N D O N

Starting out as a men's shirt specialist in Glasgow in 1988, Ted Baker quickly gained the title of 'No Ordinary Designer Label' and has since become an international lifestyle brand, offering menswear, womenswear and everything in between. The brand's unconventional approach to fashion, quirky sense of fun and unswerving focus on quality, design and attention to detail has helped establish a loyal and ever-expanding following worldwide.

Market

Ted Baker operates globally across a number of highly competitive fashion markets although its primary focus is clothing and accessories. In 2010, Group revenue increased by 7.2 per cent to £163.6 million for the 52 weeks ending 30th January 2010 (the equivalent 2009 figure was £152.7 million). Profit before tax and impairment increased by 3.6 per cent to £20.3 million (2009: £19.6 million) and profit before tax increased by 9.8 per cent to £19.5 million (2009: £17.8 million).

The clothing sector has shown stronger than expected growth during the recession. According to a report by Mintel, this has been driven by the surprisingly robust shopping habits of consumers and the younger end of the market, in particular. The report found that the clothing market grew by 1.4 per cent in 2009 to £41.3 billion (US$65.6 billion) and should increase by a further 1.5 per cent in 2010 to reach £41.9 billion (Source: 'Fashion: Impact of the Recession' Mintel 2010).

Mintel highlighted Ted Baker as one of the top five performers for clothing over the 2009 Christmas period. Mid-market and aspirational brands with a younger consumer base have outperformed the rest of the market, while some benefited from launching a much wider range of fashion online and increasing spend on marketing as other brands slashed their advertising and marketing budgets.

Product

Ted Baker creates distinctive collections with a particular emphasis on offering significant value through its high quality product design and attention to detail. There are four main launches every year: spring, summer, autumn and Christmas. Ted also has season changeover transitional collections and fresh product stories launching weekly throughout each season.

While times and fashions may change, Ted's aim to create a wardrobe for men who take real pride in their appearance has never altered. The menswear collection offers everyday items such as shirts, jersey, knitwear, denim and outerwear alongside the Phormal range (formalwear with a fashion edge), which features products from the Mainline range, Endurance suiting line and the luxury, limited edition Global collection – the latter being

1987	1990	1997	1998	1999	2003
The idea for a global brand is conceived by Ted Baker. The first store opens in Glasgow the next year, soon followed by stores in Manchester and Nottingham.	Ted Baker's first London store starts trading in Covent Garden.	With its first continental franchise in Zurich, the brand branches further into Europe and in the same year becomes a public company.	The first standalone Ted Baker store opens on American soil in New York, and the brand's first website launches.	Ted Baker's largest store to date opens in Bluewater Shopping Centre. The Endurance range of suits is launched, as is a new fragrance: Woman.	Ted Baker's luxury collection, Global, launches alongside its own limited edition fragrance of the same name.

an innovative combination of leading-edge technology and traditional tailoring techniques. The most recent addition to the Phormal collection, Pashion, offers the ultimate in sharp suiting, shirts, knitwear and ties and is designed to inject passion back into formalwear.

The womenswear collection at Ted Baker was launched in 1995, and has changed emphasis dramatically over the last few years. There has been a conscious move towards developing more sophisticated, on-trend silhouettes, prints and colours to remain relevant yet

half the price' – and this maxim is also applied to its burgeoning accessories collections for men and women. These ranges are designed to complement the clothing collections, incorporating the same directional colours, patterns, textures, trims and prints.

Achievements

2010 was a significant year for Ted Baker, with the launch of more than 12 new stores across the globe, including in Kuwait, Sydney, Abu Dhabi and New York, and a bespoke online store in the US. Ted Baker now has 80 stores worldwide and more than 110 concessions

innovative communications approach that focused on forging a personal relationship with the customer. This core principle of establishing a direct and engaging connection with customers has been at the forefront of the brand's communication strategy ever since.

Ted Baker's communications synergise closely with the product, store environment and service delivery to create an integrated brand and customer experience. Humorous and off the wall, the brand's communications are never ordinary; irreverent window displays, unusual store events and quirky messages, games,

distinctive in an increasingly competitive industry. Dresses remain an integral part of the collection with styles, fabrics and shapes aimed at accommodating wide-ranging tastes and preferences. Sophisticated knitwear, jersey, outerwear, denim and tailoring in high quality natural fabrics complete the offer.

Overall, the brand prides itself on delivering superior quality for less – 'twice the product for

selling its clothing collections and range of accessories, which span footwear and jewellery to eyewear and fragrances.

Recent Developments

With store expansion a key area of brand development in recent years, the launches in 2010 are being further bolstered by blossoming new relationships with Coin in Italy and Brown Thomas in Ireland.

Another new venture, meanwhile, has been the launch of the latest Ted Baker store concept, the Grooming Room, where men can experience the art of Turkish barbering, all delivered in Ted's own inimitable style.

Promotion

Ted Baker has prided itself on building a truly global reputation without the help of conventional advertising. As one of the pioneers of experiential marketing, the brand's irreverent sense of fun is used to connect and engage with consumers and engender customer loyalty.

The first Ted Baker store, offering a shirt laundry service to customers, established an

gifts and giveaways are designed to surprise and delight the customer – adding value to their experience each time they visit a store. Brand communications are aimed at creating and retaining customer loyalty and endeavour to deliver a healthy return on investment.

Brand Values

Ted Baker's values lie in the uncompromising quality of its products coupled with attention to detail and an innate sense of fun. It is this irreverent humour, quirkiness and refusal to follow the fashion crowd that makes the brand stand out as a global leader in its field.

Things you didn't know about Ted Baker

Ted Baker's company home is called the Ugly Brown Building and has a 60ft waterfall at its centre.

Ted has been involved in two Guinness World Records: 'Most people in pants in one place' was achieved in partnership with Everyman and Cosmopolitan (147 people), and 'Most gigs attended in seven days' was won by Ted's Gig Race Champion, Richard Halligan (15 gigs).

Ted's store opening in Manhattan's Meatpacking District featured removal men distributing 'packed' items (such as benches and bikes), all tagged with 'Signed, Sealed, Delivered, Ted's Yours'.

2005/06	2007	2008/09	2010
Ted Baker launches Archive, the classic shirt and tie collection, and becomes the official suit supplier to Australia's Socceroos for the FIFA World Cup™.	Pashion menswear launches, as does the childrenswear collection, Baker by Ted Baker. Eleven new stores also open, including a womenswear boutique in Covent Garden.	Ted Baker celebrates its 20th year in 2008 by opening a new store concept in London's Cheapside, Ted Baker & Friends, then more stores across the globe.	Ted Baker's Floral Street London store undergoes a 'typically Ted' creative refurbishment, Ted's first Grooming Room opens in London, and a new US website goes live.

The **co-operative**
good for everyone

As the UK's largest co-operative, wholly owned by its members, The Co-operative is built on trust and sound ethics. Under The Co-operative brand, its family of businesses is experiencing a renaissance as consumers increasingly see the value in its integrity. The rebrand of the Somerfield estate and the merger of the Britannia Building Society with The Co-operative Financial Services have cemented The Co-operative as one of Britain's strongest brands.

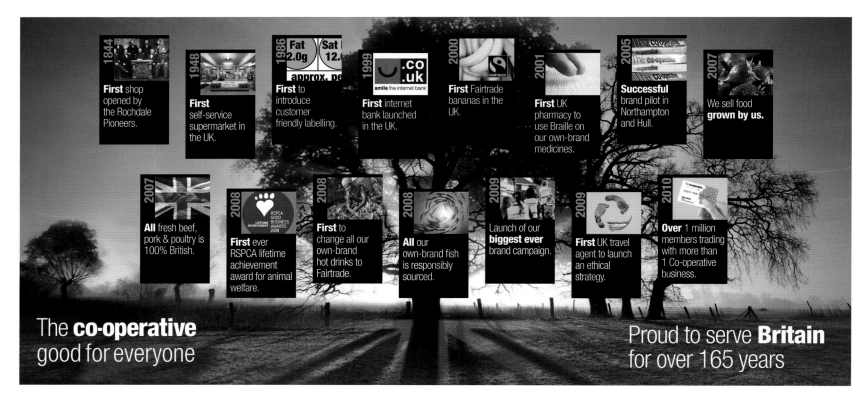

First shop opened by the Rochdale Pioneers.

First self-service supermarket in the UK.

First to introduce customer friendly labelling.

First internet bank launched in the UK.

First Fairtrade bananas in the UK.

First UK pharmacy to use Braille on our own-brand medicines.

Successful brand pilot in Northampton and Hull.

We sell food **grown by us.**

All fresh beef, pork & poultry is 100% British.

First ever RSPCA lifetime achievement award for animal welfare.

First to change all our own-brand hot drinks to Fairtrade.

All our own-brand fish is responsibly sourced.

Launch of our **biggest ever** brand campaign.

First UK travel agent to launch an ethical strategy.

Over 1 million members trading with more than 1 Co-operative business.

The **co-operative** good for everyone

Proud to serve **Britain** for over 165 years

Market

The Co-operative is now the clear leader in the community food sector – the fastest growing area of the grocery market. Since 2009, The Co-operative has become the fifth largest food retailer in the country, accounting for eight per cent market share. In its food business alone, the 3,000 stores generate annual sales of more than £7 billion, with over 20 million customers per week.

With footholds in food, funerals, travel, pharmacy, electrical, motors, farms, financial services and legal services, The Co-operative's broad portfolio has helped it to increase both turnover and profits in a difficult climate. Its operating model, which means it does not answer to stock markets and speculators, has appealed to those concerned by the way in which big businesses operate, especially in light of the recent economic crisis.

More than four million new members have joined The Co-operative since it relaunched its membership scheme in 2006, and there are currently 6.3 million members of The Co-operative Group. Members are able to have a say in how the business operates and are rewarded by sharing in the organisation's profits. In 2009, the Group's members earned £49.1 million as a share of profits.

Product

Now united under the The Co-operative's umbrella brand, its businesses embrace multiple sectors and offer unparalleled reach across all areas of the country. Best known for its food stores, The Co-operative is also one of the most diversified financial businesses in the UK; is the third largest retail pharmacy chain; and has become Europe's leading funeral business.

1844	1872	1942	1965	1985	1992
The Rochdale Pioneers create a local co-operative and open their first store to avoid exploitation by unscrupulous shopkeepers.	The Co-operative Bank is set up, initially as the CWS Loan and Deposit Department.	The first self-service shop is opened by the London Co-operative Society. By 1950, 90 per cent of all the self-service stores in the UK are operated by co-operatives.	Dividend Stamps are introduced as an alternative to the traditional methods of paying the 'divi'. The CWS launches the national Dividend Stamp Scheme in 1969.	The CWS stops all animal testing on its own-brand toiletries and household products. It co-sponsors a Private Member's Bill to improve labelling for products tested on animals.	The Co-operative Bank becomes the world's first bank to introduce a customer-led Ethical Policy.

Perhaps less well known amongst its activities is the fact that The Co-operative is the UK's largest farmer, with more than 50,000 acres in England and Scotland. It is also diversifying into wind farms and aims to generate 15 per cent of its own energy by 2012 through these and other renewable energy sources such as hydropower, biomass and ground-source heat.

In 2006, The Co-operative set out on the largest rebranding exercise in UK corporate history when it began the task of converting its entire estate to 'The Co-operative'. The £1.5 billion upgrading exercise involves refitting and rebranding its stores; to date, 4,200 of its 5,000 outlets have undergone this transformation.

Achievements
At the World Retail Awards 2010, the Bob Dylan 'Blowin' in the Wind' brand launch campaign won The Co-operative the title of Best Use of Traditional Media, while at the Transform Awards The Co-operative won Best National Rebrand and Best Campaign for a Corporate Rebrand.

In the same year, The Co-operative Financial Services claimed the prestigious title of Financial Times Sustainable Bank of the Year, beating 110 other financial institutions from 44 countries in the process.

The Co-operative won the Corporate Social Responsibility and Sustainability Award at the 2010 National Business Awards and also picked up Responsible Retailer of the Year at the 2010 Oracle Retail Week Awards, for the third year running.

The Co-operative Group has seen unprecedented growth over the past few years and this continued in 2010. Interim results for 2010 showed Group revenues were up eight per cent and Group profits up 17 per cent. The food business trading profits grew by 13 per cent, boosted by the ongoing rebrand to The Co-operative. The Co-operative brand increased in value by £660 million in 2010 and is now valued by Brand Finance at £2.88 billion.

Recent Developments
By October 2010, The Co-operative had rebranded the 500th Somerfield store to its award-winning Co-operative brand, and the rebranding of the entire Somerfield estate is due for completion in 2011.

The Co-operative Bank merger with the Britannia Building Society has created a business of real scale with £70 billion of assets, nine million customers, 12,000 employees, more than 300 branches and 20 corporate banking centres.

In October 2010 The Co-operative announced a proposed joint venture with Thomas Cook to create the UK's largest travel retailer.

Promotion
Following the successful 2009 Bob Dylan 'Blowin' in the Wind' brand campaign to raise awareness of The Co-operative's family of businesses and reassert itself as the pioneer of ethical business, the company will focus on its strong corporate social responsibility (CSR) stance in 2011.

Following a poll amongst its members, The Co-operative is focusing on three key community plans: Inspiring Young People, Tackling Global Poverty, and Combating Climate Change.

The Co-operative is inspiring young people to change their world for the better through education, opportunities and campaigning; a launch event was held in June 2010 to communicate the breadth and reach of current activity, and to unveil new initiatives that together will directly benefit more than 250,000 young people across the UK.

In November 2010, The Co-operative launched the second strand of its community plan: Tackling Global Poverty. The Co-operative aims to bring about a fairer world where basic human needs are met and where rights are respected. It will invest £7 million per annum to help tackle global poverty; continue to show

The co-operative
good for everyone

We're The Co-operative and we're good for everyone. We're good for your health and your wealth.

Good for quality and value.
We're good for the shoppers and the savers.

For the travel lovers and the home makers.
We're good for the young and the old.

We're good for communities, from the highest highland to the lowest island. For our farmers and for Fairtrade.

We're also doing good for the environment and animal welfare.

We're a successful, growing business that believes all organisations can work for good.

We're owned by you, our members and led by our principles so we work together to make changes for the better.

Together we're The Co-operative and we're good for everyone.

the greatest commitment to Fairtrade; continue to champion human rights; and campaign anew for trade justice.

Along with Combating Climate Change, these three areas will form part of a revitalised CSR programme to be introduced in 2011.

Brand Values
The Co-operative's vision is to be 'Good for Everyone' with five key components forming the DNA of its brand: consistent quality, trustworthy, rewarding, championing and community.

The Co-operative is a consumer-owned business in which its members have a democratic say in the way the business is run, how its profits are distributed, and how it achieves its goals. Just £1 allows anyone to join The Co-operative and each member has an equal say: collective action lies at the heart of the business.

Things you didn't know about The Co-operative

The Co-operative is the only UK high street bank with an Ethical Policy shaped by its customers.

The Co-operative has more than 5,000 branches powered by renewable energy.

The Co-operative operates in every postal area in the UK.

The Co-operative has turned away more than £1 billion of loans to businesses that contravened its Ethical Policy.

2003	2007	2009	2010
The Co-operative switches all own-brand coffee to Fairtrade, generating an extra £1 million each year for coffee farmers in the developing world.	The Co-operative Group and United Co-operatives merge, successfully becoming one business within one year.	The Co-operative acquires Somerfield, merges with Britannia Building Society, and launches its biggest ever brand campaign.	The rebrand of the 500th Somerfield store to The Co-operative takes place.

The Law Society

The Law Society is the representative body for more than 145,000 solicitors, qualified in England and Wales, practising both at home and abroad. The Society's aim is to protect and promote the interests of the profession by providing advice, training, products and services to its members, and to develop new legal markets and international networks. It also influences law and policy through representation to governments, regulators and the wider community.

Market

The Law Society has more than 145,000 members. Private practice remains the profession's biggest sector, encompassing firms of all sizes from sole practitioners in high street firms to global law firms. A large and growing number of solicitors work in the employed sector in commerce and industry as well as in local and central government.

Product

The Law Society engages with and meets the diverse needs of solicitors through special interest groups. More than 10,000 solicitors take advantage of the specialist help provided by the Law Society's sections, which includes continuing professional development (CPD) accredited events, online seminars, e-alerts, websites, magazines providing free CPD, discounts, campaigns, publishing, discussion forums and networking opportunities.

Generic products and services include helplines, an online CPD centre, a website and weekly e-newsletter, the Law Society Gazette, Law Gazette Jobs online, a library and information service, and titles from Law Society Publishing.

More than 16,000 solicitors belong to the Law Society's accreditation schemes, benefiting from free promotion online and in print. Customers can be confident that members' skills, knowledge and experience have been thoroughly tested and certified. A new quality scheme for conveyancing practitioners was launched in 2010.

The Lexcel quality mark is a sign of excellent client service, cost efficiency and minimum risks. Implementing the Lexcel framework across a practice provides the potential to secure lower professional indemnity insurance premiums. Almost 900 practices are already accredited.

Achievements

The Law Society is a major player on the international legal stage, and uses its influence to create opportunities for solicitors and law firms from England and Wales operating in markets overseas. Its efforts have resulted in important advances in jurisdictions including Japan, China, South Korea and Singapore. The Society promotes England and Wales as the jurisdiction of choice for dispute resolution.

At home, the Law Society represents solicitors' interests by lobbying the Government, parliament and thought leaders at all levels. It has successfully represented its members on a wide range of issues that include the new regulatory regime; threats to legal professional privilege; the funding of legal aid; stamp duty bureaucracy; proposed changes to small claims; and problems around professional indemnity insurance.

The Law Society is proud to showcase the profession's achievements at its annual Excellence Awards. In 2010 Nigel Priestley from Ridley & Hall LLP in Huddersfield won Solicitor of the Year – Private Practice in recognition of his passion for correcting the injustices of society; he recently won two landmark cases

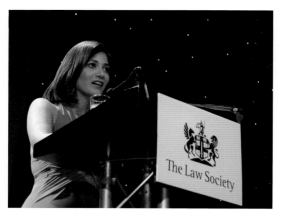

1825	1903	1983	2007	2009	2010
The Society of Attorneys, Solicitors, Proctors and others not being Barristers, practising in the Courts of Law and Equity of the United Kingdom is formed.	The Society's name is changed to the Law Society.	The Law Society establishes the Office for the Supervision of Solicitors to deal with complaints about solicitors.	The Law Society refocuses to work on helping, supporting and promoting solicitors as independent boards are established for regulation and complaints handling.	The Law Society leads the debate on the future for legal businesses under the Legal Services Act.	The Law Society wins a crucial victory for families and access to justice when the High Court rules that the Legal Services Commission acted illegally over proposed changes to legal aid contracts.

2009. The Law Society provides comprehensive support to enable solicitors to understand and benefit from the changes.

Promotion

'Qualified to answer' is the strapline used in recent consumer campaigns developed with DML Marketing. The campaigns aim to persuade consumers that solicitors are the best choice for legal advice.

In 2010 advertisements ran across the national press as well as on trams, metros, railway stations, buses, taxis and online. The Society helped solicitors to piggyback the campaign through their local media, and secured coverage worth a further £1,044,518 in advertising equivalent value. The pay-per-click campaign represented more than 90 million 'opportunities to view', and generated 85,000 click-throughs to the Society's customer guides and 'Find a solicitor' search engine.

For business-to-business communications, electronic and traditional face-to-face techniques are used, ranging from generic and specialist e-newsletters, to events and direct interaction with regionally based staff.

Brand Values

The Law Society's brand values are defined as professional, authoritative, influential, forward-looking, modern, accessible, responsive, transparent, accountable and value for money.

that have national implications. The winner of Solicitor of the Year – In-house, Anna Gardner, was selected for the huge breadth of her work, her team approach, and her skills and success in new business development at Hewlett-Packard.

There is a long tradition of pro bono work in the legal profession; it is estimated to be worth around £340 million per year and two-thirds of private practice solicitors undertake such work during their careers. The Law Society has been involved in the organisation of National Pro Bono Week since its inception in 2002, raising awareness of the free advice that is available and encouraging more solicitors to get involved.

In 2007 the Legal Sector Alliance was launched in association with DLA Piper and Business in the Community. The partnership aims to drive environmental sustainability in the legal sector. The Alliance currently has 192 members, representing more than 30 per cent of solicitors in private practice in England and Wales.

The Law Society's Diversity and Inclusion Charter, developed with BT and the Society of Asian Lawyers, is the bedrock of its work to foster best practice across the legal sector. The Society launched a Procurement Protocol alongside the Charter and together they are gathering widespread support from across the profession and from large consumers of legal services.

The Society campaigns in support of solicitors in jurisdictions where human rights and the rule of law are under threat. In 2007 it set up an international action team through which solicitors and law students can get involved with human rights work.

Developing legal systems are also supported in jurisdictions such as Nigeria. Working in partnerships with bar associations, non-governmental organisations and overseas governments, schemes are delivered that support the rule of law and access to justice, and encourage economic development.

Recent Developments

The establishment in 2007 of independent boards to address regulation and complaints handling freed the Law Society to become a modern and responsive representational professional body. Since then, the Society has established a strong record in lobbying robustly and campaigning successfully for its members, and for providing relevant, valued products and services.

The Legal Services Act 2007 presents both opportunities and threats for solicitors. The Law Society lobbied to improve the proposals in the original Legal Services Bill, which led to significant changes to the legislation. A new regulatory regime is central to the Act, and the Society continues to lobby for proportionate regulation. Legal disciplinary practices, in which up to 25 per cent of partners in a law firm can be non-lawyers, came into being in March

Things you didn't know about the Law Society

Black and minority ethnic solicitors currently make up 24 per cent of new entrants to the profession, and women now constitute 60 per cent.

The Law Society's Hall contains many unusual architectural features, including stained glass from Serjeants' Inn.

In 1922 Carrie Morrison became the first female solicitor admitted to the roll.

The Law Society owns the only known copy (a first edition) of the Law List from 1775.

Since Thomas Cook's inaugural trip in 1841, his name has come to represent a pioneering approach to tourism. Introducing the first overseas package tour in 1855, today Thomas Cook takes six million British holidaymakers abroad each year. Thomas Cook Group plc has a network of more than 3,400 stores across 21 countries and over 22.3 million customers, making it one of the world's leading leisure groups.

Market

In an increasingly competitive industry, Thomas Cook has ensured it is well placed to retain its position as one of the world's leading leisure travel groups. Operating across five key geographical areas puts the brand at the heart of its core markets. Supporting key growth drivers is an integral part of its strategy and opens up potential opportunities to bolster the brand and increase its market share further through mergers, acquisitions and partnerships. Thomas Cook is not only focused on ways in which to consolidate established markets and maximise value from them, but is also committed to encouraging new growth areas in emerging markets such as the online and independent travel sectors.

Product

In addition to its leading mainstream brands such as Thomas Cook, Airtours, Cruise Thomas Cook and Direct Holidays, its diverse portfolio continues to evolve in response to market trends and changing consumer buying habits, offering tailored services to suit individual

budgets and tastes. The MyStyle concept, for instance, part of the Thomas Cook Style Collection, offers a collection of unique five-star resorts in some of the world's most beautiful beachfront locations.

For the family market, Thomas Cook offers a range of holidays to keep the whole family entertained; from its hugely successful Aquamania water park resorts to its four new familyWORLD resorts – introduced for summer 2011 – that promise families a unique programme of activities for all ages to enjoy.

Thomas Cook Sport, Europe's leading sports travel operator, was also announced as the Official Travel Partner for Manchester United and has launched its first ever dedicated brochure of sports breaks for major sporting events around the world in 2011.

Achievements

Thomas Cook's company approach and values have stood the test of time since its founding father described himself as "the willing and devoted servant of the travelling public". In 2010 its commitment to the industry was further recognised through a host of awards including Short Haul Tour Operator of the Year for Thomas Cook, Seat Only Operator of the Year for Gold Medal, and Agent of the Year at the TTG Travel Awards. Additional accolades came in the form of Best All Inclusive Tour Operator, Best Sports Tour Operator, Best Cruise Retailer, and Best Tour Operator to Europe, Middle East and Africa at The British Travel Awards.

The company remains committed to being a responsible business: working with the Travel Foundation, contributing towards worldwide

1841	1855	1874	1939	1977	2003
Thomas Cook's first excursion, a rail journey from Leicester to a temperance meeting in Loughborough, takes place.	Thomas Cook's first continental tour: Cook leads two parties from Harwich to Antwerp, then on to Brussels, Cologne, Frankfurt, Heidelberg, Strasbourg and Paris.	Cook's Circular Note, the first travellers' cheque, is launched in New York.	Holidays by air on chartered aircraft are included in the summer brochure for the first time.	Thomas Cook opens its new administrative headquarters at Thorpe Wood in Peterborough.	Thomas Cook rebrands its airline to Thomas Cook and launches a tour-operating brand under the same name.

sustainable tourism projects, and through its charity – The Thomas Cook Children's Charity – which raised £1 million in 2010 through employee fundraising and customer donations, and aims to make dreams come true for sick and disadvantaged children worldwide.

Recent UK projects include providing day trips or holidays for more than 2,000 children, installing state-of-the-art touch screen computers and flight simulator software in 10 children's hospices, and funding the redevelopment of the Congenital Heart Unit at Leicester's Glenfield Hospital.

Recent Developments

Back in 1896 Thomas Cook escorted UK customers to the first modern Olympic Games in Athens. With the 2012 Games being staged in London, the brand has revived this strong historical link by being appointed in 2010 as the Official Provider of short breaks to the London 2012 Olympic and Paralympic Games. Thomas Cook will provide a range of Games Breaks to suit all budgets as part of 'Everyone's Games', to which 'Everyone's Invited'. Options range from affordable one or two night family stays with guaranteed events tickets, to Games Break Plus, an upmarket option that includes dedicated transport, exclusive use of a private

hotel hospitality lounge, and specially arranged lunches and dinners at top London restaurants.

Further recent brand developments centre on the burgeoning sector of independent travel. A sustained growth in online technologies has led to an increasing number of consumers desiring customised holiday packages. This sector also includes scheduled tours – either tailor-made or with pre-packaged itineraries – and wholesale business, in which Thomas Cook acts as an intermediary between suppliers and other agents by providing the business acumen.

Future changes and investments in the area of independent travel are currently in the pipeline to further strengthen Thomas Cook's position as a competitive online travel agent.

Promotion

Created in 1984 by advertising agency Wells Rich Greene, 'Don't just book it. Thomas Cook it.' quickly became one of Britain's better-known advertising slogans. The strapline, reintroduced in 2008, has been extended in 2010's campaigns that explore what 'it' from the slogan is. The approach provided the springboard for one of the company's most successful advertising campaigns, featuring husband and wife celebrity

couple Jamie and Louise Redknapp. What began as a dreamy, inspirational and accessible TV-led advertising campaign has since been supported by other promotional media including press and cinema.

The campaign improved overall brand awareness, reaching record levels of nearly 68 per cent – a significant increase on the previous year. In addition TV advertising recall and recognition levels increased by 32 per cent. Of customers who saw the TV advertising, first choice consideration to book with Thomas Cook increased by more than 50 per cent. Since then Thomas Cook has continued to strengthen its brand position in the travel market and develop 'standout campaigns' in what can be a very cluttered marketplace.

Brand Values

Committed to keeping the customer at the heart of everything it does, Thomas Cook believes that people are its greatest asset and key differentiator in a highly competitive marketplace.

A modern, forward-thinking business dedicated to finding new ways in which to pioneer, Thomas Cook takes pride in its heritage and trusted brand to drive results and add value.

2007	2008	2009	2010
Thomas Cook UK & Ireland becomes a FTSE 100 company on the London Stock Exchange, and Thomas Cook Group plc forms after a merger with MyTravel Group.	Thomas Cook reintroduces its classic slogan: 'Don't just book it. Thomas Cook it.'	Thomas Cook is appointed Official Provider of short breaks to the London 2012 Games.	Thomas Cook announces plans to merge its UK retail operations with those of Co-operative Travel, creating the UK's largest chain of travel agents.

Things you didn't know about Thomas Cook

Thomas Cook personally conducted the first round-the-world tour in 1872/73. The tour took 222 days and cost around £300.

Thomas Cook's monthly European Rail Timetable, still published today, was first sold in 1873.

Thomas Cook owned and operated a funicular railway at the top of Mount Vesuvius for more than 50 years.

In 1919 Thomas Cook became the first travel agent to offer pleasure trips by air.

Thomas Cook first advertised trips to the moon in 1950.

Millions of families have grown up with Tommee Tippee, the UK's best-known baby brand for nearly 50 years. Traditionally known for cups and tableware, in 2006 the brand's leading position was reinforced with the launch of Closer to Nature, an infant feeding range now credited with revolutionising the way mothers feed their babies.

Market

The baby accessories market is estimated to be worth almost £200 million in the UK (Source: Information Resources Incorporated (IRI) 2010 and Company Data) and encompasses everything from bibs and bottles to monitors and harnesses. It does not include nappies, wipes, toiletries, formula milk or baby food.

Tommee Tippee is the leading brand in a fiercely competitive market. More than half of consumers that buy products from the top three brands will only buy Tommee Tippee (Source: Kantar Worldpanel 2010). Tommee Tippee has more than one-third of the total market share by value and volume and is growing at twice the rate of the market.

The brand has more than 96 per cent distribution through all channels including specialist baby stores, nursery shops, supermarkets, independent chemists and department stores. Internationally, it is sold in more than 60 countries.

Product

Tommee Tippee has more than 200 products in its range and is the only baby accessory brand to cater for parents' and children's needs from pregnancy through to the reception class gates. The brand prides itself on its commitment to innovation and has patents in place for most products. Its offering is enhanced by a promise of quality, safety, simplicity, convenience and value.

The brand was the first to design a non-spill cup in the 1980s (Sip 'n' Seal), a groundbreaking bottle babies could hold themselves (the Nipper Gripper), and a teether filled with purified water that could be cooled for effective relief from the pain of teething.

In recent years significant additions to the product portfolio have included the Closer to Nature range, the Sangenic patented nappy disposal system and Explora, a product category dedicated to helping children feed and develop independently. Closer to Nature products have been designed to mimic the natural flex, feel and movement of a mum's breast, making it easier for her to combine breast and bottle feeding. The Sangenic

1965	1985	1986	1988	1997	2001
Manufacturing rights are acquired for Tommee Tippee baby products in the UK and Europe.	Tommee Tippee moves into new headquarters at Cramlington, Northumberland and starts moulding plastic products.	Tommee Tippee introduces Pur, the first silicone teat, to the market.	Sip 'n' Seal, the first non-spill baby cup, is launched.	Tommee Tippee buys Sangenic – a patented nappy disposal system.	Easiflow becomes the first baby cup to be accredited by the British Dental Health Foundation.

system hygienically and conveniently twists and seals away the smells and germs from used disposable nappies, wrapping them individually in antibacterial film.

Achievements
Tommee Tippee is the fastest-growing baby brand in the UK (Source: IRI 52 w/e 9th October 2010) and is rated the sixth biggest baby accessories supplier globally. Out of the top 10 categories in the baby accessories market in which the brand operates, Tommee Tippee is number one in eight of them (Source: IRI 2010).

The Closer to Nature brand has won Best Buy awards from all the leading parenting titles in the UK, including the Mother & Baby Gold Award for Best Bottle three years out of the last four. The brand's electric breast pump, launched in 2009, has helped to make Tommee Tippee Closer to Nature the leading breastfeeding range in the UK (Source: IRI 2010).

In 2006 Tommee Tippee's Sangenic system won the Queen's Award for International Trade in recognition of the outstanding growth achieved internationally.

Recent Developments
In January 2010, the brand launched in North America under an exclusive agreement with Toys R Us, the leading baby specialist in the US.

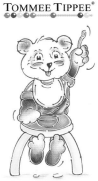
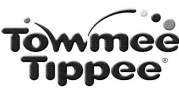
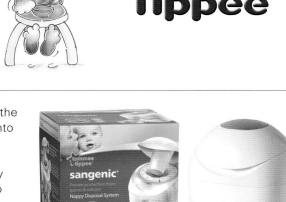

In product development, October 2010 saw the introduction of a superior antibacterial film into the Sangenic nappy disposal system.

In January 2011 Closer to Nature digital baby monitors, including one with a sensor pad to relay a baby's every sound and movement, were introduced. This was followed in February by the addition of a new hygiene range to the Closer to Nature portfolio, including long-lasting germ-busting surface sprays, hand gels and sterilants – all featuring a groundbreaking antibacterial agent that is being used for the first time in specialist baby products.

Promotion
Tommee Tippee is one of the key partners in the UK Baby Shows, a series of consumer exhibitions attracting more than 75,000 parents and pregnant women every year. The brand also works closely with the top parenting titles and has invested in a dynamic social media programme. In addition, its online presence – tommeetippee.com – currently operates in 21 countries.

A trained midwife works as the brand's health liaison manager, enabling a strong relationship with health professionals directly involved with the care and welfare of new babies.

Brand Values
Tommee Tippee products are designed to be simply intuitive, making life easier for parents at every stage of a child's development. The brand's established reputation and continuing commitment to quality and innovation ensures that brand loyalty is passed not only from generation to generation but also from parent to parent.

Social responsibility is important to Tommee Tippee and as a result the brand donates products to support vulnerable communities at home and overseas, such as Women's Aid refuges, feeding projects in Africa and orphanages in Romania.

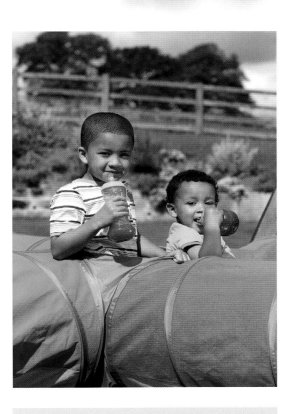

Things you didn't know about Tommee Tippee

Tommee Tippee's first product was a weighted base cup and was so named because it didn't tip over.

Sangenic products wrapped up more than 350 million nappies in over 50 countries in 2010.

If you took all the Tommee Tippee cups sold in the UK in 2010 and laid them end-to-end, the line would stretch from London to Manchester – 209 miles.

2006	2007	2009	2010
The launch of Closer to Nature changes the face of newborn feeding through radical innovation.	The Closer to Nature bottle wins a second Mother & Baby Gold Award for Best Bottle.	Tommee Tippee's new 'star' brand identity is introduced.	The brand launches in the US and Canada.

TONI&GUY™

TONI&GUY has long been renowned as an innovator within the hair industry, bridging the gap between high fashion and hairdressing. Widely regarded as the number one global hairdressing brand, the Mascolo family's franchise model has maintained the company's high education and creative standards, protected the brand and made successes of thousands of TONI&GUY hairdressing entrepreneurs worldwide.

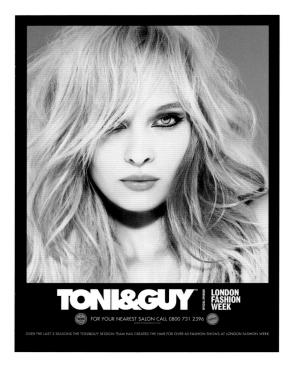

Market

In the years since the birth of TONI&GUY, hairdressing has become a sophisticated industry worth billions, spawning some of the most influential and creative artists in the beauty and fashion sector. From individual salons to global chains, competition is fierce with both men and women now seeking quality and service.

TONI&GUY has helped to change the face of the hairdressing industry on an international scale and today has an annual turnover in excess of £185 million, 228 salons and 39 essensuals salons in the UK, and 229 salons in 42 countries worldwide.

Product

TONI&GUY salons aim to offer a consistent level of service, guaranteed quality, exceptional cutting and innovative colour – in simple but well-designed salons and at an affordable price. All techniques practised by the stylists are taught by highly trained and experienced educators in 24 academies around the world.

A client's in-salon experience is enhanced by extras such as TONI&GUY.TV, the TONI&GUY Magazine and samples of luxury brands to take away. In addition, products from the professional label.m range – created and endorsed by Sacha Mascolo-Tarbuck and her International Artistic Team – can be purchased in salons, enabling clients to replicate fashion-inspired styling at home.

Achievements

TONI&GUY has a worldwide brand presence and is recognised for its strong education network, currently operating 24 teaching academies globally – three in the UK and 21 internationally.

An average of 100,000 hairdressers are trained each year, with more than 5,500 employees in the UK and a further 3,500 worldwide. This philosophy of motivation and inspiration is seen as fundamental to the brand's success.

TONI&GUY has won in excess of 50 British Hairdressing regional and UK awards including Best Artistic Team a record 11 times and British Hairdresser of the Year three times. Co-founder and chief executive Toni Mascolo is a former winner of London Entrepreneur of the Year and in 2008 received an honourable OBE in recognition of his services to the British hairdressing industry.

Toni's daughter, global creative director Sacha Mascolo-Tarbuck, was the youngest ever winner of Newcomer of the Year at just 19 years old. Other awards since include Hair Magazine's Hairdresser of the Year 2007; Creative Head's Most Wanted Look of the Year in 2006, and its Most Wanted Hair Icon in 2009; and Fashion Focused Image of

1963	1982	1985	2001	2003	2004
TONI&GUY is launched from a single unit in Clapham, South London by Toni Mascolo and his brother Guy.	The TONI&GUY Academy launches.	TONI&GUY's first international salon opens in Tokyo, Japan.	The TONI&GUY signature haircare range is launched. The following year Toni and Pauline Mascolo launch the TONI&GUY Charitable Foundation.	TONI&GUY Magazine and TONI&GUY.TV are launched in the UK. The brand also expands into different markets, opening an optician and a deli-café.	TONI&GUY becomes the Official Sponsor of London Fashion Week.

the Year from the Fellowship for British Hairdressing in 2008 as well as its 2010 Hairdresser of the Year.

TONI&GUY branded haircare products have received recognition through numerous trade and magazine awards over the years including accolades from Hair Magazine, Pure Beauty, Grazia, FHM, Beauty Magazine and Cosmopolitan to name a few.

From the TONI&GUY electrical range, 2010 has seen the Innovation Touch Control Digital win two highly coveted industry awards including Gadget/Accessory Launch of the Year 2010 and Best Electrical Appliance Launch 2010.

In addition, the company was the first ever winner of Hair Magazine's Readers' Choice Award for Best UK Salon Group in 2006.

Recent Developments

In 2007, the TONI&GUY signature range of products was relaunched with a 45-piece colour-coded haircare system. The aim was to improve navigation between products and their specific benefits.

In the same year the Model.Me haircare range launched: a collection of 15 products developed in partnership with leading fashion and music personalities Erin O'Connor, Helena Christensen and Jamelia. Model.Me was recognised in its launch year with awards such as Best Use of Press at the Beauty Magazine Awards 2007, and has received more recent endorsements from Company and Cosmopolitan magazines.

2008 saw both TONI&GUY.TV and TONI&GUY Magazine rolled out across all territories, enhancing the client experience in every TONI&GUY salon and Academy. This was followed in 2010 by the launch of a redesigned website, which attracted three million users in its first nine months. The website features an online booking system, salon microsites, e-learning facilities, an online store, and style galleries to inspire clients.

Promotion

As a brand, TONI&GUY juggles the need for consistency, the desire to be fashionable and the reassurance of solid service values, with the excitement of the avant-garde, supported by its philosophy of continual education.

TONI&GUY.TV launched in 2003 to enhance clients' in-salon experience. Containing up-to-the-minute content, from music to fashion and travel, it receives more than 90,000 views per week in the UK. It has also become an outlet for associated, appropriate brands to communicate to this sought-after audience and recently won Best Use of Video at the 2010 APA Awards.

TONI&GUY Magazine was also launched in 2003 to echo and communicate the brand's heritage and philosophy, focusing on key trends in fashion, the arts, beauty, grooming and travel. Distributed in salons across Europe and globally as far afield as Australasia, the magazine promotes an inspirational yet accessible face of the company to customers, employees and franchisees alike. In November 2004 it was named Launch of the Year at the APA Awards and in 2010 won Best Consumer Publication.

TONI&GUY remains committed to its vision to link the fashion industry with hairdressing through its sponsorship of London Fashion Week and London Fashion Weekend, a partnership that began in September 2004. The TONI&GUY session team works on more than

60 shows per year in London, New York, Paris and Milan and offers support to key British design talent including Giles Deacon, Todd Lynn and William Tempest. This commitment to support the fashion industry is highlighted by the appointment of Sacha Mascolo-Tarbuck and James Tarbuck to the British Fashion Council/Vogue Designer Fashion Fund for the support of new design talent.

Brand Values

TONI&GUY's reputation has been built on an impeccable pedigree and foundation of education, fashion focus and friendly, professional service. TONI&GUY aims to encompass the importance of local and individually tailored, customer-led service, promoting an authoritative, cohesive and – most importantly – inspiring voice.

TONI&GUY is one of the most powerful hairdressing brands in the world, offering some of the best education and guaranteeing innovative cutting and colour. It aims to be fashionable but friendly to provide the ultimate link between fashion and hair – pioneering, passionate and inspirational.

Things you didn't know about TONI&GUY

TONI&GUY co-founder and chief executive Toni Mascolo still cuts hair once a week, alternating between London's Sloane Square and Mayfair salons.

TONI&GUY has published 34 collection books as well as 30 video/DVD educational collections. It now produces one DVD each year, which is bought by more than 20,000 hairdressers.

TONI&GUY educates more hairdressers than any other company in the world.

2005	2007	2008	2010
The professional haircare range, label.m, launches, growing to include more than 45 products that are distributed in over 47 countries.	The Model.Me haircare range is launched, as is an electrical line.	Toni Mascolo is awarded an OBE for his services to the British hairdressing industry.	Sacha Mascolo-Tarbuck and James Tarbuck join the British Fashion Council/Vogue Designer Fashion Fund. The company comprises 267 salons in the UK and 229 internationally.

Virgin is known for applying its brand values across many sectors, making it arguably one of the most diverse brands in the world. Throughout its history, Virgin has focused on quality and service and strives to offer industry innovation. There are now more than 200 Virgin-branded companies worldwide, a testament to its diversity and longevity.

Market

Since it was established by Richard Branson in 1970, the Virgin Group has gone on to operate in sectors ranging from music and travel to financial services and retail, with three key brands: Virgin Atlantic, Virgin Holidays and Virgin Media.

Product

The Group's flagship airline, Virgin Atlantic, serves the long haul flight market and carries around six million people annually on 38 aircraft. Virgin Atlantic operates three cabin classes on board its flights – Upper Class, Premium Economy and Economy – and focuses on quality and service, striving to offer industry innovation. It was the first to introduce seatback televisions in all cabins and to create the Premium Economy cabin. Unlike many rivals, it continues to offer frills such as Oscar-winning films, drinks and a choice of three meals at no extra cost. Its new Upper Class Wing at Heathrow's Terminal 3 has been dubbed the world's fastest check-in by Wallpaper*

magazine and along with its multi-award-winning Heathrow Clubhouse, demonstrates how Virgin Atlantic continues to strive for exacting standards within the airline industry.

Virgin Holidays offers bespoke holiday experiences throughout the world, from Alaska to Zanzibar, backed up with expert knowledge and innovative customer service from booking through to resort. It is the UK's largest long haul holiday company and the market leader to the US, the Caribbean and the Middle East. Its extensive retail network of Virgin Holidays stores – 46 throughout the UK – offers an alternative to the traditional high street travel agent experience.

Launched in 2007, Virgin Media was the first company to provide for all of its customers' digital needs in one package, bringing broadband, television, phone and mobile services to almost 12 million homes nationwide. It owns the largest fibre optic network in the UK and it is purpose-built for the way digital media is consumed today. Films, television, music, games and social networks can be accessed simultaneously, across multiple devices at home and out and about.

Virgin Media delivers the UK's fastest broadband with 10Mb, 20Mb and 50Mb products offering superior average speeds. With the roll out of up to 100Mb continuing into 2011, services are only going to get faster.

Achievements

Virgin Atlantic has won an array of awards for its service and product innovation including Best Business Class, Best Premium Economy, Best Economy and Best Airline Lounge from the likes of Business Traveller, SkyTrax and Travel Weekly, to name but a few. It has also been commended for leading the way in environmental air travel and was the world's first commercial airline to successfully fly biofuel at 30,000ft.

The brand's memorable Still Red Hot 25th birthday campaign, which recreated the airline's launch in June 1984, was a notable achievement and listed as one of the top 10 marketing moments of 2009 by Campaign magazine. Virgin Atlantic's recent focus on building its social media presence has seen the airline rated as one of the most positively perceived and talked-about brands, according to the independent Kaizo Advocacy Index.

virginatlantic.com/experience

Rise and outshine.

upperclass Fully flat bed. Your airline's either got it or it hasn't. virgin atlantic

1984	1992	1999	2003	2006	2007
Virgin Atlantic is established. The inaugural flight takes place on 22nd June, from London to Newark. This is followed in 1985 by the birth of Virgin Holidays, carrying 14,000 passengers in its first year.	Virgin Atlantic introduces the revolutionary Premium Economy class, which goes on to be replicated by several other airlines.	Richard Branson sells a 49 per cent stake of Virgin Atlantic to Singapore Airlines.	The Upper Class Suite is launched, complete with the longest fully flat bed in any business class.	Virgin Atlantic adds Montego Bay and Dubai to its list of destinations, an industry-leading environmental strategy is unveiled, and Virgin Atlantic becomes James Bond's airline of choice in Casino Royale.	ntl:Telewest merges with Virgin Mobile and virgin.net, relaunching as Virgin Media. An internal brand and culture programme is rolled out.

Virgin Holidays achieved unprecedented success in 2010 with a record 13 trophies at the British Travel Awards including the Gold Award for Large Holiday Company of the Year. It was also voted Long Haul Operator of the Year at the Travel Trade Gazette Awards and topped the tourism category in the 2010 UK Customer Services Index.

Recent Developments
In December 2010, Virgin Media launched the next generation of television powered by TiVo. A groundbreaking service, it not only offers a search and browse facility through past and future TV listings, but also learns what the customer likes and suggests shows they might enjoy – and with a terabyte hard drive, can hold up to 500 hours of programming. Virgin Media television boasts more than 200 channels and the best in high definition and 3D programming, as well as an unrivalled TV on demand service, with thousands of hours of programmes, movies and music.

The key to Virgin Media's success is putting the customer at the heart of everything. More than 750,000 individual customer comments and Net Promoter® Scores have been collected, helping Virgin Media find solutions to issues that are important to its customers.

Promotion
Virgin Atlantic has recently revamped its advertising approach, concentrating on different aspects of each of its cabin classes and highlighting their specific product benefits, from the no-extra-cost frills in Economy to the wider seats with more leg room in Premium Economy and the fully flat bed in Upper Class. Its promotional strategy has been designed to differentiate Virgin Atlantic from other airlines that may fly the same planes from the same airports but don't offer the same standard of service.

The launch of its first global television campaign aimed at reinforcing the airline's 'it' factor was a brand milestone in 2010. It was aired across the UK and for the first time in the brand's history, in cities across the US including New York, Washington, Boston, San Francisco and LA. Featuring the strapline 'Your airline's either got it or it hasn't', it takes viewers on a metaphorical flight with Virgin Atlantic – a journey through a surreal and glamorous world of airline iconography dramatising how it feels to fly with Virgin. As with the Still Red Hot campaign, Virgin Atlantic's cabin crew feature in the advertising, showcasing the brand's uniquely engaging service style and injecting

a sense of humour, qualities inherent to the airline's brand. Featuring 'Feeling Good' by Muse as its soundtrack, it is one of the few advertising campaigns for which the band has licensed a track.

Rockstar Service is the latest campaign from sister company Virgin Holidays. Centred on the misguided adventures of fictional rock band 'The Danke Schons', it is based on the brand's belief that exceptional service should come as standard for everyone. The TV spot was picked by viewers as one of the UK's top 20 advertisements of 2010 in ITV's Ad of the Year programme.

Brand Values
Virgin has an appealing youthful personality and since its inception has endeavoured to adhere to its brand values: Fun, Value for Money, Quality, Innovation, Competitive Challenge and Brilliant Customer Service. These brand values focus on putting Virgin customers' needs first, constantly challenging the status quo by putting innovation at the heart of its philosophy and always encouraging staff to think the impossible, with resulting benefits for its customers.

Things you didn't know about Virgin

Virgin Atlantic's aircraft are all female and have carried more than 65 million passengers since the airline launched in 1984.

Exclusive to Virgin Holidays, v-rooms are the world's first and only airport lounges dedicated entirely to people going away on holiday.

Virgin Media's V+ HD box lets viewers pause, rewind and record live TV. Unlike those supplied by other service providers, it allows two programmes to be recorded while a third is watched.

Virgin Broadband is up to twice as fast as other providers

Fibre optic broadband
The fastest in the UK

2008	2009	2010	
Also in 2007, Virgin Atlantic places an order for 23 fuel-efficient Boeing 787 Dreamliners – the largest order in Europe – and its new Terminal 3 facility opens at Heathrow.	Virgin Media launches its 50Mb broadband and is ranked the sixth Most Loved Brand in a survey carried out by Joshua-G2 and Marketing magazine.	Virgin Media upgrades 4.2 million customers from 2Mb to 10Mb, and Virgin Atlantic celebrates its 25th birthday.	Virgin Holidays announces plans for the Branson Centre for Entrepreneurship, and Virgin Atlantic introduces a new direct route from Manchester to Las Vegas.

VISA

With more than 2.2 billion cardholders worldwide, Visa is the world's leading consumer payment brand (Source: The Nilson Report). In Europe alone, there are more than 400 million Visa-branded payment cards and these cards can be used in more than 200 countries around the world. By providing consumers with a convenient, secure and globally accepted electronic payment solution, Visa's goal is to be the preferred alternative to cash and cheques.

Market

In October 2007, Visa Europe became independent of Visa Inc, with an exclusive licence to operate in Europe. Visa Europe operates in 36 countries; however, Visa cardholders can use their cards in more than 200 countries worldwide. In addition, Visa/PLUS is one of the world's largest global ATM networks, offering cash access in local currency from more than 1.4 million ATMs globally.

Every year, Visa Europe facilitates 20 billion point of sale transactions. Its 4,000-plus member banks issue 400 million Visa-branded debit, credit and prepaid payment cards to European consumers. Each bank has access to the same powerful Visa brand, a range of products and services, marketing and other support, plus advanced technological systems to authorise, secure and process Visa transactions. Visa competes with rivals in electronic payments as well as with cash and cheques.

Product

From the creation of the credit card in 1958 through to the invention of the dial-up terminal, the move to magnetic stripe, the shift to chip and PIN and the creation of contactless payments, Visa has been at the forefront of change in the payments sector.

Today, recognising that every day and every person is different, Visa offers three cashless payment models to suit individual needs and circumstances: pay now – the debit card; pay later – the credit card, charge card and deferred debit card; and pay in advance – the prepaid card.

Achievements

Research conducted by Visa shows that consumers know, like and trust the brand, which is seen as setting the standard among its competitors. Indeed, in 2010 an independent survey of 23,000 Reader's Digest readers in Europe revealed Visa as the third most trusted brand in Europe and the most trusted of all financial service brands.

For its member banks, the strength of the Visa brand brings tangible business value. In the UK, for example, it is reported that Visa-branded debit cards generate seven times more international usage than other competitor-branded debit cards (Source: Apacs). The 2010 BrandZ report shows Visa to have leapt up 18 places since 2009 to 18th position, making it the highest riser in the group. Interbrand's 100 Best Global Brands list for 2010 also shows Visa as one of the five top risers, with its brand value up 26 per cent on the previous year's result.

Recent Developments

With its history as a pioneer in payment options, recent years have been as prolific as

1958	1976	1983	1986	1993	1999
Bank of America launches BankAmericard, the first successful general purpose credit card.	BankAmericard changes its name to Visa. Three years later Visa introduces the first point of sale electronic terminal.	Visa launches the world's first 24-hour ATM network. The following year the 'dove' hologram is introduced to cards for the first time.	Visa becomes the first card payment system to offer multiple currency clearing and settlement and begins its worldwide sponsorship of the Olympic Games.	Visa issues the first smart card to accrue loyalty points, plus corporate business and purchasing cards.	Visa conducts the world's first euro transaction using a payment card.

Life flows better with VISA — Proud Partner of the FIFA World Cup™

ever for Visa. Visa contactless removes the need to insert the card into a terminal and enter a PIN or provide a signature; transactions are completed in less than a second as cards are touched on a contactless reader.

Visa Mobile takes contactless technology further by allowing consumers to use mobile phones equipped with near field communication (NFC) technology to complete transactions, while prepaid Visa contactless combines the speed of contactless payments with the convenience of a prepaid card.

Visa has led an initiative to introduce integrated card payment technology into London's black taxis. Since December 2010 a growing number have been enabled, to allow passengers to pay their fare in the back of the cab by card via a PIN pad device that is connected to the taxi meter. Chip and PIN, contactless and magnetic stripe acceptance are fully supported.

Visa SimplyOne is a multi-application card combining a debit and credit card, which can be used at point of sale, online, over the phone and at ATMs. Visa SimplyOne is designed to give cardholders flexibility, allowing them to use different payment accounts on a single card.

In addition to these recent developments, Visa has also seen unprecedented and exponential

growth in the online shopping arena. In Europe, online shopping continues to rise with approximately 14 per cent of all spend using Visa products now done online. In 2010, UK shoppers spent £377 million over Christmas and Boxing Day with online sales accounting for nearly one-third of the total transactions.

Promotion

In 2008, Visa launched its 'Life flows better with Visa' campaign with the 'Running Man' TV commercial. It built on this equity with a campaign featuring dance and media artist 'Bill' in 2009, followed by 'Football Evolution' in 2010. A uniting theme across these spots is Visa's role as the enabler on these 'journeys', encouraging people to look at Visa in a new way – not just as a debit or credit card provider but as a trusted alternative to cash that can bring convenience to their lives.

2010 focused on leveraging Visa's sponsorship of FIFA, with a multi-media approach that went from TV to social media and everything in between. The activity spanned 18 markets with a range of brand and promotional activity to engage and incentivise its target audience.

This strategic direction has proved successful for Visa in driving advertising impact and during 2011 the Flow campaign will be developed further.

As 2012 approaches, Visa's sponsorship of the London Olympic and Paralympic Games provides the brand with an exceptional opportunity to drive its business across Europe.

Brand Values

Visa provides trusted services and products that facilitate millions of financial transactions every day. Visa aims to help life flow better by taking the friction out of those transactions, by providing a product that is safe, quick and easy to use, and accepted in more than 200 countries worldwide.

Visa's corporate ambition is to be the world's most trusted currency. Trust, simplicity, energy and progressiveness are values that the brand holds dear as it strives to be dynamic, reliable, purposeful, positive and an enabling force in people's lives.

Things you didn't know about Visa

During the period leading up to the FIFA World Cup™ kick-off through to the end of the tournament (1st June – 11th July 2010), spending by international visitors in South Africa on Visa payment cards exceeded US$312 million.

In the 12 months ending June 2010, Visa cards were used to make purchases and cash withdrawals to the value of more than 1.4 trillion euros.

£1 in every £4 is spent on a Visa card in the UK.

On the busiest shopping day before Christmas 2009, Visa Europe processed 894 transactions every second.

At point of sale, 12.5 per cent of consumer spending in Europe is with a Visa card and more than 70 per cent of that is on Visa debit cards.

It takes around 20 milliseconds for Visa to process a transaction.

2000	2004	2008	2010
A world first, Visa issues its one billionth card.	Visa is incorporated into Europe and becomes Visa Europe. The following year it revitalises its brand identity for the first time in its history.	Visa celebrates its golden anniversary. The following year Visa announces it is a presenting partner of Team 2012 – a group of 1,200 Olympic and Paralympic athletes in the UK, all striving to compete in London 2012.	Visa SimplyOne launches: two Visa payment applications on a card. The number of Visa contactless cards in circulation reaches 12 million.

wbs
WARWICK BUSINESS SCHOOL

Warwick Business School (WBS) is in the top one per cent of global business schools and has an ambition to be the leading university-based business school in Europe. Students come from more than 148 countries to learn at undergraduate, masters, MBA and PhD levels. The new WBS dean is now on a mission to publish leading-edge research; to produce world-class business leaders; and to provide a return on investment for students, alumni and sponsors.

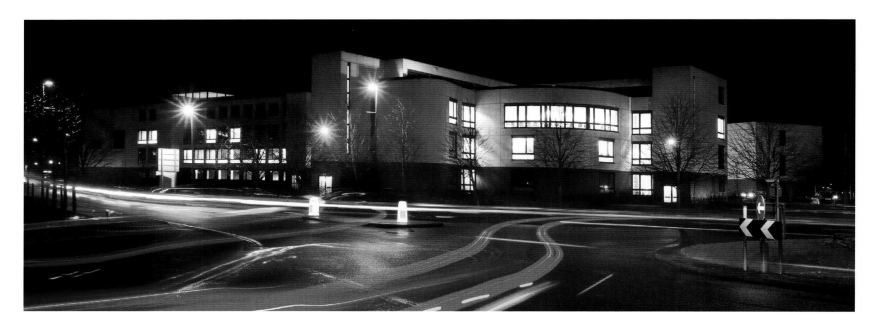

Market

There are numerous business schools across the world, all aiming to develop the next generation of business leaders. WBS is one of the largest in Europe, is in the world's top 40 (Source: The Economist 2010) and is in the top one per cent worldwide. As the largest department of the University of Warwick, WBS offers its students both excellent facilities and a prestigious reputation.

A high quality business education is valued by employers and employees alike; employers can gain competitive advantage by recruiting and developing talent with knowledge and critical thinking skills, while individuals can gain new options for career progression. With literally thousands of schools offering MBAs worldwide, the business school

market is incredibly competitive. To be a success and to attract successful people, a respected brand is required. In 1999, WBS became the first UK school to be endorsed by all three international business school accreditation schemes.

WBS academics produce world-leading research in all fields of management. With recognised research leaders across disciplines as diverse as behavioural science, innovation strategy, public sector governance, enterprise, knowledge management, business strategy and sports management, people go to WBS to explore grounded, well researched ideas that work in the real world. WBS research and expert opinion is valuable, sometimes crucial, to the success of corporations, not-for-profit organisations, the Government and society.

Product

WBS has something to offer individuals at every stage of their career and currently offers 27 courses to more than 7,000 students, 64 per cent of whom are from outside the UK. It provides a range of business and management undergraduate degrees; 10 specialist masters courses; a full-time MSc in Management; the unique Warwick Global Energy MBA as well as the popular and flexible Warwick MBA; its public sector equivalent, the Warwick MPA; and one of the world's most respected PhD programmes.

For corporate clients and individuals, it also offers a range of diplomas, short courses and customised programmes. WBS consults with industry to keep its programmes fresh, relevant and accessible. The fact that many graduates

1965	1981	1986	1989	1997	1999
The University of Warwick is founded by Royal Charter. In 1967 WBS is created as the School of Industrial and Business Studies, with just three courses.	The Warwick MBA brand is launched.	The Warwick MBA by distance learning launches.	WBS achieves five-star rating for research excellence.	On its 30th anniversary, WBS has 3,160 students, 263 staff and a turnover of £12.4 million.	WBS becomes the first business school in the UK to hold accreditation from all three global management education bodies: AMBA, EQUIS and AACSB.

return for further study at WBS later in their careers demonstrates its effective blend of academic research with the practicalities of the workplace. Learning by sharing experience and insight is key to the student experience at WBS. Alumni members, which number around 27,000, have cited the combination of a highly intelligent and internationally diverse cohort as being a major benefit of their learning experience as well as their future careers.

Achievements

WBS has achieved a global reputation for excellence in just 40 years. It has one of the broadest subject bases and most highly regarded faculty of any business school in the world. The most recent Research Assessment Exercise (December 2008) rated 75 per cent of WBS research at 3* and above, placing it third in the UK. WBS submitted 130 academics for assessment, a real reflection of high quality, running across the breadth and depth of research at WBS. These research credentials are fundamental to its culture and differentiate it from teaching colleges and commercial training companies.

The performance of its undergraduate degree programme continues to excel, ranking first in the 2011 Guardian University Guide, and its BSc in Accounting & Finance is number one in the 2011 editions of both The Complete University Guide and The Times Good University Guide.

In addition, its portfolio of 11 masters courses provides highly specialised learning in areas of business that are increasingly important in the search for sustainable competitive advantage.

More than 30 years of combined learning experience enables WBS to deliver the Warwick MBA to nearly 2,600 experienced managers each year, wherever they are in the world. In 2009, WBS launched the Warwick Global Energy MBA, a groundbreaking new programme that is developing strategic leadership for the future energy industry.

WBS – we look at things differently
wbs.ac.uk/go/different

Its long-standing commitment to work across the private, public and voluntary sectors created the Warwick MPA – the first MBA for the public sector in the UK.

The reputation of WBS means its graduates are highly sought after by business leaders and can be found in senior positions around the world. Its expertise is clear from its diverse list of clients and sponsors, including Accenture, The Bank of England, BP, Capgemini, Deloitte, Deutsche Post, E.ON, GlaxoSmithKline, HSBC, IBM, Islamic Bank of Britain, Johnson & Johnson, J.P.Morgan, The National Health Service, Nestlé, PepsiCo, Procter & Gamble, PZ Cussons, Rolls-Royce, Santander, Siemens, UBS Investment Bank, Unilever and Vodafone.

Recent Developments

WBS celebrated its 40th anniversary in 2007 and now has a turnover of £40 million. The course portfolio continues to refresh, expand and diversify with new MSc courses planned in both behavioural science and accounting.

WBS has an established Fund for Academic Excellence, which invests in future leaders, faculty and its learning environment. Since August 2003, the fund has helped to support many students, recruit 16 new professors and expand facilities with a £9 million building completed and £20 million earmarked for further development. WBS recognises that to retain competitive advantage, it is essential to continue to gain funding for growth.

Promotion

WBS maintains a solid global presence with a range of below- and above-the-line segmented

international marketing. September 2010 saw a major rebrand for WBS, with a fresh new look giving its promotional materials a contemporary and crisp feel while aligning it more closely with the University of Warwick.

WBS uses many creative advertising channels but ultimately, its highly successful graduates are its best adverts and advocates, with many returning for further study at WBS later in their career.

Brand Values

WBS has simple core values: excellence in all it does, nurturing fresh-thinking in staff and students, ensuring a positive impact from the ideas it creates, and continuing to be international and creative in outlook and approach. From these foundations WBS aims to continue to challenge minds, change lives and create tomorrow's leaders.

Things you didn't know about Warwick Business School

Professor Mark Taylor, the new dean of WBS, was previously a managing director at BlackRock and is one of the most cited researchers in the world for finance and economics.

WBS is culturally diverse; more than a third of faculty have qualifications from international institutions, have worked abroad, or hold non-UK or joint nationality.

In the last six months, the WBS bespoke online learning environment my.wbs has been accessed by 9,000 students and 1,500 members of staff from across the University.

WBS academics have written more than 120 books in the last five years and 2,254 papers in the last 12 months.

2003	2005	2009	2010
The Guardian survey of top employers rates WBS graduates as the most employable in the UK.	The launch of four new masters programmes takes the WBS masters portfolio to 11 courses.	The Warwick Global Energy MBA is launched.	WBS undergraduate courses are top-ranked in The Complete University Guide, The Times Good University Guide, and the Guardian University Guide.

WEBER SHANDWICK

Advocacy starts here.

Weber Shandwick is a full service public relations agency, helping clients to manage their reputation and achieve their business goals. Putting advocacy at the heart of all its work, its mission is to create an army of believers and fans for every client. The company's creative talent, communications expertise and specialist teams work for some of the biggest organisations and most innovative brands across the private, public and not-for-profit sectors.

Market

Despite the continued economic climate of the past 12 months, and against a backdrop of industry budget cuts, the UK public relations (PR) market continued to grow steadily in size and diversity in 2010.

With many companies and organisations continuing to switch their marketing resources from traditional advertising to PR, key growth areas for the industry in 2011 will include digital and social communications, public health, consumer and sports marketing, and corporate reputation.

The UK consultancy sector currently supports hundreds of marketing-orientated public relations firms, from one-man operations to UK-only agencies and international players.

Product

Internationally, Weber Shandwick maintains the largest public relations network in the world. With a core of 81 owned offices in 40 countries and affiliates that expand the network to 120 offices in 74 countries, Weber Shandwick operates in virtually every major media, government and business centre on six continents.

In the UK, Weber Shandwick has seven specialist practice groups in consumer marketing, digital and social media communications, technology PR, healthcare PR, financial communications, corporate communications and public affairs.

With eight regional offices in London, Manchester, Glasgow, Edinburgh, Aberdeen,

Inverness, Belfast and Dublin, it also offers cross-practice consultancy in multicultural and internal communications, crisis and issues management, corporate social responsibility, cleantech, strategic planning, lifestyle marketing, over-fifties marketing, broadcast PR, sports PR and market research.

Achievements

Weber Shandwick's focus on creating ambassadors and advocates for its clients has not gone unnoticed by its peers. In 2009 it was

recognised on an international level, winning a Silver Lion at the prestigious Cannes Lions International Advertising Festival and becoming the only UK PR firm to win a Cannes PR Lion award in both years since the programme launched in 2009.

Weber Shandwick was also named Global Agency of the Year by the UK Public Relations Consultants Association (PRCA), as well as International Consultancy of the Year by the Holmes Report – for the second consecutive year. In addition it was recognised as Public Relations Agency of the Year at the International Business Awards (The Stevies) and named Best Multinational Firm To Work For in EMEA by the Holmes Report.

In the UK alone, Weber Shandwick won more than 20 industry accolades for client work in 2010 including: Campaign of the Year at the UK PRWeek Awards; International Campaign of the Year at the PRCA Awards; PR Campaign of the Year at the International Business Awards; Best Public Affairs Campaign at the European Excellence Awards; and four European SABRE Awards including Best Multi-Cultural Communications Campaign.

Recent Developments

To build on its reputation for excellence in traditional PR, Weber Shandwick continues to invest in innovation and thought leadership, setting a new agenda for the future of the PR industry.

The recent launch of a dedicated Sport PR practice harnesses expertise from across the Weber Shandwick UK network and leverages

1974	1987	1998	2000	2001	2010
Shandwick International is founded in London with a single client and a global vision.	The Weber Group is founded in Cambridge, Massachusetts as a communications agency for emerging technology companies. In less than a decade it goes on to become a top 10 PR firm.	Shandwick International is acquired by The Interpublic Group.	Shandwick International merges with The Weber Group and becomes Weber Shandwick.	BSMG Worldwide merges with Weber Shandwick.	Weber Shandwick continues to win leading industry awards and is recognised for its work internationally.

SABRE Awards, INLINE Communications are not independent offline, online and experiential activities – but rather are campaigns that tell a consistent story across the spectrum of media that most influence the audience targeted.

Brand Values

Weber Shandwick's values are creativity, passion and commitment.

As one of the world's leading communications agencies, 2010 saw Weber Shandwick continue to grow, invest, innovate and prosper. It has continued to build on its reputation for excellence in traditional PR to set a new agenda for the future of the industry. The past 12 months have seen the company expand its global network, launch new products and services, invest in its people and win more industry awards than ever before.

the universal and emotional appeal of sport to help clients build their reputations and achieve their business goals. Achieving outstanding new business success within its first 12 months, the practice now works for numerous pan-European and national clients including Coaching for Hope, Foresters Friendly Society's sponsorship of Archery GB, World Series of Boxing, Rio Ferdinand Foundation, UFC and EMC's sponsorship of London Wasps RUFC.

Most recently, in the run up to the London 2012 Olympic and Paralympic Games an Olympics marketing offering has been added to the UK Sports PR practice, providing organisations and industry bodies with a unique insight into Games marketing, helping them to navigate the surrounding complexities. Specialist consultancy services include strategic communications planning, brand marketing, sponsorship activation, athlete profiling, digital communications, event management and community engagement.

Promotion

Following the launch of the 'Advocacy starts here' positioning in 2007, which illustrated the company's shift to communications programmes that forge emotional bonds and higher levels of involvement with stakeholders,

Weber Shandwick has continued to embed advocacy into all of its agency work with the aim of creating an army of believers and fans for every client.

Advocacy has quickly become the most influential channel and the most powerful force in business. A five-step Advocacy Ignition process is designed to increase positive recommendations for clients, based on the knowledge that real and virtual conversations between people are what truly influence the opinions and behaviours of individuals and communities. This single-minded focus on advocacy has helped cross-market collaboration and united global markets around a common methodology.

INLINE

Weber Shandwick has also continued to lead the way in digital excellence by providing INLINE Communications: simple and straightforward solutions to planning and executing 21st century public relations. Winner of Product of the Year at the 2010 European

Things you didn't know about Weber Shandwick

Part of the Interpublic Group of marketing companies, Weber Shandwick works closely with sister companies McCann Erickson (advertising), FutureBrand (branding consultancy), Jack Morton (event management) and Octagon (sports marketing) to deliver truly integrated client campaigns.

In 2010, European and UK CEO Colin Byrne was named one of GQ's Most Influential Men in Britain for the eighth consecutive year.

Organisations benefiting from Weber Shandwick's Making a Difference programme, which encourages its employees to do pro-bono and community relations work, have included The Moyer Foundation, World Wildlife Fund, Habitat for Humanity and War Child.

Founded in 1934 by the late William Hill, the eponymously named company has grown in stature and presence to dominate the UK betting industry and become a historic British brand. Today its operations cover three channels: online, telephone and high street shops. It boasts a 25 per cent share of the retail betting market with 2,300 shops in its estate, contributing to takings in excess of £15 billion during 2009.

Market

The UK gambling market is one of the most mature and stable industries in Britain, estimated to be worth around £2.5 billion in gross win. This figure is driven by revenue from betting shops (retail), telephone betting and online businesses based in the UK.

In the retail market five large high street players dominate: William Hill, Ladbrokes, Tote, Coral and Betfred which, combined, account for 80 per cent of all betting shops. William Hill is the largest, owning 25 per cent of all shops and reaching about 45 per cent of regular bettors.

In online betting, category leaders include William Hill, Ladbrokes, Totesport, Coral, Betfred, Boylesports and Betfair. According to recent data, 31 per cent of regular online sports bettors hold an account with William Hill (Source: Kantar October 2010).

Listed on the London Stock Exchange since 2002, the company employs more than 16,600 people in the UK, Ireland, Gibraltar, Israel, Bulgaria and Manilla.

Product

William Hill is one of the best known names in the market thanks to its in-depth knowledge of fixed odds betting and its customer service.

In retail it is investing in its estate and enhancing the range of products it offers as well as ensuring high quality customer service. The company has around 2,300 betting shops across the UK and Ireland, most of which are open seven days a week. Gaming machines

inside the shops offer customers roulette, slots and other random number generated events.

William Hill successfully extended its high street product to reach consumers around the world through internet betting and gaming. The online channel has been the focus of significant investment since William Hill Online was established in 2008. Developments keep pace with changing regulations and opportunities as more countries create a legal framework for online gambling.

William Hill's online Sportsbook now serves customers in more than 175 countries, in six languages and 11 currencies. Its gaming

website, meanwhile, offers casino, poker, bingo and skill games. William Hill launched online in Austria in 2010 with further launches being planned during 2011. The company is now among the top three gambling companies in Europe and approximately 40 per cent of its online revenues come from outside the UK.

Achievements

In 2010 William Hill won a number of accolades at the industry Betview Awards including Bookmaker of the Year, Chain of the Year and Manager of the Year. Its retail staff have also been finalists in the Racing Post Betting Shop Manager of the Year Awards each year since the accolade was created.

1934	1966	1971	1988	1998	2000
William Hill founds his business as a postal and telephone betting service.	The business buys into betting shops, and betting duty is imposed for the first time.	After William Hill's death the company becomes part of Sears Holding Group.	William Hill is merged with Mecca Bookmakers under the William Hill name. The following year the company becomes the world's largest credit betting operation.	William Hill goes online with the launch of the internet betting service, Sportsbook. The following year William Hill is sold to Cinven and CVC Partners for £825 million.	William Hill becomes the first major bookmaker to offer a deduction-free betting service to UK-based clients via the internet. The online casino also launches.

Recent Developments

William Hill's Sportsbook put emphasis on further improvements to its market-leading in-play service in 2010. William Hill Online now produces more pre-match and in-play markets on football matches than any of its market rivals; around 170 markets are offered before kick-off and up to 100 are available in-play.

In-play offerings are not restricted to football, however, with a wide range of sports betting opportunities available both pre-event and in-play for popular events such as cricket and golf, as well as for the more diverse sports of hurling and pool.

The boom in iPhone technology has seen investment from William Hill into new applications. December 2010 saw Shake-A-Bet come to market on the iPhone platform. The application allows William Hill mobile bettors a new way to find selections, where a 'shake' of an iPhone will find selections from the best-backed teams or horses and present users with a ready-made bet.

A joint project between Racing Post and William Hill, meanwhile, saw the introduction of another unique product in the mobile betting market. The iPhone app allows customers seamless betting on content from Racing Post, direct from William Hill.

Promotion

Online has emerged as the most rapid route to deliver products and services to millions of customers around the world, and the williamhill.com product offering has been transformed. Improved web content such as dedicated betting news, blogs and online radio allows William Hill to satisfy a new generation of internet user.

Outside the UK, the company's primary target remains Europe. Continuing 2010's initiatives to build the brand profile and use established and proven marketing channels to promote products remains key. At the same time,

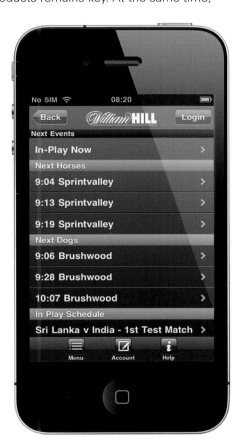

looking further abroad to opportunities outside Europe, where other countries are regulating online gambling, will remain on the agenda.

Brand Values

William Hill's position within the UK is secure; it is a trusted brand that has taken a natural place as 'The Home of Betting' with a heritage that spans more than 75 years.

The William Hill brand remains committed to offering unrivalled customer service. Its business culture is led by helping and understanding its customers, and it responds to their needs with a continually evolving suite of innovative products and services. William Hill's knowledge and expertise, along with its unparalleled range of betting and gaming opportunities, mean that customers have more choice on what to wager on than ever before.

Expansion and development will continue worldwide with changing technologies building the right products at the right time in the right place – on the high street, online, on the telephone and increasingly, on the move.

Things you didn't know about William Hill

William Hill paid out £8 million when Frankie Dettori rode seven consecutive winners at Ascot in 1996.

On an average Saturday, William Hill offers betting opportunities on more than 40,000 different markets.

In December 2010, the company took bets from residents in 140 countries.

In 2010 William Hill processed almost one million bets on a single day – for the Grand National.

2001	2002	2005	2008
In October betting duty is abolished and replaced by gross profits tax. Offshore telephone betting and internet Sportsbook operations are repatriated to the UK.	William Hill floats on the London Stock Exchange at an offer price of 225 pence per ordinary share.	William Hill buys the Stanley Leisure retail bookmaking operations in Great Britain, Northern Ireland, Republic of Ireland, Jersey and the Isle of Man.	William Hill combines its online business with purchased assets from Playtech, creating William Hill Online – the leading online gaming and sports betting business in Europe.

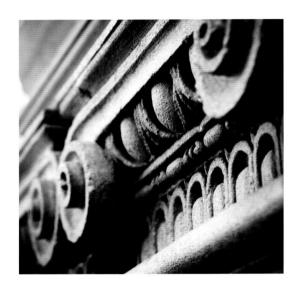
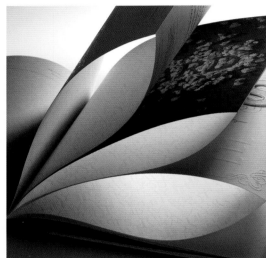
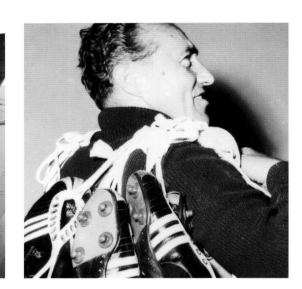

QUALITY RELIABILITY DISTINCTION

The Conversation Chasm

By Tim Bourne
CEO
exposure

What can Talkonomics teach us?

There is a chasm in modern marketing. The chasm exists between two different conversations. On the one hand, there are the conversations that brands are having with consumers (e.g. 'BMW is all about joy'). On the other, there are the conversations that consumers have with each other about brands (e.g. 'We've had our BMW for five years and it's been extremely reliable'). The content in each of these conversations is very different. The messages that brands send out are rarely the ones people talk about in ordinary conversations in their everyday lives.

This Conversation Chasm became clear to us as soon as we received the results back from the four-month 'Talkonomics' project that exposure conducted with The Centre for Brand Analysis. Talkonomics is a research platform that goes beyond the truism that word-of-mouth is the most powerful driver of brand behaviour, and seeks to examine what it is exactly that people say when they talk about brands. We developed a major, in-depth study into the issue of brand conversation and what motivates it. Over four months, blogs and online conversations were analysed alongside in-depth qualitative and quantitative research to give the most comprehensive picture yet of the real conversations that people have about brands.

Most simply we can tell the story like this. Traditionally, marketing has involved marketers conveying messages to their target audiences to create awareness, while also creating a brand image based upon an emotional hook targeted at our individual motivations – to look good, to seem clever, to belong to this social group, to be successful and so on. For example: 'Wear this dress and you'll look sexier', 'drink this and you'll belong', or 'this car will make you look cooler and more successful'. These appeal on an individual level. But the research indicates that what actually motivates real-world brand conversations are social drivers such as 'wanting to give good advice' and 'helping others'. Moreover, these more altruistic motivations for brand talk tend to focus more on tangible, evidence-based experiences of the brand such as usage, reliability, service encounters or product features.

It is clear that what people are talking about are the things that affect the daily lives of their friends, families and extended social circle. In general, talk of brands is not focused on advertising messages but on how – and which – brands deliver what it is that they need, be it something to improve their lives, save them money or make their lives easier.

When someone who is not a tech geek asks a more tech-savvy friend what computer to buy, the knowledgeable friend is not going to say, 'buy this brand because it's cool and sexy'. They will talk about how often it crashes, whether it is easy to use, whether the battery lasts – so that the recipient of the conversation can act according to evidence and usage and not brand image claims. As such, conversational exchanges are about the practical, the useful and the experience of usage. Yet these are not the things often focused on in social media or even conversational strategy. Isn't it about time in this age of the conversation economy that listening brands start to talk to consumers about the things consumers want to talk about?

In effect, marketing strategies and key messages around products often ignore what consumers are saying when talking about their brands. While it may be perfectly effective to maintain marketing activities such as celebrity

The Conversation Chasm

There is gap between the messages that marketing traditionally sends out to people and the things that people really discuss when talking about brands.

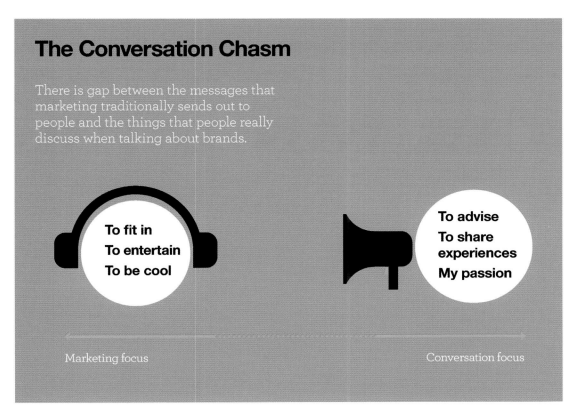

To fit in
To entertain
To be cool

To advise
To share experiences
My passion

Marketing focus

Conversation focus

is a step in understanding what these might need to be, and future iterations and investigations under the Talkonomics platform will explore these ideas in more detail and with specific application to particular brands and projects.

However, what is true for all brands, whether they are the Superbrands of today or the brands that will become the Superbrands of tomorrow, is that participating in consumer conversations requires a great deal more than merely sending out existing messages into the endlessly proliferating series of channels where people are talking. In real life, conversation follows a path that all participants determine, and you can only follow this path after you have done as much listening as talking. It feels as though, with the relatively recent rise of social media, brands have only just begun this process; but the Superbrands of the future will more than likely be those that are the best brand conversationalists.

endorsements and publicity stunts because they influence people's individual choices, it is no longer acceptable to pump these same stories in to the social conversations that brands take part in. High profile 'key influencers' are not what will drive word-of-mouth advocacy, however powerful they may be as individual motivators.

What is required to cross the conversational chasm? First of all, a recognition that brands need to segment their messaging – not just to different groups but also across the social–private divide. They need to align more tangible, usage-based messaging in the social sphere, and more image-based messaging when targeting individual motivations. These insights are of practical use to marketers and should be used in developing their strategies, messaging segmentations and even the allocation of their budgets. For example, a car can still be positioned as a thing of joy, but it needs an adjacent conversational strategy based on the tangible functional pillars that create that joy, i.e. reliability, safety, performance, in-car features and the like.

Marketers need to think more intelligently about how to get people who have tried their product to talk about it – not just through product trial but by effective after sales conversation that turns happy users into active advocates. Relevance is, as ever, key. What matters to a mid-20s male living in London is probably not what concerns a 50-something woman in Yorkshire. Take Land Rover, for instance. In Scotland, with its preponderance of country roads, principal concerns in conversation focus on reliability; whereas in London, where vehicles are used for shopping or school runs, design is most important. So Land Rover's marketing needs to reflect this.

We believe the findings of this first Talkonomics study have the potential to alter certain fundamental marketing paradigms, norms and beliefs. The one-size-fits-all brand message may continue to hold sway in the big broadcast occasions, but ordinary day-to-day conversations between human beings run a little deeper than that. In a more fragmented, digitally mediated, community-managed future, there is an ever more significant role for social and conversational strategies. Talkonomics

☐ **exposure**

exposure
exposure believes that for brands to succeed they need to have 'Never Ending Conversations' with their consumers. It believes this because in a world where social media is as influential as paid-for media, brands can't control conversations that are taking place about them; but they can influence them if... they make the right connections and create ongoing dialogue.

By creating and igniting this influence through its network of connections and the content it creates, exposure stimulates conversations for its clients to drive their business and brand growth.

Heineken, Martini, Coca-Cola, Dr. Martens, Claire's, Levi's® and Nike are a selection of exposure's current clients, for which it is busily creating 'Never Ending Conversations'.

exposure.net

Branding from the Front Line

**By Joshua Gilbertson
Commercial Director
Sandler Training**

Trust: hard to gain, easy to lose

The past decade has witnessed an erosion of consumer trust driven by the failings of both government and business. This loss of trust has inflicted widespread damage to corporate reputation. And few have escaped unscathed. In the UK, all of the dominant industry sectors score low on trust according to the latest Edelman Trust Barometer, especially banks and financial services.

Trust and transparency are now as important to corporate reputation as the quality of products and services that companies produce. In fact, trust has emerged as a key driver of business success. And those companies that recognise the importance of rebuilding this trust will reap the rewards.

But it's not going to be easy. Millions are spent on marketing in an attempt to create an emotional connection that will create a bond of trust. But consumers and business buyers alike have become increasingly hardened to advertising messages and sceptical of the promises made.

The point often overlooked in this exchange is that the most powerful emotional connection

comes not from what we say, but from what we do. And it's the people at the front line of the business – sales executives, account teams and customer relationship managers – that are charged with creating that trust and delivering on the promise.

But frontline employees must be equipped to develop trust with potential clients and customers while still growing the business. The attitude and outlook that companies and individuals adopt, the perception they have about their company and the product or service they are selling, and the market they are in will all shape how others see them.

A step-by-step plan is crucial to shaping a positive mindset, as is having a systematic approach in place that encourages the behaviours necessary to build trust. Without a defined plan, it is easy for those at the front line of the business to adopt an air of desperation and come across as overly pushy, scaring clients and prospects away.

Having strategies and tactics in place ensures they live up to brand values and avoid being perceived as the traditional sales person or free consultant – either becoming too forceful

and losing the sale or giving away hours of free consultancy but not closing.

A lack of process can trigger unease in potential customers or clients, leading to growing suspicion and distrust. And it won't be long before those at the front line start blaming the problem on changes in the market, lack of management support or ineffective marketing.

The way to avoid this scenario is to have consistent communication between what advertising and marketing are saying and what frontline people are doing.

Traditionally, advertising and marketing have focused on establishing an emotional connection to invite interest, while sales would champion features and benefits to rationalise and help close the deal. But to help the prospect discover both compelling emotional and rational reasons to do business with you, a bond of trust needs to be established first. Trust is the point where selling begins.

The challenge for those at the front line is to live up to the promises that the brand has made and deliver on them from a basis of trust. As trusted advisors they can help

Images: istockphoto.com © linearcurves

clients' and prospects' communication styles and then adapt their language to suit.

2. Establish an up-front contract

Ensure your people understand how to agree up-front what both they and the prospect want to achieve from the relationship. Ground rules establish behavioural boundaries, decision-making steps and the necessary actions that must be taken to fulfil those expectations.

3. Uncover and probe your prospect's 'pain'

People buy emotionally and make decisions rationally. One of the most intense emotions that people experience is pain – without uncovering the prospect's pain first there is no easy sale. Your people must know what series of questions will help prospects discover both the intellectual and emotional reasons to buy from your company and not the competition. People buy emotionally and justify this intellectually.

4. Get all the money issues out on the table

Not only address the cost of what they are selling but also highlight the cost to the prospect of doing nothing and the financial cost of the pain you have identified.

5. Discover your prospect's decision-making process

Show your people how to discover whether prospects and clients can make a decision to invest now independently or whether other people will be involved.

6. Present a solution that will solve your prospect's pain

Teach your people to be 'trusted advisors' and show them how to demonstrate to prospects and clients that your product or service can remove the specific pains they face. Prospects do not buy features and benefits; they buy ways to overcome or avoid pain to get to where they wish to be.

7. Reinforce the sale with a post-sale

Make sure they don't let the sale slip away. Make sure they have a post-sales step in place or they may find themselves being assaulted by your competitors before you secure the client or even during the relationship.

potential customers and buyers identify the problems that they in turn can help solve; through effective questioning, they can offer compelling, emotional reasons to buy now. Without trust this questioning will yield little or no results. People buy from people and brands they trust. And conversely, they are unlikely to reveal their problems and goals to those they don't.

Marketing communications and frontline interaction must work together to level the playing field. The front line must reinforce the initial brand promise and transform it into a two-way bond of trust that treats both buyer and seller equally.

At Sandler, we typically help clients achieve this transformation by developing their people against a 'seven step' process:

1. Establish rapport

Stop acting like a sales person. Prospects erect a defensive 'wall' if they think they are being sold to. Your people will get them comfortable by showing they understand their problems, from the prospect's perspective. Establish rapport and maintain this throughout the entire relationship. Teach your people to identify

Sandler Training
Finding Power In Reinforcement

Sandler Training

Working with FTSE 100 companies and entrepreneurs from across the globe, Joshua Gilbertson's agency provides innovative sales and sales management training and advanced diagnostic recruitment services. With clients ranging from the technology and new media sectors to financial and advertising houses, the company helps people to take charge of their sales and client development processes through a distinctive, non-traditional selling approach. Programmes are designed to create lasting 'performance improvement' rather than the motivational 'quick fix' typical of much seminar-based training, while behaviour and competency recruitment processes are designed to understand the company–employee match, reducing clients' risk of disappointment and ensuring candidates deliver.

londoncity.sandler.com

Join the Culture Club

By Adam Kaveney
Creative Director
The Writer

'But I already know how to write.' As somebody with more than a passing interest in brands (if you're reading this, brands probably pay your mortgage) you've heard that old chestnut before. Frustrating, isn't it?

The truth is that effective language can give your brand real power. The most successful brands use words to show their personality in everything they do. Yet our clients often come across the same obstacle: the rest of the company – finance, HR, PR, legal – just don't see why it should apply to them.

'Can't we just do what we've always done? Isn't it just something that the marketing people do?' Looking closely at the most successful brands, the answer to both questions is 'no'.

During my time at Virgin Mobile, I watched as a company grew from an idea on the back of a cigarette packet into a company worth nearly £1 billion, with five million customers. In seven years. It won an award for best customer service in its first year – and continued to do so year after year. And people were a huge part of the success. Virgin Mobile had always stuck firm to Richard Branson's mantra: happy people equals happy customers.

Culture was important at Virgin Mobile (and other Virgin brands), and words were a big part of that culture. They weren't just for the marketing stuff, but for the people, too. On letters from the HR team. On the intranet pages and internal email updates. Even in letters about employee share schemes and on the signs in the loos. And the team followed suit. They wrote emails, presentations, proposals – even updates about their IPO – in the same way. The brand came to life everywhere. It was real; the way things were done.

So it would seem that a good route to making your tone of voice stick is to make it a cultural thing. Bring it to life everywhere, and watch as it becomes part of your brand's DNA.

And now you're asking the obvious question: 'How?'

Resistance is fertile

Let's go back to the beginning of this article. You get it – and you'll probably have some people with a natural inclination towards all things wordy. But there's going to be a group who are worried about changing. 'Are we really allowed to do this? Will my clients still see me as professional?'

To win them over, you're going to need more than a set of guidelines. Changing the way people write is a big deal. Asking them to ditch business jargon and corporatespeak takes a massive cultural shift. People are understandably wary of abandoning the comfort of the familiar.

A great set of guidelines is clearly a good start – after all, you all want to know what you're aiming for. And they help explain the nuts and bolts of your approach. But when we're

working on a tone of voice project, we spend a lot of time with our clients up front, figuring out a plan to lift the principles off the page and get people using them.

Because what makes a successful tone of voice project – one that moves outside the brand team, into the rest of the business – is how well you support the cultural bit.

Use the carrot, not the stick
What you need to do is bring people along on the journey. The most likely cause of failure is enforcing a tone of voice on people. You're in a battle for hearts and minds – and the command-and-control approach, no matter what anybody says, is less successful than persuasion.

Luckily, there are six things you can do to get people on your side.

1. Call in the big guns
'I like it, but the boss won't.' It's a common objection, along with: 'Yes, but my clients are expecting something formal.' Our usual argument is to point out that you are just like your reader – and what would you prefer to read? Buzzwords and formality? Or something engaging and to-the-point?

But if that doesn't win them round, show them it's OK by leading by example. The most successful shift in perception we've had is with one client who had a super tone of voice. But it wasn't sticking as well as it could internally (what marketers call 'gaining traction'). When we won over their chief financial officer – and made him the biggest advocate – word spread like wildfire. If someone on the board was doing it, they could too.

2. Launch with a bang
We've seen brand triangles. Brand hexagons. We've even come across a 'brand pantheon' or two. And they're often accompanied by 70 pages of dense rules and regulations. Ditch them. If the first thing people see is a confusing set of guidelines and some abstract brand theory, they'll switch off.

Instead, start as you mean to go on. Get your CEO to do a video, backing the idea. Ask your clients to do the same. Write all your launch communications in your new tone of voice. Then invite people along to workshops, so they can try it out for themselves. Show them it's a big deal.

3. Do it everywhere
On the desk. In the car park. In the kitchen. One of the best ways to make your tone of voice stick is by using it everywhere, in the places people usually forget. We harass our clients until they give the 'tone of voice treatment' to meeting room signs, visitors' passes, the signs above the photocopier, the instructions for the microwave… It makes tone of voice a part of everyday life.

4. Hand over control
People often learn best from their peers. So set up a network of tone of voice coaches. Your project is more likely to be a success if people feel engaged – if they 'own' the process. So search out the best, most enthusiastic writers you've got, train them to be a supportive coach, and let them run the show.

5. Maintain the momentum
When your people have learned about your tone and they're on side, keep it fresh in their minds. Send them interesting emails about words each month. Arrange for guest speakers

to come in and talk about words. And arrange 'drop-in' clinics where they can come and get writing help and advice.

6. Keep doing numbers 1–5
If you don't keep the fire burning, don't be surprised when it fizzles out.

TheWriter™

The Writer
The Writer does three things:

1. **Thinking.** It helps people shape messages, stories and brands.

2. **Writing.** Everything from crisp packets to bids.

3. **Training.** It helps people become more effective, more confident, engaging writers.

The Writer is on a mission to fight against the lazy, the boring, the ineffective. To rescue its clients from the tyranny of corporatespeak. In its place, it helps people use words to change how people see them, to make and save them money, and to change how their people feel. And it does it with people like the BBC, Virgin, The Economist and Twinings.

thewriter.com

Images: istockphoto.com © Alan Merrigan

Culture Brands

By Anna Vinegrad
Head of Visual Arts & Culture
Idea Generation

What becomes of arts and culture in an age of austerity? This is the question many who work in the creative economy are asking in the wake of the Comprehensive Spending Review, which has cut the public subsidy for the arts across the sector by an average of just under 30 per cent. While this may not seem of immediate concern in a report such as this, the reality of the situation is that, now more than ever, there exists the opportunity for consumer brands to reach and directly engage with new and existing customers, partnering with artists and arts organisations in novel and exciting ways.

Alternative funding models

Arts & Business recently published a report in which they advocated the need to generate new revenue streams through better financial

management and more imaginative exploitation of cultural assets as well as measures to promote private and corporate giving to the arts. There are some interesting examples of alternative funding models already. Culture Label, an online venture that unites the retail outlets of 60 British arts institutions, allowing worldwide access to their products, aims to generate up to 30 per cent additional revenue for museums and galleries, while the Own Art scheme, an Arts Council initiative, offers an interest-free credit facility for the public to acquire works of art from around 200 UK galleries.

Culture vultures and branded culture

In the past decade, the so-called golden age of the arts in Britain has given rise to a public ever more engaged and hungry to consume 'culture' in all its guises, be that music, theatre, opera, museums or galleries. The British Museum attracted over five and a half million visitors in 2009, the festival landscape has grown exponentially, with some 450 music, literary and multiarts festivals taking place across the country each year, while the incredible success of Tate has seen it elevated to the status of a Superbrand in its own right. The good news is that consumers today are far more at ease with the idea of business supporting the arts. Research carried out by the Promise Corporation showed that while the public expresses concern about loss of artist integrity due to business interference, they feel that supporting the arts is essential and that business should benefit also from this support.

Equally, they appreciate the role that business plays in democratising the arts, and bringing them to a wider community.

This is not about a return to old-style corporate philanthropy. With the UK economy barely out of recession, the colder climate is not limited to the public sector. Marketing budgets have been shaved back and opportunities examined with a fresh eye with a renewed attention to ROI and the bottom line. Activity must resonate with and reference the brand, and be understood by the consumer. Yet logos and brand visibility per se no longer cut the mustard for anyone, business or consumers. The opportunity now is for brands to truly get under the skin of the arts, to activate from within and imperceptibly become part of that experience.

The power of immersion

From sponsorships to working with artists on major campaigns, brands have always engaged with the arts and artists, both drawing on and feeding the creative sector. But historically consumers were in large part passive receptors of the message, buying into the myths without participating in them. Enabled by technology, today's consumers are a far more savvy and sophisticated bunch.

Many corporations already recognise and draw on this, with user and open innovation strategies in place to tap into customer ideas and test and develop new products. Marmite engaged consumers in a bold and clever series

© Heidi Elainne for Spencer Tunick

of successful initiatives using social media, appointing the 'Marmarati' to advise on product development, and creating a love–hate party campaign during the general election. In the arts sector, audiences are similarly evolved, demanding more involvement and becoming protagonists in cultural events rather than simply viewers. Drinks brands have been ahead of the curve on this, with brands like Absolut continuing to build on their long history of credible collaborations with the arts to develop new initiatives, such as the Absolut Artists' Salon that ran over Frieze Weekend 2010.

Experiential and immersive are the new buzz words, now part and parcel of arts offerings and festivals across the country. Antony Gormley's commission for the Fourth Plinth in Trafalgar Square saw over 35,000 people applying for their hour on the plinth during 2009 and more than 500,000 unique users to the project website. Produced by Artichoke in collaboration with Sky Arts, the project was fantastically successful, achieving blanket media coverage and an enduring place in the cultural lexicon. Whether it's Punchdrunk's immersive theatre collaborations with everyone from Manchester International Festival to ENO to Kevin Spacey at the Old Vic Tunnels; Spencer Tunick's photographic choreography of mass nudity at The Big Chill; Rankin's live studio shoot where 1,000 eager volunteers instantly became part of his celebrity exhibition; or the Vauxhall Art Car Boot Fair, which annually sees hundreds of people queuing to buy collectable yet affordable art

from the likes of Sir Peter Blake and Gavin Turk: audiences enthusiastically participate in, and are hungry for, the interactive experience and the stamp of authenticity that this brings.

What this all adds up to is a perfect storm enabling consumer brands to use culture to connect with their customers in a cost-effective, credible and authentic way and become culture brands. It was these observations that led Idea Generation's associate director Kate Statham to set up a Brands & Partnerships department 18 months ago. The funding gap means that cultural institutions, creative communities and artists who previously relied on public sector funding, are all more receptive to the idea of collaborating with brands. Audiences are happy for brands to be involved, if this means that the arts will continue to thrive. This ticks a lot of boxes. Supporting creatives early on in their careers and connecting with them in a genuine way will generate loyal brand ambassadors to draw on for the future. The participatory aspect works well in terms of corporate social responsibility. The regional opportunity is particularly compelling, since this is both where funding will suffer most, and where consumers remain relatively deprived of and therefore eager for the kind of cultural experiences that are regularly on offer in the capital.

Kate Statham offers the following advice on how to become a culture brand:
- Develop a real understanding and empathy with the current arts and culture landscape (or work with someone who already has this).

- Identify which sectors and areas most align with your brand values and appeal to your brand's target audience (take advice from experts!).

- Engage the creatives in a direct and meaningful way – encourage dialogue and collaboration between them and your brand.

- Create innovative and exciting content that engages audiences with the brand and complements the creative vision/event.

- Continue to build and develop contacts to forge long-term, meaningful collaborative relationships.

© David Parry

Idea Generation

Founded in 2001, Idea Generation is one of the UK's leading arts, entertainment and cultural PR agencies. It is a multiservice agency with specialisms across visual arts & culture; film, media & performing arts; music & entertainment venues; and lifestyle & events, delivering projects such as Edinburgh Comedy Festival, The Big Chill, Clothes Show Live and the Vauxhall Collective for Vauxhall Motors.

Headed by Kate Statham, the Brands & Partnerships division specialises in creating high-impact cultural campaigns for some of the world's leading consumer brands. Its extensive network and original ideas have already combined to generate innovative campaigns for the likes of Absolut, Stella Artois, BA Metrotwin, Beck's and Skype.

ideageneration.co.uk

© Douglas Slowcombe

The Centre for Brand Analysis

The Centre for Brand Analysis (TCBA) manages the research process for all Superbrands programmes in the UK. It compiles the initial brand lists, appoints each Expert Council and manages the partnership with the panel providers, whose panels are used to access consumer or business professionals opinion.

About TCBA

TCBA is dedicated to understanding the performance of brands. There are many ways to measure brand performance. TCBA does not believe in a 'one size fits all' approach; instead it offers tailored solutions to ensure the metrics investigated and measured are relevant and appropriate. Its services aim to allow people to understand how a brand is performing, either at a point in time or on an ongoing basis, and gain insight into wider market and marketing trends. Services fall into three categories:

Brand analysis – principally measuring brand strength and/ or values. This might require surveying the attitudes of customers, opinion formers, employees, investors, suppliers or other stakeholders.

Market analysis – for example, providing intelligence, trends and examples of best practice from across the globe.

Marketing analysis – reviewing brand activity including campaign assessment; image/brand language assessment; marketing/PR review; agency sourcing and ROI analysis.

TCBA works for brand owners and also provides intelligence to agencies and other organisations. It utilises extensive relationships within the business community and works with third parties where appropriate.

tcba.co.uk

THE CENTRE FOR
BRAND
ANALYSIS

Superbrands
Selection Process

The annual Consumer Superbrands and Business Superbrands surveys are independently administered by The Centre for Brand Analysis (TCBA). Brands do not apply or pay to be considered; rather, the selection processes are conducted as follows:

• TCBA researchers compile lists of the UK's leading business-to-consumer (B2C) and business-to-business (B2B) brands, drawing on a wide range of sources, from sector reports to blogs to public nominations. From the thousands of brands initially considered, between 1,200 and 1,600 brands are shortlisted for each survey.

• Each shortlist is scored by an independent and voluntary Expert Council, which is assembled and chaired by TCBA's chief executive. Each survey has a separate council, refreshed each year. Bearing in mind the definition of a Consumer Superbrand or a Business Superbrand, the council members individually award each brand a rating from 1–10. Council members are not allowed to score brands with which they have a direct association or are in competition to, nor do they score brands they are unfamiliar with. The lowest scoring brands (approximately 40 per cent) are eliminated after each council has ratified the scores.

• The remaining brands are voted on by a YouGov panel. For the Consumer Superbrands survey, the panel comprises a nationally representative sample of more than 2,000 British consumers aged 18 and above. For the Business Superbrands survey, the panel comprises 2,000 individual business professionals – defined as those who have either purchasing or managerial responsibilities within their organisation.

• For the Consumer Superbrands survey, the number of consumer votes received by each brand determines its position in the final rankings. For the Business Superbrands survey, the views of the council and the business professionals are taken into equal account when determining each brand's position in the official league table. In both cases, only the top 500 brands are deemed to be 'Consumer Superbrands' or 'Business Superbrands'.

Definition of a Superbrand:

All those involved in the voting process bear in mind the following definition:

'A Consumer Superbrand or Business Superbrand has established the finest reputation in its field. It offers customers significant emotional and/or tangible advantages over its competitors, which customers want and recognise.'

In addition, the voters are asked to judge brands against the following three factors:

Quality. Does the brand represent quality products and services?

Reliability. Can the brand be trusted to deliver consistently against its promises and maintain product and service standards at all customer touch points?

Distinction. Is the brand not only well known in its sector but suitably differentiated from its competitors? Does it have a personality and values that make it unique within its marketplace?

Superbrands
Expert
Councils

Stephen Cheliotis
Chairman, Expert Councils
and Chief Executive,
The Centre for Brand Analysis (TCBA)

In 2007, Stephen founded TCBA, which is dedicated to understanding the performance of brands and runs the selection process for Superbrands' annual UK programmes.

Stephen works with a variety of brands and agencies on brand, market and marketing analysis whilst delivering brand insights at conferences and for international media.

Business Council

Jaakko Alanko
Chairman, McCann
Enterprise

Starting out in advertising with McCann Erickson in Finland, Jaakko moved to the company HQ in New York before switching to B2B marketing and establishing Anderson & Lembke in London. In 2001 he merged the agency with McCann Erickson and launched McCann Enterprise. His focus is on Enterprise Branding: the belief that an organisation whose people are emotionally and behaviourally aligned has a competitive edge.

James Ashton
City Editor, The Sunday
Times

James writes for the business pages of The Sunday Times on a range of companies and sectors as well as writing the Inside the City column. He joined from the Daily Mail in October 2007, where he was chief city correspondent, and has also written for The Scotsman and Reuters.

Richard Bush
Founder & CEO, Base
One Group

Richard is the driving force behind the international, multi-disciplined B2B specialist agency Base One Group. In addition, he is a regular presenter at the Institute of Direct Marketing, and writes and speaks on occasion for a number of industry publications and institutions, including B2B Marketing, the Internet Advertising Bureau and the Association of Business-to-Business Agencies.

Chris Cowpe
Partner, The Caffeine
Partnership

Chris is a co-founder of Caffeine, an international consultancy specialising in helping companies, brands and people to grow. Its services include business development for professional service organisations, brand development, and internal engagement and coaching/training. Previously he worked for more than 30 years in advertising, latterly as joint chief executive of DDB (formerly BMP/DDB).

Steve Dyer
Managing Director,
Clockwork IMC

Steve founded Clockwork IMC, a dedicated B2B integrated agency, in 1993. He has more than 20 years' B2B agency experience, supporting various industrial, technology and professional service brands. A strategic communications marketer, he has helped to develop and drive a number of industry initiatives while on the DMA's B2B Committee, and as a past vice chair of the Association of Business-to-Business Agencies.

Paul Edwards
Chairman,
TNS-Research
International UK

Paul joined Research International UK in 2007. Prior to this he was group chief executive and chairman for Lowe & Partners, taking particular responsibility for serving clients' integrated marketing needs. He has also been chairman and chief executive of The Henley Centre, working on future strategic direction for a wide range of clients.

Pamela Fieldhouse
Managing Director,
International Corporate
Communications, FD

Pamela is a senior communications consultant with more than 20 years' experience in corporate reputation, issues and crisis management, brand strategy, change management and business communications. She provides strategic counsel to senior executives from both the public and private sector and currently advises clients across a wide range of industry sectors.

Clamor Gieske
Manager, Vivaldi
Partners London

Clamor manages the UK office of Vivaldi Partners, a global management consultancy headquartered in New York. He has a mix of international experience from working on strategy, innovation, marketing and brand consulting projects. This has involved him advising clients across the UK and Europe but also in countries as diverse as Saudi Arabia and Russia.

Richard Glasson
Former Chief Executive,
GyroHSR

Richard is the former chief executive of GyroHSR, the world's leading specialist B2B marketing agency, which works with top brands such as Virgin Atlantic, American Express, Sony and Hewlett-Packard. Richard left in 2010 after eight years with the company. Prior to GyroHSR, he had been an investor in and director of a number of fast-growth companies across a range of B2B sectors including IT and recruitment.

Joanna Higgins
Consultant Editor
and Writer

Joanna has been a business writer and editor for more than 15 years, most recently launching an award-winning business website for CBS Interactive. Before that, she was group editor of the Institute of Directors' publications, editing Director magazine and overseeing the development of new editorial products including a leisure and lifestyle title, After Hours.

Steve Kemish
Director, Cyance Limited

Steve has more than 13 years' experience in digital marketing. Having worked client-side in both B2B and B2C, he offers considerable expertise in consulting, training and lecturing, and is chair of the IDM Digital Council. He has worked on digital marketing and strategy with global brands including Cisco, ITV, IoD, npower, Skype, BBC, British Airways and Oracle, and has spoken widely on the subject of digital marketing.

Darrell Kofkin
Chief Executive, Global
Marketing Network

Darrell is chief executive of Global Marketing Network, the worldwide membership association for marketing and business professionals. It is supported by a world-class Global Faculty comprising many of today's widely respected and most-published marketing thought leaders. Darrell also regularly speaks, lectures and writes on the subject of global marketing strategy.

Ardi Kolah
CEO, Guru in a Bottle

Ardi is a commercially astute senior executive with strong strategic communication experience and a successful track record of managing communications with multi-disciplinary teams. With both client and international agency experience, Ardi is a recognised management author and currently runs a specialist communication company working with some of the world's leading organisations.

Clive Mishon
Chairman, Pulse Group
and Institute of
Promotional Marketing

Clive has worked with promotional agencies for more than 25 years. In 1988 he acquired Marketing Drive, which was sold successfully in 1998. In 2001 he set up Mentor Marketing & Investment, supporting businesses that include Kitcatt Nohr Alexander Shaw, Pulse Group, Evoke and Mtivity. Clive became chairman of the Institute of Promotional Marketing in 2006 and currently sits on the Advertising Association Council.

Vikki Mitchell
Director, BPRI Group

Vikki specialises in branding, positioning and creative development research. Passionate about handling technically challenging issues on a global scale, she has particular interest in the Asian components of projects where her foreign language skills can be usefully employed. Vikki is on the board of the BIG Group, which represents the business-to-business research and market intelligence services.

Ruth Mortimer
Associate Editor,
Marketing Week

Ruth is associate editor for Marketing Week. In addition to her current role, she often appears on CNN, Sky and the BBC as an expert on business issues and is author of two books about marketing effectiveness. She is also a regular speaker at marketing conferences.

Andrew Pinkess
Director of Strategy
& Insight, Lost Boys
International (LBi)

Andrew has 20 years' experience in brand, advertising, digital and marketing consultancy. His specialisms include brand strategy and development; digital strategy; integrated communications; branded content and social media. His client experience spans business-to-business, business-to-consumer and the public sector.

Russell Place
Chief Strategy Officer,
UM London

Russell has worked at UM for seven years, creating ROI-focused, award-winning work for clients such as Sky, Autoglass®, Nickelodeon and Bacardi – and has overseen UM London's wider awards success in recent years. He has also led a number of highly successful new business initiatives, most recently the £13 million UK Dairy Crest win.

Shane Redding
Managing Director, Think Direct

Shane is an independent consultant with more than 20 years' international direct marketing experience. She provides strategic marketing advice and practical training to both end-users and DM suppliers. Shane has also been awarded an IDM honorary fellowship and is co-founder of the digital and direct B2B agency Cyance.

Elizabeth Renski
Editor, CEO Today

Elizabeth, who has 13 years' experience in the B2B magazine publishing sector, became the editor of CEO Today in 2004, shortly after its launch. Elizabeth is also the editor of Climate Change – an ambitious publishing initiative providing a platform for collaboration between governments, businesses and NGOs in tackling climate change and creating a low-carbon economy.

Gareth Richards
CEO, Ogilvy Primary Contact

Following a PhD in Biochemistry, Gareth has more than 20 years' experience in B2B marketing communications with spells on both the agency and client sides of the business. He runs B2B agency Ogilvy Primary Contact, and is client service director for UPS, Syngenta and FM Global.

Damon Segal
Founder & Managing Director, Emotio Design Group

Coming from a traditional marketing and design background, Damon built his first website in 1996 and has remained heavily involved in online design, development and marketing ever since. He is a founder member of the Advisory Council for the Global Marketing Network, an advisor for the BPP/ARU/GMN Global Marketing Practice MSc, and speaks professionally for organisations including the Academy for Chief Executives.

Matthew Stibbe
Writer-in-Chief, Articulate Marketing

Matthew runs Articulate Marketing, a specialist marketing and copywriting agency that helps high-technology companies and government communicate with customers, citizens and employees. Clients include Hewlett-Packard, Microsoft, VeriSign, NetJets and several government departments. He also writes the popular blog BadLanguage.net.

David Willan
Chairman, Circle Research

A co-founder of BPRI (now part of WPP), David has worked in B2B marketing research for more years than he's prepared to admit to. A frequent contributor to the likes of B2B Marketing, David is also a guest speaker at Ashridge Business School. He is currently chairman of B2B marketing research agency Circle Research and works as a practitioner in branding, development and customer relationship management.

Chris Wilson
Managing Director, Earnest

Chris has spent 15 years in B2B marketing, working with some of the world's largest brands in the technology, telecommunications and financial sectors. Chris founded the agency Earnest in 2009 to help B2B marketing step out of the shade and stop being a poor cousin to FMCG. Chris also chairs the Association of Business-to-Business Agencies.

Simon Wylie
Co-Founder, Xtreme Information

Simon co-founded Xtreme Information (which merged with Ebiquity plc in 2010) and has more than 20 years' experience within the field of advertising, media intelligence, research and insight. Throughout this period he has worked with major global brands as well as a number of European NGOs, the European Commission and other regulatory bodies.

Consumer Council

Niku Banaie
Global Chief Innovation
Officer, Isobar

Niku joined Isobar, one of the leading full-service digital networks, in June 2008. Prior to this he was the youngest partner at Naked Communications. He has created award-winning work for Nokia, Honda, Orange, E4 and Nike among others.

Nick Blunden
UK CEO, Profero
London

Nick joined Profero London as client services director in 2004, successfully developing relationships with Apple, Mini, COI and J&J. In 2007 he became MD, leading further expansion of core disciplines – media, advertising and technology – and in 2010 he was appointed UK CEO, responsible for all the UK businesses.

Tim Britton
Chief Executive, UK,
YouGov

Tim has almost 20 years' experience working directly and indirectly in the research industry in the UK, culminating in his current role as chief executive of YouGov UK. His experience in research is both on and offline, in areas ranging from financial services through business-to-business research, to work on public policy.

Vicky Bullen
CEO, Coley Porter Bell

Vicky has spent her career in the design industry, becoming chief executive of Coley Porter Bell in 2005. There she leads work for many of the world's largest brand owners, including Unilever, Nestlé, Coca-Cola and Pernod Ricard. She won a Design Effectiveness Award and a Marketing Grand Prix for Kotex. Vicky also sits on the Ogilvy UK Group Board.

Colin Byrne
CEO, UK & Europe,
Weber Shandwick

Colin is one of the UK's leading PR practitioners, with more than 20 years' experience spanning domestic and international media relations, politics, global campaigns and issues management. Colin joined Weber Shandwick in 1995 and is now CEO of the global agency's European network and a member of the global management team.

Vikki Chowney
Editor, Reputation
Online

Vikki is editor of Reputation Online, the latest addition to the new media age family at Centaur Media. Before this, Vikki worked as a freelancer, spending time at Contagious Magazine and writing a weekly tech column for BitchBuzz.com. A G20 Voice blogger at the recent London and Pittsburgh Summits, her work has featured on the Global Cool blog, Mobile Industry Review and within Marketing Week.

Jackie Cooper
Founding Partner,
Jackie Cooper PR

Jackie is one of the pre-eminent voices and influencers in UK brand marketing today. Jackie sold Jackie Cooper PR to Edelman in 2004 and now serves as creative director and vice chair of Edelman. She continues to deliver strategically powerful campaigns across the myriad of Edelman practices.

Stephen Factor
Managing Director,
Global Consumer
Sector, TNS

At the beginning of 2006, Stephen took global responsibility for the FMCG business of TNS, supporting the world's leading brand owners in 70 countries. With some 25 years' experience in global market research agencies, he blends hands-on corporate management experience with a deep understanding of FMCG markets and brands.

Avril Gallagher
Group Client Managing
Director, EMEA,
Starcom MediaVest
Group

Avril joined Starcom MediaVest Group in 2004 as a business director, was appointed UK client services director in 2005 and client managing director in 2006, extending her role to cover business in EMEA in 2007. She was appointed to her current role – group client managing director, EMEA – in 2009.

Cheryl Giovannoni
President, Global Key
Client Relationships,
Landor Associates

As president of Landor's global key client relationships, Cheryl is a leading presence in the branding community and a strong advocate for the transformational power of design in building brands. Having run the London office of Landor, as well as the European network during the last five years, Cheryl has expertise across a diverse portfolio of corporate, service and fast-moving consumer brands.

Paul Hamilton
Managing Director,
Addiction London

Paul started his advertising career at D'Arcy before moving on to M&C Saatchi to run the Direct Line, Lucozade Sport, RBS and Trinity Mirror accounts. He later moved to Chick Smith Trott before joining Addiction London as managing director. The agency currently retains the Remington, Chupa Chups and Krispy Kreme accounts amongst others.

Martin Hennessey
Founder, The Writer

Martin is founder of language consultancy, The Writer. The Writer is on a mission to rescue business and brands from the tyranny of linguistic mediocrity. Martin is also co-founder of not-for-profit organisation 26.org.uk.

Graham Hiscott
Deputy Business Editor,
Daily Mirror

Graham was appointed consumer editor of the Daily Express in March 2005. In March 2008 he moved to the Daily Mirror as deputy business editor, covering City as well as consumer stories. A string of exclusives earned Graham the London Press Club's Consumer Journalist of the Year award in 2007.

Mike Hughes
Director General, ISBA

Following a career in marketing and general management at Coca-Cola, Guinness and Bulmer, Mike assumed his current role as director general of ISBA, The Voice of British Advertisers, in 2007. A member of all key UK industry bodies, Mike also sits on the executive committee of the Worldwide Federation of Advertisers.

Lucy Johnston
Founder, The Neon
Birdcage

Lucy is a curator and innovation strategist, consulting for a wide range of leading brands and organisations including Google, Levi's®, Courvoisier, Coca-Cola, London 2012 and Edelman. She founded The Neon Birdcage in July 2009, as a curation platform to promote creative talent and effervescent thinking across the consumer brand industries and beyond.

Paul Kemp-Robertson
Editorial Director &
Co-Founder, Contagious
Communications

Paul co-founded Contagious in 2004. This quarterly magazine, online intelligence resource and consultancy service reports on marketing innovation and the impact of new technologies on brands. Paul has written articles for numerous publications, co-edited D&AD's The Commercials Book, appeared on BBC radio and frequently speaks at advertising conferences around the world.

John Mathers
Managing Director,
Holmes & Marchant

John joined Holmes & Marchant in late 2009 as the group's managing director, prior to which he held senior roles at The Brand Union, Fitch and Blue Marlin. An active member of the design industry, John was president of the Design Business Association for three years and still works with the Design Council.

Toby Moore
Founding Partner,
Mesh Marketing

Toby is a founding partner of Mesh Marketing, one of the UK's leading and fastest growing shopper marketing agencies, which specialises in helping FMCG and retail brands to convert shoppers into buyers.

Marc Nohr
Managing Partner, Kitcatt Nohr Alexander Shaw

Marc is a founding partner of integrated agency Kitcatt Nohr Alexander Shaw. Four-times winner of Agency of the Year, the agency's clients include Waitrose, John Lewis, Lexus, Toyota and NSPCC.

Julian Pullan
Executive Vice President & Managing Director, EMEA, Jack Morton Worldwide

Julian is executive vice president and managing director of brand experience agency Jack Morton Worldwide, EMEA. Rated among the top global marketing service agencies, Jack Morton integrates live and online experiences, digital and social media, and branded environments that engage consumers, business partners and employees for leading brands worldwide.

Crispin Reed
Managing Director, Brandhouse

Crispin has a rounded perspective on brands having worked in leading global advertising and design agencies, brand consultancy and client-side in the fragrance and beauty sector. In addition to his current role, Crispin is an associate of Ashridge Management College and sits on the Advisory Boards of the Global Marketing Network and the Branded Content Marketing Association.

James Sanderson
President, Digitas London

James has spent the last 15 years navigating the digital communications landscape with some of the world's largest clients. In the mid-1990s he helped start up digital agency DNA, moving on to interactive TV consultancy Smashed Atom in 2000. He joined Glue London in 2002, progressing to group COO. He joined Digitas London in 2009 as president, leading its work on multiple P&G brands, Nissan, Shell, Body Shop and Samsung.

Tom Savigar
Partner, The Future Laboratory

Tom is a partner at The Future Laboratory and joined the business in 2005. He is director of the company's bespoke client projects and services. Clients include American Express, Louis Vuitton, Laurent-Perrier, Absolut, Lamborghini, Marks & Spencer, British Gas, Coca-Cola and Vogue. Tom also presents at conferences worldwide on subjects such as the future of ecommerce, retail, luxury, marketing and branding.

Raoul Shah
Joint CEO, exposure

Raoul is a visionary strategic thinker with more than 20 years' experience in marketing and communications. In 1993 he launched exposure, a business built on the power of network and word-of-mouth. Today, the agency employs more than 200 individuals in London, New York, San Francisco and Tokyo. Clients include Coca-Cola, Vitamin Water, Levi's®, Nike, Umbro, Dr. Martens, Microsoft, Edun, Hunter and Globe-Trotter.

Professor Robert Shaw
Honorary Professor, Cass Business School and Director, Value Based Marketing Forum

As a consultant, businessman and best-selling author of Marketing Payback, Improving Marketing Effectiveness, and Database Marketing, Robert is a top authority on value-based marketing and customer relationship management. He is in demand both in the UK and overseas as a conference chairman and keynote speaker and also teaches on in-company executive education programmes.

Andrew Walmsley
Digital Pluralist

Andrew co-founded digital agency i-level in 1999 and built it to more than £100 million turnover, winning a Queen's Award for Enterprise and achieving Agency of the Year eight times, before selling to private equity in 2008. He is now an investor, active non-exec and advisor to a number of companies seeking success in the digital economy.

Mark Waugh
Global Managing Director, Newcast, ZenithOptimedia Worldwide

Mark advises worldwide clients on communications solutions that go 'beyond advertising' – branded content, short- and long-form ad-funded programming, and experiential marketing. This scope, coupled with his experience across almost every market category, from motors to luxury goods to FMCG, gives him a unique perspective on what exactly it is that can make a brand 'Super'.

About YouGov

YouGov – What the world thinks

YouGov is the authoritative measure of public opinion and consumer behaviour. It is YouGov's ambition to supply a live stream of continuous, accurate data and insight into what people are thinking and doing all over the world, all of the time, so that companies, governments and institutions can better serve the people that sustain them.

YouGov's full service research offering spans added value consultancy, qualitative research, field and tab services, syndicated products such as the daily brand perception tracker BrandIndex, and fast turnaround omnibus.

YouGov's sector specialist teams serve financial, media, technology and telecoms, FMCG and public sector markets.

In the UK, YouGov operates a panel of over 250,000 members representing all ages, socio-economic groups and other demographic types, with excellent response rates. The quality of its panel allows YouGov to access difficult to reach groups, both consumer and professional.

YouGov has developed an extensive B2B offer, owing to its ability to access thousands of business decision makers on its panel. Clients can research specialist markets or get an overview with the YouGov Small Business Omnibus, a fast, cost-effective way of interviewing 500 decision makers of small businesses every week.

YouGov dominates Britain's media polling and is one of the most quoted research agencies in the UK. Its well-documented track record demonstrates the accuracy of its survey methods and quality of its client service work.

YouGov Panels are accessed to survey British consumers and business executives as part of the selection process. More details on the full research methodology can be found on page 182.

Tim Britton
Chief Executive, UK

yougov.co.uk
info@yougov.co.uk
+44 (0)20 7012 6000

YouGov®
What the world thinks

Superbrands
Results Highlights
2011

By Stephen Cheliotis
Chairman, Expert Councils
and Chief Executive,
The Centre for Brand Analysis

INTRODUCTION

The annual Consumer Superbrands and Business Superbrands surveys aim to identify the UK's strongest business-to-consumer (B2C) and business-to-business (B2B) brands, respectively, from a wide variety of sectors and industries. Both processes are subjective and take into account the views of a relevant council of experts together with those of consumers and potential consumers of those brands. The research is commissioned by Superbrands (UK) Ltd and for the past five years, has been independently managed by The Centre for Brand Analysis (TCBA).

Whilst the final results for Consumer Superbrands are generated entirely from the views given by the British public, for Business Superbrands the final rankings are determined by a combination of the views given by its Expert Council and more than 2,000 business professionals with purchasing or managerial responsibility. When ranking the brands in both the Consumer and Business Superbrands surveys, all participants are asked to judge against the following three criteria: quality, reliability and distinction. Numerous Superbrands studies have concluded that these three factors are vital for a brand to be a 'Superbrand' and also essential for generating positive word-of-mouth.

As ever, neither Superbrands survey solicits entries; rather, in order to find the best all of the key brands are incorporated into the research, regardless of their interest in being involved or not. From the thousands of brands initially considered in both processes, only the top 500 in each are deemed to be Superbrands. Both top 500 lists are featured in this book, as are case studies that shed light on the stories and achievements of many of those brands.

This article highlights the overall winners in both surveys, together with some of the biggest movers and shakers. TCBA creates bespoke presentations to provide further insights into the performance of specific brands over the years and analyses the patterns and trends within specific categories.

For full details of the selection process, see page 182.

CONSUMER SUPERBRANDS

As ever, this year's Consumer Superbrands results and rankings feature a combination of consistency and volatility. As in previous years, those at the top tend to be the more consistent. These significant and well-regarded brands are seeing relatively small shifts in sentiment towards them.

In terms of the top 10 Consumer Superbrands, eight of the 10 remain the same as last year. This year's top six all featured in last year's top 10, although their order has changed. Notably this is the first time in five years that the top spot has not been taken by either Microsoft or Google. The software giant was number one in 2006/07, 2007/08 and 2009/10, with search leviathan Google leading the pack in 2008/09.

Microsoft, whilst still performing incredibly strongly in sixth place, sits in its lowest position over the five-year period. Equally Google, whilst moving back above Microsoft this year to sit in fifth, experiences its worst performance in four years – in the previous three years it finished in third, first and third.

Moving Microsoft and Google aside is Mercedes-Benz, which takes pole position for the first time. That said, its five-year record is very impressive, consistently finishing in the top 10. Its five-year record (working back from 2011) is first, sixth, third, ninth and fourth.

Other brands retaining their top 10 berths include Rolex, the BBC, Coca-Cola, British Airways and Apple. Despite both the BBC and British Airways coming under scrutiny and having their fair share of bad publicity, both again prove the doubters wrong by preserving their place in the hearts and minds of the British public. Indeed, the BBC is a picture of strength and consistency, having placed in the top five for the last five years. Equally, the consistent top 10 ranking of British Airways really does defy the many problems it has experienced; although this is its worst performance in five years, taking eighth place is hardly bad!

The two brands in last year's top 10 that fail to retain their placing in the top echelon are LEGO® and Encyclopaedia Britannica; the former falls to 16th, continuing its year-on-year rise and fall between the top 20 and the top 10 over the five-year period. The latter falls to 30th, which might seem to be a disappointing result but is in fact still a very credible performance; its three-year record is 30th, 10th and 29th.

CONSUMER SUPERBRANDS 2011 – OFFICIAL TOP 20

Rank	Brand	Category	2010 rank	Year-on-year change
1	Mercedes-Benz	Automotive – Vehicle Manufacturer	6	↑ 5
2	Rolex	Watches & Accessories	2	—
3	BBC	Media – TV Stations	5	↑ 2
4	Coca-Cola	Drinks – Carbonated Soft Drinks	7	↑ 3
5	Google	Internet – General	3	↓ 2
6	Microsoft	Technology – Computer Hardware & Software	1	↓ 5
7	BMW	Automotive – Vehicle Manufacturer	16	↑ 9
8	British Airways	Travel – Airlines	4	↓ 4
9	Apple	Technology – Computer Hardware & Software	9	—
10	Jaguar	Automotive – Vehicle Manufacturer	21	↑ 11
11	Marks & Spencer	Retail – General	13	↑ 2
12	Royal Doulton	Household – General	33	↑ 21
13	Dulux	Household – General Consumables	15	↑ 2
14	Duracell®	Household – General Consumables	12	↓ 2
15	AA	Automotive – General	43	↑ 28
16	LEGO®	Leisure & Entertainment – Games & Toys	8	↓ 8
17	Virgin Atlantic	Travel – Airlines	11	↓ 6
18	Royal Albert Hall	Leisure & Entertainment – Destinations	36	↑ 18
19	Guinness	Drinks – Beer & Cider	31	↑ 12
20	Thorntons	Food – Chocolate & Confectionery	45	↑ 25

The two brands entering the top 10 this year are both automotive brands, in the form of BMW and Jaguar. Both brands have been entrenched in the top 40 over the five-year period with Jaguar never far from the top 10. This is the first time, however, that the British marque has entered this elite group, although it is the second appearance for BMW.

As always, the top 10 brands as voted by the Expert Council – whose ratings determine the top 60 per cent of brands from the initial shortlist that then go through to the final consumer vote – differ markedly to the consumer top 10. Indeed, aside from Google and Microsoft, the only other brands to feature in both top 10s are the BBC and Coca-Cola. Making the Expert Council top 10 but not the consumer top 10 are Dyson, Manchester United, Nike, John Lewis, Facebook and YouTube. The consumer positions for these brands are Dyson in 31st; Manchester United, 73rd; Nike, 32nd; John Lewis, 21st; Facebook, 133rd; and YouTube, 151st. As can be seen, the difference in opinion between the experts and the public is particularly marked for the online brands.

Back to the consumer voting results and in the official top 500 the highest new entry is Beechams, entering in 72nd place; the brand has featured in the top 100 in the past but was not put forward by the Expert Council last year. Other high new entries are Glenmorangie (which was considered in the process for the first time), and travel brands Thomson Holidays and P&O Cruises. Thomson Holidays did not make it past the council vote in the last two years but its new brand-led advertising is clearly having the right effect on the experts. In regards P&O Cruises, this is the first time it has been considered in the process, although P&O Ferries was in the top 500 last year.

Some of the biggest fallers in the overall list include Original Source, Kiehl's and L'OCCITANE.

CONSUMER SUPERBRANDS 2011 – CATEGORIES REPRESENTED IN THE TOP 500

Category	Number of brands in the top 500	Category leader	Category leader's rank
Food – General	55	Kellogg's	26
Toiletries & Cosmetics	42	Gillette	95
Retail – General	30	Marks & Spencer	11
Pharmaceutical	24	Beechams	72
Clothing & Footwear	23	Levi's®	52
Drinks – Spirits	21	Glenfiddich	47
Technology – General	19	Bang & Olufsen	40
Food – Chocolate & Confectionery	18	Thorntons	20
Household – Cleaning Products	17	Fairy	23
Household – Appliances	16	Dyson	31
Household – General	14	Royal Doulton	12
Drinks – General	13	Robinsons	55
Drinks – Beer & Cider	12	Guinness	19
Financial	12	Visa	92
Leisure & Entertainment – Games & Toys	12	LEGO®	16
Media – Newspapers & Magazines	11	National Geographic	121
Automotive – Vehicle Manufacturer	10	Mercedes-Benz	1
Drinks – Coffee	10	Twinings	39
Leisure & Entertainment – Destinations	10	Royal Albert Hall	18
Restaurants & Coffee Shops	10	Starbucks	113

BUSINESS SUPERBRANDS

As in Consumer Superbrands, this is the first time since 2007 that the Business Superbrands ranking has not been headed up by Microsoft or Google.

Microsoft took the number one spot in 2010, with Google topping the rankings in 2008 and 2009. Before either brand panics, however, Microsoft remains in third and Google in fourth, so it's hardly a catastrophic drop. We did predict last year that both brands might have reached their zenith and could start to slowly decline; this has been borne true but the

question now is whether we are proved wrong and both brands bounce back or whether they slide again next year.

Taking the top spot this year, as we last year predicted it might, is one of Britain's few remaining global engineering success stories: Rolls-Royce Group. Having occupied second place for the last two years – and having been in the top 10 every year since 2007 – it finally takes the number one position. BlackBerry also rises one position from last year, moving from third into second.

Mimicking Consumer Superbrands, eight of this year's top 10 also featured in last year's top 10. This shows that whether operating in the B2B or B2C space, the possession of a powerful brand creates a huge barrier to others; these brands are clearly extremely hard to dislodge and their consistently strong performance shows how highly regarded they are.

As well as Microsoft, Google, Rolls-Royce Group and BlackBerry, the other brands in that B2B power eight are the London Stock Exchange, accountancy and consulting giant

BUSINESS SUPERBRANDS 2011 – OFFICIAL TOP 20

Rank	Brand	Category	2010 rank	Year-on-year change
1	Rolls-Royce Group	Aerospace & Defence	2	↑ 1
2	BlackBerry	Electronic & Electrical Equipment	3	↑ 1
3	Microsoft	Software & Computer Services	1	↓ 2
4	Google	Media – Marketing Services – Advertising Solutions	5	↑ 1
5	Apple	Technology – Hardware & Equipment	18	↑ 13
6	London Stock Exchange	Financial – Exchanges & Markets	6	—
7	PricewaterhouseCoopers	Support Services – Accountancy & Business Services	10	↑ 3
8	GlaxoSmithKline	Pharmaceuticals & Biotech	7	↓ 1
9	Visa	Financial – Credit Cards & Payment Solutions	9	—
10	Bosch	Construction & Materials – Tools/Equipment	13	↑ 3
11	Shell	Oil & Gas	12	↑ 1
12	FedEx Express	Industrial Transportation – B2B Delivery Services	24	↑ 12
13	Nokia	Electronic & Electrical Equipment	19	↑ 6
14	Virgin Atlantic	Travel & Leisure – Airlines	4	↓ 10
15	Vodafone	Telecommunications – Mobile & Online	22	↑ 7
16	Ernst & Young	Support Services – Accountancy & Business Services	21	↑ 5
17	DHL	Industrial Transportation – B2B Delivery Services	37	↑ 20
18	Boeing	Aerospace & Defence	23	↑ 5
19	Hertz	Travel & Leisure – Automobile Rental	15	↓ 4
20	UPS	Industrial Transportation – B2B Delivery Services	48	↑ 28

PricewaterhouseCoopers, pharmaceutical goliath GlaxoSmithKline and payment processors Visa. Five of the eight were also in the top 10 two years ago, namely Google, Microsoft, Rolls-Royce Group, GlaxoSmithKline and PricewaterhouseCoopers.

The two brands entering the top 10 this year are Apple – which was 18th last year and has been in the top 20 for the past five years – and Bosch, which was 13th last year.

Conversely, falling out of the top 10 this year are the two airlines: Virgin Atlantic and British

Airways. The former falls to 14th this year, a drop of just 10 positions, whilst the latter falls further, to 48th. The British Airways brand is clearly finally suffering in the B2B space, contrary to its position in the Consumer Superbrands survey in which it has retained its top 10 position. Of course, as the airline makes considerable revenue from its business and first class travel offerings, this is extremely worrying.

Looking at the difference of opinion between the views of the Expert Council and those of the business professionals, their top 10s contain

only five of the same brands: BlackBerry, Microsoft, Google, Rolls-Royce Group and Visa. Those making the council's top 10 but not the professionals' are Apple, the London Business School, eBay, Bosch and Vodafone. Conversely, the brands in the professionals' top 10 but not the council's are the London Stock Exchange, Shell, GlaxoSmithKline, PricewaterhouseCoopers and Boeing.

In the wider B2B list the biggest fallers are JCB and NETJETS, falling 263 and 235 places, respectively. Big risers include TotalJobs.com, which climbs 223 places; business information

BUSINESS SUPERBRANDS 2011 – CATEGORIES REPRESENTED IN THE TOP 500

Category	Number of brands in the top 500	Category leader	Category leader's rank
Technology – Hardware & Equipment	27	Apple	5
Support Services – Associations & Accreditations	22	The Law Society	77
Industrial Engineering – General	20	Siemens	29
Support Services – General	20	RAC	100
Construction & Materials	16	Pilkington	43
Retailers – Office Equipment & Supplies	16	Staples	98
Support Services – Information Providers	16	Bloomberg	63
Executive Education, Training & Development	15	London School of Economics and Political Science	23
Financial – Banks	15	Deutsche Bank	80
Media – Trade Publications	15	The Grocer	148
Pharmaceutical & Biotech	15	GlaxoSmithKline	8
Support Services – Consultancies	15	IBM Global Services	107
Travel & Leisure – Business Hotels	15	Hilton	39
Aerospace & Defence	14	Rolls-Royce Group	1
Construction & Materials – Tools/Equipment	12	Bosch	10
Insurance & Risk Management	12	Lloyd's of London	37
Software & Computer Services	12	Microsoft	3
Support Services – Recruitment	12	Reed	145
Support Services – Legal	11	Clifford Chance	184
Utilities	11	EDF Energy	136

group Informa, which rises 220 places; Henderson Global Investors, also jumping 220 places; and the FSC (Forest Stewardship Council), which rises 216 positions. Also bouncing back after a big fall last year is credit rating agency Moody's, climbing 212 positions.

High new entries include The Met Office, which has jumped straight into 156th position, and Virgin Media Business, which comes straight into the rankings at number 172. Other big new entries are American Express Travel, which is in 265th place, and Associated British Ports, which has come in at 334th.

SUMMARY

This year we have seen a new brand crowned number one in both the Consumer and Business Superbrands rankings, with Mercedes-Benz and Rolls-Royce Group taking the helm, respectively. Conversely, falling from the top perch is Microsoft. Despite this shift at the summit of the surveys the overall top 10 and indeed top 50 in each ranking remain relatively stable, with the vast majority of the leading brands once more reaffirming – and in many cases extending – their advantage over rivals.

As has been the case in the last few years, beyond the group of leading brands there is a great deal of movement at both an overall and sector level. As in previous years, TCBA will be exploring some of these underlying trends and changes, along with specific brand shifts, with brand owners and marketing services agencies. In the meantime we hope that this overview and the top-line rankings prove to be of interest once again.

stephen.cheliotis@tcba.co.uk

Qualifying Business Superbrands

3	CARPHONE WAREHOUSE	GULFSTREAM	MARSHALLS	SCOTTISH EXHIBITION AND
3I	CASIO	HANSON	MASSEY FERGUSON	CONFERENCE CENTRE (SECC)
3M	CASS BUSINESS SCHOOL	HAPAG-LLOYD	MASTERCARD	SCOTTISH HYDRO
AA	CASTROL	HARGREAVES LANSDOWN	MCAFEE	SCOTTISH POWER
ABB	CATERPILLAR	HARRIS	MCCANN-LONDON	SCREWFIX
ABTA	CB RICHARD ELLIS	HARROGATE INTERNATIONAL CENTRE	MCKINSEY & COMPANY	SECURITAS
ACCA	CBI	HAY GROUP	MEDIACOM	SERCO
ACCENTURE	CBS OUTDOOR	HAYS	MERCK	SEVERN TRENT WATER
ACCOUNTANCY AGE	CEMEX	HEATHROW EXPRESS	MERRILL LYNCH	SHANKS GROUP
ACER	CHARTERED MANAGEMENT INSTITUTE	HEIDRICK & STRUGGLES	MICHAEL PAGE INTERNATIONAL	SHARP
ADDISON LEE	CHI & PARTNERS	HENDERSON GLOBAL INVESTORS	MICROSOFT	SHELL
ADECCO	CHUBB	HENLEY BUSINESS SCHOOL	MICROSOFT ADVERTISING	SIEMENS
ADOBE	CIMA	HERTZ	MILLENNIUM	SIMMONS & SIMMONS
ADT	CIPD	HILL & KNOWLTON	MILLWARD BROWN	SIR ROBERT MCALPINE
AEGON	CISCO	HILTON	MINDSHARE	SKANSKA
AIM	CITI	HISCOX	MINTEL	SKF
AIRBUS	CITY & GUILDS	HITACHI	MITIE	SKYPE
AKQA	CITY LINK	HOGAN LOVELLS	MITSUBISHI ELECTRICS	SLAUGHTER & MAY
AKZONOBEL	CLEAR CHANNEL OUTDOOR	HOLIDAY INN	MONSTER	SMITH & NEPHEW
ALCATEL-LUCENT	CLIFFORD CHANCE	HONEYWELL	MOODY'S	SMITHS
ALLEN & OVERY	CLOSE BROTHERS	HOOVER'S	MORGAN STANLEY	SMITHS NEWS
ALLIANCE HEALTHCARE	COMPASS GROUP	HOWDENS JOINERY	MOTOROLA	SMURFIT KAPPA
ALLIANZ INSURANCE	CONQUEROR	HP	NATIONAL	SNAP-ON
ALSTOM	CONSTRUCTION NEWS	HRG (HOGG ROBINSON GROUP)	NATIONAL EXPRESS	SODEXO
AMD	CORUS	HSBC	NATIONAL GRID	SOIL ASSOCIATION
AMEC	COSTAIN	HSS HIRE	NATWEST	SONY PROFESSIONAL
AMERICAN EXPRESS	COSTCO	IBIS	NEC	SOPHOS
AMERICAN EXPRESS	CRANFIELD SCHOOL OF MANAGEMENT	IBM GLOBAL SERVICES	NICEDAY	SOUTHERN ELECTRIC
BUSINESS TRAVEL	CREDIT SUISSE	ICAEW	NIELSEN	STAEDTLER
ANGLO AMERICAN	CROWN TRADE PAINTS	IMPERIAL COLLEGE BUSINESS SCHOOL	NOKIA	STAGECOACH
APPLE	CROWNE PLAZA	INGERSOLL RAND	NORTHROP GRUMMAN	STANDARD & POOR'S
ARCHITECTS' JOURNAL	D&B	INITIAL	NORTON	STANLEY
ARRIVA	DATAMONITOR	INMARSAT	NORTON ROSE	STAPLES
ARUP	DE LA RUE	INTEL	NOVARTIS	STRUTT & PARKER
ASHRIDGE BUSINESS SCHOOL	DE VERE VENUES	INTERBRAND	NOVO NORDISK	SWISS RE
ASSOCIATED BRITISH PORTS	DELL	INTERLINK EXPRESS	NOVOTEL	SWISSPORT
ASTRAZENECA	DELOITTE	INVENSYS	NPOWER	SYMANTEC
ATKINS	DESIGN WEEK	INVESTEC	NYSE EURONEXT	TARMAC
AVERY	DEUTSCHE BANK	INVESTORS IN PEOPLE	O2	TETRA PAK
AVIS	DEWALT	IOD	OFFICE ANGELS	THALES
AVIVA	DHL	IPSOS MORI	OFFICE DEPOT	THAMES WATER
AXA	DOW CHEMICALS	J.P. MORGAN	OGILVY & MATHER	THE BALTIC EXCHANGE
AXA PPP HEALTHCARE	DOW CORNING	J.P. MORGAN CAZENOVE	OLYMPUS	THE CO-OPERATIVE BANK
BAA	DRAPER	JANES	OPODO	THE FAIRTRADE FOUNDATION
BABCOCK INTERNATIONAL	DRAPERS	JC DECAUX	ORACLE	THE GROCER
BAE SYSTEMS	DTZ	JCB	ORANGE	THE ICC BIRMINGHAM
BAIN & COMPANY	DULUX TRADE	JEWSON	OXFORD BLACK N' RED	THE LAW SOCIETY
BAKER TILLY	DUPONT	JOHN LAING	OYEZ STRAKER	THE LAWYER
BALFOUR BEATTY	DURHAM BUSINESS SCHOOL	JOHNSON & JOHNSON	PA CONSULTING	THE MET OFFICE
BARCLAYCARD	E.ON UK	JOHNSON MATTHEY	PANASONIC	THE NEC BIRMINGHAM
BARCLAYS	EADS	JOHNSTONE'S TRADE PAINTS	PARCELFORCE WORLDWIDE	THE OPEN UNIVERSITY
BASF	EALING STUDIOS	JONES LANG LASALLE	PARK PLAZA	BUSINESS SCHOOL
BASILDON BOND	EASYJET	KALL KWIK	PAYPAL	THE QUEEN ELIZABETH II
BAYER	EBAY	KC	PC WORLD BUSINESS	CONFERENCE CENTRE
BBH	EDDIE STOBART	KIDDE	PEARL & DEAN	THISTLE
BDO	EDF ENERGY	KIER GROUP	PFIZER	THOMSON LOCAL
BELL POTTINGER	EDINBURGH INTERNATIONAL	KIMBERLEY-CLARK PROFESSIONAL	PHILIPS MEDICAL SYSTEMS	THOMSON REUTERS
BG GROUP	CONFERENCE CENTRE (EICC)	KING STURGE	PHS GROUP	THYSSENKRUPP
BHP BILLITON	EGON ZEHNDER INTERNATIONAL	KITEMARK	PILKINGTON	T-MOBILE
BIFFA	ELI LILLY	KNIGHT FRANK	PINEWOOD STUDIOS GROUP	TNS-RESEARCH INTERNATIONAL
BLACK & DECKER	ELSTREE STUDIOS	KONICA MINOLTA	PINSENT MASONS	TNT
BLACKBERRY	ENTERPRISE	KORN/FERRY WHITEHEAD MANN	PITNEY BOWES	TOMTOM
BLOOMBERG	EPSON	KPMG	PITMAN TRAINING	TOSHIBA
BLUE ARROW	EQUIFAX	KROLL	PORTAKABIN	TOTAL
BMI	ERICSSON	KUEHNE & NAGEL	POW WOW	TOTALJOBS.COM
BNP PARIBAS	ERNST & YOUNG	LAFARGE	PRATT & WHITNEY	TRAFFICMASTER
BOC GASES	ESTATES GAZETTE	LAING O'ROURKE	PREMIER INN	TRAVELEX
BOEHRINGER INGELHEIM	EUROPCAR	LAND SECURITIES	PRESS ASSOCIATION	TRAVELODGE
BOEING	EUROSTAR	LATEROOMS.COM	PRICEWATERHOUSECOOPERS	TRAVIS PERKINS
BOMBARDIER	EUROTUNNEL	LAZARD	PRONTAPRINT	UBS
BOOKER	EVERSHEDS	LENOVO	PRUDENTIAL	UNIPART
BOOZ & CO.	EXCEL LONDON	LETTS	QINETIQ	UNISYS
BOSCH	EXPERIAN	LEWIS SILKIN	RAC	UNITED BUSINESS MEDIA
BOSTON CONSULTING GROUP	EXPERIAN HITWISE	LEXISNEXIS	RADISSON EDWARDIAN	UNITED UTILITIES
BOURNEMOUTH	EXXON MOBIL	LEXMARK	RAMADA JARVIS	UNIX
INTERNATIONAL CENTRE	FEDERATION OF SMALL BUSINESSES	LEYLAND TRADE PAINTS	RAYTHEON SYSTEMS	UPS
BRISTOL-MYERS SQUIBB	FEDEX EXPRESS	LG	REED	VENT-AXIA
BRITISH AIRWAYS	FIRST	LINKEDIN	REED ELSEVIER	VEOLIA ENVIRONMENTAL SERVICES
BRITISH DENTAL ASSOCIATION	FLIGHT INTERNATIONAL	LINKLATERS	REGUS	VIKING
BRITISH GAS BUSINESS	FLYBE	LLOYD'S OF LONDON	RENTOKIL	VIRGIN ATLANTIC
BRITISH GYPSUM	FREIGHTLINER	LLOYDS TSB	RETAIL WEEK	VIRGIN MEDIA BUSINESS
BRITISH LAND	FRESHFIELDS BRUCKHAUS DERINGER	LOCKHEED MARTIN	REXAM	VIRGIN TRAINS
BRITISH RETAIL CONSORTIUM	FREUD COMMUNICATIONS	LOGICA	REXEL	VISA
BROTHER	FSC	LOGITECH	RIBA	VODAFONE
BRUNSWICK	FTSE	LONDON BUSINESS SCHOOL	RICS	WALES MILLENNIUM CENTRE
BSI	FUJITSU	LONDON CITY AIRPORT	RIO TINTO	WARWICK BUSINESS SCHOOL
BT	FUJITSU TECHNOLOGY SOLUTIONS	LONDON SCHOOL OF ECONOMICS	ROCHE	WEBER SHANDWICK
BUDGET	G4S	AND POLITICAL SCIENCE	ROLLS-ROYCE GROUP	WESTFIELD
BUILDING	GALLUP	LONDON STOCK EXCHANGE	ROYAL MAIL	WICKES
BUPA	GARMIN	LONMIN	RS COMPONENTS	WINCANTON
BUSINESS DESIGN CENTRE	GATWICK EXPRESS	M&C SAATCHI	RSA	WOLFF OLINS
CABLE & WIRELESS	GE	MAERSK LINE	RYMAN	WOLSELEY
CALOR	GENERAL DYNAMICS UK	MAGNET TRADE	SAATCHI & SAATCHI	WOOLMARK
CAMBRIDGE JUDGE BUSINESS SCHOOL	GETTY IMAGES	MAKRO	SAGE	XEROX
CAMPAIGN	GFK NOP	MALMAISON	SAID BUSINESS SCHOOL,	XSTRATA
CANARY WHARF GROUP	GKN	MAN GROUP	UNIVERSITY OF OXFORD	YAHOO! NETWORK
CANON	GLAXOSMITHKLINE	MANCHESTER AIRPORTS GROUP	SAINT-GOBAIN	YALE
CAPGEMINI	GOLDMAN SACHS	MANCHESTER BUSINESS SCHOOL	SAMSUNG	YELLOW PAGES
CAPITA	GOOGLE	MANPOWER	SANOFI-AVENTIS	ZENITHOPTIMEDIA
CARBON TRUST	GRANT THORNTON	MARKETING	SAP	ZURICH
CARILLION	GREAT PORTLAND ESTATES	MARKETING WEEK	SAVILLS	
CARLSON WAGONLIT TRAVEL	GROSVENOR	MARRIOTT	SCHRODERS	

Please note that some brand names have been changed since the research was conducted. These lists reflect the brands as they are generally marketed (at the time of going to press) and may differ slightly from the name analysed in the survey.